Neo-Baroque Aesthetics and Contemporary Entertainment

Media in Transition

David Thorburn, *series editor*
Edward Barrett, Henry Jenkins, *associate editors*

Neo-Baroque Aesthetics and Contemporary Entertainment

Angela Ndalianis

The MIT Press
Cambridge, Massachusetts
London, England

This book was set in Perpetua on 3B2 by Asco Typesetters, Hong Kong, and was printed and bound in the United States of America.

Library of Congress Cataloging-in-Publication Data

Ndalianis, Angela, 1960–
 Neo-Baroque aesthetics and contemporary entertainment / Angela Ndalianis
 p. cm. — (Media in transition)
 Includes bibliographical references and index.
 ISBN 0-262-14084-5 (hc. : alk. paper)
 1. Motion pictures. 2. Mass media. 3. Mass media—Technological innovations.
4. Cinematography—Special effects. 5. Civilization, Baroque. 6. Video games.
I. Title. II. Series.
PN1995.N374 2004
791.43—dc22 2003059383

10 9 8 7 6 5 4 3 2 1

Contents

Illustrations

Series Foreword

David Thorburn, *editor*
Edward Barrett, Henry Jenkins, *associate editors*

New media technologies and new linkages and alliances across older media are generating profound changes in our political, social, and aesthetic experience. But the media systems of our own era are unique neither in their instability nor in their complex, ongoing transformations. The Media in Transition series will explore older periods of media change as well as our own digital age. The series hopes to nourish a pragmatic, historically informed discourse that maps a middle ground between the extremes of euphoria and panic that define so much current discussion about emerging media—a discourse that recognizes the place of economic, political, legal, social, and cultural institutions in mediating and partly shaping technological change.

Although it will be open to many theories and methods, three principles will define the series.

- It will be historical—grounded in an awareness of the past, of continuities and discontinuities among contemporary media and their ancestors.
- It will be comparative—open especially to studies that juxtapose older and contemporary media, or that examine continuities across different media and historical eras, or that compare the media systems of different societies.
- It will be accessible—suspicious of specialized terminologies, a forum for humanists and social scientists who wish to speak not only across academic disciplines but also to policymakers, to media and corporate practitioners, and to their fellow citizens.

Neo-Baroque Aesthetics and Contemporary Entertainment by Angela Ndalianis

This book explores the resemblances between the baroque art and music of the seventeenth century and the media forms of the late twentieth century. The baroque project

of creating environments in which the sacred could be imagined and experienced, Ndalianis argues, has a partial counterpart in the ambition of many contemporary entertainment forms to explore the future or to create alternative worlds. Focusing on such elements as seriality, spectacle, reflexivity, and immersion, Ndalianis sees continuities in eras that are often described in terms of their innovations. Rejecting the conventional separation of high and popular culture, the book examines such contemporary forms as comic books, amusement park rides, video games, and movies and invites us to reconsider the art, music, architecture, and theater of the seventeenth century.

Acknowledgments

My gratitude is extended to a number of individuals. First and foremost, I thank Vivian Sobchack, who supervised this project in its previous life as a dissertation. Her inspired thinking and guidance encouraged me to challenge myself and to engage critically and creatively with the ideas I developed in this book. I am also grateful to Henry Jenkins for his unflagging faith in what I had to offer, and for his invaluable advice and support. Thanks go to those who have read and commented on pieces of this work at various stages, including Roger Benjamin, Adrian Martin, Mark MacDonald, and, in particular, Lisa Beaven. I am especially indebted to Jim Collins and Scott Bukatman, who gave valuable critical responses to an earlier draft of this material as a doctoral thesis. I must also emphasize how fortunate I have been to have had valuable feedback from the MIT Press readers of this book. Their suggestions and criticisms ranged from the insightful to the enlightened, often opening up new directions that were a delight to follow. I am also grateful to all the following colleagues and friends for their critical input, and for putting up with my ramblings about neo-baroque spectacle, computer games, and theme park rides over the last few years: Felicity Colman, Leonie Cooper, Carmel Giarratana, Charlotte Henry, Alison Inglis, Shirley Law, Margaret Manion (whose faith in me has never faltered), Anne Marsh, David Marshall, Simon McLean, Mehmet Mehmet, Sue Russell, and Saige Walton. Thanks also to my family—with special mention of the squirts Zoe and Amelie—who put up with me and saw me through some of my more eccentric moments while working on this project.

In addition, I especially acknowledge the encouragement and kind support of the Australian Academy of the Humanities for awarding me a publication subsidy grant. I am also indebted to the following institutions and individuals for their invaluable assistance and for granting permission to reprint images from their collections gratis: Roger Stoddard and Denison Beach (Houghton Library, Harvard University); Kathy Wheeler (Universal Studios, Orlando); David McKee (Universal Studios, Manchester);

Michael Gilligan (Universal Studios, Japan); Fox Studios; Sony Interactive Entertainment America, Inc.; and Sierra Entertainment, Inc. I also acknowledge the support of the following publishers for permission to reprint portions of previously published materials: "The Rules of the Game: *Evil Dead II* . . . Meet Thy Doom" in *Hop on Pop: The Politics and Pleasures of Popular Culture* (ed. Henry Jenkins, Tara McPherson, and Jane Shattuc, 2002); "Architectures of the Senses: Neo-Baroque Entertainment Spectacles" in *Rethinking Media Change: The Aesthetics of Transition* (ed. David Thorburn and Henry Jenkins, 2003); "Special Effects, Morphing Magic, and the '90s Cinema of Attractions" in *Meta-Morphing: Visual Transformation and the Culture of Quick Change* (ed. Vivian Sobchack, 2000); and "'Evil Will Walk Once More': *Phantasmagoria*—The Stalker Film as Interactive Movie?" in *On a Silver Platter: CD-Roms and the Promises of a New Technology* (ed. Greg Smith, 1999). Thanks also to David Thorburn and Henry Jenkins for including this book in the Media in Transition series and to the expert editorial team at the MIT Press: Valerie Geary and Deborah Cantor-Adams, who have been a delight to work with, and my editor Douglas Sery, who patiently persevered with this project right up until the end (which, at times, I thought would never come). And finally, words could not do justice to the gratitude and admiration I have for Wendy Haslem, whose assistance in finalizing this book was itself a baroque effect.

Neo-Baroque Aesthetics and Contemporary Entertainment

Introduction: The Baroque and the Neo-Baroque

Postclassical, Modern Classicism, or Neo-Baroque? Will the Real Contemporary Cinema Please Stand Up?

Once upon a time there was a film called *Jurassic Park* (Spielberg 1992), and on its release, audiences went to cinemas by the millions to be entertained by the magic that it had to offer. On the one hand, the film's story enthralled its viewers. Recalling that other monster, King Kong, in *Jurassic Park*, genetically engineered dinosaurs were brought to life by an entrepreneur who was determined to place them within a theme park habitat so that they could become a source of pleasure and entertainment for millions. On the other hand, the computer effects that so convincingly granted filmic life to these dinosaurs that inhabited the narrative space astounded audiences. Then, once upon another time soon after, the dinosaurs migrated to another entertainment format and roamed the narrative spaces of the Sony PlayStation game *The Lost World: Jurassic Park*. To engage with this fictional world, audiences inserted a PlayStation disk into their consoles and a different, yet strangely similar, narrative scenario emerged. Dinosaurs were still genetically engineered; however, now the game player became integral to the way the narrative unraveled. Trapped on an island inhabited by various dinosaur species, the player now "performed" by interacting with this digital entertainment format, in the process progressively adopting the roles of dinosaurs and humans alike in a struggle that culminated in the final survival of one dominant species.

And yes, once upon yet another time, there was a land called "Jurassic Park," but this was no film or computer space. This was a geographical locale with which the audience physically engaged, one of the many lands in Universal's Islands of Adventure theme park in Orlando, Florida (figure I.1). Here the audience experienced an alternate version of the *Jurassic Park* story by traversing a land that was littered with animatronic dinosaurs. Literally entering the fictional space of Jurassic Park, the participant

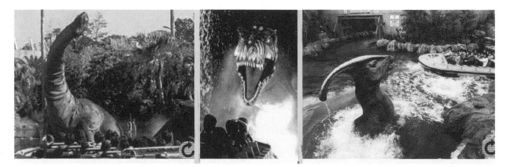

Figure I.1 The Jurassic Park Ride, Universal Studios, Orlando, Florida. By permission of Universal Studios.

now experienced the narrative space in architecturally invasive ways by taking a ride through a technologically produced Jurassic theme park. Traveling along a river in a boat, participants floated through a series of lagoons (including the "Ultrasaurus Lagoon") whose banks were inhabited by animatronic versions of hadrosauruses, dilophosauruses, triceratops, and velocitators. Soon after, however, the wonder of seeing such deceptively real spectacles of extinct beings was destroyed, and the participants of the fiction found their wonder turn to terror when they were stalked by raptors and a mammoth Tyrannosaurus, barely escaping with their lives by plunging to their escape down an eighty-five-foot waterfall.[1] Although each of these "tales" can be experienced and interpreted independent of the others, much can be lost in doing so, for these narratives belong to multiple networks of parallel stories that are all intimately interwoven. Each "tale" remains a fragment of a complex and expanding whole.

In the last two decades, entertainment media have undergone dramatic transformations. The movement that describes these changes is one concerned with the traversal of boundaries. In the film *Jurassic Park* (and its sequels *The Lost World: Jurassic Park II* and *Jurassic Park III*), film technology combines with computer technology to construct the dinosaur effects that are integral to the films' success. Like the *Jurassic Park* films, the *Terminator* films and the *Spiderman* comic books find new media environments in the theme park attractions *Terminator 2: 3D Battle across Time* and *The Amazing Adventures of Spiderman* (both at Universal Studios). Computer games[2] like *Phantasmagoria I* and *II* and *Tomb Raider I, II*, and *III* cross their game borders by incorporating film styles, genres, and actors into their digital spaces. And the narratives of the *Alien* films extend into and are transformed by a successful comic-book series. All these configurations have formal repercussions. Media merge with media, genres unite to produce new hybrid forms, narratives open up and extend into new spatial and serial

configurations, and special effects construct illusions that seek to collapse the frame that separates spectator from spectacle. Entertainment forms have increasingly displayed a concern for engulfing and engaging the spectator actively in sensorial and formal games that are concerned with their own media-specific sensory and playful experiences. Indeed, the cinema's convergence with and extension into multiple media formats is increasingly reliant on an active audience engagement that not only offers multiple and sensorially engaging and invasive experiences but also radically unsettles traditional conceptions of the cinema's "passive spectator." Additionally, many of the aesthetic and formal transformations currently confronting the entertainment industry are played out against and informed by cultural and socioeconomic transformations— specifically, the contexts of globalization and postmodernism.

In "Modern Classicism," the first chapter of *Storytelling in the New Hollywood: Understanding Classical Narrative Technique* (1999), Kristin Thompson asks the question "Just what, if anything, is new about the New Hollywood in terms of what audiences see in theaters?" (2). For Thompson, it would appear that the answer to this question is "very little." In this book, however, my response to this question is "a great deal." Disputing claims to a "postclassical" or "postmodern" cinema, Thompson argues that, essentially, post-1970s cinema has continued the storytelling practices of the classical Hollywood period. I agree that, fundamentally, Hollywood has retained many of the narrative conventions that dominated its cinema between the 1910s and the 1940s: the cause-and-effect patterns that drive narrative development; the emphasis on goal-oriented characters; the clear three-part structure that follows an Aristotelian pattern of a beginning, middle and end (wherein narrative conflict is finally resolved); and psychologically motivated characters with clearly defined traits.[3] Indeed, I would suggest that, with respect to its narrative, a film like *Jurassic Park* is not only a classical narrative, but a "superclassical" narrative: the goals of the narrative and characters are spelled out explicitly and economically, and the cause-and-effect patterns pound along at a gripping pace until narrative disequilibrium (the threat of the dinosaurs and the planned theme park) is removed. In this respect I agree with Thompson when she suggests that *Jurassic Park* has as "well-honed [a] narrative as virtually any film in the history of Hollywood" (1999, 9). In *Storytelling in the New Hollywood* Thompson has contributed a fine body of research that seeks to locate the continuing relevance of the classical narrative tradition; the creature that now is (or, indeed, ever was) "Hollywood" cannot be limited to its narrative practices alone, however, especially when some of these narrative traits are also being transformed.[4] The cinema, like culture, is a dynamic being that is not reducible to a state of perpetual stasis. In the words of

Jay David Bolter and Richard Grusin, "media technologies constitute networks or hybrids that can be expressed best in physical, social, aesthetic, and economic terms" (1999, 9).[5]

While revealing contemporary cinema's connections with the classical era of storytelling, *Jurassic Park* also highlights a great many of the radical transformations that have occurred in the film industry in the last three decades. Thompson claims that, although the "basic economic system underlying Hollywood storytelling has changed . . . the differences are essentially superficial and nonsystemic" (1999, 4).[6] The fact is, however, that the economic structure of the industry today is fundamentally different from that of the pre-1950s era. Our society, technologies, audiences, and cultural concerns have altered dramatically in the interim. Conglomeration of the film industry since the 1960s has reshaped the industry into one with multiple media interests. One outcome of this conglomeration has been new convergences between diverse entertainment media—comic books, computer games, theme park attractions, and television programs—that have also had formal ramifications.[7] The advent of digital technology (and the economic advantages it offers) has altered the film industry's production practices, with the result that new aesthetics have emerged. The home market saturation of VCRs, cable, and DVD technology has produced not only what Jim Collins calls new forms of "techno-textuality" (1995, 6), but also alternate modes of audience reception and an intensity of media literacy never before witnessed in the history of the cinema.

Although she acknowledges the new synergies and emphases on spectacle and action that the contemporary film industry favors, Thompson states that industry features such as tie-in products, publicity, and marketing have been a part of the industry since the 1910s and that currently the industry is involved merely in "intensifications of Hollywood's traditional practices." It is all, says Thompson, a matter of "degree" (1999, 3).[8] Yet this matter of degree is surely an important one: "Intensification" can reach a point at which it begins to transform into something else. In the instance of the contemporary entertainment industry, this "something else" has embraced classical storytelling and placed it within new contexts, contexts that incorporate a further economization of classical narrative form, digital technology, cross-media interactions, serial forms, and alternate modes of spectatorship and reception. "Hollywood filmmaking," states Thompson, "contrary to the voices announcing a 'post-classical' cinema of rupture, fragmentation, and postmodern incoherence, remains firmly rooted in a tradition which has flourished for eighty years and shown every sign of continuing" (336). I agree. Not only does the classical still persist, but it is also integrated into al-

ternate modes of media discourse. A new order emerges. This book is concerned with this new order, an order that I call the "neo-baroque." As I will stress later, the terms "baroque" and "classical" are not used in this book in any oppositional sense: The baroque embraces the classical, integrating its features into its own complex system.

In this book I argue that mainstream cinema and other entertainment media are imbued with a neo-baroque poetics. Points of comparison are identified between seventeenth-century baroque art and entertainment forms of the late twentieth and early twenty-first centuries to establish continuous and contiguous links between the two eras. In suggesting parallels between the two periods, I do not propose that our current era stands as the mirror double of the seventeenth century. Different historical and social conditions characterize and distinguish the two periods. There are, however, numerous parallels between the two that invite comparison in the treatment and function of formal features, including an emphasis on serial narratives and the spectacular: forms that addressed transformed mass cultures. Throughout this book, therefore, "baroque" will be considered not only as a phenomenon of the seventeenth century (an era traditionally associated with the baroque), but also, more broadly, as a transhistorical state that has had wider historical repercussions.

I am especially concerned with evaluating the transformed poetics that have dominated entertainment media of the last three decades. It is suggested here that, as a result of technological, industrial, and economic transformations, contemporary entertainment media reflect a dominant neo-baroque logic. The neo-baroque shares a baroque delight in spectacle and sensory experiences. Neo-baroque entertainments, however—which are the product of conglomerate entertainment industries, multimedia interests, and spectacle that is often reliant upon computer technology—present contemporary audiences with new baroque forms of expression that are aligned with late-twentieth- and early-twenty-first-century concerns. The neo-baroque combines the visual, the auditory, and the textual in ways that parallel the dynamism of seventeenth-century baroque form, but that dynamism is expressed in the late twentieth and early twenty-first centuries in technologically and culturally different ways. Importantly, underlying the emergence of the neo-baroque are transformed economic and social factors.

This book belongs to an expanding set of works that position the cinema and new media in relation to earlier forms of representation and visuality. Because I adopt a baroque model, my ideas are especially indebted to the research of Barbara Maria Stafford, Jay Bolter, and Richard Grusin, who, from alternate perspectives, discuss the inherent "historicity" of media. As Stafford states in *Artful Science: Enlightenment*

Entertainment and the Eclipse of Visual Education, "we need to go backward in order to move forward" (1994, 3). By our going backward, various parallels between epochs may emerge, thus allowing us to develop a clearer understanding of the significance of cultural objects and their function during our own times. Stafford establishes these links specifically between the eighteenth and late twentieth centuries. For Stafford, the audiovisuality of the baroque was transformed and given an "instructive" purpose in the eighteenth century to usher in a new era of reason that came to be associated with the Enlightenment. With specific attention given to the dominance of digital media in our own era, Stafford posits that our culture is undergoing similar pivotal transformations. Our optical technologies—home computers, the Internet, cable, and other information technologies—provide a means of using the image in ways that may transport users to a new period of technological reenlightenment (1994, xxiii).

In *Remediation: Understanding New Media*, Jay Bolter and Richard Grusin are more expansive in their historical focus. They argue that all media, no matter how "new," rely on a media past. New media always retain a connection with past forms. Like painting, architecture, and sculpture, which have a longer history of traditions to draw upon, contemporary media such as the cinema, computer games, and the Internet "remediate" or refashion prior media forms, adapting them to their media-specific, formal, and cultural needs. In short, according to Bolter and Grusin, "No medium today, and certainly no single media event, seems to do its cultural work in isolation from other media" (1999, 15). This interdisciplinary, cross-media, and cross-temporal approach remains integral to the ideas that follow.

Although this book focuses on diverse media such as computer games, theme park attractions, and comic books, as well as mainstream cinema, following the works of John Belton (see, in particular, his 1992), Scott Bukatman (1993, 1995, 1998), Jim Collins (1989, 1995), Vivian Sobchack (1987, 1990), Janet Wasko (1994), and Justin Wyatt (1994), this book considers the cinema's continuing relevance in a world that has become infiltrated by new media technologies and new economic structures. In its combination of narrative, image, and sound, the cinema remains paradigmatic and, as is evident in the works of the above-mentioned historians and theorists, much of the best analysis of new media emerges from cinema studies. Likewise, the writings of Sobchack (1987), Bukatman (1993, 1995, 1998) and Brooks Landon (1992) have been especially influential in the priority they give to science fiction and fantasy cinema as fundamental vehicles that offer insight into the impact of new media technologies in the context of postmodernism. The new historical poetics that this book explores are particularly evident in these genres. As Bukatman (1998) has noted, since the release

of *Star Wars* in 1977, not only has science fiction become paradigmatic of the cross-media and marketing possibilities of conglomeration, but the films narrativize the implications and effects of new technologies as well as implementing new technologies in the construction of the films' special effects. Science fiction and fantasy films, computer games, comic books, and theme park attractions become emblematic of changing conditions—cultural, historical, economic, and aesthetic—as played out across our entertainment media. In my efforts to delineate the transformations that the entertainment industry has undergone in light of economic and technological shifts, I have reconsidered the research of the academics mentioned above from alternate angles, considering and elaborating on their arguments from the perspective of the neo-baroque. Before we travel the path of the neo-baroque, however, a brief overview and clarification of the usages of the term "baroque" is in order.

. . . Of Things Baroque

"The baroque" is a term traditionally associated with the seventeenth century, though it was not a label used by individuals of the period itself to describe the art, economics, or culture of the period. Although when the term "baroque" was originally applied to define the art and music of the seventeenth century is not known, its application in this way—and denigratory associations—gathered force during the eighteenth century. During this time, "baroque" implied an art or music of extravagance, impetuousness, and virtuosity, all of which were concerned with stirring the affections and senses of the individual. The baroque was believed to lack the reason and discipline that came to be associated with neoclassicism and the era of the Enlightenment. The etymological origins of the word "baroque" are debatable. One suggestion is that it comes from the Italian "barocco," which signifies "bizarre," "extravagant"; another is that the term derives from the Spanish "barrueco" or Portuguese "barrocco," meaning an "irregular" or "oddly shaped pearl."[9] Whatever the term's origins, it is clear that, for the eighteenth and, in particular, the nineteenth century, the baroque was increasingly understood as possessing traits that were unusual, vulgar, exuberant, and beyond the norm. Indeed, even into the nineteenth century, critics and historians perceived the baroque as a degeneration or decline of the classical and harmonious ideal epitomized by the Renaissance era.

As stated, the life span of the historical baroque is generally associated with the seventeenth century, a temporal confine that is more often a matter of convenience (a convenience to which I admittedly succumb in this book), as it is generally agreed

that a baroque style in art and music was already evident in the late sixteenth century[10] and progressed well into the eighteenth century, especially in the art, architecture, and music of northern Europe and Latin America.[11] Until the twentieth century, seventeenth-century baroque art was largely ignored by art historians. The baroque was generally considered a chaotic and exuberant form that lacked the order and reason of neoclassicism, the transcendent wonder of romanticism, or the social awareness of realism. Not until the late nineteenth century did the Swiss art critic and historian Heinrich Wölfflin reconsider the significance of the formal qualities and function of baroque art. Not only were his *Renaissance and Baroque* (1965; originally published in 1888 and revised in 1907) and *Principles of Art History: The Problem of the Development of Style in Later Art* (1932; originally published in 1915) important in their earnest consideration of the key formal characteristics of seventeenth-century art, but they established the existence of a binary relationship between the classical (as epitomized by Renaissance art) and the baroque[12] that has persisted into the twenty-first century.[13]

Although I draw on the studies of Wölfflin, Walter Benjamin, Remy Sasseilin, and José Maravall on the seventeenth-century baroque, one of the most influential works on my own deliberations is Henri Focillon's *The Life of Forms in Art*, originally published in 1934. Focillon's arguments diverge from those of the above-mentioned authors. Despite his strictly formalist concerns and lack of engagement with cultural issues beyond an abstract framework, Focillon understood form in art as an entity that was not necessarily limited to the constraints of time or specific historical periods. Quoting a political tract from Balzac, Focillon stated that "everything is form and life itself is form" (1992, 33). For Focillon, formal patterns in art are in perpetual states of movement, being specific to time but also spanning across it (32): "Form may, it is true, become formula and canon; in other words, it may be abruptly frozen into a normative type. But form is primarily a mobile life in a changing world. Its metamorphoses endlessly begin anew, and it is by the principle of *style* that they are above all coordinated and stabilized" (44).

Although the historical baroque has traditionally been contained within the rough temporal confines of the seventeenth century, to paraphrase Focillon, I suggest that baroque form still continued to have a life, one that recurred throughout history but existed beyond the limits of a canon. Therefore, whereas the seventeenth century was a period during which baroque form became a "formula and canon," it does not necessarily follow that the baroque was frozen within the temporal parameters of the seventeenth century. Although the latter part of the eighteenth century witnessed the dominance of a new form of classicism in the neoclassical style, baroque form con-

tinued to have a life, albeit one beyond the limits of a canon. For example, later-twentieth-century historians and theorists of the baroque have noted the impact of the baroque on nineteenth- and twentieth-century art movements. Sassone, for example, has explored the presence of a baroque attitude to form in the artistic movements of surrealism, impressionism, and neo-gongorism (Overesch 1981, 70, citing Sassone 1972). Buci-Glucksman (1986, 1994) equated what she labeled a baroque *folie du voir* with the early-twentieth-century modernist shift toward abstraction. Similarly, Martin Jay (1994) liberated the baroque from its historical confines, stating, like Buci-Glucksman, that the inherent "madness of vision" associated with the baroque was present in the nineteenth-century romantic movement and early-twentieth-century surrealist art. In associating it with these instances of early modernist art, the word "baroque" is being adopted by historians and theorists who recognize the modernist and abstract qualities inherent in the baroque; the baroque becomes a tool critical to understanding the nature of these early modernist artistic movements.

With respect to the cinema, the baroque is often conjured up to signify or legitimate the presence of an auteurist flair in the films of specific directors. In most cases, the term "baroque" is used rather loosely to describe a formal quality that flows "freely" and "excessively" through the films of particular directors, the implication being that to be baroque implies losing control (whereas on the contrary, as will be explained later, seventeenth-century baroque often revealed an obsessive concern with control and rationality). To be baroque is (supposedly) to give voice to artistic freedom and flight from the norm. Classical Hollywood, contemporary Hollywood, and art cinema directors alike have been evaluated from the perspective of the baroque. The films of directors Federico Fellini,[14] Tim Burton,[15] Michael Powell and Emeric Pressburger, Tod Browning, James Whale, Michael Curtiz,[16] Raul Ruiz,[17] and Peter Greenaway[18] have been discussed as reflecting baroque sensibilities. When the word "baroque" is used to describe particular films, again the term carries with it connotations of something's being beyond the norm or of a quality that is in excess of the norm. Thus the Soviet film *Raspoutine, l'Agonie* (Klimov 1975) is analyzed as baroque given its emphasis on themes of aberration, the mystical, and the fantastic (Derobert 1985). The Italian film *Maddalena* (Genina 1953) is defined as baroque because of its melodramatic style and its focus on the excess spectacle of the Catholic church.[19] *Mad Max: Beyond Thunderdome* (Miller 1995) may be understood as baroque because of its "mythic proportions," its grandeur, and its sense of the hyperbolic.[20] In interviews, Baz Luhrmann repeatedly refers to the baroque logic—the theatricality, lushness, and spectacle of the mise-en-scène and editing—that inspired his trilogy *Strictly Ballroom*

(1997), *Romeo + Juliet* (1999), and *Moulin Rouge!* (2001). And Sally Potter's *Orlando* (1992) has been described as a postmodern, neo-baroque film that draws upon baroque devices, including intertextuality, parody, and a carnivalesque attitude that transforms Virginia Woolf's 1928 novel *Orlando: A Biography* (on which the film was based) into a "staged" world of stylistic excess and performativity.[21]

To return to Focillon's argument regarding the simultaneously fluid and stable properties of art form, in all the instances cited above, baroque traits flow fleetingly through various art movements and films but retain their freedom of motion: the baroque, in this case, is not "frozen" or "canonized" as a style. With the exception of the seventeenth century, it was not until the twentieth century that baroque form underwent a series of metamorphoses that resulted in the stabilization of the baroque as a style. Throughout the twentieth century, baroque form altered its identity as a style in diverse areas of the arts, continuing restlessly to move on to new metamorphic states and cultural contexts.[22]

The "Baroque Baroque" and the Hollywood Style: The 1920s and 1930s

Whereas art-historical and historical research on the seventeenth-century baroque came into its own only in the latter part of the twentieth century, the impact of the baroque on early-twentieth-century culture made itself felt in even more immediate ways within the public sphere. While the Western world was experiencing a modernist revolution in art through postimpressionism, cubism, surrealism, constructivism, and German expressionism, the baroque also experienced a stylistic resurgence.

In *Baroque Baroque: The Culture of Excess*, Stephen Calloway traces the direct impact of seventeenth-century baroque design, art, and architecture on twentieth-century culture. Labeling the self-conscious fascination with the baroque in the twentieth century the "baroque baroque" (1994, 15), Calloway traces its influences in the worlds of theater, cinema, architecture, interior design, and haute couture fashion. The 1920s and 1930s in particular can be characterized as stabilizing a new baroque style. In London, an elite and influential group of upper-class connoisseurs in the 1920s formed the Magnasco society (named after a rather obscure seventeenth-century painter Alessandro Magnasco, who was known for his "fantastic" style) with the intention of exhibiting baroque art (48). Soon, what came to be known as a "neo-baroque" style was all the rage. As Calloway states, "magazines of the day decreed that the neo-baroque was in," especially in interior design (50). As early as 1906, Sir Edwin Landseer Lutyens's Folly Farm residence (West Berkshire, 1906–1912) introduced

decorative schemes that included trompe l'oeil illusions influenced by the seventeenth-century baroque. In the 1920s Lord Gerald Wellesley's bedroom in his London townhouse displayed the "Magnasco society taste," and a neo-baroque form was evident in his bizarre and spectacular bed, the paintings that hung on the walls, and other baroque-inspired schemes in the room's decoration (48). Likewise, Cecil Beaton's neo-baroque house, Ashcombe—which included baroque furniture, door cases, putti sculptures, trompe l'oeil effects and mirrors, as well as light sconces on the walls that were cast in plaster in the form of human arms (a feature that was to reappear in Cocteau's *La Belle et la Bête* of 1946)—set many trends (86–90).[23]

A taste for things neo-baroque was also filtering into the exuberant and "dandified fashions" of eccentric characters like Cecil Beaton and Sacheverell Sitwell (whose book on the seventeenth-century Spanish baroque also contributed to an understanding of earlier baroque culture) (Calloway 1994, 32). These more eccentric tastes were soon to enter a more mainstream market when fashion designers like Coco Chanel, Helena Rubenstein, and Elsa Schiaparelli chose to market the "new concept of Chic" by producing stage salon shows and fashions that were marked by a baroque extravagance (79–81).[24] This renewed interest in the baroque was also evident in the theater and ballet of the period. For example, the entrepreneur Seregei Diaghilev greatly influenced the look of the Ballets Russes, reigniting a concern for the spectacle of the baroque through the inclusion of exotic costumes of baroque design, baroque settings, and spectacular firework displays traditionally associated with seventeenth-century theater.[25]

In the United States, the young film industry began a love affair with baroque flair and monumentality. The sets, costumes, themes and designs of grand Hollywood epics like *Intolerance* (Griffith 1926), *Queen Kelly* (von Stroheim 1928), *The Scarlet Empress* (von Sternberg 1934), and *Don Juan* (Crosland 1926) (whose interiors were modeled on those of the Davanzanti palace in Florence) reiterated the spectacular grandeur of baroque style (Calloway 1994, 52–59). According to Calloway, the "visual richness of film culture" and the evident success of the star system by the 1920s shifted the cinema's evocation of fantasy and glamour off the screen and onto the private lives of its stars and the public sphere they inhabited (56). Film culture nurtured an environment that allowed baroque form to infiltrate the space of the city (specifically Hollywood and Beverly Hills). A baroque opulence the likes of which had never been seen since the seventeenth century soon exploded, and what came to be known as the "Hollywood style" emerged. Following the likes of stars like Douglas Fairbanks and Mary Pickford, whose palatial abode, Pickfair, was constructed on the outskirts of

Hollywood, a spate of movie moguls and film stars commissioned grand mansions that often explicitly imitated the seventeenth-century palazzi of European aristocrats and monarchs. The designs of Hollywood picture palaces followed suit. An aristocratic style was reborn to herald a new aristocracy, one engendered by the Hollywood film industry. The most famous fantasy mansion of the period was, of course, William Randolph Hearst's San Simeon (figure I.2). Adorned with booty plundered from throughout Europe, this mansion (which approached the size of a city) also included a cinema in the style of Louis XIV (57).

The monarchs in this new Hollywood aristocracy were the movie stars and media moguls, and they asserted their power and starlike qualities through a baroque visual splendor. The cultural space of Los Angeles was imbued with a new identity, one that would resurge with a revised fervor at the end of the century, when the neo-baroque was to become canonized within a radically different cultural context.[26]

The Latin American and Spanish Neo-Baroque

Omar Calabrese (1992), Peter Wollen (1993), Mario Perniola (1995), and Christina Degli-Esposti (1996a, 1996b, 1996c) have evaluated (from different perspectives) the affinities that exist between the baroque—or, rather, the neo-baroque—and the postmodern. It is as a formal quality of the postmodern that the neo-baroque has gained a stability that emerges from a wider cultural context. Initially, the strongest connection between the postmodern and the baroque emerged in the context of Latin American literature, art,[27] and criticism, in particular, in the writings of the Cuban author Severo Sarduy, who consciously embraced the baroque as a revolutionary form, one capable of countering the dominance of capitalism and socialism (Sarduy 1975; Beverley 1988, 29). From the 1950s, in Latin America, the baroque was revisited as the neo-baroque, becoming a significant political form in the process. Particularly in literature, the seventeenth-century baroque's obsessive concerns with illusionism and the questionable nature of reality was adapted to a new cultural context, becoming a formal strategy that could be used to contest the "truth" of dominant ideologies and issues of identity, gender, and "reality" itself.

Generally, literary historians have associated the Latin American neo-baroque with the rise of the metafictional new-historicist novel that flourished during the boom period (1960s–1970s) and particularly in the postboom period of the 1980s. Although which authors are to be considered part of the boom period and which are part of the postboom is much debated, the tendency to equate both (and in particular the latter)

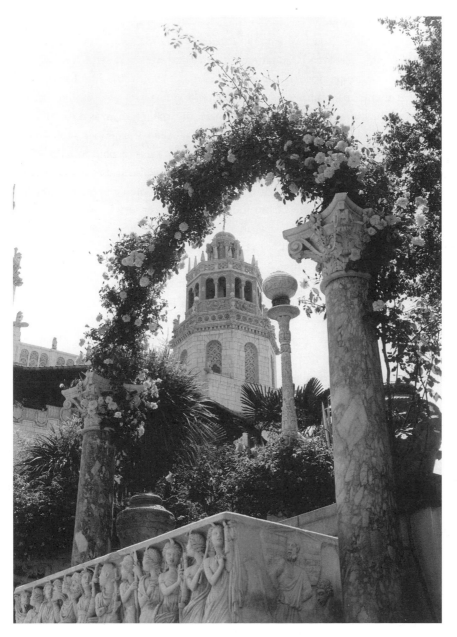

Figure I.2 William Randolph Hearst's California residence, San Simeon. By permission of The Kobal Collection.

with the neo-baroque is a point rarely debated. Novels such as Fernando del Paso's *Noticias del Imperio* (1987), Roa Bastos's *Yo, el Supremo* (1975), and Carlos Fuentes's *Terra Nostra* (1976) are viewed as simultaneously emerging from a postmodern context and as reflecting neo-baroque formal concerns (Thomas 1995, 170). Emphasizing the radical and experimental possibilities inherent in baroque form (as also outlined in the writings of Buci-Glucksman and Jay), Latin American writers such as Luis Borges, Severo Sarduy, Fernando del Paso, José Lezama Lima, Alejo Carpentier, and Carlos Fuente developed a deconstructive style that owed a great deal to philosophical writings of theorists such as Jacques Derrida, Michel Foucault, and Fredric Jameson. Embracing the postmodern, these novelists also consciously melded theoretical concerns with stylistic strategies adapted from the seventeenth-century baroque tradition: the instability and untrustworthiness of "reality" as a "truth"; the concern with simulacra; motifs like the labyrinth as emblem of multiple voices or layers of meaning; and an inherent self-reflexivity and sense for the virtuosic performance. The movement that emerged as a result came to be known as the neo-baroque.[28] Additionally, many of the writings of these authors also invested in a Bakhtinian concern with the carnivalesque, intertextuality, dialogic discourse, and "heteroglossic, multiple narrative voices"; as Peter Thomas states, in all, a "neobaroque verbal exuberance . . . [and] . . . delirious" style ensued (1995, 171).

In "The Baroque and the Neobaroque," Severo Sarduy suggests that, whereas the Latin American baroque (of the seventeenth and eighteenth centuries) was simply a colonial extension of the European (and, in particular, the Spanish) baroque, the neobaroque embraces a more critical stance by returning to the European (as opposed to colonial) origins (Thomas 1995, 181; Sarduy 1975, 109–115).[29] The aim was to reclaim history by appropriating a period often considered to be the "original" baroque, thereby rewriting the codes and "truths" imposed on Latin America by its colonizers. By reclaiming the past through the baroque form, these contemporary Latin American writers could also reclaim their history. The new version of history that resulted from this reclamation spoke of the elusive nature of truth, of historical "fact," of "reality," of identity and sexuality. According to the neo-baroque, truth and reality was always beyond the individual's grasp.

In Spain, the baroque transformed along similar formal lines, becoming associated in the second half of the twentieth century with the literature of the period and with postmodernism. Freeing themselves from the oppressive censorship of the Franquist regime, in the 1960s and 1970s Spanish writers began to experiment with modernist and antirealist literary styles.[30] Critics labeled the emerging Spanish style, which was

influenced by the Latin American boom authors who had deliberately embraced the styles and concerns of Golden Age writers such as Miguel de Cervantes and Calderón de la Barca, "baroque" or, more often, "neo-baroque" (Zatlin 1994, 30; Overesch 1981, 19). Following the lead of many Latin American authors, Spanish writers such as José Vidal Cadellán, Maria Moix, José María Castellet, Manuel Ferrand, and Juan Goytisolo adopted stylistic features integral to seventeenth-century Spanish baroque literature.[31] Francisco Ayala's *El Rapto* (1965), for example, retells one of the stories recounted in Cervantes's *Don Quixote*. Reflecting on the layered nature of the baroque, Ayala travels back in time to the seventeenth century to comment on Spain of the present, particularly on the "disorientation pervading contemporary Spanish society" under the post-Franco regime (Orringer 1994, 47). As with the Latin American neo-baroque, particular features of a baroque poetics emerged:[32] minimal or lack of concern with plot development and a preference for a multiple and fragmented structure that recalls the form of a labyrinth; open rather than closed form; a complexity and layering evident, for example, in the merging of genres and literary forms such as poetry and the novel; a world in which dream and reality are indistinguishable; a view of the illusory nature of the world—a world as theater; a virtuosity revealed through stylistic flourish and allusion; and a self-reflexivity that requires active audience engagement (Overesch 1981, 26–60).[33] For these Latin American and Spanish writers, the neo-baroque became a potent weapon that could counteract the mainstream: They embraced the neo-baroque for its inherent avant-garde properties.[34] The contemporary neo-baroque, on the other hand, finds its voice within a mainstream market and, like the seventeenth-century baroque, directs its seduction to a mass audience.

The Spatial Aspect of the Cultural System

In recent decades, the neo-baroque has inserted its identity into diverse areas of the arts, continuing restlessly to move on to new metamorphic states and contexts, nurtured by a culture that is attracted to the visual and sensorial seductiveness integral to baroque form. In the late twentieth and early twenty-first centuries, we have experienced the reemergence and evolution of the baroque into a more technologically informed method of expression. A baroque mentality has again become crystallized on a grand scale within the context of contemporary culture. The spectacular illusionism and affective charge evident in Pietro da Cortona's ceiling painting of *The Glorification of Urban VIII* (Palazzo Barberini, Rome, 1633–1639), the virtuosic spatial illusions painted by Andrea Pozzo in the Church of S. Ignazio (Rome, 1691–1694) (figure I.3),

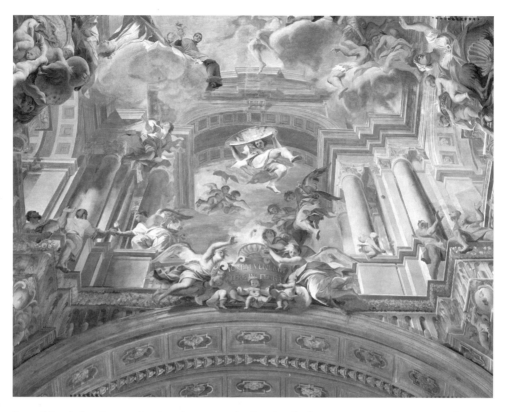

Figure I.3 Andrea Pozzo, *The Glory of S. Ignazio* (detail), Church of S. Ignazio, Rome, 1691–1694. © Photo Vasari, Rome.

the seriality and intertextual playfulness of Cervantes's *Don Quixote* (1605 and 1615), and the exuberant and fantastic reconstruction of Versailles under Louis XIV have metamorphosed and adjusted to a new historical and cultural context. Specifically, I follow the lead of Omar Calabrese (1992), Peter Wollen (1993), and Mario Perniola (1995), all of whom understand (from different perspectives) the neo-baroque and the postmodern as kindred spirits. Although I recognize the multiple and conflicting theoretical responses to the postmodern condition, however,[35] postmodern debates do not constitute the primary concern of this book. A specifically neo-baroque poetics embedded within the postmodern is my primary point of reference. Although some postmodern tropes and theories underpin the analysis to follow, I am not concerned with reiterating the immense body of literature and analysis that has already been

articulated so admirably by numerous writers, including pioneers like Fredric Jameson, Jean Lyotard, Robert Venturi,[36] Jean Baudrillard, Perry Anderson, and Steven Best and Douglas Kellner. It is within the context of the postmodern that the neo-baroque has regained a stability that not only is found in diverse examples of entertainment media cultures but has exploded beyond the elite or marginalized confines of eccentric European aristocrats, Hollywood film stars, and closed literary circles and into our social spaces.

That which distinguishes earlier phases of the twentieth-century baroque from its current guise is the reflexive desire to revisit the visuality associated with the era of the historical baroque. The "baroque baroque" deliberately reintroduced variations of seventeenth-century fashion, theatrical, and architectural designs, grand-scale spectacle, and baroque historical narratives in the context of the cinema, theater, and ballet. The Latin American and Spanish neo-baroque emerged from a conscious effort on the part of writers to manipulate seventeenth-century baroque techniques for contemporary, avant-garde purposes. The late-twentieth- and early-twenty-first-century expression of the neo-baroque emerges from radically different conditions. As was the case with the seventeenth-century baroque, the current expression of the neo-baroque has logically emerged as a result of systemic and cultural transformations, which are the result of the rise of conglomeration, multimedia interests, and new digital technology. Cultural transformation has given birth to neo-baroque form. The neo-baroque articulates the spatial, the visual, and the sensorial in ways that *parallel* the dynamism of seventeenth-century baroque form, but that dynamism is expressed in guises that are technologically *different* from those of the seventeenth-century form. In the last three decades in particular, our culture has been seduced by visual forms that are reliant on baroque perceptual systems: systems that sensorially engage the spectator in ways that suggest a more complete and complex parallel between our own era and the seventeenth-century baroque. In this respect, my concern is with broader issues and general tendencies that give rise to dominant cultural sensibilities.

As history has shown us, human nature being what it is, we cannot resist the drive to locate and label such dominant sensibilities: baroque, Renaissance, medieval, modernist, postmodernist. Underlying all such categories is a desire to reduce and make comprehensible the complex and dynamic patterns and forces that constitute culture. In his study of German baroque tragedy, Benjamin raises a significant query with regard to issues of categorization, in particular, the typing of "historical types and epochs" such as the Gothic, the Renaissance, and the baroque (1998, 41). The problem

for the historian lies in homogenizing the cultural phenomena (and, indeed, the culture) specific to different historical epochs:

> As ideas, however, such names perform a service they are not able to perform as concepts: they do not make the similar identical, but they effect a synthesis between extremes. Although it should be stated that conceptual analysis, too, does not invariably encounter totally heterogeneous phenomena, and it can occasionally reveal the outlines of a synthesis. (41)

Systematization of cultural phenomena need not preclude variety. Likewise, categorization of dominant and recurring patterns need not reflect the revelation of a static cultural zeitgeist. The value of historical labeling and searching for a synthesis of dominant forces—ranging from the thematic, to the stylistic, to the social—is that it enables critical reflection. As Benjamin notes, the "world of philosophical thought" may unravel only through the articulation and description of "the world of ideas" (43). Like Benjamin, I do not seek to defend the methodological foundation that underlies the arguments in this book; I do, however, draw attention to my reservations with "zeitgeisting" and reducing the complex and dynamic processes in operation in cultural formations to simplistic and reductive conceptual observations, and I hope that what follows does not travel that path.

In recent years, a number of historians, philosophers, and critical theorists, including Omar Calabrese, Gilles Deleuze, Mario Perniola, Francesco Guardini, Peter Wollen, and José Maravall, have explored the formal, social, and historical constituents of the baroque and neo-baroque. Deleuze understood the baroque in its broadest terms "as radiating through histories, cultures and worlds of knowledge" including areas as diverse as art, science, costume design, mathematics, and philosophy (Conley 1993, xi). Likewise, in his historical and cultural study of the seventeenth-century Spanish baroque, Antonio Maravall observed that it is possible to "establish certain relations between external, purely formal elements of the baroque in seventeenth-century Europe and elements present in very different historical epochs in unrelated cultural areas.... [Therefore] it is also possible [to] speak of a baroque at any given time, in any field of human endeavour" (1983, 4–5).

Maravall, who is concerned with the seventeenth century, is interested in the baroque as a cultural phenomenon that emerges from a specific historical situation. Maravall also, however, privileges a sense of the baroque that encompasses the breadth of cultural diversity *across* chronological confines. His approach is a productive one.

While exploring distinct centuries that have sets of cultural phenomena particular to their specific historical situations, it is nevertheless possible to identify and describe a certain morphology of the baroque that is more fluid and is not confined to one specific point in history.

The formal manifestations of the baroque across cultural and chronological confines also concern Omar Calabrese in his *Neo-Baroque: A Sign of the Times* (1992). Dissatisfied with postmodernism as a consistent, unified framework of analysis that explains aesthetic sensibilities, Calabrese suggests that the neo-baroque offers a productive formal model with which to characterize the transformations of cultural objects of our epoch (1992, 14). Recognizing, like Maravall before him, that the baroque is not merely a specific period in the history of cultures situated within the seventeenth century, (though with greater focus than Maravall on the twentieth century), Calabrese explores the baroque as a general attitude and formal quality that crosses the boundaries of historical periodization. For Calabrese, therefore, "many important cultural phenomena of our time are distinguished by a specific internal 'form' that recalls the baroque" in the shape of rhythmic, dynamic structures that have no respect for rigid, closed, or static boundaries (5). The protean forms that he locates in blockbuster films, televisual serial structures, and the hybrid alien or monstrous hero are, in turn, placed (briefly) within a broader cultural sphere in which chaos theory, catastrophe theory, and other such "new sciences" reflect similar fluid transformations that contest prior scientific "norms" (171–172).

According to Calabrese, neo-baroque forms "display a loss of entirety, totality, and system in favour of instability, polydimensionality, and change" (1992, xii). Following Yuri Lotman's organization of knowledge according to "the spatial aspect of the cultural system," Calabrese suggests that space must have a border:

> When used of systems (even of cultural ones), the term "border" should be understood in the abstract sense: as a group of points belonging simultaneously to both the inner and outer space of a configuration. Inside the configuration the border forms part of the system, but limits it. Outside the configuration the border forms part of the exterior, whether or not this too constitutes a system. . . . We might say that the border articulates and renders gradual relations between the interior and the exterior, between aperture and closure. (47–48)

Although the formal and aesthetic attributes of the (neo-)baroque remain the focus of this book, historical and cultural transformations also underpin the analysis that

follows. As Rémy Saisselin has observed, "the arrival of a new style may herald changes within a society" (1992, 4). Specific sets of stylistic trends and aesthetic norms are complexly interwoven with the institutional structures that give rise to them (Jenkins 1995, 103). In *Universe of the Mind* Yuri Lotman has argued that cultures operate within the spatial boundaries of the *semiosphere*, the semiotic space in which cultures define their borders (1990, 123):

> Since symbols are important mechanisms of cultural memory, they can transfer texts, plot outlines and other semiotic formations from one level of a culture's memory to another. The stable sets of symbols that recur diachronically throughout culture serve very largely as unifying mechanisms: by activating culture's memory of itself they prevent culture from disintegrating into isolated chronological layers. The national and area boundaries of cultures are largely determined by a long-standing basic set of dominant symbols in cultural life. (104)

Symbols, in other words, relate to and are the products of their cultural context (104). Recurring language systems, or what Lotman characterizes as smaller units of *semiosis*, respond to a larger semiotic space that is culture. For Lotman, the spatial models created by culture are evident in an "iconic continuum" whose "foundations are visually visible iconic texts" (204). The larger semiotic space informs smaller semiotic units that are, for example, embodied in cultural artifacts like paintings and the cinema. Although Calabrese's analysis of the "semiotic space that is culture" is minimal, he explores these semiotic spaces according to two coexisting systems, the classical and the baroque. Importantly, flouting the traditional oppositional relationship between the classical and baroque (a point to which I will return), Calabrese suggests that the two forms always coexist and that the one form dominates the other at different historical points in time.

Lotman's abstract ruminations on the spatial formations inherent in culture fascinate me for a number of reasons. First, I am attracted to the deceptively simplistic notion that the dominant aspects of a culture can be expressed in spatial terms. How does such space articulate itself? How does it find a voice across various cultural domains? How are the spatial formations of one culture to be distinguished from those of another, and is a distinct break or transition point visible from one cultural dominant to another? Considering such questions, I was drawn to the issue of why I have always been fascinated by these two different points in history: the seventeenth and late twentieth/early twenty-first centuries. Primarily, it was the articulation of the

semiotic units within periods of cultural transformation that lured me: the dominant social and cultural drives that resulted in an equally dominant production of a baroque formal system. Both epochs underwent radical cultural, perceptual, and technological shifts that manifested themselves in similar aesthetic forms. Although both were the products of specific sociohistorical and temporal conditions, both gave voice to wide-scale baroque sensibilities. Although the specific historical conditions surrounding each differ radically, a similar overall formal effect resulted from both. Social crisis and change "created a climate from which the baroque emerged and nourished itself" (Maravall 1983, 53). Informing the semiospheric boundaries of both eras is a spatial attitude dictated by economic and technological transitions. The more I researched and studied examples from both periods, the more I was convinced that this transitional state is reflected semiotically in open, dynamic visual and textual forms.

Drawing on the influential study by Thomas Kuhn, *The Structure of Scientific Revolutions* (1970), in *The Postmodern Turn* (1997), Steven Best and Douglas Kellner reconsider Kuhn's evaluation of "paradigm shifts": According to Best and Kellner,

> a "paradigm" is a "constellation" of values, beliefs, and methodological assumptions, whether tacit or explicit, inscribed in a larger worldview. Kuhn observed that throughout the history of science there have been *paradigm shifts*, conceptual revolutions that threw the dominant approach into crisis and eventual dissolution, a discontinuous change provoked by altogether new assumptions, theories and research programs. In science, Kuhn argued a given paradigm survives until another one, seemingly having a greater explanatory power, supersedes it. (1997, xi)

The seventeenth century is an era frequently associated with transition. Indeed, Kuhn's work focuses on such a transition from the perspective of the scientific revolution. Maravall has considered the baroque era more broadly as a period of wide-scale social and economic transition. Paradigm shifts were evident in religion, economics, the sciences, the social, the class system, philosophy, and the arts. Extending Kuhn's argument, Best and Kellner assert that during any period, the cultural dominants of any discipline can be challenged and overturned so that "a new approach . . . emerges through posing a decisive challenge to the status quo; if successful, this new approach becomes dominant, the next paradigm, itself ready to be deposed by another powerful challenger as the constellation of ideas continues to change and mutate" (1997, 30). They argue that we are currently experiencing a "postmodern turn" in which the "postmodern paradigm" has infiltrated "virtually every contemporary theoretical

discipline [industry, technology, economics, politics, science, and the arts] and artistic field," which, in turn, has influenced culture and society on a wide scale (1997, xi). The development of new imaging and information technologies, the dominance of globalization and transnational corporatism, and new theoretical paradigms in the sciences (such as quantum mechanics and chaos theory) not only have transformed our entertainment media but are also "challenging our definitions of subjectivity and objectivity" (Best and Kellner 1997, 30).

As Best and Kellner eloquently observe, however, "Historical epochs do not rise and fall in neat patterns or at precise chronological moments" (31). Identifying sudden and complete breaks with history is an impossible feat, just as it is impossible to detach the present from its historical past. Consider the term "transformation": It suggests the coexistence of the-thing-that-has-been-transformed *and* that-which-it-has-been-transformed-into. As Best and Kellner note, "Often what is described as 'postmodern' is an intensification of the modern, a development of modern phenomena such as commodification and massification to such a degree that they appear to generate a postmodern break" (31). Maravall argues a similar point with respect to the seventeenth century. He understands the baroque not as a break with history (particularly, the Renaissance and mannerist periods that preceded it), but as a condition that is intimately connected to history. The Renaissance, he asserts, is a prelude to the baroque shift to modernity. The conditions that were transformed and the innovations that were introduced during the baroque were "inherited from the preceding situation" (1986, 3–4).

We have reached a point at which the old and the new coexist, when older paradigms that dominated throughout the modern era are being unsettled and contested. This is a time of cultural shift; chaos and uncertainty appear to reign—and from the ashes, a new order emerges. For writers like Baudrillard, our times mark the "end of history." Francesco Guardini follows a similar train of thought. Guardini understands the seventeenth-century baroque as leading to modernity, "while the Neobaroque moves away from it," being more aligned with the concerns of the postmodern (1996, n.p.). The baroque and neo-baroque, he suggests, operate as "interfaces" that are informed by innovative changes. Guardini understands our culture as being, like the seventeenth-century era that ushered in the scientific revolution, in the "eye of an epochal storm, in the middle of a gigantic transformation" of cultural and socioeconomic proportions.

I too understand the baroque and neo-baroque as emerging during periods of radical cultural transformation. My divergence from Guardini, however, lies in the conclu-

sions he draws. In his deliberation on the effects of the neo-baroque (in particular, the neo-baroque's postmodern reliance on computer culture), he turns to "new Cassandras" such as Alvin Toffler who foresee centuries of doom, with democracy itself in danger (1996, n.p.). I wish to avoid such simplistic cause-and-effect patterns that lapse into predictive ruminations on the destruction of society as we know it. Through the vehicle of science fiction, I am more concerned with synthesizing features of the neo-baroque to evaluate the nature and form of the parallels across both eras, while also considering traits that distinguish the baroque from the neo-baroque. The establishment of oppositions and hierarchies (the modern/the postmodern, the classical/the (neo-)baroque, coherent culture/incoherent culture) will be avoided. Indeed, I do not understand (neo-)baroque as a degenerative state that opposes its harmonious, classical double and reflects cultural decay through formal means. Instead, I will argue that underlying the seeming chaos of the neo-baroque is a complex order that relies on its own specific system of perception.

The Neo-Baroque and Contemporary Entertainment Media

"A long time ago in a galaxy far, far away. . . ." So it began. The *Star Wars* franchise has been one of the greatest success stories in the history of entertainment cinema, and in many respects, the franchise has become paradigmatic of the directions that contemporary entertainment media have taken. George Lucas's strategy was heavily reliant on his expansion of the original film into multiple story variations that also extended media boundaries. The beginning of *Star Wars* (1977) (figure I.4) alludes to a serial tradition from an earlier period in the history of the cinema: the B-serial. The film commences with textual narration viewed against the backdrop of an infinite, dark universe, and the story is immediately situated as an imaginary continuation of a previous series. The text relates events that took place prior to the film's commencement, events that tell of the rebel forces' first victory against the evil Galactic Empire and the acquisition of secret plans for the Empire's "death star" station, which is capable of destroying an entire planet. This textual introduction recounts the events of earlier narratives that did not (up until 1999) yet exist.[37] The seriality and polycentrism that was to emerge from *Star Wars* is typical of a neo-baroque attitude toward space. Henri Focillon has stated that baroque forms

> pass into an undulating continuity where both beginning and end are carefully hidden. . . . [The baroque reveals] "the system of the series"—a system composed of

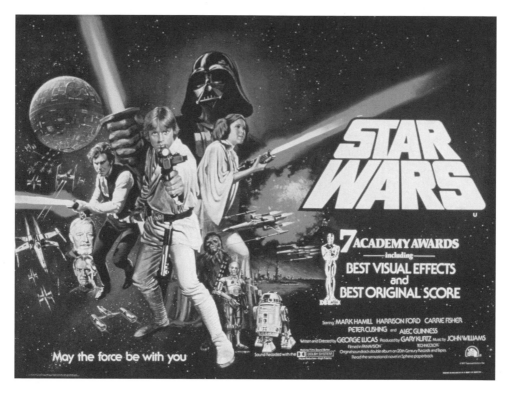

Figure I.4 Promotional poster for the phenomenally successful Lucas franchise *Star Wars* (1977). By permission of The Kobal Collection.

discontinuous elements sharply outlined, strongly rhythmical and . . . [that] eventually becomes "the system of the labyrinth," which, by means of mobile synthesis, stretches itself out in a realm of glittering movement and color. (1992, 67)

Claiming itself as a story continuation rather than a new beginning, *Star Wars* recalls Focillon's "hidden beginning" of baroque form—a beginning that lies somewhere in a mythical past (which was, in 1999, finally revealed to the audience in *The Phantom Menace*). It is appropriate to begin an analysis of what constitutes the formal properties of the (neo-)baroque by outlining its traditional opposition: the classical. History has made rivals of these two entities. Yet from the perspective of the baroque, the two operate in unison. The baroque relies on the classical and embraces its "rules," but in doing so it multiplies, complicates, and plays with classical form, manipulating it with

a virtuoso flair. In the baroque's deliberate establishment of a dialectic that embraces the classical in its system, the classical is finally subjected to a baroque logic.

The baroque's difference from classical systems lies in its refusal to respect the limits of the frame that contains the illusion. Instead it "tend[s] to invade space in every direction, to perforate it, to become as one with all its possibilities" (Focillon 1992, 58). The lack of respect for the limits of the frame is manifest in the intense visual directness in (neo-)baroque attitudes toward spectacle, a topic that will be the focus of the second part of the book. In the case of narrative space, if we consider classical narrative forms as being contained by the limits of the frame (as manifested in continuity, linearity, and "beginnings and endings"), then the perforation of the frame—the hidden beginnings and endings—are typical of the (neo-)baroque. Like (neo-)baroque spectacle, which draws the gaze of the spectator "deep into the enigmatic depths and the infinite" (Perniola 1995, 93), (neo-)baroque narratives draw the audience into potentially infinite, or at least multiple, directions that rhythmically recall what Focillon labels the "system of the series" or the "system of the labyrinth."

The central characteristic of the baroque that informs this study is this lack of respect for the limits of the frame. Closed forms are replaced by open structures that favor a dynamic and expanding polycentrism. Stories refuse to be contained within a single structure, expanding their narrative universes into further sequels and serials. Distinct media cross over into other media, merging with, influencing, or being influenced by other media forms. The grand illusions of entertainment spectacles such as theme park attractions and special-effects films seek to blur the spaces of fiction and reality. Film companies seek to expand their markets by collapsing the traditional boundaries and engaging in multimedia conglomerate operations. And so it continues. Entangled in this neo-baroque order is the audience. True to the (neo-)baroque, the passive remains suspect, and active audience engagement dominates (Perniola 1995, 100). (Neo-)baroque form relies on the active engagement of audience members, who are invited to participate in a self-reflexive game involving the work's artifice. It is the audience that makes possible an integral feature of the baroque aesthetic: the principle of virtuosity. The delight in exhibitionism revealed in displays of technical and artistic virtuosity reflects a desire of the makers to be recognized for taking an entertainment form to new limits.

Chapter 1 of this book explores issues of narrative and spatial formations, in particular, the serial structures and serial-like motions that characterize contemporary media and culture. The seriality integral to contemporary entertainment examples succumbs

to an open neo-baroque form that complicates the closure of classical systems. A polycentric system is favored, one that provides a capacity to expand narrative scenarios infinitely. Integral to this emerging neo-baroque logic is an economic rationale. In the seventeenth century, the emergence of capitalism and mass production was an integral cultural backdrop to the development of baroque form. The expansion of the masses into urban environments was accompanied by the mass production of media that had been steadily on the rise since the Renaissance. The burgeoning print industry recognized the economic possibilities of consumerism on a mass scale, and as the dissemination of plays, novels, biblical texts, and printed books, as well as other media such as the theater, opera, and mass-produced paintings, proliferated, a nascent popular culture emerged, one that was accompanied by a new fascination with the serial and the copy.

During our own times, entertainment industries have responded to the era of conglomeration. The film industry that emerged in the post-1950s recognized the competitive nature of a new, conglomerate economic infrastructure that increasingly favored global interests on a mass scale. Entertainment industries—film studios, computer game companies, comic-book companies, television studios, and theme park industries—expanded their interests by investing in multiple companies, thus combating growing competition within the entertainment industry more effectively and minimizing financial loss or maximizing financial gain by dispersing their products across multiple media. Horizontal integration increasingly became one of the successful strategies of the revitalized film industry, and formal polycentrism was supported by a conglomerate structure that functioned according to similar polycentric logic: Investments were dispersed across multiple industry interests that also intersected where financially appropriate.

The dialectic between economics and production further perpetuated a transformation in audience reception: a rampant media literacy resulted in the production of works that relied heavily on an intertextual logic. A serial logic of a different form ensued. As will be explored in chapter 2, "meaning" became reliant upon an audience that was capable of traversing multiple "texts" to give coherence to a specific work riddled with intertextual references and allusions. Simultaneously adhering to an older cultural system *and* adjusting to a new mass culture, the seventeenth-century aristocracy, the learned, and the lower classes became more active in the ways they participated in the deciphering of works of art. During our own times, the rise of audiovisual technologies such as VCRs, DVDs, cable, and the Internet has amplified the ability of audiences to familiarize themselves with multiple examples of entertainment culture.

The polycentrism of seriality persists, but in this instance it is the intertextual allusions themselves that weave the audience seductively into a series of neo-baroque, labyrinthine passageways that demand that audience members, through interpretation, make order out of chaos. As in the monadic structure proposed by the baroque philosopher Gottfried Leibniz and the baroque "folds" described by Gilles Deleuze, each unit (whether in the form of a serial, a specific allusion, or a distinct media format) relies on other monads: One serial folds into another, and into yet another still; one allusion leads to an alternate path outside the "text," then finds its way back to affect interpretation; or one medium connects fluidly to another, relying on the complex interconnectedness of the system as a whole. The series of monads make up a unity, and the series of folds construct a convoluted labyrinth that the audience is temptingly invited to explore. Yet the baroque and neo-baroque differ in a significant way. Digital technology, especially as used within the world of computer games, has created more literal labyrinths for players to traverse. Highlighting a crisis in traditional forms of symptomatic interpretation, the multilinear nature of game spaces suggests that our modes of interpretation need to reflect an equally neo-baroque multiplicity.

The labyrinthine paths effected by digital technology have broader ramifications. Whereas the seventeenth century was the culmination of a radically new understanding of space in light of newly discovered lands and altered perceptions of the nature of outer space and Earth's place in relation to it, our own era explores the mysterious realms of the computer. Cyberspace, like the newly discovered material spaces of the seventeenth century, has expanded not only our conception and definition of space, but also our understanding of community and identity. Chapter 3 focuses more directly on issues of space, particularly in relation to the baroque mapping of newly discovered spaces and the neo-baroque mapping of expanding digital environments.

The (neo-)baroque's fascination with expanding spatial parameters is further highlighted in its love of spectacle. Chapter 4 evaluates the contexts of the seventeenth and late twentieth and early twenty-first centuries' shared fascination with spectacle, illusionism, and the principle of virtuosity. Focusing on two genres—seventeenth-century *quadratura* painting and the post-1970s science fiction film—I will make a comparison between technical and scientific advances of seventeenth-century spectacle and technological advances of late-twentieth- and early-twenty-first-century spectacle to evaluate and distinguish between the baroque and neo-baroque nature of these forms. I will argue that a dual impulse, resulting from an alliance between artist and scientist, operated in both eras, leading to a (neo-)baroque aesthetics. First, scientific and technological advances in optics in both eras pushed the boundaries of the understanding of

human perception to new limits. Second, artists in both eras consciously produced art that exploited scientific and technological developments by perceptually collapsing the boundaries that separated illusion from reality. It will be suggested that (neo-)baroque spectacle strategically makes ambiguous the boundaries that distinguish reality from illusion. With unabashed virtuosity, the (neo-)baroque complicates classical spatial relations through the illusion of the collapse of the frame; rather than relying on static, stable viewpoints that are controlled and enclosed by the limits of the frame, (neo-)baroque perceptions of space dynamically engage the audience in what Deleuze (1993) has characterized as "architectures of vision." Neo-baroque vision, especially as explored in the *quadratura* and science fiction genres, is the product of new optical models of perception that suggest worlds of infinity that lose the sense of a center. Whereas critical and historical writings have focused on baroque spectacle and vision, it is argued here that the word "spectacle" needs to be reevaluated to encompass other senses, especially in the context of current entertainment experiences.

Inherent in (neo-)baroque spatial illusions is a desire to evoke states of transcendence that amplify the viewer's experience of the illusion. The underlying concern with evoking an aesthetic of astonishment reveals the baroque heritage present in the beginning of the cinema. As Tom Gunning (1990) has explained in his analysis of the pre-1907 film period (a cinema he characterizes, via Eisenstein, as a "cinema of attractions"), astonishment is achieved in spectacle through the ambivalent relationships generated in the spectacle's construction of a spatial perception that emphasizes rational and scientific principles, while also eliciting a seemingly contrary response that evokes states of amazement in the audience that have little to do with rationality. Remediations of technologically produced optical illusions that evoked similar responses in audiences of the seventeenth century are early examples from cinema. In its continuing the production of magical wonders like the magic lanterns, telescopes, cameras obscuras, and multireflective mirrors on display in *wunderkammers* such as that of the Jesuit Athanasius Kircher, the cinema has never lost the baroque delight in conjuring illusions. Its inherently baroque nature has, however, revealed itself especially during periods of technological advancement: during the pre-1907 period that ushered in the invention of the cinematic apparatus; briefly during the 1920s, when experiments with wide-screen technology were conducted but the format failed to become standardized; during the 1950s, which ushered in a more successful version of neo-baroque audiovisuality by showcasing new wide-screen and surround-sound technology through the epic and musical genres; and finally, during our own times, which have provided a more conducive climate for the stabilization of the neo-baroque. Deleuze

has stated that "the essence of the Baroque entails neither falling into nor emerging from illusion but rather *realizing* something in illusion itself, or of tying it to a spiritual presence" (1993, 124). The baroque logic of contemporary media is revealed with a greater intensity when they are compared to those of these earlier periods that recall features of a baroque tradition. Like its seventeenth-century counterpart, science fiction cinema relies on visual spectacles that themselves embody the possibilities of "new science." The neo-baroque nature of science fiction cinema partly resides in a magical wonder that is transformed into a "spiritual presence"—a presence effected by scientifically and technologically created illusions.

Omar Calabrese took a brave first step in claiming that contemporary popular culture, as opposed to modernist traditions, has reignited baroque identity. Calabrese's approach is, essentially, a formalist one. There is much to be gained by pursuing formalist concerns, and in this book, I savor folding my own words into various examples—baroque and neo-baroque—through close analysis. Calabrese, however, neglects to consider the possibilities inherent in understanding the present through the past. Adopting the tropes of the baroque, but none of the works themselves, he does not consider the specifics of remediation or the audience's experience of the baroque. As a result, other dimensions of the (neo-)baroque that exist beyond the strictly formalist are bypassed. What are the parallels and differences between the baroque and neo-baroque? What is to be gained by considering the neo-baroque's formal properties, particularly its historical and cultural dimensions? This book proposes that there is a great deal to be learned about the (neo-)baroque as a spatial formation. Like the precious baroque mirror, culture and its cultural products nurture and reflect back on one another in a series of endless folds, producing reflections that fracture into multiple, infinitesimal pieces, which finally also comprise a single entity.

1 Polycentrism and Seriality: (Neo-)Baroque Narrative Formations

Seriality and the (Neo-)Baroque

The preface to the second part of Miguel Cervantes's *Don Quixote* (published in 1615) begins with Cervantes's alter ego, Cid Hamet Ben Engeli, insulting an unnamed author from Tordesillas who published his own sequel to the first part of *Don Quixote* (published in 1605). He tells the reader: "You would have me, perhaps, call him an ass, madman, coxcomb: but I have no such design. Let his own sin be his punishment" (1999, II:551). In the final chapter of the book, however, Hamet Ben Engeli warns: "Beware, beware, ye plagiaries; Let none of you touch me; for this undertaking (God bless the king) was reserved for me alone. For me alone was Don Quixote born, and I for him . . . and in despite of that scribbling impostor of Tordesillas, who has dared, or shall dare, with his gross and ill-cut ostrich quill, to describe the exploits of my valorous knight" (1999, II:74, 1117).

Creating fact out of fiction and blurring fictional space with the reader's space, at numerous points throughout the second part, Cervantes's fictitious character Don Quixote meets other fictitious characters who act as if they inhabit a material realm of existence that parallels the reader's own. Frequently, Don Quixote defends his "authenticity" as the "real" Quixote to individuals who are familiar with another version of the Quixote story: that dealing with the adventures of the "false" Quixote represented in the *Second Part of the Ingenious Gentleman Don Quixote de la Mancha*, the Tordesillan sequel to Cervantes' original book. Throughout Cervantes' own sequel to *Don Quixote*, his protagonist continually defends his authenticity to characters in light of the other Quixote. For some characters who have read the Tordesillan sequel, however, it is the "imposter" who constitutes the authentic version of the hero Don Quixote.[1]

Issues of authenticity and the copy recur frequently in *Don Quixote*. In the latter section of part II, Don Quixote happens across a printing house where he and the owner discuss conditions of production that reflect changes occurring in the seventeenth century. Initially, Quixote engages the printer in a discussion about the Castilian translation of the Italian *Le Bagatelle*. As author and translator of the book, the printer is drawn into Don Quixote's queries regarding the validity and authenticity of the translated version with respect to the Italian original (1999, II:62, 1042). In addition to deliberating on artistic issues regarding originality, the two exchange opinions about sales abroad, and Don Quixote asks the author of *Le Bagatelle* if he printed the book himself then sold it to a bookseller. Informing Don Quixote that he receives 1,000 ducats on the first print of 2,000 copies, the author responds to Quixote's question in the negative, observing that if a bookseller were involved, a portion of the profits would go to him. In his words, "Profit I seek, without which fame is not worth a farthing" (1999, II:62, 1002).

The structure and content of *Don Quixote* reflects the changing cultural conditions that nurtured the production of the book and also witnessed the rise of capitalism and mass production. Cervantes frequently and self-reflexively invites the reader to engage in a dialogic relationship with the novel's characters on issues dealing with artistic production in light of historical and economic transformations. In his analysis of Spanish (and European) baroque culture of the seventeenth century, Maravall refers to a number of radical changes that occurred during the period. At that time, urban populations in Europe rose because of the migration of rural populations into major cities. This shift was instrumental in the formation of what was to become mass culture and the modern era. Folk culture began to transform into new forms of popular culture, initiating the beginnings of consumerism on a mass scale (1983, 82). A new market based on an emergent consumer population led to the articulation of different kinds of art, literature, and a variety of "distractions" and new forms of public entertainment associated with a new leisure class. One of the problems addressed throughout the second part of *Don Quixote* is a problem familiar to our contemporary era: the relationship that exists between the copy and the original, and debates regarding authenticity that emerge as a result. Furthermore, the relationship between the copy and the original is placed in *Don Quixote* within the context of serial form, a phenomenon that manifested itself with great force during the seventeenth century as a result of developing social, technological, and economic infrastructures.

Expressing their seriality in alternate ways and through alternate forms of media, contemporary entertainments reveal a serial logic that has emerged from the contexts

of globalization, postmodernism, and advances in new technology. In the last decade in particular, the nexus between contemporary cinema and other media forms has altered dramatically. Entertainment forms such as computer games, comic books, theme parks, and television shows have become complexly interwoven, reflecting the interests of multinational conglomerates that have investments in numerous media companies. One media form serially extends its own narrative spaces and spectacles and those of other media as well. Narrative spaces weave and extend into and from one another, so much so that, at times, it is difficult to discuss one form of popular culture without referring to another.[2] In turn, this phenomenon has given rise to theoretical catchphrases that are believed to be specific to our era—an era of the simulacra and the fragmentation of "meaning."

Evaluating the different ways baroque and neo-baroque forms articulate their serial and polycentric spaces, this chapter explores the spatial configurations shared by the baroque and neo-baroque eras. It is argued that the serial structure integral to the (neo-)baroque is an open form that complicates the closure of classical systems. Lotman's proposition regarding culture and the construction of spatial formations remains the foundation of the ideas that follow. In the context of the seventeenth century, examples such as *Don Quixote* and Louis XIV's Versailles project are analyzed from the perspective of the articulation of a specifically baroque seriality. It is suggested that economic, political, and technological transformations—specifically, the emergence of capitalism in conjunction with the power of the monarchy—resulted in the production of a baroque aesthetic. With respect to the late twentieth and early twenty-first centuries, through an examination of cross-media variations such as the *Alien* serials, consideration is given to issues of economics and globalization. Likewise, the negative assumptions embraced by some postmodern models are viewed through the lens of the neo-baroque. Rather than interpreting the serial logic of contemporary entertainment media as the product of an era steeped in sterile repetition and unoriginality, I will argue that the repetition inherent in serialized form is the result of a neo-baroque "aesthetic of repetition" that is concerned with variation, rather than unoriginality and invariability.

The term "seriality" serves a twofold function. First, it relates to the copy that seeks to reproduce, multiply, or allude to versions of an "original." Second, it suggests the general movement of open (neo-)baroque form. The articulation of the latter form of seriality—especially since the twentieth century—encompasses the series, serial, and sequel.[3] Historically these three forms have developed distinct formal configurations, particularly in more recent times. More recently, however,

the distinctions between them have progressively blurred, highlighting a neo-baroque polycentrism.

Globalization, Seriality, and Entertainment Media

Currently we are immersed in an information age that Jim Collins observes is characterized by new forms of "techno-textuality" (1995, 6). As will be argued further in chapters 2 and 3, this techno-textuality has resulted in new forms of textuality and audience reception; from the perspective of seriality, however, it is driven by technologies that highlight the reproducible nature of the neo-baroque. Audiovisual technologies such as cable television, the VCR, laser disks, DVDs, VCDs (video compact discs), CDs, computers, the Internet, and digital television all highlight our epoch's heightened obsession with the copy. Our VCRs, VCD recorders, and DVD recorders involve technologies that allow us to record and keep copies of our favorite films or television shows; our CD burners can burn copies of cherished computer games or audio CDs; videos and DVDs permit audiences to repeat viewings of recent or older films; cable allows us continual access to repeats of films and television shows that span the history of the cinema and television; and digital television promises a database that will provide access to multiple entertainment formats ranging from films to computer games and the Internet.

The "copy" dimensions of seriality are manifested in the production of serials that seek to reproduce the basic narrative premise of specific stories. Not only has the sequel become a phenomenon associated with contemporary Hollywood cinema, but also in recent decades audiences have been exposed to an increase in story and media crossovers, one that reflects a new aesthetic that complicates classical forms of narration. Batman, like Superman (figure 1.1), began as a character in a comic-book serial in the late 1930s then was accompanied by media crossovers into films in the 1940s and television in the (in)famous 1960s series. More recently, however, the cross-media serialization of Batman has become more extreme. In addition to its multiple comic-book variations (*Batman*, *Detective*, *Shadow of the Bat*, *Legends of the Dark Knight*, *Gotham Nights*, and occasional crossovers into *Robin*, *Nightwing*, and *Catwoman*), the Batman story has also found a popular form of expression in four blockbuster films and numerous computer games. Other serial productions have followed suit. The computer game *Tomb Raider* continued its story in its game sequels and then migrated its story space into two blockbuster films and a comic-book series. *Buffy the Vampire Slayer*

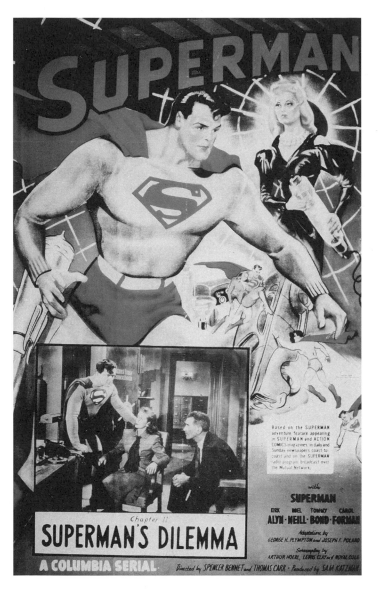

Figure 1.1 An early example of a Superman media crossover: A poster for the B-film serial *Superman's Dilemma* (1948). By permission of The Kobal Collection.

began as a film; its story possibilities expanded into the popular television series, which produced the spin-off *Angel*—and both television series inspired their own comic-book serials. Paul Verhoeven adapted the novel *Starship Troopers* to film in 1999; it then became a digitally animated television series and, more recently, a computer game. In these few of many possible examples, narratives are not centered or contained within one enclosed, static structure (in one film or one comic book). Instead, stories extend beyond their formal and media limits, encompassing rhythmic motions that intersect characters and stories across media. The spatial formations of narratives reveal polycentric movements driven by a like-minded polycentrism from the perspective of economics, in particular, the context of globalization.

The meaning of the word "globalization" is as multifarious and debated as that of the term "postmodernism." Yet certain key concepts recur in any definition of the term. In particular, globalization implies the "expansion of world communication through technological means" and of the "world market through economic means"; cultural theorists such as Fredric Jameson view postmodernism and globalization as being closely intertwined: The logistics of the latter gives rise to the former (Anderson 1998, 62). In the culture of late capitalism, multinational corporations have extended their production to a global level. For Jameson, who identifies postmodernism with a new stage of capitalism, "globalization is a communicational concept which masks and transmits cultural or economic meanings" (1998b, 55). In particular, since the 1980s, national markets have been integrated into an expansive system of economics that spans and connects the globe through transnational corporations whose concern for capital extends across multiple countries (1998b, 57).[4] According to Miyoshi, globalization and transnational corporatism transform society, culture, and the political into a "commercial program" (1998, 259), and the entertainment industry has embraced corporatism to its financial advantage.

Let's consider this commercial program from the perspective of the Alien franchise. Crossover variations on the blockbuster *Alien* films, which were produced by Twentieth Century Fox, have, for example, proved especially successful. Not only did 1979's *Alien* (Scott) inspire its own film sequels, but the movie's stories also migrated into comic-book and computer game formats. As examples of the sequel phenomenon that marks mainstream cinema, the *Alien* films signal a shift away from a centralized or closed narrative that progresses toward resolution and closure. Whereas *Alien* may have closed off meaning by presenting the viewer with narrative closure in the supposed demise of the Aliens,[5] the Alien narrative was then opened up by *Aliens* (Cameron 1986), *Alien³* (Fincher 1992), and *Alien Resurrection* (Jeunet 1997), so as to

continue the ongoing battle between humans and Aliens. A brief description of the plots of these films makes the point.

In *Alien*, the crew of a commercial spaceship, members of which are on a mission for an Earth corporation, receive what they believe to be an S.O.S. from a nearby planet. Hearing the call, some of the crew travel out to discover the source emitting the signal. A creature emerges from an egglike form and attacks one of the crew-members, Kane. Returning to the spaceship, the crew soon discovers that Kane has been used as an incubator for a rapidly growing Alien being that proceeds to hunt down and kill all the crew members except Ripley, the female heroine. In *Aliens*, after years asleep inside the spaceship sleep pod, Ripley is saved and revived. Joining a military outfit, she journeys back to the planet of Alien origin to discover the whereabouts of missing settlers from Earth who migrated to the planet during the years that Ripley slept. On the planet, she discovers instead an Alien colony, and the quest for human survivors results in the discovery of a young girl named Newt. In *Alien*[3], Ripley, sporting a shaved head, finds herself on an isolated prison-planet. Not only do Aliens again pose a threat, but in this third installment of the series, Ripley discovers she has been impregnated by an Alien; this knowledge leads her to orchestrate her own death at the movie's end. *Alien Resurrection* finds a solution to Ripley's demise. Cell remnants from Ripley's dead body are used to clone a new Ripley, who, as a result of her earlier Alien impregnation, has taken on characteristics of the Aliens. In the course of the film, it is revealed that Ripley has "mothered" an Alien child (who has grown into an Alien mother) who, in turn, has also provided Ripley with an Alien-human hybrid grandchild. Despite the implied closure with which each of the first three films ends, the sequel that follows opens up the "Alien" narrative premise by exploring alternative story dimensions.

It is not in the movies alone, however, that the "Alien" narratives continue. The "Alien" story has extended beyond the film medium, and a serial effect is produced by the migration of the film narratives to the comic-book environment by the Dark Horse Comics company, which produced further "Alien" serials, which, in turn, inspired their own sequels.[6] The comic book *Aliens: Earth War* (1991) begins by undercutting the events that presumed the safety of Newt and Ripley at the end of the film *Aliens*. Both wake some years later having to make their way back to the Alien planet. Meanwhile, in the years they have slept, Earth itself has been invaded by the Aliens; as a result, the Aliens' entire story is redirected, with Earth now the focal point of the action. *Aliens: Book One* (1992) takes place ten years after these events, and the protagonist is now Newt. Earth has found a new religion that involves the worship of an

Alien mother, and amid Alien invasion and chaos, Newt manages to fall in love with a cyborg, thereby undercutting the convention of Ripley's mistrust of cyborgs (Ash in *Alien* and Bishop in *Aliens*). *Aliens: Stronghold* (1994) continues with the cyborg theme; readers are introduced to a talking cyborg-Alien creature called Jeri, who is a "good guy" and has developed a penchant for smoking cigars. *Aliens: Music of the Spears* (1994) explores the Aliens-on-Earth scenario further, with humans discovering a new designer drug, a jelly composed of pheromones, whose scent drives Aliens into a frenzy. This drug is especially popular at rock concerts, and during one of these concerts the Aliens go on a pheromone-inspired killing spree.

Moreover, the seriality of the "Alien" stories is not limited to crossovers between film and comics. Seriality has now slipped into a more enveloping entertainment environment. *Alien War*, inspired more by the comic-book variations than the films, sees Earth itself infested by the deadly, acid-bleeding Alien extraterrestrials. But although influenced by the *Alien* comics, *Alien War* is no comic: It is a live-action tour that individuals can take, a tour set in the underground passages of Leicester Square in London. Accompanied by combat soldiers, paying customers are guided through a military installation's labyrinthine corridors, only to discover that the Aliens held captive in the installation's laboratory have escaped. In this version of the "Alien" story, the audience becomes part of the narrative action, stalked through the dark, smoky corridors by people dressed in Alien costumes; and within this live-action serial extension of the Aliens' tale, it is conceivable that participants can take on the role of Ripley, fighting off the Aliens as they lunge toward them. Similarly, the "Alien" story is revised in the computer game *Aliens Trilogy* and in the deceptively titled computer game *Alien: A Comic Book Adventure*. Even traditional comic-book superheroes are not safe from the clutches of the Aliens. Superman does battle with the Aliens when he returns to his home planet in the three-part comic-book serial *Superman vs. Aliens*, and in *Batman/ Aliens* Batman confronts the acid bleeding Aliens during one of his missions into the South American jungle. (Batman also has numerous battles with the warrior predators, made famous in the *Predator* films.) The wealth of expanding narrative possibilities continues to unfold and grow.

All the above-mentioned creative serial extensions of the "Alien" story are, however, closely interwoven with and reliant on economic imperatives of globalization and multinational corporatism that drive current entertainment industries. The *Alien* films were produced by Twentieth Century Fox; in turn, Fox formed a partnership with Dark Horse Comics to extend the film franchise into the comic-book medium and similar partnerships with the various computer game companies that produced the

Alien games and with the Scottish-based group who devised the Leicester Square adventure. Finally, the Superman/Alien and Batman/Alien comic-book crossovers were the result of collaborations involving Twentieth Century Fox (which owns the rights to *Alien*), DC Comics (which owns the rights to Superman), and Dark Horse Comics (which was responsible for integrating the two superhero trademarks). Additionally, for the Batman/Alien crossovers, Dark Horse negotiated a deal between Twentieth Century Fox and DC Comics (Batman's originator), the latter company also being a subsidiary of Time-Warner.

The "relationship between economics and aesthetics" has become crucial to the formal properties of entertainment media: Economics gives rise to new aesthetics (Wyatt 1994, 160). Of course, the same may be said of the relationship between aesthetics and economics that eventuated during the classical Hollywood era.[7] Since the 1960s, however, Hollywood has progressively evolved from a "Fordist mode of production, consisting of the vertical organization of the assembly line factory of studios," to a post-Fordist mode of production reliant upon horizontal organization (Gabilondo 1991, 128). Today, film production is only one component of the economic drive of the conglomerates that dominate the contemporary entertainment industry. The contemporary entertainment aesthetics that emerge from this drive support an industry that has multiple investment interests. In turn, the serial structure that manifests itself in entertainment narratives is supported by an economic infrastructure that has similarly expanded and adjusted its boundaries. Hollywood industry has always been concerned with investing in multiple media forms beyond film products.[8] Since the 1980s, however, the transnational effects of globalization have expanded the film industry's economic interests, shifting economic concerns to the global market (Wasko 1994, 6). In addition to the general global expansion that occurred in the 1980s, changes specific to the entertainment industry were nourished by a transnational climate. As Wasko observes, the deregulation of previously regulated media markets, including cable, the development of new computer technologies and the computer game industry, and corporate mergers that integrated companies with diverse media interests contributed to the emergence of an entertainment industry that not only thrived on investment in multimedia forms but aimed at dispersing multimedia entertainment products to a global market.[9]

Current industry affiliations highlight that the polycentrism that informs the story extensions of examples such as *Alien* is also manifested on the level of cross-ownership or multiple investment interests in various media products. For example, the $180 billion merger of America Online and Time Warner in January 2000 is one of many

conglomerate transformations that Warner Brothers has undergone in the last two decades (as have numerous other "film" companies).[10] With each new change in the conglomerate structure, new possibilities for media expansion become possible.[11] Prior to this most recent merger, Warner Brothers business activities included the 1978 takeover of Orion Pictures, followed in 1986 by the acquisition of Lorimar Telepictures Corporation; on March 6, 1989, Time Inc. and Warner Communications merged to become Time Warner; in 1993 Lorimar and Warner Brothers Television joined forces to become WB Television Productions, followed soon after by the formation of the WB Television Network; and in 1996, Time Warner created a storm by acquiring the Turner Broadcasting System for $7.5 billion. The current interests of the corporation reflect its concerns with diversification. Warner Brothers Television has interests in the WB Television Network and Warner Brothers Television Animation; cable investments include Time Warner Cable, CNN, Home Box Office, and Turner Broadcasting; feature film companies consist of Warner Brothers Pictures, New Line Cinema, Castle Rock Entertainment, and Telepictures Productions; Warner Home Video caters to the home video market; publishing interests comprise *Time*, *Sports Illustrated*, *Fortune*, *Life*, *Entertainment Weekly*, Warner Books, DC Comics, *Mad Magazine*, and Time Life Inc.; music companies include the Elektra Entertainment Group, Warner Brothers Records, WEA Inc., and Maverick Records; retail interests consist of Warner Brothers International Theaters, Warner Brothers Studio Stores, Warner Brothers Recreational Enterprises, and Warner Brothers Worldwide Licensing; theme parks include the Six Flags and Warner Brothers theme parks; and in addition to the merger with America Online, interactive interests comprise Warner Brothers Online.[12]

Taking one of Time Warner's most successful franchises, Batman, as an example: Warner Brothers Pictures reaps the financial benefits from the successful blockbuster film *Batman* and its sequels; DC Comics continues to disseminate the Batman story through the comic book medium; WB Television produces the successful animated *Batman* series and the futuristic *Batman of the Future*; Warner Brothers Records is responsible for the soundtracks for the *Batman* films, including the highly successful Prince soundtrack for *Batman* (Burton 1989); Warner Home Video releases the film and animation products on video; Time Warner Cable ensures delivery of the "Batman" stories on cable; and Time Warner's online ventures vary the "Batman" tale by offering *Gotham Girls*, an online comic serial that focuses on the Batworld "vixens": Batgirl, Catwoman, Poison Ivy, and Harley Quinn ⟨www.gothamgirls.com⟩. In addition, entertainment industries like Time Warner regularly join forces for limited deals

that act as vehicles of further diversification. More recently, the Burger King Corporation offered a *Batman of the Future* Kid's Meal in a promotional partnership with DC Comics and Warner Brothers; this five-week promotion included eight different toys based on characters from the *Batman of the Future* television series that appears on the WB Television Network.[13]

In all these instances, neo-baroque seriality is the end product of an industry that is driven by cross-media extensions and cross merchandizing. The dynamism and the multicentered narratives that characterize entertainment forms of recent years are therefore paralleled by a serial economic rationale that is concerned with self-promotion. Late-twentieth- and early-twenty-first-century seriality is the outcome of a marketing strategy that aims at squeezing from a product its fullest marketing potential. Financial risk and gain is reduced or amplified by promoting serial variations based on previously successful formulas in the hope of reproducing their success in sequel or cross-media format. At times this entails affiliations with companies beyond the corporate fold. Ideally, however, major economic benefits are to be reaped when a corporation owns subsidiary companies that can serialize a story franchise and thus extend potential profits across the corporation's multiple investment interests.

Capitalism, Seriality, and the Baroque

The serial formations associated with the seventeenth-century baroque are the product of different economic, social, and technological forces than the serial formations associated with the late twentieth and early twenty-first centuries, yet globalization provided an underlying impetus for serialization in both eras. Globalization has been viewed by some as the final of three stages of global transformation that began in 1945.[14] Others, however, have argued that the twentieth century did not herald a historical break in relation to capitalist expansionism; the twentieth and twenty-first centuries, according to these observers, merely developed along economic lines that were initiated with the first wave of colonialism and early capitalism that began in the sixteenth and seventeenth centuries (Mignolo 1998, 32; Miyoshi 1998, 247). As Miyoshi states, "capitalism has always been international," and changes in global expansion since the sixteenth and seventeenth centuries have been a matter of degree (1998, 268). Whichever position we adopt, during our times, global expansion has reached a level not witnessed before.

Dussel understands the social shifts toward modernity and capitalism that were cemented during the seventeenth century as reaching their point of culmination in

the late twentieth century. He states that, with the abdication of the Roman Emperor Charles V in 1557, "the path [was] left open for the world system of mercantile, industrial, and, today transnational capitalism" (Dussel 1998, 10).[15] Considering his comments with respect to the premise of this book, the baroque therefore finds its point of culmination in the neo-baroque. The seriality witnessed in the late twentieth and early twenty-first centuries is the product of "late capitalism," and the seventeenth century nurtured the emergence of capitalism's early stage. We have come full circle. From the perspective of economic infrastructures, both eras signaled radical transformations: The seventeenth century ushered in the era of capitalism and closed off connections with feudalist structures; our own era, from Jameson's perspective, signals not an opening, but a closure whereby capitalism finds its zenith in the shape of transnational corporatism and globalization. As suggested in the Introduction, however, both eras, past and present, signal the emergence of new orders. They are epochs of transition in which the "old" coexists with a "new" that is struggling to articulate its presence with greater force until it finally dominates. At the point of the closure of one circle and the opening of another, where the seventeenth century meets the late twentieth and early twenty-first centuries, the baroque and neo-baroque find expression.

John Beverley has stressed that an understanding of the baroque does not solely entail an appreciation of its status as "style-concept"; a fuller comprehension encompasses a complexity of cultural transformations, one of the most significant being "the transition from feudalism to capitalism," a process that had begun in the sixteenth century but progressed more dramatically during the seventeenth (1988, 28). Seventeenth-century Europe has often been associated with royal absolutism, but the role of nobility, as Munck points out, was far from static during this period, changing enough to be "sufficient to merit a shift or crisis" (1990, 145). The initial shift in the role of nobility began in the late fifteenth century, as monarchs and the church accessed newfound sources of wealth and power. During the sixteenth century, Spain, in particular, emerged as the "first modern European state" (Beverley 1988, 27). The potential for capital growth first accompanied Columbus in 1492 on his return to the Hapsburg kings of Spain, Queen Isabella and King Ferdinand, with gold from Hispaniola (Burkholder and Johnson 1998, 34). Reflecting the early commercial concerns of European exploration, further voyages to the Americas aimed at reaping the financial benefits of rich mineral deposits of the newly discovered countries. During the sixteenth century, the newly established colonies enhanced the economic base of the Iberian kingdoms. The profits of trade, the mining of gold and silver, the export of

sugar and spices all benefited the Crown's coffers—and its control of parts of central Europe, Germany, Burgundy, and the Netherlands—transforming "Castille into the financial core of the Catholic order in Europe" (Stein and Stein 1999, 53).[16] With money comes power.

The seventeenth century, however, was a financial turning point for the Iberian kingdom, bringing a major decline in revenue that came from the New World. In the wake of Philip II's bankruptcy in 1557 (as a result of wars and excessive royal expenses), further systemic crises occurred,[17] as a new capitalist order progressively superseded the power of the Crown. The "first modernity" has been associated with the Iberian colonization of the Americas. It was driven by concerns with establishing a world empire that was headed by monarchical interests. During the "second modernity" of the seventeenth century, Holland (followed by England and France) became the leader of a new world system that initiated a new economic attitude that laid the foundations for capitalism and the establishment of a new economic world system (Dussel 1998, 11–13). This second modernity, which coincides with the baroque era, establishes a new modern paradigm associated with the "governmentalism or the management of an enormous world-system in expansion" (Dussel 1998, 15).

Unlike Iberian expansion through colonization, Dutch expansion occurred through private capitalist enterprises (the East India Company and that of the Western Indies), founded at the turn of the seventeenth century and later followed by the establishment of English and Danish companies, that were private and driven by mercantilism (Dussel 1998, 27).[18] The aggressive nature of this new Iberian capitalist order was evident in the series of wars that raged throughout the seventeenth century, including the Anglo-Dutch Wars in 1652–1654, 1664–1667 and 1672–1674, and later the French-Dutch War of 1674–1678 (Ferro 1997, 56),[19] all fought for commercial and economic control over colonized lands and the seas that provided the routes to them.

Likewise, during the seventeenth century merchants attained greater social power and independence, a shift that was paralleled by greater monarchical unease with regard to their control over the economy and society (Maravall 1986, 13). For Maravall, the phenomenon of the baroque (in particular, the Spanish baroque) was interwoven with urbanization and the emergence of a mass culture that was intimately intertwined with the emerging capitalist system. European cities developed "corporate autonomy" from seigneurial powers.[20] Similarly, the development of mercantile capitalism in countries like Italy and the Netherlands generated a growth in urbanism (Cohen 1985, 96). In addition to the expansion of the urban population throughout Europe, urban growth was even more pronounced in the colonies. By 1630, 58 percent of the

population of Mexico City were Spanish and in Lima, the Spanish population reached 55% with similar growth occurring in other cities (Burkholder and Johnson 1998, 184).

The changing social and economic dynamic fostered an environment that gave rise to a transformed class structure. A new middle class emerged that included entrepreneurs and shopkeepers (Munck 1990, 181). The seventeenth century is characterized especially by the phenomenon of social mobility, and on the basis of capital gains, vertical mobility in the social stratum became increasingly possible (Maravall 1986, 16). In fact, the extent of the transformation of the class system is visible in *Don Quixote*. Written and published during this period of transition, Cervantes' *Don Quixote* is littered with examples of characters who, as a result of monetary gains, live comfortable lives traditionally associated with the nobility. Through characters like Teresa Panza, who recognizes the possibilities of upward mobility that a capitalist structure provides, Cervantes explores the social changes that have occurred to allow economic success to advance one's place in the social hierarchy (Cascardi 1997, 185).

Urban growth throughout Europe resulted not only in new urban planning and building to accommodate the growing urban populations but an increase in everyday commodities such as glassware, furniture, clocks, paper, books, and other household goods and luxury items (Munck 1990, 116; Maravall 1986, 11), all of which increased the need for businesses that could produce and meet the growing demand. Likewise, there was growing demand for education, printing, and book production (Munck 1990, 116).

The print revolution that commenced in the fifteenth century was boosted in the seventeenth century by the new economy and a developing urban culture (Godzich and Spadacchini 1986, 49).[21] Print culture became instrumental in the emergence of a specifically baroque form of expression. The expansion of the masses into urban environments was accompanied by the mass production of media, which had been steadily on the rise since the Renaissance. During the baroque era the printing industry flourished: The seventeenth century may not have had broadcast television, the cinema, cable television, and the Internet, but it did have books, paintings (addressed to a new middle-class market), popular songs, commercialized theatrical presentations, and reproducible images (Maravall 1983, 83–85). Since the mid-sixteenth century, printed books had been produced inexpensively and in great quantities, and in the seventeenth century the print industry expanded to meet the market needs of an emerging mass audience, one that included audiences in the new and burgeoning colonial cities of the Americas (Burkholder and Johnson 1998, 236). These new printing infrastructures nurtured the commodifiable possibilities of the copy.

The extent of competition opened up by the burgeoning print industry (and the new economic climate) is reflected in the dilemma that confronted the merchant Giovanni Giacomo De Rossi and his etcher Giovanni Battista Falda. In an effort to win Pope Alexander VII's favor, De Rossi and Falda produced a series of prints, *Il nuovo teatro delle fabriche et edificii in prospettiva di Roma moderna*. The book, begun in 1657 and completed in 1665, showed the new and partly finished buildings of modern Rome—all building projects promoted by Alexander VII (Consagra 1995, 188). Aware of the competitive nature of the print industry, De Rossi petitioned the Pope to grant him a twenty-year copyright not only on this book, but all other publications that were produced from his business. On November 29, 1664, De Rossi wrote:

> Most Blessed Father,
> Giovanni Giacomo de Rossi, printer of copperplates at the via della Pace . . . having published at his own expense and discomfort diverse works and being ready to publish others, novelties never before made because he has to suspect that while he is alive, that as he publishes them, they are copied by others, whom would be the total ruin of this poor petitioner. . . . [Such a privilege] would not be a prejudice to the other printers, but rather force each one to make new images that differed from those of the petitioner. (Consagra 1995, 197)

Although he did not grant the twenty-year protection De Rossi requested on his publications, Pope Alexander did grant him a ten-year copyright.[22] As De Rossi's predicament reveals, print technology not only increased the production and dissemination of texts but created a competitive market and new consumers. Additionally, the preference for elite languages such as Latin was yielding to the vernacular as the language of popular publication (Munck 1990, 289).[23] Production and consumption of published materials were no longer limited to the elite upper classes; publications were now available to the emerging middle and, to a lesser extent, lower classes.[24] Printed texts became available to a wider public and, as Godzich and Spadacchini argue, the "addressee was no longer 'homogeneous' but developed a mass-oriented identity that drew on a variety of classes" (1986a, 54). Emerging forms of popular culture—including chapbooks, street music, concerts, opera, pamphlets, ballads, almanacs, novels, and books of secrets and natural magic[25]—addressed themselves to individuals from diverse social groups. A mass culture began to form (Munck 1990, 271, 308–314).

The open nature of the baroque is especially evident in its development of serials generated by print media. Product demand engendered by new mass and middle-class

audiences created a market for sequelizations of novels such as Cervantes' *Don Quixote* (including the Cervantes and Tordesillan sequels) and Lucas Rodríguez and Lorenzo Sepúlveda's *Romancero general* of 1600 (Godzich and Spadacchini 1986a, 56). *Don Quixote* also refers to Cervantes's *Galatea*. The priest in *Don Quixote* who discusses *Galatea* is of the opinion that it is an inventive book, but notes that although its author "proposes something . . . [he] concludes nothing"; this problem, he suggests, may be resolved in the sequel that Cervantes is writing (1999, I:63).

Additionally, parts I and II of *Don Quixote* relate numerous stories from other novels that are themselves serialized within *Don Quixote* by being retold and extended across numerous chapters. So familiar had audiences become with exposure to multiple story formations that Cervantes, drawing on the seventeenth century's famed play-within-a-play motif, included numerous story "digressions" in his *Don Quixote* sequels.[26]

Printing presses also facilitated a proliferation of image copies of paintings, sculptures, and architecture, providing artists—and the public—with access to works that previously could be seen only in situ or through rarer print versions that had a limited and more elite and specialized audience. In the mid- to late sixteenth century, the demand for prints had increased so dramatically that it instigated changes in conditions of print production (Hind 1963, 118).[27] Once the possibilities of this burgeoning market were recognized, the new profession of the print seller emerged (Hind 1963, 118).[28] Art markets were also transformed as the production of a new leisure culture industry nurtured their expansion. Art production was no longer purely the domain of princely patrons or church officials. Independent art dealers established shops throughout Europe, selling to and ordering commissions for buyers from a new middle-class market. The emerging social hierarchies embodied in mass and middle-class audiences supported a new economy that included the middle-class art dealer: Copies of paintings and mass-produced images became a successful industry.[29]

Jacob van Swanenburgh was a Dutch artist working in Naples during the first decade of the seventeenth century. One of his specializations was the production of infernal landscapes such as *Seven Deadly Sins* (Rijksmuseum, Amsterdam) (figure 1.2) and *Hell Scene* (Lakenhal Museum, Leyden) (figure 1.3), both of which incorporate recurring motifs like the mouth of hell, demonic creatures, and witches' sabbaths. The infernal landscape had been popularized in Italy by northern European artists like Jan Brueghel the Elder, who, during the late sixteenth and early seventeenth centuries, had worked almost exclusively for aristocratic patrons such as the Medici in Florence and the Gonzaga in Milan. The demand for such hell scenes, however, and the altered free market conditions that made possible the growth of small business opened up for

Figure 1.2 Jacob van Swanenburgh, *The Seven Deadly Sins*, c.1600–1610, Rijksmuseum, Amsterdam (Inv. No. SK-A-730). By permission of the Rijksmuseum.

Figure 1.3 Jacob van Swanenburgh, *Hell Scene*, c.1600–1610, Stedelijk Museum de Lakenhal (Inv. No. S.251). By permission of the Stedelijk Museum de Lakenhal.

artists like Swanenburgh new opportunities directed toward a new consumer. Working during an era that blurred distinctions between science and magic, in 1608 Swanenburgh faced the dreaded Inquisition, having to defend his choice of subject matter. The Inquisition was especially concerned about the fact that three of his paintings (which the Inquisition had recently confiscated) included witches and demons, some of whom were shown abducting children for suspect purposes. Swanenburgh was asked how he was familiar with such events, whether he had met any witches, and how he knew of the rituals involved in witch worship of the devil (Amabile 1891, 17–23).[30] The Inquisition documents recording Swanenburgh's interrogation are fascinating not only in their revelation of the church's paranoia when confronted with the changing scientific conditions of this transitional period in history (an issue I will return to in the latter part of the book), but in the extent to which they highlight the transformed social and economic conditions of the time.

Reflecting the rise of mercantilism and the shift away from courtly patronage, Swanenburgh stated in response to the inquisitors' questions that he painted and sold his paintings from his workshop, which was near the Chiesa della Caritá in Naples. He exhibited his works on the walls of his shop interior and exterior, and his business relied not on aristocratic patronage, but on individuals who happened to pass by his shop—who, ironically, included "many spiritual fathers" who visited the shop and "said nothing" (Amabile 1891, 62). Swanenburgh explained that an unnamed gentleman gave him a smaller version of a scene that represented a meeting of witches, commissioning him to reproduce the work in larger dimensions (1891, 18). Swanenburgh was already known for producing serial variations of similar scenes (such as *The Seven Deadly Sins* and *Hell Scene*, which repeated images of the mouth of hell but varied the characters and actions that inhabited the landscape). He stated that in addition to the copy he had produced for the client, he had also produced a copy of the gentleman's painting for himself. For the larger version produced for his client, he added characters, such as demons and figures of witches, that he had copied directly from a painting by Andrea Molinari, who had a workshop nearby in a street near the Church Spirito Santo.[31] Recognizing the effects of the altered market conditions, artists like Swanenburgh tapped into the financial advantages of mass-produced popular images.

The phenomenon of seriality and the copy also manifested itself in other cultural arenas. During the seventeenth century operas flourished with the support of aristocratic patrons such as the Medici in Florence and the Barberini in Rome. Operatic productions also adjusted, however, to changing social conditions. Opera productions

sponsored by the Medici in Florence accompanied aristocratic events such as marriages and performances were held in theaters built on the property of the aristocracy. These operas and theatrical productions were performed once—and only occasionally repeated—for the event that they commemorated. In Venice, theaters specifically for the purpose of opera and other performances were constructed for the public and supported by ticket sales, and managers were hired to assemble companies of performers and supply performances for an entire season (Palisca 1968, 119). Palisca explains that this system was so successful that by 1700, sixteen theaters had been built and 388 operas had been performed; for the first time librettists, performers, composers, designers, and stage managers were allowed more than occasional opportunities to repeat their work.[32] Traveling troupes that included performers of the commedia dell'arte also became popular, repeating their performances throughout Europe (figure 1.4). Cesti's *Orontea*, for example, was first performed successfully in 1649 at the Teatro Santissimi Apostoli in Venice then repeated over a period of forty years in cities that included Lucca, Rome, Naples, Innsbruck, Florence, Genoa, Turin, Milan, Bologna, and Chantilly (Palisca 1968, 125).

The popularity of theater that reached a diverse audience made permanent commercial theaters financially viable. In the wake of the commercial success of Venetian theaters, theaters were constructed in cities such as Paris, Madrid, and London, offering performances of commissioned plays composed by authors like Shakespeare, Marlowe, and Lope de Vega (Cohen 1985, 136). Reflecting the transitional nature of the times, the seventeenth century witnessed intense competition between public, commercial theaters and the private theaters of the aristocracy. Culture was transforming and commercial theaters continued to thrive, with construction of theaters even expanding to include lower-class areas (Cohen 1985, 267).[33]

Seigneurial Seriality: Serial Form and Baroque Allegory

Seriality also became a potent strategic tool for the aristocracy and the church in the seventeenth century. For these entities, however, seriality became a method for combating an alternative form of competition. During this transitional time, the power of the aristocracy and of the church simultaneously grew and faltered as capitalism and new social formations began to take hold. The spatially invasive logic that underlies the serial and drives baroque form found one of its paramount forms of expression in the project undertaken by France's King Louis XIV to reconstruct the royal residence at Versailles. Following his ascendancy to the French throne in 1661, Versailles became

Figure 1.4 Comics performing in the Piazza San Marco, Venice. Giacomo Franco, *Abiti d'Uomini e Donne Veneziani*, 1610 (Museo Correr, Venice). By permission of The Art Archive/Museo Correr Venice/Dagli Orti (A).

an obsession for Louis XIV, functioning both as a realm of pleasure and a site of his power. Under the reign of his father, Louis XIII, the château at Versailles was a retreat used for hunting purposes; under Louis XIV's reign, not only had Versailles's territory expanded from 500 to 15,000 acres, but by 1682 it had also become the official seat of the French government (Lablaude 1995, 8–16).

The "world" that was to be built at Versailles over some decades became symbolic of Louis XIV's power.[34] Versailles became a microcosm of Louis's dominance as a monarch who had ensured his nation's control of other European nations and new colonies in the Americas. As Lablaude explains, the two main facades of Versailles served ideological functions. The majestic palace that faced the town symbolized the court and the king's power over the French nation and colonial interests. The private garden was for aristocratic eyes and was emblematic of Louis XIV's "reign over the world in microcosmic form" (Lablaude 1995, 12). Furthermore, Louis XIV merged the emblem of the golden sun rays that he had adapted from his ancestor Charles VI with the symbolism of the Greek god Apollo, "deifying himself in the process" (38). In this respect, Louis XIV also adopted an image that had been associated with the Barberini Pope Urban VIII, and in doing so, he also laid claim to the transfer of Urban's power into his own persona and into the country he ruled.[35] Berger outlines in detail the complex Apollonian iconographic program that the Petite Academie (which first met in February 1663) devised, in consultation with the king, for the decoration of Versailles and its gardens (1985, 22). The emblematic rays of sunlight, especially as associated with the sun god Apollo, became a symbol that appeared in serial narratives throughout Versailles: in the gardens, festivals, interior decoration, paintings, and architecture.

Although physically separated from one another in their distribution, serialized narratives connected by the figure of Apollo integrate statue groups that are interspersed throughout the gardens of Versailles. As in the Aliens examples discussed earlier, key iconographic features (the figure of Apollo on the one hand, and Aliens, cyborgs, and Ripley-style heroines on the other) remain as stable features across the serial web. Narrative form becomes dispersed, because each serial example interlaces across a larger story network; nevertheless, the key iconographic motifs (the franchise) reign in the complex series of stories that unravel along their own distinct paths. In the gardens of Versailles, the *Apollo Fountain* (1667–1672) depicts the story of the sun god Apollo rising from the waters in his horse-drawn chariot at dawn, breaking in a new day (figure 1.5). In the *Grotto of Tethys* (1667–1672), his task as Helios-Apollo completed, he descends—bringing dusk with him—into Tethys's (his wife's) underwater world.

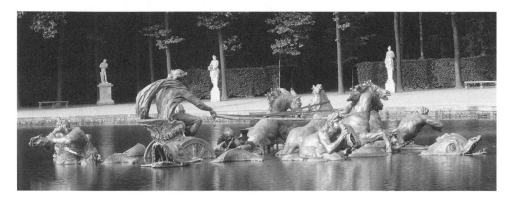

Figure 1.5 *Apollo's Chariot*, Versailles (1667–1672). By permission of The Art Archive/Nicolas Sapieha.

This statue pairing is imbued with a further allegorical dimension whereby "a parallel between the repose of the Sun God and the repose of Louis XIV" is established: Like the sun god, Louis "retires to Versailles after the completion of his royal duties" (Rosasco 1991, 2).[36] Apollo and Louis converge. Louis XIV established himself as the power center of the known world, with Versailles itself as microcosm of the world, and "it was into this palace that the Sun (equated with Apollo) retired every evening after finishing his arduous daily task of illuminating the world" (Berger 1985, 22).[37]

The serial connection between the two statue groups, *Apollo Fountain* and *Grotto of Tethys*, is evident in the symbolic connection that depicts the rising and setting sun. Breaking with the linear sequence of story events, in the *Latona Fountain* (1668–1670) the tale returns to Apollo's past: Outraged by Jupiter's affair with Latona, Juno orders a python to pursue Latona, who is pregnant with Jupiter's children, the twins Apollo and Diana (Berger 1985, 27). The sequel to this statue group, the *Dragon Fountain*, continues the story immediately after the birth of Apollo, and the Python is shown slain by the infant's arrows.[38] Beyond dealing with the mythological events of Apollo's life, the *Latona* and *Dragon* fountains also function as potent allegory that conveyed the power of the Sun King. According to Berger, "Latona represents Anne of Austria the mother of Louis XIV beleaguered with her two children (Louis and his brother Philippe) during the Fronde when Anne was Regent." The "Ovidian story of how Latona and her two divine children were refused water by the wicked peasants, and how Latona called down punishment from heaven" by asking for Jupiter's intervention is allegorically transformed into a story of contemporary significance "warning against those who might challenge a divine-right ruler." The Frondeurs, like the python, will

suffer the "punishment of their rebelliousness" (1985, 27). Significantly, whereas Apollo slays the python in the mythical interpretation, on the allegorical level, Apollo the child is also transformed into Louis XIV, heir to the future throne and punisher of those who question his royal authority.

The fresco designs of Versailles's interior also continued the symbolic associations of Louis XIV with Apollo. Allegorizing contemporary events associated with Louis's reign and the story of Apollo, the series of frescoes throughout Versailles rely on the same seriality that gives meaning to the garden statuary. Part of the vault decoration for the fresco of the *Escalier des Ambassadeurs* (1674–1680, now destroyed) included a painting of *Apollo with the Dead Python*. Depicting another version of the *Dragon Fountain* in an alternate media format, this work, like its sculptural variation, also functioned as an allegory of the Fronde (Berger 1985, 67). The royal suites, or planetary rooms, of Versailles were influenced by the decorative schemes of Pietro da Cortona and Cirro Ferri for the Palazzo Pitti in Florence, with this allusion firmly establishing Louis XIV as successor to the "grandeur of imperial Rome" (Berger 1985, 3, 48). The king's throne room, or the Salon d'Apollon, included the ceiling painting *Rising of the Sun* (c.1672–1681); repeating the subject matter of the gardens' statue arrangement in another media format, the painting depicted Apollo in his horse-drawn chariot as he soared into the sky ushering in the new day.[39] With the central room focusing its design on the sun god Apollo, the other six rooms were dedicated to the planets Mercury, Venus, Earth (with the moon), Jupiter, Saturn, and Mars. Although it is still debatable whether the schema and sequence of the rooms was informed by a Ptolemaic or Copernican solar system, the centrality of the sun god motif as symbolic of the Sun King's power is not an issue of debate.[40]

Construction of the Galerie des Glaces began in 1678. It was designed by Jules Hardouin-Mansart and illustrated the propagandistic logic of the decorative schemes that were dispersed throughout Versailles. Whereas the original design centered on narratives dominated by Louis's mythic person, the sun god Apollo,[41] the final fresco scheme represented Louis XIV performing glorious deeds, including his victory in the Dutch war (1672–1678), which established France "as military and diplomatic victor and elevated the international prestige of Louis XIV," and personifications depicting the vices of hostile nations such as Germany, Spain, and Holland (Berger 1985, 52–56). As Berger notes, however, the "long gallery was a room about power" (56). The influence of the Salon de los Espejos, or the Hall of Mirrors, in the Alcarar in Madrid was no mere artistic allusion. The Salon de los Espejos not only included

Hapsburg portraits and functioned as the reception room where Spanish kings received ambassadors and nobility, but it was also a monument to the Spanish Hapsburgs. The Galerie des Glaces not only rivaled the Salon de los Espejos in scope and scale but was symbolically meant to embody Louis's rivalry with and defeat of Spain during his reign (Berger 1985, 57).

As will be explored further in chapter 2, intertextuality in conjunction with seriality became potent vehicles of monarchical absolutism for the aristocrats of the seventeenth century. Such intertextuality and seriality often relied on allegory for the articulation of its meaning. In *The Origin of German Tragic Drama* (1998), Walter Benjamin has famously argued his position regarding the function of allegory in baroque theater, specifically, the German *Trauerspiel* of writers such as Opitz, Gryphius, and Lohenstein. The political function of allegory, according to Benjamin, was integral to baroque logic, and the frequent comparison of the prince with the sun stressed the monarch's "ultimate authority" (1998, 67). Drawing on the example of Spanish theater, in particular, the plays of Calderon, Benjamin suggests that these works delight "in including the whole of nature as subservient to the crown creating thereby a veritable dialectic of setting" (93). As seen in the example of the Versailles project, such allegorical posturing whose function is the display of monarchical power is not limited to the world of theater. Through the process of serialization, at Versailles, the Apollonian allegory geographically and polycentrically invades a space that stands as microcosm to the world itself.

Not perceiving baroque allegory as "a conventional relationship between an illustrative image and its abstract meaning," Benjamin insists that it functions instead as a dialectic "form of expression" that "immerses itself into the depths which separate visual being from meaning" (162–165). Any overt connection between the sign and its meaning is ruptured, "and the hieratic ostentation [becomes] more assertive" (169). As seen in the Apollo program at Versailles, the various serial depictions of Apollo's life serve a more complex allegorical function that collapses the figures of Apollo and Louis XIV into one another, the intent being to highlight the monarch's grandiose obsessions and claims to power. In the words of Benjamin, "Any person, any objects, any relationship, can mean absolutely anything else" (175). He continues: "But it will be unmistakably apparent, especially to anyone who is familiar with allegorical textual exegesis, that all of the things which are used to signify derive from the very fact of their pointing to something else, a power which makes them appear no longer commensurable with profane things, which raises them onto a higher plane, and which can, indeed, sanctify them" (175).

Although they lack the blueness of royal blood that is ostensibly characteristic of the aristocracy, interestingly, contemporary entertainment industries rely on allegorical logic similar to that of the Apollo program at Versailles. Driven by the demands of globalization and multinational corporatism, contemporary entertainment industries have an economic rationale, audience, and allegory of power that is radically different from those espoused by monarchs such as Louis XIV. Nevertheless, the seriality that has become integral to the industry also functions as allegorical vehicle: The sign that is serialized (whether it is Batman, Lara Croft, or *Star Trek*) also becomes an allegorical emblem of the corporate power that gave birth to it (Time Warner, Eidos Interactive, and Paramount/Viacom, respectively, in the examples just given).

An Aesthetic of Repetition and the Drive for Perfection

For Walter Benjamin, the function of allegory as fragment is a crucial one. With regard to the baroque, he observes that "in the use of highly charged metaphors—the written word tends towards the visual. It is not possible to conceive of a starker opposite to the artistic symbol, the plastic symbol, the image of organic totality, than this amorphous fragment which is seen in the form of allegorical script" (1998, 176). "Allegories are," he continues, "in the realm of thoughts, what ruins are in the realm of things. . . . That which lies here in ruins, the highly significant fragment, the remnant, is, in fact, the finest material of baroque creation" (178). What is especially fascinating about Benjamin's deliberations on the literary baroque fragment and ruin is that similar issues of fragmentation and decay recur in the writings of many postmodern cultural theorists. Jameson, in particular, has led the field in this respect. Although theories of the postmodern have been outlined in depth elsewhere and are of concern here only as they intersect with the (neo-)baroque, a brief summation is in order. In "Postmodernism and Consumer Society" (1998a),[42] Jameson argues that the expansion of transnational corporatism, technological advancement, and expanded communications has resulted in the "death of the subject": New subjectivities emerge and are characterized by the fragmentation and schizophrenic nature of the subject. Nostalgically presuming that modernist forms retained a sense of totality and "meaning," like Benjamin's ruins, examples of popular culture are viewed as fragmentary, vacantly alluding to and recalling past "signs" in a piecemeal manner. But where for Jameson, especially in the context of consumerism, postmodernism makes few allowances for original creations, in Benjamin's writings I find an alternate, even inspired possibility. In addition to conjuring notions of decay, the ruin and fragment also

engender creativity. That which has succumbed to the ordeals of time also embodies an awareness of the process of time. Likewise, that which has become a fragment may also be metamorphosed into a creation in its own right.

Although Benjamin does not discuss it in these precise terms, from the perspective of the eighteenth and nineteenth centuries, the baroque period, like the postmodern, was also considered to be a period of decay, its art revealing an exuberant style that echoed the collapse of the Renaissance spirit and the classicism it espoused. In fact, this sentiment also found a voice during the seventeenth century. To return to part II of Cervantes's *Don Quixote*, the audience is confronted there—in fictional form—with the very debates that plague many postmodernists. Don Quixote himself is the fragmented, schizophrenic, postmodern subject. His library includes numerous books and poems of the heroic and chivalric traditions. Not only does Quixote quote from and allude to many of these during his adventures—*Amadis de Gaul*, *The Adventures of Esplandian*, *Don Olivante de Laura*, *Amadis of Greece*, *The Knight of Platir*, and *The History of the Renowned Knight Tirante the White*, among many others[43]—but they construct him, transforming him from Alfonso Quijada into Don Quixote. These accumulated fragments constitute his subjectivity. Significantly, as Cascardi reflects, *Don Quixote* reflexively unveils the complex array of references at work that inform Cervantes's novel. In addition to the allusions to multiple works and other authors, emphasis is placed on the fact that all "original" models that Don Quixote craves have been lost (1997, 198), existing in an era long gone. Quixote and Jameson have much in common.

In adopting the identity of Cid Hamet Ben Engeli, Cervantes distances himself from the role of author and, in the process, presents a sophisticated understanding of the complexities entailed in debates about authorship and originality. Is there such a thing as an "original"? If so, does its reproduction, through the process of simulation or serialization, render later variations inauthentic? *Don Quixote* provides a context in which a dialogic relationship exists[44] between characters and the opinions they espouse. Like the fictional author Cid Hamet Ben Engeli, Don Quixote is outraged by the discovery of the "fake," ruinous version of his adventures. While visiting the printer in the latter part of the novel, after much civil debate, Don Quixote comes across the *Second Part of the Ingenious Gentleman Don Quixote de la Mancha*, written by the "plagiarist" Tordesillan, in the printer's collection of books. Disgusted, Don Quixote storms out of the printing house (1999, II·62, 1043). Earlier, from his room in an inn, Quixote overhears a conversation in the next room: Someone is asking Señor Don Jerónimo to read a chapter of the *Second Part of the Ingenious Gentleman Don Quixote de la Mancha*; Don

Jerónimo responds by demanding to know how anyone could read such absurdity from this imposter after reading the original (1999, II:59, 1009). Incensed, Quixote storms into the room and the two comfort him by finding problems with the "inauthentic sequel": The language is Aragonian, the plagiarist sometimes fails to include articles, and Sancho's wife is incorrectly called Mari Gutierrez. Sancho, who had also been present during the reading, added that characters in this second book are not "legitimate" because Cid Hamet Ben Engeli did not compose them (1999, II:59, 1010). Offering an alternative view, however, in chapter 70, Quixote discusses the Tordesillan version of Don Quixote with a musician, who states emphatically that "among the upstart poets of our age, it is the fashion for every one to write as he pleases, and to steal from whom he pleases . . . and, in these times, there is no silly thing sung or written, but it is ascribed to poetical license" (1999, II:70, 1092–1093).[45] Interestingly, a similar reference to poetic license was made by Swanenburgh in his response to the Inquisition: Having outlined the numerous sources from which he copied images, Swanenburgh responded that the confiscated paintings were produced as "una burla" (a joke) or a "capriccio" that inspires flights of the imagination (Amabile 1891, 61–62).[46]

Like the musician in *Don Quixote*, a postmodern theoretical tradition counter to the Jamesonian has also flourished. Numerous writers including Jim Collins and John Docker have considered the postmodern in a more positive light. For these writers, postmodernism is a phenomenon to be celebrated. Among the fragmented, self-reflexive forms of popular culture, they argue, it is possible to find a complex coherence, one that has little to do with a lack of originality or a corruption of meaning that poses a "danger to civilization" (Docker 1994, xvii).[47] Even so, it is the negative associations of the postmodern, especially as it informs contemporary entertainment media, that persist like a litany of ritual observation. Increasingly, the "fractured" narratives typical of seriality have been perceived as reflecting a "dispersal" or "corruption" of meaning: the revelation of a lack of "true" artistry. Reiterating the postmodern stances of Jean Baudrillard and Fredric Jameson, Timothy Corrigan, for example, characterizes contemporary Hollywood film viewing as comprising "distracted viewings" (1991, 16). The "glance aesthetic" familiar to television viewing replaces the "gaze aesthetic" of traditional Hollywood film viewing of the pre-1970s era (31).[48] In a divergence from the concerns of the classical paradigm with continuity, characterization, and closure, contemporary images and narratives are viewed as fragmented. As their significance and meaning is dispersed, signs of narrative coherence are eliminated (6).

Corrigan recognizes that the process of "dispersal" is a characteristic of contemporary cinema's inherently intertextual and serial nature. His argument, however, is informed by nostalgia. He understands current transformations in narrative form as symptoms of a state of cultural degeneration:[49] Contemporary cinema is viewed as resisting legibility and interpretative depth. Whereas the historical reception of films emphasized "reading," thus implying the capacity to interpret, for Corrigan, the postmodern era reflects a Baudrillardian view (see Baudrillard 1983 and 1984). The transformation of popular culture is marked by "social entropy" that leads to the "implosion of meaning" as the spectator engages in an exhausted fascination with signs (Corrigan 1991, 52–63; see also Baudrillard 1983).

According to the holy trinity of postmodern theory—Jameson, Baudrillard, and Lyotard—variations of the same theoretical narrative are often retold. Signs become the means not to the production of meaning, but to economic production and consumption. The drive for "sterile repetition" apparently typical of seriality in postmodern culture suggests that all culturally significant meaning has been destroyed and that all "true artistry" has been exhausted, replaced by the economic concerns of the conglomerate era (Best and Kellner 1991, 125). Julian Stallabrass's *Gargantua: Manufactured Mass Culture* (1996) is, in many respects, exemplary of this tradition. Although Stallabrass asserts his distaste of postmodern models[50]—in particular, models that celebrate postmodernism's open form, its scope for embracing multiple forms of subjectivity, its playfulness—his arguments often parallel those articulated by the postmodern trinity, especially Jameson's ruminations about contemporary economics and capitalist regimes. Discussing the cultural ramifications of globalization, Stallabrass states that "what happens to a culture when it is mass-produced and mass-marketed, like any other industrial product; when, like most other businesses, it is subject to increasing globalization and concentration of ownership; and when, like the rest of society, it is founded on a grossly unequal distribution of resources" (1996, 1).

Cultural production, its aesthetics, its formal qualities, and its relation to audience responses are ultimately reducible to forces of globalization and the corporate power of multinationalism. Above all, Stallabrass castigates mass culture's insatiable appetite for appropriation in the name of monetary gain,[51] for such insatiability thwarts attempts by "high art" to assert itself: "Movie spin-offs, whether of *Indiana Jones* or *Robocop*, are only the most obvious example of an increasing mutual dependence. Flagrant plagiarism and the quoting of cinema plots, motifs and designs are common, a whole sub-genre of games being founded around *Star Wars*" (1996, 86). He asserts that:

High art may try constantly to work against the productions of mass culture, but it is prey to rapid assimilation as advertisers and designers plunder it for ideas and prestige. This assimilation is dangerous, for in it meaning and the particularity of a word or a style are generally lost, as they come to participate in the competition of equally empty ciphers arbitrarily matched to commodities. (1996, 5)

Stallabrass chastises academics for devising "convenient theory" that seeks "various kinds of theoretical justification" of mass culture at the expense of high art (6). "Much of this theory," Stallabrass continues, "[which] bears the name 'postmodern,' is politically convenient to the status quo, fostering a sense of powerlessness or a facile optimism" (7). Jameson, an optimist? A fosterer of the status quo? Ironically, Stallabrass succumbs to the same nostalgic yearning that is found in many of Jameson's writings. An interplay is established between closed "grand narratives," which are seen as culturally productive and brimming with "meaning," and serial, repetitive structures that are indicative of postmodern culture in the stages of decay asserted to be typical of late capitalism.[52] Because economics and commerce drive the entertainment industry, film critics and theorists often respond to Hollywood and other entertainment industries as forms of commerce rather than an art.[53] As such, criticism places emphasis on the marketable aspects of stories rather than their "originality": The very fact of marketability excludes originality, which "remains the territory of art" (Wyatt 1994, 14). The entertainment industry's drive toward commercialism through repetition is viewed as yielding artifacts that either remain in states of repetitive stasis or move toward states of degeneration. Certainly an important element to the logic of entertainment media is the result of financially motivated concerns for reproducing successful formulas. Reducing popular culture to a perpetual state of invariability and economic rationale, however, fails to come to terms with the inherent formal transformations underlying contemporary entertainments.

It is undeniable that all cultural forms—not only popular culture—must be considered in regard to their economic, political, and ideological ramifications. Approaches such as these are valuable in their articulation of certain aspects of contemporary media, for example, their relation to economic infrastructures and ideological operations. However, the singular focus of such approaches refuses to engage with alternate facets of the formal and structural changes that have occurred in recent years. Such an insistently myopic position closes off other avenues of understanding, avenues that permit us to evaluate and consider the significance and logic of popular culture as an art form whose effects on audiences need not always be understood in a singularly

negative ideological light. In believing this, if I too am succumbing to seeking "theoretical justification," then so be it. I enjoy popular culture and I do not believe its existence needs to be justified. It exists. It will not go away, and our culture cannot return to a state of tabula rasa.

To offer insight into the internal logic of neo-baroque seriality and its propensity for reproducibility, our understandings of entertainment media should also consider other approaches. As Jim Collins observes, what audiences now "conceive of as entertainment has changed so thoroughly that the cultural function of popular storytelling appears to be in a process of profound redefinition" (1989, 16).[54] What alternative paths can we follow to instigate this redefinition? For the moment, I take a leaf out of Benjamin's book. As has been mentioned, for Benjamin, the baroque fascination with the fragment and the ruin is not a negative condition. It is the condition of baroque artistry itself: "For it is common practice in the literature of the baroque to pile up fragments ceaselessly without any strict idea of goals and, in the unremitting expectation of a miracle, to take the repetition of stereotypes for a process of intensification. The baroque writers must have regarded the work of art as just such a miracle" (1998, 178).

Like the fragment and ruin, the seriality particular to allegory accumulates multiple pieces of its kind, seeking to produce a new whole in the process. Like ruins, which contain within them the memory of past existence, an understanding of the meaning of the fragment functions as nostalgic remnant or emblem of the past, but it also reinvents itself as a unique whole that belongs to its own time.[55]

The Fragment and the Whole: Aliens/Predator: The Deadliest of the Species

One of the earliest art historians to define the characteristics of classical and baroque form was Heinrich Wölfflin, who said that whereas the classical stresses the closed, the linear, and the "limit of things," the baroque explores the painterly and the open and turns toward the limitless (1932, 14–15). The classical aspects of Renaissance art and the classical Hollywood narrative are typified by a closed form that remains "a self-contained entity pointing everywhere back to itself." Open form, which is characteristic of the baroque, "points outwards beyond itself and purposely looks limitless" (124). Borders reflect a fluidity that opens up and encompasses other narrative formulations. In the neo-baroque realm, classical systems of spatial and narrative organization are disturbed and a dialectic is developed between the whole and the fragment

(Calabrese 1992, 68). Distinguishing between the detail and the fragment, Calabrese states that the detail assumes and depends on its relationship to the whole, whereas the fragment signifies parts of the whole, "but the whole is in absentia" (73). Unlike the detail, the fragment is both reliant on and independent of the whole.

Although the contemporary entertainment industry draws from a pool of common images, characters, styles, or narrative situations, its success lies in its capacity to differentiate both its film products and its cross-media connections (Wyatt 1994, 14), that is, to establish autonomous fragments within a polycentric whole. According to Calabrese, contemporary media operate like the replicants in *Blade Runner* (Scott 1982), marking the birth of a new aesthetic of repetition. The serial, sequel, and series as fragments of an expanding whole are "born of repetition and a perfecting of the working process." From some critical perspectives, "repetition and serialism [are] . . . regarded as the exact opposite of originality and the artistic" (1992, 27). The aesthetic of repetition found in seriality, however, does not merely represent itself as a simulacrum or inferior and unoriginal copy of an evasively authentic model or "original" (45). Comic-book variations of the "Alien" saga, for example, are not the less-creative cousins of the "more authentic" film narratives. In fact, the success of the comics depends on their *refusal* to simply reproduce the film stories. According to the logic of neo-baroque form, in addition to involving similarity and invariability, repetition also embraces variation on a theme.

While emphasizing elements of repetition, the authors of each variation may also be intent on outperforming and developing preceding works: refashioning the past. New story fragments introduced therefore dynamically interact with other story fragments, uniting to create multiple, yet unified, story formations. Within such polycentric systems the notion of the self-contained, closed text disappears and the reader or viewer becomes enraveled in the intricate network of connections that intersect numerous stories and media. The reader or viewer is invited to participate actively in a game that involves the recognition of prior signs and in the variations introduced to the narrative signs. As Calabrese suggests, like the replicants in *Blade Runner*, who were more perfect human versions than the humans themselves, the aesthetic of repetition present in the fragment strives toward perfection. Each variant aims at complicating and competing with other fragments or narrative centers within the neo-baroque, serial whole.

Discussing the baroque fascination with collecting objects of curiosity in the famous *wunderkammers* (a phenomenon to which I will return in later chapters), Horst Bredekamp has provided a fascinating interpretation of the function served by the ancient ruin in collections, especially in catalogues of such collections of the bizarre. In the

late sixteenth century, Michele Mercati, superintendent of the papal botanical gardens under Pius V, founded a natural-history museum that contained objects collected by the Vatican. The frontispiece of his catalogue *Metallotheca*, which was finally published in 1717, comprises a copper engraving by Anton Eisenhoit that includes the Metallotheca in the foreground and, in the distance, an image of a temple "in the form of ruins that have been reclaimed by nature" through the process of erosion (Bredekamp 1995, 18). Again, in the 1677 catalogue of Ferdinando Cospi's *Museo Cospiano*, Cospi stressed the significance of "[t]hose brilliant creations . . . of art and Nature exalting the memory of antiquity" (Bredekamp 1995, 41), and in 1762, the engraver Clement Pierre Marillier depicted the *kunstkammer* as an arcade comprising a massive arch damaged by time. Symbolizing antiquity through the fragmentary ruin, the scene also includes another character that Benjamin associates with the baroque: the figure of the infant Melancholia. In both Eisenhoit's and Marillier's engravings, the scenes include contemporary artifacts such as paintings, sculptures, and sundry scientific objects that belonged to the *wunderkammer*, all representing "evidence of man's creativity" (Bredekamp 1995, 44). As is the case with Eisenhoit's engraving, not only does the ruinous arch in Marillier's scene represent the interface between the creations of man and those of nature, but in including a portrait of Descartes, this ruinous landscape stands as "an affirmation of the truth of Cartesian philosophy, which symbolically radiates rays of sunlight that bypass the infant Melancholia and ultimately illuminate a round mirror. . . . The arch holds in its keystone a key to eliminating the conceptual boundaries between the creations of nature and of man, thereby transforming the ancient ruin into the triumphal arch of Cartesianism" (Bredekamp 1995, 45).

Not only is nature a teacher, but past emblems of human creation serve to reignite and inspire the human imagination to conjure new creations. Reflecting a specifically baroque attitude to art, the *kunstkammer* and *wunderkammer* embodied the baroque function of the fragment and the ruin: References to the past that existed within this microcosmic space coexisted with objects and creations of the present. The two were united in the production of a creative process. The copy magically metamorphosed into an original.

Even though the stories, media, and eras are different, the fluid approach to space, narrative, and the relationship between the fragment and the whole that is visible in Versailles's Apollo allegory finds similar treatment in neo-baroque examples like the "Alien" crossovers. In the Apollonian theme of Versailles, serialization parallels the traversal of the spectator through the gardens and interior. The "Alien" stories, on the other hand, produce seriality through the spatial relocation of the "Alien" narrative across diverse media. Each serial fragment acknowledges its connection to the

"Alien" ruins that predate it, while also recreating itself and refashioning the ruins. If the products of the neo-baroque serve an allegorical function, then each fragment functions as emblem to the entertainment company that gave birth to it. Embodying the potential of the conglomerate, each addition into the serial pool not only repeats but also reasserts the creative possibilities of the franchise. Operating according to the aesthetic of repetition, each additional entry into the system functions as a "guarantee of the dignity of the copy, of its fight to survive. . . . [Its] importance . . . lies precisely in the fact that it accentuates and underlines the physical presence of the past in the present" (Perniola 1995, 42). Ruins discovered from a popular-culture past become monuments of a popular-culture present.

Since the 1980s, the expansion of narrative borders has reached excessive proportions, with a far more fluid interaction occurring across the narrative worlds of different media. Whereas the cinema may have introduced the Alien and the Predator in distinct tales of individual films, their stories have now developed and thrived in intermingled form in the comics, as seen in *Aliens/Predator: The Deadliest of the Species*, the comic-book continuation of the films *Alien* (Scott 1979) and *Predator* (McTiernan 1987).[56] This twelve-part comic-book series, published by Dark Horse Comics, collapses the stories of two distinct film aliens, the Predator and the Alien, into one series. In the film *Predator* the character Dutch (played by Arnold Schwarzenegger) is sent into a South American jungle with a group of Special Weapons and Tactics (SWAT) professionals on a mission to rescue a missing group of individuals. Dutch's team discovers that an unidentified creature (soon to be revealed as an alien hunter) is hunting them. (As a result of the film's title, these aliens have come to be known as Predators.) One by one the team members are hunted down, and in the end, Dutch is left alone to do victorious combat with the Predator. In *Predator 2* (Hopkins 1990) the story continues as the Predator arrives in Los Angeles, seeking to do battle with individuals considered to be warrior material.

The spatial configuration that previously contained each of these aliens within the separate *Alien* and *Predator* films (fragments) is extended by the comic-book series. As the serial continuation of other "Alien" and "Predator" films and comic-book stories, *Aliens/Predator: The Deadliest of the Species* is the product of a narrative flow or exchange across media borders. Even within the comic-book series, a serial effect is produced: first, through the structure that ends each comic-book episode with a cliffhanger effect, thus revealing the porous borders that frame each episode; and second, through the series' reference to other media examples, including film and television. The issue of intertextuality and self-reflexivity remains fundamental to the logic of the serial in that both depend on audience awareness of preceding examples, implying a spatial and

temporal continuity that intertwines the prior ruins of entertainment culture into a new whole. Boundaries are fluid, and each new fragment introduced into the series whole by necessity transforms the whole.

Aliens / Predator: The Deadliest of the Species inhabits a polycentric system. In addition to its serial connection to other popular narratives of its kind, *Aliens / Predator* also possesses a logic of its own, being one of many narrative centers in the "Alien" / "Predator" stories. It is at once closed (in being contained within its twelve-part series) and expanding (in that it is connected to the multiple other "Alien" and "Predator" stories that exist in a variety of media forms). Within the spectrum of multiple "Alien" narratives like *Alien, Aliens, Alien Resurrection, Aliens: Stronghold, Alien Wars*, and *Aliens / Predator: The Deadliest of the Species*, one narrative center is not given priority over another. Instead, multiple narrative centers dominate, and the resulting polycentric structures engage in a process of intertextual and serial interaction that depends on a dynamic exchange between systems.

Set during a period in Earth's history when Aliens (also known as "Bugs") have invaded Earth, the story of the comic-book series *Aliens / Predator: The Deadliest of the Species* centers on a female protagonist, Caryn Delacroix (who, we discover, is a clone who had her origins in a woman named Ash Parnall).[57] Caryn is a bizarre union of Dutch from *Predator*—as is echoed in one of the jungle scenarios that recall *Predator*—and Ripley from the *Alien* films. As a genetically engineered human, called a "trophy," Caryn also recalls the "replicants" of the film *Blade Runner* and has been constructed to serve a single function: to be a satisfying wife to her husband, the big corporate boss Lucien Delacroix.[58] True to the science fiction tradition, corporations mean trouble, and things go wrong. Caryn begins having nightmares that seem to collapse into reality, in particular, nightmares about being stalked by a Predator called "Big Mama". The reference to the Predator as "Big Mama" further complicates the extent of interaction and border crossing between media in that, according to prior narrative conventions in the "Alien" series, the mother role is one traditionally assigned to the Alien Mother, not the Predators. Eventually meeting in reality, which, true to baroque form, may also be another layer of the dream, they discover that they share a past (during Caryn's precloned life as Ash Parnall),[59] Caryn and Big Mama team up on a mission that unravels the complexities of Caryn's nightmare. Together they fend off numerous foes, including "teksec" robots engineered to destroy the Aliens (who recall the T-800s in the *Terminator* films), lethal human/Predator/Alien hybrids (bred by the corporation), and an Alien Queen. At one stage well into the final part of the series, Caryn's appearance, as she undergoes one of her many physical transformations,

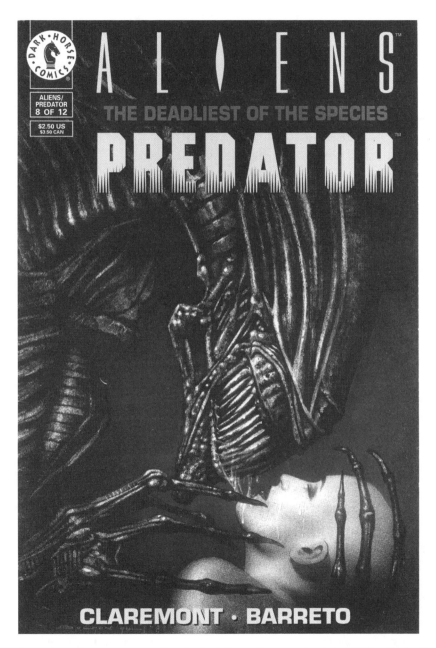

Figure 1.6 Cover page to no. 8 in the Dark Horse Comics series *Aliens/Predator: The Deadliest of the Species* (1993–1994). By permission of Fox.

alludes to Ripley's famous bald phase in *Alien³* (figure 1.6) and, of course, the association between Caryn and Ripley compels the reader to expect the worst: alien impregnation. What Caryn gives birth to, however, is an Alien/human hybrid that gives humanity (and the predators) hope against future Alien wars (figures 1.7 and 1.8). (The Alien/human hybrid was, in turn, later developed in the film *Alien Resurrection*.) The comic-book series ends, however, with the revelation that a computer-generated being called "Toy" has orchestrated the entire narrative. Like Q (from the television series *Star Trek: The Next Generation*), Toy used hologram technology to immerse his victims in a ruthless game that placed him in the role of God.

Aliens/Predator: The Deadliest of the Species takes the basic signs, or what Jim Collins calls the syntactic structures, that also belong to other centers like *Aliens*, *Predator*, and *Blade Runner*, further expanding these syntactic structures, and thereby adding additional centers to the narrative web. In his analysis of the "Batman" myth, Collins has suggested that the complexity of popular culture, revealed in processes of intertextuality and the cross-media effect, immerses each media example in the "negotiation of an array" (that which has already been said).[60] In this instance, the array relates particularly to the "Alien" and "Predator" myths of film and comic-book "originals" and sequels, while also connecting with the array of "that which has already been said" in the films *Blade Runner* and *Terminator* and in the television series *Star Trek: The Next Generation*. Within this array, the *Aliens/Predator* comics attempt to map out their own space and center, while also producing labyrinthine connections across stories, serials, sequels, and media. Each addition to the system opens up new narrative meanings that rearrange the signs, codes, and worlds of the "Alien" and "Predator" narratives.[61] Collins's exploration of the array reflects a neo-baroque attitude to open form. All "Alien" fragments or smaller narrative units belong to the larger, multicentered array of the "Alien" narrative and other intersecting narrative universes.

The fragment may succumb to aspects of classical order, yet the (neo-)baroque often draws upon classical form to complicate its structure, with the result that the baroque and classical are in perpetual states of conflict. Within the (neo-)baroque system, the fragment can become the whole (the fragment as classical whole), but the whole can as easily become a fragment within an even greater whole, thus invoking a baroque polycentric system. In one respect, the fragment that is the comic-book series *Aliens/Predator: The Deadliest of the Species* retains its own narrative center, thus implying classical ordering. The closure so typical of the classical system is, however, within the (neo-)baroque, more susceptible to being reopened, as is evident in the continuation of the "Alien" saga. In the wake of *Aliens/Predator: The Deadliest of the Species*, not

Figure 1.7 One of the Alien/human hybrids, from no. 6 in the Dark Horse Comics series *Aliens/Predator: The Deadliest of the Species* (1993–1994). By permission of Fox.

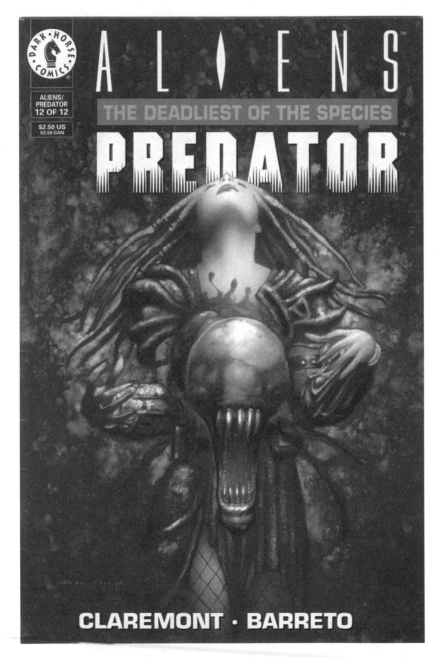

Figure 1.8 Cover to the final issue of the twelve-part Dark Horse Comics series *Aliens/Predator: The Deadliest of the Species* (1993–1994). By permission of Fox.

only was the film *Alien Resurrection* released, but numerous comic books such as *Aliens vs. Predator: Eternal* (1998), *Aliens: Survival* (1998), and *Aliens: Kidnapped* (1998) have also extended the story further.

The use of multiple narrative centers (multiple originals) typical of seriality requires a reconsideration of traditional perceptions of linearity and closed narrative form. Neo-baroque seriality demands that a single linear framework no longer dominate the whole. Operating on the impetus of a repetitive drive, the baroque work produces "an aesthetic of repetition," and it is precisely this aesthetic of repetition that underlies the logic of the serial whole and its relationship to the fragment. Pleasure for the audience is obtained from fragments that are parts of a whole yet retain their autonomy (Calabrese 1992, 89). Instead of these fragments' being viewed as examples of fractured meaning typical of our postmodern era—of narratives reflecting cultural decay—from a neo-baroque perspective, an alternative logic emerges. It is not a fractured, incoherent system that underlies the logic of the neo-baroque; rather, neo-baroque seriality is concerned with the reconstruction of order, an order that emerges from complex and expanding spaces. Although the audience may initially become disoriented when confronted with the narrative gaps present in some fragments, by understanding the fragments within the context of the whole, the audience can rediscover order (Calabrese 1992, 131).

As with the serial technique of the fugue in music, which was introduced during the baroque era, most famously by Johann Sebastian Bach in his *Art of Fugue* (1750–1751),[62] a polyphonic experience ensues. In the *Art of Fugue*, Bach manipulated one main theme in a cycle of fifteen fugues: The theme is developed, extended, and repeated in cyclical motions; the dialogue between melodies highlights both repetition and variation and, above all, emphasizes virtuosity of performance.[63] The listener recognizes this virtuosity only when each cycle—each fragment—is considered in relation to the system as a whole. Acknowledging himself as virtuoso who masterfully creates uniqueness out of repetition, Bach also added a fugue in which his name (B-flat, A, C, B-natural) was repeated as a theme. Although they involve alternative media, neo-baroque serials involve a similar game of reception that engages the audience on the level of the relationship between fragment and whole. The fragment also invites the reader or viewer, while accepting the fragment on its own terms, to place it gradually within a web of multiple formations. Providing an alternative to Buci-Glucksman's argument that the baroque presents a challenge to reason and order (1994, 22), the (neo-)baroque in fact asserts its own reason that emerges from the order of the labyrinth, a structure that will be explored in chapter 2.

2 Intertextuality, Labyrinths, and the (Neo-)Baroque

"Intertextual Arenas" and (Neo-)Baroque Folds

In *The Open Work* (1989), Umberto Eco explores serial thought from the perspective of the "open work." According to Eco, the "theory of the open work is none other than a poetics of serial thought" which is "open and polyvalent" (1989, 218). The poetics of the open work are characteristic of our contemporary era, an era that Eco was to later characterize as the "neo-baroque" (1992, viii–ix). Whereas structural thought is concerned with discovering and tracing signs back to an original source, serial thought develops along alternate paths. According to a structural order, signs and messages belong to a shared or preestablished code that can be "decoded." In serial thought, however, messages disturb prior codes by replacing them with their own distinctive variations. As Jennings suggests, "even though it is possible for communication to be rooted in an ur-code [original code] that underlies all cultural exchange, the main goal of serial thought is to allow codes to evolve historically and discover new ones" (1996, 350, n. 13). Serial thought is intent on producing new signs. That which is important in the message or sign is not information but its aesthetic equivalent: "its poetic meaning" (Eco 1989, 59). Serial thought is concerned with form itself, with what Deleuze has called the "infinite work in process" (1993, 34).

Writing in the 1960s, Eco was more concerned with both the seriality inherent in modernist traditions of writing and in the possibilities inherent in interpreting a work "in a way that differs from the intentions of the author" (1992, ix). In Eco's foreword to Calabrese's *Neo-Baroque: A Sign of the Times*, he acknowledges, however, that, in the 1960s, openness was a phenomenon found in the avant-garde but extraneous to the messages circulating in mass media. Since the 1980s, however, the distance between the avant-garde and mass media has closed. We are no longer dealing with works and interpreters, but with processes, flows, and interpretative drifts that concern not

single works, but the totality of messages that circulate in the area of communication (ix). This chapter evaluates the ways in which (neo-)baroque serial thought reflects the infinite work in process. Specifically, the metaphors of the fold and labyrinth will be applied to analyze the mode of serial engagement particular to (neo-)baroque intertextuality.

As seen in the "Alien" examples in chapter 1, the serial logic of contemporary media is reliant on a rampant self-reflexivity: Each addition to the serial whole is reliant on an intertextual awareness of serial predecessors. The *Resident Evil* computer games engage consciously with tropes from the Romero "living-dead" films (*Night of the Living Dead*, *Dawn of the Dead*, and *Day of the Dead*), the Italian horror *Demon* films, and first- and third-person action and role-playing games like *Duke Nukem 3D* and *Tomb Raider*. The comic book *Batman/Judge Dredd: The Ultimate Riddle* (DC Comics, 1995) depends on an audience that is familiar not only with the Batman and Judge Dredd comic-book traditions, but with character types from games like *Doom* and *Mortal Kombat* and science fiction films like *Robocop*.[1] Verhoeven's *Starship Troopers* delivers its dark social message via an intertextual exchange of western genre themes, nighttime soap character types á la *Melrose Place*, 1950s science fiction motifs, and propaganda films like Leni Riefenstahl's *Triumph of the Will*.[2] *The Simpsons* . . . well, where to start with *The Simpsons*? And so it continues.

The boundaries of films, computer games, and other entertainment media are expanding ever outward as they intersect with diverse media in a multitude of ways. The neo-baroque nature of these media is not only reflected in their open form. The active and reflexive engagement of spectators and game players in a critical understanding of the process of meaning production is also integral to the neo-baroque. Collins perceptively observes that the result of the complex web of intertextual references inherent in these neo-baroque media is that narration is not simply limited to completing the plot or contributing to the "syntagmatic axis of the narrative" (1991, 168). Instead, the "layering of intertexts that occurs simultaneously informs those same topoi along a paradigmatic axis of antecedent representations" (169). Story concerns are therefore not the primary drive of contemporary entertainment; allusions to other media examples that have had an impact on these neo-baroque examples are just as integral to the player's, reader's, or viewer's involvement and interpretation. Intertextual citation engages the audience in a game that is about paying homage to and renegotiating the past (Calabrese 1992, 173). The resulting "hyperconsciousness" permits participants to become engrossed in the narration in a more conventional sense, with the story and themes unraveling along syntagmatic lines; but players are

also encouraged to participate with the work on the paradigmatic level via multi-layered intertextual references (Collins 1991, 173). To return to Eco, it is on this paradigmatic level that "poetic meaning" and engagement with the infinite work in process occurs. On this level, the (neo-)baroque concern with virtuosity comes into play.

In a way that recalls Benjamin on the baroque, these entertainment forms function like ruins and fragments, evoking the existence of a past in the present while simultaneously transforming the ruin into a restored, majestic structure that operates like a richly layered palimpsest. Martin has observed that the seventeenth-century baroque produced "an intensified 'style-consciousness'" driven by virtuosity (1977, 35) that grew out of an effort to outperform predecessors and contemporaries. According to Sypher, a distinction needs to be made between style and stylization or technique. Style, Sypher says, "is based on the technique it transcends" (1960, xxiv). The seventeenth-century baroque has, like the postmodern, often been depicted negatively as an era of eclecticism, the copy, and the unoriginal. Baroque eclecticism, however, is concerned with the assimilation and adaptation of past techniques or stylizations into new forms. Baroque style involves a synthesis of signs or past techniques to transcend or perfect those techniques. Additionally, stylistic coherence in the baroque is the result of the reorganization of past signs and stylizations into new combinations so that a discourse emerges between past and present, between "original" and sequel. One of the grandest and most virtuosic restored ruins of the neo-baroque is the film sequel *Evil Dead II* (1987), directed by Sam Raimi. The film's self-reflexive attitude to its creative process is reliant upon the relationship between past and present. Raimi responds to the film's historical context, specifically, its relationship to the "original" film on which it builds, *The Evil Dead* (Raimi 1983), in the process critically engaging with issues of originality and creative process.

Multiple Temporalities and Monadic Logic: The Evil Dead *and* Evil Dead II, *the "Original" and the Sequel*

The forms of interaction invoked in *Evil Dead II* highlight the forces of expansion particular to the (neo-)baroque: stretching the limit and excess. Calabrese observes that the neo-baroque can stretch against the limit of a system, thus testing "the elasticity of the border, but without destroying it," or through excess, it can escape the limit of the system "by breaking through. It crosses the threshold by making an opening, a breach" (1992, 49). The term "excess" "describes the overcoming of a limit in terms

of an exit from a closed system" (49). *Evil Dead II* does not merely stretch the limits of its system; through excess, it forces the spectator to stand outside the film and interrogate its structure. McDonagh's *Broken Mirrors, Broken Minds* makes a comment on its subject, Dario Argento, that could easily be applied to Sam Raimi's approach to filmmaking. Argento's films, McDonagh argues, often "sublimate their narratives to *mise en scènes* whose escalating complexity is characterised . . . by a series of baroque stylish devices"[3] (1991, 14) that, in their excessiveness, warp and rupture the limits that comprise the horror genre. Excess is not just "more" but is concerned with a realm that lies outside whatever system the viewer has adopted to make sense of the film (1991, 22–23). *Evil Dead II* confronts the viewer with an excess that causes the mind to rebel, because expectations have been shattered and everything does not seem to make sense "according to the rules" (23). Raimi produces this response from the spectator in *Evil Dead II* not only in the way the film sometimes exceeds the limits of the conventions of horror to produce comedy,[4] but also in the way it challenges the audience to unravel its formal structure, especially in the opening minutes. Calabrese explains that traditionally, "elements accused of excess are external to the system," whereas in baroque epochs, "an endogenous phenomenon is produced. . . . The excess is genetically internal" (1992, 58). In the neo-baroque system, excess is, above all, aligned with virtuosity. *Evil Dead II*'s preoccupation with its status as sequel becomes one of the most challenging aspects of the film's labyrinthicity and interaction with its audience.

In the "original" *The Evil Dead* (Raimi 1981), a group of vacationing teenagers, including Ash, arrive at a cabin in the woods. In the cabin they discover a book, *The Book of the Dead*, that unleashes an evil spirit. This evil spirit attacks and possesses the characters, including Ash's girlfriend Linda, leaving Ash alone to fend off the forces of darkness. The film ends with Ash emerging from the cabin in broad daylight. With the audience assuming that his struggle has been successful, in the final shot of the film the audience's vision is thrust into the point of view of a high-speed tracking shot (which the film associates with a demon's view point) as it races through the woods and the cabin and finally toward Ash. So the film ends.

The opening scene of *Evil Dead II* provides the audience with an economized narration that outlines the significance of *The Book of the Dead*. The narration commences: "Legend has it that it was written by the dark ones. *Necronomicon ex Mortis*, roughly translated *Book of the Dead*. The book served as a passageway to the evil world beyond."[5] Following the opening sequence, the film's status as a continuation of the original is further emphasized. The film is literally marked as sequel when a "II"

appears on the screen and stamps itself visibly and audibly over the words "Evil Dead" during the title sequence. From its beginning the film tells the audience "I am a sequel" and establishes an expectation of the sequel as repetition of the original.

After the opening narration and titles of *Evil Dead II*, the spectator is introduced to the two main characters, Ash and Linda, as they drive up toward the cabin. This sequence presents a "minifilm" that is self-consciously presented as a reduced version of the original film, *The Evil Dead*, that recounts in reduced form the events in the original. The spectator is introduced to the same lead actor (Bruce Campbell) with the same name, Ash (figure 2.1). In a drive similar to that in the "original," through similar woods with his similar (but not identical) girlfriend, they come across a similar bridge and arrive at a similar cabin in the woods. All of these references contribute toward an uncanny sense of the defamiliarized familiar. Then, as the ominous feeling mounts, the couple profess their love for each other in a similar way (with the narrative dwelling on the locket that Ash gives to Linda in the first film). All these cues suggest copy, formula, and repetition of the first film as well as the stalker/splatter tradition. On the one hand, the audience has this familiarity to cling onto; on the other, something is not quite right, and expectations for the familiar are undercut. A series of details begins to accumulate, and *Evil Dead II*'s opening scene introduces not only points of repetition and familiarity that connect it to *The Evil Dead*, but several variations that contradict the film's status as sequel. In doing so the film stresses the "dignity of the copy" and the originality inherent in repetition.

In *Evil Dead II*, whereas Ash is familiar from the original, his girlfriend is not the same. She has the same name, Linda, but is played by a different actress. Also, the opening cannot be depicting the identical events shown in *The Evil Dead* because none of the other characters present in the "original" are present in the sequel's opening-scene "re-creation." In the sequel, only Ash and Linda make the trip to the cabin. An alternative interpretation would be that the opening scene of the film depicts the beginning of another, different story also starring Bruce Campbell, who appears as a different character who coincidentally happens to be named Ash. However, if Campbell is playing someone else, and if the story shown in the first five minutes is taking place sometime after the events in the first film, then the bridge that Linda and Ash drive across (which was destroyed in *The Evil Dead*) should not be in one piece and functional at the beginning of *Evil Dead II*. In *Evil Dead II* the bridge is not destroyed until much later in the film than in *The Evil Dead*. Raimi presents the spectator with a puzzle to be solved, and this puzzle dares the audience to become involved in a game that asks that it actively interrogate the film's structure. The audience is placed within a

Figure 2.1 Ash (Bruce Campbell) from *Evil Dead II*. By permission of The Kobal Collection/Rosebud/ Renaissance Pictures.

confusing labyrinth and then invited to discover order. The film initially invites the spectator to follow a preexisting labyrinth of conventions established in *The Evil Dead*, while simultaneously devising an alternate labyrinth that denies the existence of the first.

The beginning of the film therefore introduces the spectator to false leads that depend on expectations established in the film's predecessor. There are enough familiar elements to suggest a reworking of *The Evil Dead* as a reduced flashback. The opening sequence also establishes a new story, however, that denies that Ash was ever in the woods in *The Evil Dead*—until, that is, the death and burial of the possessed girlfriend (which occurred halfway through the first film but occurs only minutes into the sequel). At this point, *Evil Dead II* picks up at the precise point that *The Evil Dead* left off: with the high-speed tracking shot through the cabin as it heads toward Ash. The movement sends the camera and the spectator's vision spinning as the second film finally appears to pick up where the first film ended. It takes about seven minutes of film before the desire for repetition appears to be unproblematically fulfilled and the film suddenly seems to remember it is a sequel. Yet in this tracking shot, the film again presents itself as a film that both is and is not a sequel, a narrative that is and is not a narrative continuation. In the sequel version of the tracking shot, the camera propels forward in an elaborate way, eager to establish, through sheer virtuosity and greater cinematographic flourish and special effects, its superiority to its predecessor. The camera does not just stop once it arrives at Ash's location, as it did in the original: It follows Ash as he is sent flying and somersaulting through the air.[6]

The audience of *Evil Dead II* is thus confronted with a series of riddling questions: Is this tracking shot independent of that in the first film, or is it a continuation of the events that we see in the opening sequence of the beginning of *Evil Dead II*? Is this a new story or an old one?[7] Somehow, the film is all these things, with two narratives (one present in the first film, and one in the sequel) coexisting and struggling for meaning within the one film. The contradictions, the plays on repetition, and the undercutting of expectations all have the effect of making the spectator contemplate the process of creation, as well as the production of "meaning" and how he or she extracts it. The film invites the audience, rather than passively accepting *Evil Dead II* as a sequel, to ask the question "What is a sequel?" and furthermore "What is a sequel's relationship to the original?" Raimi refuses to provide a continuation or sequel that is about sameness and the copy. Instead, the beginning of *Evil Dead II* plays on the idea of sequel as similar to *and* different from the original. The film embraces the neo-baroque aesthetic of repetition and multicursality. It draws on our

expectations while simultaneously altering and adjusting the conventions and patterns we expect.

The interpretative puzzle that Raimi presents in the sequel threatens to abandon the spectator within its confusing turns. *Evil Dead II* creates ambiguities that deliberately depend on defamiliarizing the familiar of generic historicity. In attempting to make sense of the film by relating it to its predecessor's intertextual signs, the audience is drawn into an intertextual maze that appears to lead to dead ends. To find order in the labyrinthine structure of *Evil Dead II*, the spectator must exceed the limits of the labyrinth and adopt an aerial view. From an aerial perspective—a perspective that visualizes the serial fragments as both independent from and connected to the whole—it becomes apparent to the audience that its confusion and traversal into dead-end passages has been the result of an assumption of invariability: that the sequel is the unoriginal copy of the original. *Evil Dead II* sets the audience up to believe that it is immersed in the labyrinth of *The Evil Dead*: thus the spectator's disorientation. Order comes from chaos only when members of the audience realize that they are in a different labyrinth altogether: that of *Evil Dead II*. Two distinct labyrinths, connected through points of intersection, are placed before the viewer. Although both labyrinths/films may have passages that intertwine, their separate structures lead the spectator along equally distinct and original paths.

For Deleuze, the labyrinthine complexity that characterizes baroque form is visualized by the metaphor of the fold, or, rather, that of endless folds that double over one another in continuous motions. The world of the baroque fold is a world of "converging series," and each fold expresses only "one portion of the series" that converges into the next (1993, 50). Seeing the world through baroque eyes, Deleuze was inspired by the writings of the seventeenth-century philosopher Gottfried Leibniz, particularly Leibniz's metaphysical study *Elucidation Concerning Monads*, which was finally published as *Monadology* in 1720.[8] Although both Deleuze and Leibniz are ultimately concerned with the philosophical and metaphysical dimensions of the monad—in particular, the relationship between matter and the soul, the universe, and God—for my purposes I will explore Deleuze's articulation of the fold and Leibniz's monadic model metaphorically and, for the time being, remain in the world of matter, leaving the realm of the soul for a later chapter.

According to Deleuze a labyrinth is "multiple because it contains many folds" (1993, 3). Like a piece of paper that can be repeatedly folded and unfolded, the baroque labyrinth embodies a temporal and spatial complexity that presents multiple, if not infinite, motions and possibilities. Considering *Evil Dead II* from this perspective,

one series of folds, for example, peels back to produce motions that intertextually connect the film to other examples of popular culture: the stalker film, EC Comics, the Three Stooges, the Lovecraftian Cthulu and *Necronomicon* mythos, and the *Evil Dead* predecessor. The baroque "invents the infinite work or process"; the problem, states Deleuze, is not how to finish a fold, but how to continue it (1993, 34). By reflexively involving the audience in its heritage, *Evil Dead II* places itself within the intertextual pool of popular culture. The game that is proposed by the intersections of the *Evil Dead* films presents itself as one example that further expands the process that is the intertextual array. As Collins states, on a paradigmatic level, the audience becomes actively engaged in the dynamics of that infinite process. We are placed within the labyrinth's folds by becoming involved in a game about intertextual and meaning production: the process of creation itself. Neo-baroque narration depends on folds that also enfold the audience. The film's story (its syntagmatic layer) remains stagnant and cliché; the media-literate spectator, however, quickly shifts to the exciting journey offered on a paradigmatic level, at which he or she must actively engage in the intertextual, labyrinthine connections that exist across this axis of meaning production. Within such a system, Raimi plays tricks with the audience, while also providing them with the rules of the creation he has initiated.[9]

Integral to Deleuze's understanding of the fold is the system of Leibnizian "monads," or units, which fold into one another, existing as part of a complex and unified whole. Deleuze states that monads[10] "designate a state of One, a unity that envelops a multiplicity, this multiplicity developing, the One in the manner of a 'series' . . . its implications and explications, are . . . particular movements that must be understood in a universal Unity that 'complicates' them all, and that complicates all the Ones" (1993, 23).

Adapting this system, contemporary entertainment forms complicate the relationship between the fragments (the ones), which constitute sets of prior conventions, and the whole. Multiple ones fold into each another, creating borders between worlds (81). The baroque one may be a narrative, an example of a genre, a citation or allusion. Whatever its form, and no matter how unique or original the one, it relates and folds into "an infinity of variations that make it up" (25). Like the serial examples investigated in the previous chapter, each series can undergo "many variations that are both rhythmic and melodic" (25). *Evil Dead II*, for example, is an accumulation of monadic units, many of which fold into a series of intertextual connections. The ones create a multiplicity that belongs to a "universal Unity" that encompasses the film's influences as well as its own structure. The (neo-)baroque invites the audience to

contemplate the relationship between the one and the infinite series, or the whole, while also considering the way intertextual ruins from the past can be recombined to create a new entity.

For Leibniz, the world is an infinite and converging series, and although each monad contains a segment of the series and has a logic in its own right, it also embodies the unified structure—all monadic possibilities. "There is a prolongation", states Deleuze, "or continuation of convergent series, one into the other" and this is the condition Leibniz labels "compossibility" (1993, 50). Although unique, each monad folds into the next, creating and containing the totality of the universe in its structure. For Leibniz, the compossible embodies the ultimate power of "God who conceives and chooses the world" (Deleuze 1993, 51), who makes choices with regard to following one series path over another. To drag the spiritual down to the level of the material, in the case of *Evil Dead II* it is Sam Raimi who makes such choices.

The compossibles, therefore, are the paths that God chooses to effect creation and the universe as humans finally experience it. To draw upon Deleuze's example, in the world of compossibles, Adam was a sinner, Caesar was an emperor, and Christ was the Savior (60). Compossibles become realities or lived events, however, because they compete with incompossibles. Incompossibles comprise "the series that diverge, and that from then on belong to two possible worlds" (60). They exist at the point of convergence where divisions occur in the monadic series. Leibniz expounded a theory, paralleling current theories on quantum mechanics and parallel universes—but driven by a religious foundation—of multiple possible worlds that progress as series; God's selected path (the compossibles) constitutes the existing world as it finally comes into being. The incompossibles are all those other paths that are rejected: those in which Adam was not a sinner, in which Caesar was never emperor, and in which Christ was only a man. By "positing an infinity of possible worlds," however, Leibniz asserts our world to be the only existing world because, given that it constitutes God's final choice, it is considered to be the best among all the possible scenarios, the rest of which are finally rejected (Deleuze 1993, 61).[11]

Most interestingly, in an all-too-brief passage, Deleuze points to an inherent difference between the baroque and neo-baroque. Deleuze's observations are especially applicable to the context of contemporary entertainment serials and intertextual exchanges. Like the writings of Luis Borges, in particular his *Labyrinths*, the neo-baroque does not prioritize compossibles. To phrase it another way, the path of *one* "original" or best is nonexistent in the world of the neo-baroque, which is a world of multiple originals that intersect at certain points and diverge at others. All divergent

series coexist and struggle for equal status, rendering the incompossible (the narrative path that existed but wasn't chosen to exist) obsolete. Deleuze notes with regard to Borges, who was a follower of Leibnizian philosophy, "It is clear why Borges invokes the Chinese philosopher [Ts'ui Pan] rather than Leibniz. He wanted . . . to have God pass into existence all incompossible worlds at once instead of choosing one of them, the best. And probably it would be globally possible, since incompossibility is an original relation, distinct from impossibility or contradiction" (1993, 62).

According to such neo-baroque logic, therefore, *Evil Dead II* both is and is not a sequel. Raimi complicates the intertextual folds to renegotiate new ones. Each monadic unit (a detail of mise-en-scène, a character, a bit of dialogue) may fold back to a series of citations that connect reflexively to narrative situations (the compossible paths) presented in *Evil Dead*, but in their doing so, another narrative situation (more akin to an incompossible world) also unravels, one that competes with the earlier film but is nevertheless equally valid. As such, the seemingly incompossible routes that *Evil Dead II* constructs as a "second-choice" follower of *Evil Dead* are transformed into alternate compossibles. Despite the conflict they engender through their serial coexistence, both worlds exist and, in fact, fold into one another.

In relation to Collins's narrative (syntagmatic) axis of meaning, narrative linearity may construct a center through the process of closure, but for the audience, the neo-baroque possibilities of the intertextual (paradigmatic) axis are just as significant. An important dimension of the meaning of neo-baroque forms comes not only from the cohesion provided by meaning contained within the limits of story and representation, but from following multiple, variable paths that stress the neo-baroque relationship between the one and the multiple. Rather than such system's possessing a universal point of view, an infinite number of points of view are instead discovered as the audience travels the journey of the neo-baroque fold (Deleuze 1993, 25).

The Labyrinth, Virtuosity, and the Barberini Ceiling

Omar Calabrese and Gilles Deleuze have defined (neo-)baroque form through reference to the formal system of the labyrinth.[12] The labyrinth as formal tool of analysis and interpretation is also the focus of Penelope Doob and Umberto Eco. Doob presents two possibilities for labyrinth form: the unicursal (figure 2.2) and the multicursal (figure 2.3). Although both labyrinths are designs of "planned chaos" (Doob 1990, 52; see also Borges 1964), each possesses a different structural logic. The unicursal (or one-directional), Doob suggests, follows a series of intricate linear paths that

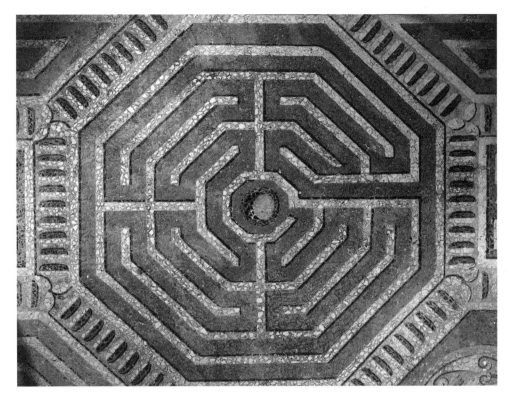

Figure 2.2 A unicursal or monodirectional labyrinth, from the sixteenth-century mosaic pavement in the Palazzo del Té, Mantua, Italy. By permission of The Art Archive/Dagli Orti.

remain singular in structure, and "confusion results from inherent disorientation rather than repeated need for choice" (50). Rather than leading the wanderer along false paths, the frustration of the unicursal labyrinth results from the fact that it takes the wanderer to the center through the longest possible linear path (Doob 1990, 48). For Eco this unicursal labyrinth is classical in form (1984, 80). The complex paths navigated remain closed and linear in structure, revealing no divergent paths.

Alternatively, the multicursal (or multidirectional) model "suggests a series of choices between paths." Unlike the unicursal model, it does not consist of a single, prolonged path; instead, mimicking the compossible and incompossible paths, it "incorporates an extended series of bivia, an array of choices" (Doob 1990, 46). Rather than the path's guiding wanderers to the labyrinth's center or exit, in the multicursal labyrinth, the wanderer must make choices when confronted with multiple

2 15 2 7 1 1 2 102 1 25 1 1 2 0 5 1 1 5 1 0 7 5 2 8 1 2 1 3

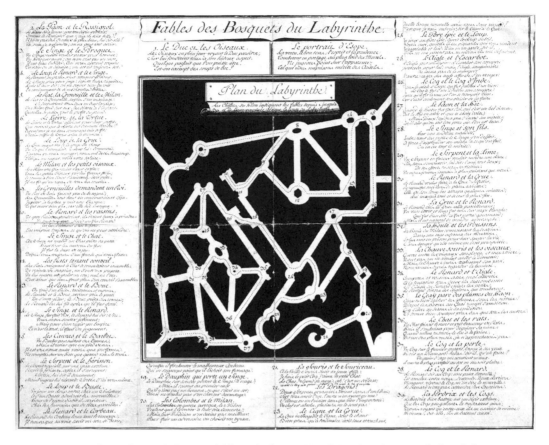

Figure 2.3 A multicursal or multidirectional labyrinth, from *Fables of the Labyrinth Grove*, which includes a plan of the labyrinth in the garden of the Château de Versailles. By permission of The Art Archive/Musée du Château de Versailles/Dagli Orti.

possibilities. Eco characterizes this labyrinth model as a maze: It "displays choices between alternative paths" (1984, 81); the discovery of exits from this system operates like a puzzle that must be solved. According to Eco, the maze (or multicursal) model emerges in the wake of the Renaissance, finding a place in the mannerist tradition. During the seventeenth century, however, the motif of the multicursal labyrinth was taken to new limits.

Doob's analysis of labyrinthine structures is a useful one. Doob explores possibilities of labyrinthine textual and visual responses. Coining the term "labyrinthicity" to define works that possess elements of the labyrinth, she locates features of these works

that are, in fact, baroque in nature. The features of the labyrinth include an enforced circuitousness, planned chaos, choice among paths, intricacy, complexity, and an invitation to the audience to engage reflexively in the diverse linear formations that drive the multidirectional form (1990, 2). Seventeenth-century culture's fascination with the form of the multicursal labyrinth is especially evident in "labyrinth poems," which had been written during the Renaissance but reached their peak of popularity during the baroque era. Portugese poets such as Luis Nunes Tinoco, Conde de Villaflor, Sancho Manuel, and Manuel de Faria e Sousa were masters in constructing poems that both visually and textually traversed labyrinthine paths. In these poems, a seemingly random and decorative arrangement of letters from the alphabet confronts the reader with a "complexity and the profusion of paths" that can be deciphered (Hatherly 1986, 52). Depending on the reading paths the reader follows, a variety of poetic verses or individuals' names emerge. Ann Hatherly, for example, has located a verse labyrinth (attributed to Tinoco) that is constructed like a chessboard, with text included in alternate squares. Beginning at the center of the chessboard with the words "Carmine concelebret," the reader may then follow horizontal, vertical, or diagonal reading paths that construct numerous possible poetic compositions. In fact, Hatherly has located an amazing 14,996,480 readings that can be made depending on the path the reader has taken, a figure identical to that for another labyrinth poem published in the Spaniard Juan Caramuel de Lobkowitz's book of verse, *Metametrica*, of 1663 (Hatherly 1986, 53).

Offering an alternate labyrinthine formation, Pietro da Cortona's ceiling painting *The Glorification of Urban VIII* (Rome, 1633–1639) in the Palazzo Barberini (figure 2.4) overwhelms the spectator with the scope and dimensions of its spectacle and iconographic program. Cortona has divided the vault of the ceiling into five parts, each dealing with separate narratives, which are demarcated by painted stucco frames (whose boundaries are nonetheless transgressed through artistic strategies that include figures and clouds that "escape" the distinct narratives and "float" across the frames). A personification of Divine Providence floats in the central panel, asserting that Urban VIII became pope by the divine power of God. The four other scenes depicted on the vault are allegories that reflect on the pope's attributes and works.[13] In a way that recalls the motions of seriality, the work has no obvious beginnings and endings; instead, it is possible to enter the work at any of its multiple "narrative" points. Once "inside," the viewer travels along paths that provide multiple choices. For example, allowing his or her gaze to drift into *Minerva and the Fall of the Giants* (figure 2.5), the spectator is invited to follow the formal, fluid arrangement of the composition and

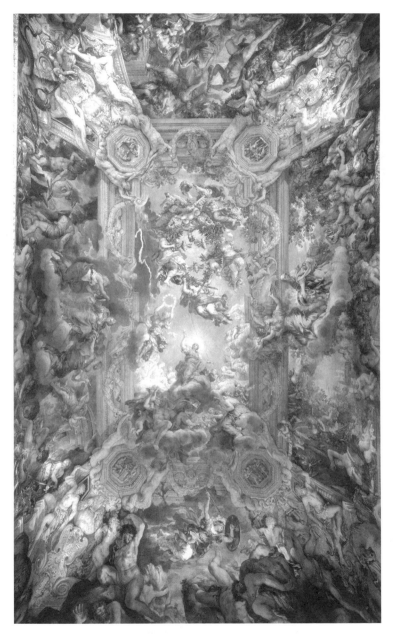

Figure 2.4 Pietro da Cortona's *Divine Providence / The Glorification of Urban VIII*, Palazzo Barberini, Rome (1633–1639). Copyright Photo Vasari, Rome.

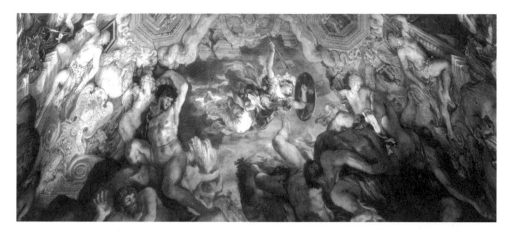

Figure 2.5 *Minerva and the Fall of the Giants*, detail from Pietro da Cortona's fresco painting in the Palazzo Barberini, Rome (1633–1639). Copyright Photo Vasari, Rome.

explore a number of avenues. Pursuing the movement of the giant on the left who crashes into the herm, the spectator is tempted then to follow the herm's gaze. The herm looks upward and to the left at another herm who languishes on the stucco frame, a pose that then leads the spectator's gaze to the next scene, *Furor and Fury*. Another option is to follow the vertical forms of the clashing giant and herm upward along the swirling forms of the herms who encircle the medallion in *Fortitude*. This path then leads the spectator into the central panel, *Divine Providence*, where other numerous narrative and iconographic paths confront him or her. As in the labyrinth poems, despite the centrality of the *Divine Providence* scene, the combinations and choices of paths that lead to and from the center are limitless, and any singularly linear direction implied by one-directional reading is denied.

Furthermore, it is not the formal structure of the Barberini Ceiling alone that reproduces the motions of the multidirectional labyrinth. The ceiling painting also draws the audience into what Doob considers to be a metaphorical maze or labyrinth, one that is informed, like the labyrinth poems, by possibilities of interpretation. Although intertextual and eclectic interplay has always been a feature of the arts, the baroque aspects of labyrinthicity emerge when the construction of the labyrinth itself—its "paradigmatic" level—becomes a significant source of the work's meaning.

The complex iconographic program in the Barberini Ceiling, in conjunction with its formal structure and intertextual array, was a source of great confusion for audiences in the seventeenth century. The program, constructed by the poet Francesco Braccio-

lini (in association with Cortona) (Scott 1991, 137), reflects a complexity akin to the puzzle structure of *Evil Dead II*. Solving the interpretative puzzle that underlies the iconographic program allows the audience to exit the maze. Those who fail to solve its mysteries leave the Salone of the Barberini Ceiling stunned at the work's overall virtuosity of execution, yet confused as to the meaning of many of the images represented. Rosichino, the doorman of the Palazzo Barberini and the Salone at the time Cortona's work was opened to the public, published a guidebook to the work entitled *Dichiaratione delle pitture della Sala de' Signor Barberini* (Description of the Paintings in Signor Barberini's Room) (Rome 1640). In the book Rosichino stated that many people who saw the Barberini Ceiling failed to understand its complex imagery and continually turned to him to provide an explanation. He wrote that although the work could be appreciated for its beauty, "such pleasure does not extend beyond the form and disposition of the color and figures, [therefore] the observers, remaining deprived of the enjoyment and understanding of the meaning, continually turned to me . . . and asked me to explain the paintings to them" (Rosichino in Scott 1991, 218).[14] Rosichino became so frustrated at the number of people requesting an interpretation of the work's general meaning that he finally produced the pamphlet, which explained, in broad terms, the meaning of the dense iconographic program (Scott 1991, 195).

Scott's research into the target audience of the Barberini Ceiling suggests that although it was aimed primarily at a middle-class viewer, the ceiling painting was deliberately constructed to reach out to the "entire spectrum of potential viewers" (1991, 196). Rosichino, in fact, makes it clear that the Salone was open to any member of the public "who could make a presentable appearance at the gate during appropriate hours" (1991, 193). Bracciolini divided the audience into three categories: "the vulgar common person, the noble gentleman, and the literato . . . The vulgar are plebians, who for the most part are not educated; the noble gentlemen, who, held back by their comfortable circumstances, do not immerse themselves in study and who tend to be moderately literate; and the literati, who spend their years over books" (Scott 1991, 195–196).

In constructing the program for the Barberini Ceiling, Bracciolini catered to these three groups, providing "low-brow amusements," such as the fall of the giants and the drunken Silenus for one end of the spectrum (Scott 1991, 196) and complex iconographic conceits such as *Minerva and the Fall of the Giants'* allusion to Claudian's *Gigantomachia* for the other end (Scott 1991, 139). Whereas most viewers could appreciate the work on the level of moral significance and as grand machine, the "fullest meaning of the vault imagery could be grasped only by those few 'who know a lot'" (Scott

1991, 196). In the words of John Beverley, such baroque artifice and spectacle is an "aristocratic fetish that eludes the comprehension of the crowd even as it astonishes them" (1988, 32). In this respect, as will be argued below, the baroque and neo-baroque are further distinguished in the group of literati each seeks to enfold in its intertextual labyrinths. The audience of the select and upper social stratum sought by the baroque is abandoned by the neo-baroque, which instead reaches out to the media-literate masses.

An understanding of the Barberini Ceiling's reliance on a multidirectional logic is enhanced not only by a comprehension of the complex allegorical program that relates the feats of Urban VIII, but also by the audience's awareness of the ceiling's place within the tradition of past *quadratura* and trompe l'oeil paintings, in particular, Carracci's Farnese Ceiling (1597–1608) (figure 2.6). The Barberini Ceiling's intertextual allusions, in combination with the allegorical meaning of the iconographic program, in turn, serves a significant ideological function. In addition to engaging with the ceiling's narrative and iconographic program, the viewer is invited to engage with the way it places itself in relation to prior examples to which it alludes. Calabrese observes that citation has always been a tool of genre and generic process. The baroque and neo-baroque emerge when citation becomes an instrument for rewriting the past (1992, 173). As is the case with *Evil Dead II*, the baroque principle of virtuosity is integral: Past "signs" are cited in order that they may be rewritten, perfected and expanded, and the viewer is provided with clues in the form of citation to enable him or her to recognize the "perfection" that lies within the confusion of the maze. But why is labyrinthicity intent on confusing? For Doob the answer lies in the "purely aesthetic": "Labyrinths are insurpassable paragons of architectural skill . . . [which] can be intensely complicated and artificial: the more elaborate, the more beautiful. . . . [T]he complex architectural splendor of a labyrinth makes both a compelling propagandistic statement honoring architect or commissioner and an effective defense against intrusion. Form follows function" (1990, 22–23).

The Barberini Ceiling is, of course, a virtuoso performance that serves a propagandistic function in honoring both artist and patron. Cortona self-consciously places his work in the context of a wealth of conventions. Past and present merge as Cortona situates his painting in relation to a multitude of sources and traditions including Renaissance and High Renaissance examples like Mantegna's Camera degli Sposi in the Palazzo Ducale, Mantua (c.1474), Michelangelo's Sistine Ceiling in the Vatican (1508–1512), Raphael's Vatican Loggias (c.1517–1519); Correggio's *Miracle of the Assumption* in the Parma Cathedral (1524–1530), and Giovanni and Cherubino

painting. During the eighteenth century, this style of painting, especially as exempli-
fied in the work of Cortona, came to be known as the "grand machine"; the analogy
between artwork and machine was the result of the ceiling painting's vast scale and
the complexity involved in unifying multiple segments, the manner of doing which
recalled a pictorial machine (Paul 1997, 74). Despite Renaissance examples of illu-
sionistic ceiling designs, not until the seventeenth century did this genre become a
widespread form of decoration. Illusionistic ceiling painting was traditionally reliant on
quadro riportati (the illusion of framed pictures that are painted on a ceiling) or *quad-
ratura* (painted perspectival or architectural organizations that appear to extend space);
both rely on trompe l'oeil effects that simulate three-dimensionality.

During the baroque era the conventions of the illusionistic ceiling painting tradition
were redefined through the introduction of new combinations of genres, media, and
techniques. In the seventeenth century, the illusion of the extension of real, architec-
tural space into the fictive space of the painted representation was taken to new limits.
Subject matter and scale were grand in scope, to an extent not previously experienced.
The most direct source of citation for ceiling paintings—and one of Cortona's and the
Barberini family's most determined competitors—was Carracci's earlier ceiling deco-
ration for the Farnese family in the Palazzo Farnese. Both works are typical of baroque
concerns with illusionism, Carracci's work often being associated with the beginnings
of the baroque, and Cortona's with its peak. Carracci's painting had a dramatic im-
pact on baroque developments in illusionistic painting. For Cortona, and for his pa-
tron Urban VIII, Caracci's ceiling was "the model to surpass" (Scott 1991, 126).[15]
The decoration for the Palazzo Farnese became one of the most influential models of
the seventeenth-century *quadratura* tradition, though the work has often been viewed
as "classical" in comparison to the *quadratura* developments later introduced by
Cortona.[16]

The theme of Carracci's Farnese Ceiling is from Ovid's *Metamorphosis*. The illusion-
istic structure of the ceiling relies on the construction of levels of representational re-
ality. Carracci has painted an illusionistic architectural framework onto the vault of the
ceiling, on which he has then incorporated medallions with painted scenes, stucco
herms that hold up the illusionistic entablature, and *quadri riportati* that depict scenes
from Ovid. In addition, a series of humans, putti, and satyrs inhabit the entire illu-
sionistic design, sitting on parts of the painted architecture or on the *quadri riportati*
frames, providing a unity of composition and action across all representational levels.
The dynamism of the overall design emerges from the way the gaze of the audience is

Figure 2.6 Annibale Carracci's trompe l'oeil frescoes on the vault of the Galleria Farnese, Palazzo Farnese, Rome (1597–1608). By permission of The Art Archive/Dagli Orti.

Alberti's Sala Clementina cycle in the Vatican (1596–1600), as well as the baroque example of Carracci's Farnese Ceiling, which the Barberini fresco exceeds in size. As Hammond states, the Barberini Ceiling's "immense space was not merely covered with a dropped wooden ceiling, as in the Farnese palace, but vaulted for a fresco on a scale surpassed only by the Sistine Chapel" (1994, 49). The viewers of the Ceiling become engaged in the process of labyrinth-as-game (Calabrese 1992, 135), with the game involving the recognition of intertextual references and rewriting of the past through the present.

In the Barberini Ceiling, Cortona introduced numerous innovations to one of the most popular painting traditions of the seventeenth century, the illusionistic ceiling

invited to shift focus from *quadro riportato*, to architectural framework, to medallions, to figures along the borders.

Cortona develops Carracci's technique of illusionism by creating a layering of levels of representational reality. In the case of the Barberini Ceiling, however, the system of *quadri riportati* is alluded to in the form of the painted entablature, only to be abandoned. The figures and narrative scenes, such as those in *Furor and Fury* and *The Forge of Vulcan*, undermine the framing that does exist. In these scenes the figures of Prudence, Dignity, and Power float on clouds in front of and above the entablature, refusing to be limited by its presence. Although it retains an identity that belongs to the painting medium, the Barberini Ceiling also embraces the convergence of media by simulating sculptural and architectural forms of representation. In *Minerva and the Fall of the Giants* (figure 2.5), painted images of Minerva and the giants appear to occupy a "real" space that extends beyond the walls of the room into a realm beyond the painted entablature and above the ceiling. These images, in turn, interact with painted simulations of stucco frames and with the sculptural forms of herms who float on and appear to hold up the stucco entablature. The merging of media fragments combines with the unity of action to produce fluidity within the entire fictive representation. In the scene dealing with the fall of the giants, the giants' flight creates fictive cracks in the stucco entablature that frames the scene, sending the herm sculptures into a frenzy as they attempt to escape the narrative and visual chaos that threatens to spill out of the entablature and into the real architectural space (Scott 1991, 155).

Furthermore, the flying figures that populate the work clearly reconfigure similar suspended figures that were popular in the developing genre of opera. Cortona replaced the stage machinery necessary to conjure the illusion of flight in the theater with the machinery of the painter's craft. In addition to designing stage machinery (*apparati*) himself while working for the Medici, Cortona was also witness to numerous productions that were held in the *salotto* of the Barberini palace. In 1633, the same year that Cortona began his ceiling painting, the Barberini hired Francesco Guitti, the renowned stage designer, for their palace productions. Guitti invented astounding stage machines, which, as evidenced in his productions of *Erminia* (1633) and *Sant' Alesso* (1634), included deus ex machina apparitions of Apollo and an angel descending on clouds from the heavens, images that reemerge in alternate form in Cortona's *Divine Providence* (Paul 1997, 82; Hammond 1994, 210).

The complexity of the ceiling's citational structure is taken to limits new to the baroque era. Cortona's self-conscious allusion to the Farnese Ceiling reveals two integral

features of baroque logic: a self-reflexive attitude to stretching the limits of the border or rules that previously constituted the illusionistic painting tradition, and virtuosity. As Scott has observed, the competitive impetus underlying Cortona's virtuoso performance was artistic on his part and political on the part of the Barberini. In commissioning the work from Cortona, the Barberini family, and Urban VIII in particular, were deliberately making a statement about power and the Barberini's status within the papacy, and about the Barberini's supremacy to other competitive families such as the Farnese.[17] *Quadratura* spectacles became an important means of "optical persuasion" in the seventeenth century, functioning as "powerful signs of social status and political power" (Scott 1991, 11–15). In the Barberini Ceiling, mythological, historical, and allegorical genres merge, finding a new hybrid relationship in the unity provided by the overall illusionistic ceiling program.[18] The generic specificity of mythological scenes like Minerva destroying the giants, the historical scenes in the medallions that depict historical personages such as Mucius Scaveola and Fabius Maximus, and allegories of Immortality crowning Urban VIII is overpowered by the dazzling effects and dynamism of the action and motion that formally unite each scene. The multiple centers provided by the diverse narrative and generic combinations are unified by illusionistic effects that bind narratives and genres into a complex whole. The construction of the Barberini Ceiling program shows an awareness not only of the heritage of similar artistic traditions, but of the papal families that these traditions glorified.

By situating the Barberini Ceiling within an intertextual discourse of illusionistic painting and, in particular, the Farnese Ceiling, Cortona's Barberini commission was also staking a claim for the status of the Barberini family in Rome. The painted vaults in the Palazzo Barberini "surpassed in number, extent, and programmatic purpose that of all other secular palaces in Rome" (Scott 1991, 11). Cortona combined secular traditions like the mythological genre (frequently used in palazzo decorations and also present in the Farnese Ceiling) with ceiling designs associated with ecclesiastical programs such as the allegories in the Sala Clementina in the Vatican (1596–1600). Whereas the Farnese Ceiling was a monument to the secular power of the Farnese, the vault in the Sala Clementina in the Vatican (painted by Giovanni and Cherubino Alberti) was an important monument to papal glorification. Relying on allegorical themes, the frescoed vault depicts the theological and cardinal virtues of St. Clementine. By alluding to the life of St. Clementine, the Alberti cemented a connection between St. Clementine and the reigning pope Clement VIII, who commissioned the ceiling, thus glorifying the worth and righteousness of Clement VIII's family, the Aldobrandini, as significant and important figures within the papacy (Scott 1991, 11).

By combining secular and religious traditions in the Barberini Ceiling, the Barberini were asserting their secular and ecclesiastical power within Roman society (Scott 1991, 126).

The virtuosity that Cortona achieved through his assimilation and rewriting of the past was therefore aimed in two directions: It stated the supremacy of the patron and his family in relation to other powerful families, and it staked a claim for the mastery of the artist, Cortona, in relation to other artists and prior artistic traditions. Additionally, in Cortona's overlaying the various historical and mythological events with allegorical meaning that glorifies Urban VIII, it becomes possible to conceive of an alternate, incompossible path's being created. Yet in a manner distinct from the neo-baroque, baroque allegory conceals and seals gaps in narrative contradiction, transforming original sources to achieve its allegorical purpose. The ceiling's allegorical program writes Urban into the various mythological and historical citations, thus providing cohesion for the distinct narratives (Furor and Fury, Minerva and the Giants, Mucius Scaveola and Fabius Maximus, and so on). An order emerges that permits an interpretative depth for an audience that has insight into the allegorical program. Various narrative layers may exist, but ultimately, it is the Urban VIII allegory that provides unity to the scheme, transforming the various monadic elements and multi-directional folds into a unity—into the compossible journey. *Evil Dead II*, in contrast, both accepts *and* denies the validity of its allusions, in the process creating multiple versions of narrative scenarios that then coexist. The unity of the neo-baroque embraces a more daunting task than that of the baroque, asking its audience to discover order from multiple and often contradictory, paths.

The very aim of requiring the audience to discover order out of chaos suggests that neither the baroque nor the neo-baroque can be defined as a formal structure that is in opposition to the classical. Deleuze is correct in stating that "the Baroque represents the ultimate attempt to reconstitute a classical reason" (1993, 81); the (neo-)baroque embraces the harmony associated with classical systems while also complicating them. Chaos (a term often associated with the baroque and with the neo-baroque's cousin, postmodernism) comes into play only when monadic elements (in this case, intertextual citations) are considered distinct from the whole or overall unity of the program. In the case of the baroque, Deleuze writes, "According to a cosmological approximation, chaos would be the sum of all possibles, that is, all individual essences insofar as each tends to existence on its own account; but the screen [that creates order] only allows compossibles—and only the best combination of compossibles to be sifted through" (77).

Classical order therefore emerges from the seeming chaos of the baroque. The neo-baroque presents us with an even more complicated scenario: Whereas it is, in many respects, a heightened version of the baroque, it can also be perceived as an example of the classical in its purest and most challenging guise.

The neo-baroque embraces multiple possibilities, multiple paths (often from parallel worlds), yet manages to transform them into an orderly universe. *Evil Dead II*, for example, conjures two multidirectional labyrinths—that of *Evil Dead* (labyrinth 1) and *Evil Dead II* (labyrinth 2)—yet connects these labyrinths at strategic points. The spectator may enter labyrinth 2, then find himself or herself in labyrinth 1, then back in labyrinth 2. Chaos results only when the spectator fails to understand the significance of his or her being shifted between the two labyrinths. Chaos appears to be more unfathomable than order because it requires an understanding of the coexistence of both incompossible and compossible paths and, furthermore, the significance of the transformation of incompossibles into alternate compossibles. This revelation of alternative paths results in a final order: a unity that is all the more intense. In both systems, the baroque and the neo-baroque, the classical can emerge only when the audience is capable of deciphering the system. For a non-media-literate audience, chaos reigns supreme.

Another significant difference distinguishes the baroque from the neo-baroque: a difference with regard to target audience. The decipherment of baroque intertextual allusions, particularly of the scale found in the Barberini Ceiling, is limited to an elite group of individuals who are associated with the aristocracy, their "learned" entourage, and by extension, the church. Intertexts weave their way through a series of labyrinthine sources that are available only to a limited few. The decoding of neo-baroque intertextuality, in contrast, is reliant on an alternative elite, one associated with the masses. In this case, the labyrinth's paths are successfully traversed by individuals who are literate in media that are available to many.

Certainly, the seventeenth-century baroque also allowed the new masses access to cultural objects that had previously been beyond their reach. As has been noted by Luiz Costa Lima in regard to the South American baroque, baroque literary culture was a predominantly auditive culture (1981, 14–26). The strong auditive nature of baroque culture has been noted by numerous historians: commedia, street ballads, and romances were orally delivered, then written and often published cheaply in the form of song sheets; theatrical productions of the plays of Shakespeare and Calderón, the operas of Monteverdi, and the church music of Bach were similarly presented to audiences before being published in written form (Nerhlich in Beverley 1988, 30; Godzich

and Spadacchini 1986a, 47). Texts may have been printed and more easily disseminated, in the baroque seventeenth century than in previous periods, but mass access to them was primarily through auditory means.

Cervantes reveals an insightful awareness of the changed conditions of audience reception that emerged during the seventeenth century, particularly with respect to the fact that access to a range of cultural artifacts through new media and mass production resulted in the saturation of media signs and a media literacy not previously witnessed. *Don Quixote* is as much about the way stories "have become imprinted on the consciousness of readers and listeners who bring their expectations (personal and collective) to the act of reception" as it is about the adventures of a madman who believes himself to be a knight (Godzich and Spadacchini 1986, 55). Cervantes's novel is a text that relies on a contemporary "reader" who can reflexively engage with the allusions and direct references made throughout to prior heroic traditions. Don Quixote himself tries to imitate figures of epics such as *The Cid*, fictional heroes of chivalric romances like *Amadis de Gaula*, and figures from the Moorish novels of Rodrigo de Narváez and Abindarráez (Cascardi 1997, 198). But Quixote is presented as only one of many types of readers that emerged during this period of transformation. Standing as emblem of a new and powerful middle-class audience, Quixote accesses the works in his collection at will, and more importantly, he is capable of reading them himself.

Although education for the middle and lower classes was on the increase during the seventeenth century, a great percentage of the population was still illiterate (Beverley 1988, 30).[19] This is not to say that there was no media literacy among the lower classes. As Godzich and Spadacchini stress, a "vast majority of the population participated in the culture as auditors (recipients and consumers) of verbal artifacts" (1986, 47). Chapter 32 of part I of *Don Quixote*, for example, is set at an inn where Don Quixote is staying. A priest explains to the innkeeper that Don Quixote's books of chivalry have turned his brain. The innkeeper finds the priest's comments difficult to believe, explaining that he has his own collection of books. In the harvest time, he states, many reapers come to the inn, and given that there is always someone present there who can read, they listen to stories read from the books. Thirty or so people surround the reader, explains the innkeeper, and "listen to him with so much pleasure that it prevents a thousand hoary hairs." Asking to see the innkeeper's books, the priest states they must be burned because they are lies "done for the amusement of our idle thoughts" (1999, I:32, 328). Despite his reservations, however, the persistence of the inn's occupants is strong, and the priest is convinced to read a story to the crowd.

As Lima has argued, an auditive culture differs from an oral one in that it is no longer reliant on the dissemination of narrative formulas on the basis of collective memory. Likewise, it differs from a culture based on the written text, which relies on private, as opposed to public, consumption (Lima 1981, 16).[20] Audiences and artists alike in the seventeenth century were exposed to a wealth of visual and literary sources, and the intertextuality and eclecticism that typified the art and literature of the seventeenth-century baroque was closely linked to the mass media sensibilities of a new modern era. However, as Beverley has noted, it is important to be aware of the difficulties that arise from assuming that audiences of our current era are the same as those of the seventeenth century (Beverley 1988, 29–30). Indeed, there are great divergences between the two.

Doom, Doom II, *and Neo-Baroque Forces of Expansion*

As the Barberini commissioned the Barberini Ceiling to display their seventeenth-century aristocratic and papal supremacy, so in the late twentieth century, computer game companies like id Software stake a claim for supremacy within the gaming and entertainment industries. Likewise, the hierarchical access to the unraveling of the labyrinth's interpretative secrets now lies with a redefined literati: the media-literate audience that has traditionally been associated with low-brow tastes. In the case of the computer game *Doom II*, the solution to the way out of the maze is apparent to the select few players who are both technologically adept (and thus capable of navigating their way through the complex spaces integral to first-person shooters) and to those who possess a literate familiarity with the conventions and iconographies of popular genres.

In regard to the logic of intertextuality in relation to contemporary entertainment media, especially in the realm that is traditionally labeled "genre," the complexity of the neo-baroque fold makes its presence felt all the more intensely, as does the neo-baroque's reliance on active audience engagement with its formal properties. Recently, generic categories that label a computer game like *Doom* as a "first-person shooter" emerge as a result of marketing imperatives intent on packaging a media product to sell it to its audience. The analysis of the formal properties of the *Doom* games, however, reveals a more complex merging of diverse combinations that range from multiple genres to multiple media. Although popular genres have always produced hybrid combinations,[21] and although the issue of generic labeling has always been connected to studio marketing and packaging, the extent of contemporary

hybridity has become amplified as a result of an intense level of intertextual reading formations. The formal pattern that is produced mirrors that of neo-baroque seriality, with the exception that rather than displaying a multiplicity of narrative formations, there is a labyrinthine interweaving of intertextual connections, one that blurs traditional generic boundaries and reconfigures them into new variations. Popular genres engage in such an excessive level of intertextual play that "traditional notion[s] of a genre as a stable, integrated set of narrative and stylistic conventions" are unsettled (Collins 1995, 126).

Collins suggests that the intertextuality inherent in genre films of the 1980s and 1990s is the product of changes in cultural and technological conditions.[22] He argues that "genericity," which embraces both a genre's production or historical context and the film viewing process, is crucial to understanding current emergent narrative formations.[23] As we progress into the decades following the 1960s, the accessibility of and exposure to a variety of entertainment traditions across the entire history of the cinema and television becomes even more dramatic. As Collins states, contemporary technology has expanded the possibility of the "array" or range of stories, themes, character types, and iconography to which a film (and, indeed, television programs) can allude and to which an audience can be exposed. Broadcast television, videos, laser disks, DVDs, and cable television have all intensified our connection to and familiarity with conventions that run across the entire history of the cinema. Unlike television broadcasting (which relies on programming that gives us access to films selected by others at an appointed time), these new technologies make possible more immediate and personalized access. Examples of popular culture, past and present, exist side by side, and the gap between memory and history grows smaller. The ruins of popular culture are ever present.

Furthermore, other media technologies such as computer games (CD, console, and Internet formats), theme park attractions, comic books, and the Internet have entered the array, and the boundaries that demarcate media distinctions increasingly blur. Contemporary genres not only engage in neo-baroque movements inward and outward, within and beyond a combination of generic borders contained within one medium, but they also fold beyond these borders to embrace other media. One thing that becomes clear, especially in light of this recent overlap of media, is the inadequacy of viewing genre films simply as closed systems that feed on their own heritage, history, and medium. In light of the extent of generic hybridity that informs contemporary entertainment media, traditional perceptions of "genre" as a system that encompasses common conventions familiar to a specific generic system have been exploded: A

neo-baroque model acknowledges the dialogic relationship that current examples engage in through intertextual reference to other texts, a relationship that extends beyond a single medium and embraces multiple media formats. Relying on the relationship between the fragment and the whole, contemporary "genres" (for want of a more effective term) recombine diverse generic fragments to produce new combinations of the whole. Recombining prior conventions into new configurations, contemporary genres speak "a number of languages simultaneously" (Collins 1989, 77).

The cult computer game *Doom: Evil Unleashed* (released by id Software in 1993) reveals the difficulty of categorization that faces the contemporary genre theorist. Although games like *Unreal* and the *Quake* and *Duke Nukem 3D* series have dramatically advanced the first-person shooter game since the release of *Doom*, in the heart of many a gamer, *Doom* will always be the king of first-person shooter games. The game reflects the extent of intertextual dialogism that is at play in current entertainment media. *Doom*, and its sequel *Doom II: Hell on Earth* (1994), are examples of the computer game "genre" known as the "shoot 'em up" or first-person shooter.[24] These games also, however, incorporate other genres—game, cinematic, and literary—into their structure. In addition to their form's embracing elements of action "beat 'em up" games like *Mortal Kombat*, "platform games" like *Commander Keen*, and other first-person shooters like *Wolfenstein 3D*, the science fiction/action film *Aliens* (Cameron 1986), the horror film *Evil Dead II* (Raimi 1987), and the cult Cthulhu mythos (popularized by H. P. Lovecraft) become a direct source of dialectic engagement for these games.

Although *Doom* does not employ film production techniques (including film actors and directors) to the extent that "interactive movies" such as *The X-Files* and *Max Payne*[25] do, it does depend on player familiarity with science fiction and horror film conventions, especially those evoked by *Aliens* and *Evil Dead II*. *Doom*, and its equally addictive sequel *Doom II*, introduced a filmic quality into computer game spaces and thus helped to broaden the digital market, inspiring the form and technological capabilities of later games like the *Quake* and *Resident Evil* series. In addition to these games' altering the conventions of their own first-person shooter genre, their impact reveals the potential that computer games have for dynamically interacting with other media.[26]

In his analysis of neo-baroque schemata, Calabrese suggests that the key technique of 1970s and 1980s television shows like *Columbo* was the "variation on a theme" (1992, chap. 2). In *Columbo*, episodes built on and altered the model established in prior episodes. Although narratives remained the same across episodes (a crime is

committed and Columbo solved it), they were also different from episode to episode in that slight variations were introduced (for example, the method of the crime, Columbo's unveiling of the crime and the criminal). Each episode therefore functioned as a self-contained fragment, but to recognize the variation played out in a particular episode, the audience had to have an understanding of how crimes were committed and solved in previous episodes. Relying on intertextuality, each variation on a theme repeated previous episode patterns to outperform them through variations to those patterns. Rather than revealing an open neo-baroque form through the serial extension of prior story events in subsequent episodes, in this instance, neo-baroque intertextuality expands the form by weaving its allusions through multiple past examples whose paths create a complex metaphoric labyrinth that travels back in time to both allude to and perfect its predecessors. Through the intertextual strategy of variation on a theme, the *Doom* games are exemplary of the neo-baroque concern with virtuosity.

In *Doom*, set in the future, the aim of the game is to navigate the protagonist, a marine, through doorways to three worlds—Phobos, Deimos, and Hell—to discover the reason behind the failure of the interdimensional travel experiments performed by the Union Aerospace Corporation. In the process, players must also destroy all the alien-monsters responsible for sabotaging the experiments. When (and if) players get to the end of the game, they will have defeated the demon hordes, returning to Earth victoriously—until they start the sequel *Doom II*. In that sequel, it is discovered that one of the dimensional doorways has been left open, allowing the chaos experienced in *Doom* to begin again. Players reprise their role as heroes, returning in a struggle to save humanity. The full dramatic and, at times, horrific effects of this story (at least by 1993 standards) would have been impossible to experience without the game's technically innovative three-dimensional graphics and texture and the atmospheric sound effects. These effects extended the rules of the shoot 'em up game into the already hyperviolent and hyperaction dimensions of the computer game genre.

Before *Doom* graced computer screens, the game effects of id Software's *Wolfenstein 3D* (1991) had transformed the two-dimensional game format known as the "platform game" into a separate genre known as the "corridor game," shoot 'em up, or first-person shooter genre. Before *Wolfenstein 3D*, platform games like *Donkey Kong* and *Commander Keen* had stressed action that took place on a two-dimensional plane that ran parallel to the computer screen. The layout of these games resembled a mazelike ant farm; the player navigated a two-dimensional, cartoonish character through this

mazelike layout while trying to avoid obstacles placed in his or her path. Corridor games like *Wolfenstein 3D* were instrumental in transforming this two-dimensional platform space into a more convincing three-dimensional environment. Rather than moving characters across a series of platforms that run parallel to the screen, in this three-dimensional setup, the player maneuvers the characters through a series of corridors. The corridor format stresses movement into the simulated depth of the computer screen space. The genre label "corridor game" was superseded by the term "shoot 'em up" or "first-person shooter" because the action of shooting the enemy— and the first-person point of view—is the emphasis in much of the play of corridor games. The most common example of corridor games therefore became first-person shooter variations that require players to find their way along corridors, shooting and punching all attacking enemies (and scoring points along the way).

Even a game like *Wolfenstein 3D*, however (which was groundbreaking for its time), remains unrealistic when compared to *Doom*.[27] Like Cortona's Barberini Ceiling, which stretched the *quadratura* tradition to new limits, *Doom* extended the conventions of the first-person shooter. The differences between *Doom* and *Wolfenstein 3D* are visible primarily in the ways players experience the environment in which the hero is immersed. In most first-person shooters, players adopt the viewpoint of the protagonist, whose body is not visible in its entirety; only his hands and the weapon he wields are visible at the bottom of the screen. The game-play logic is that the player's own body, which exists beyond the computer screen, "fills in" the remainder of the protagonist's body. Despite the movement from a two-dimensional into a simulated three-dimensional space, in *Wolfenstein 3D* a cartoonish, two-dimensional articulation of that three-dimensional space persists. The game world is inhabited by blocky, monotonous environments that emphasize minimal color arrangements and flat surfaces that lack texture and attention to detail. *Doom*, however, comprises environments filled with realistic details, details that flesh out laboratories, torture rooms, infernal landscapes, and military installations. Such visual details are accompanied by sound effects that include background music, the alien-monsters' cries of attack, and groans of pain coming from the hero's aching body. The result is an atmosphere of suspense, action, horror, and grueling tension. The movements of the hero further enhance the player's convincing experience of the alien world. In *Wolfenstein 3D*, players slide robotically along the corridors and confront the enemy (a continual assault of identical, cartoon-like Nazis) with a limited range of weapons. In *Doom*, not only do players face a range of demonic forms (with matching arsenal of weapons with multiple sound and

visual effects), but the hero also moves along corridors and up and down stairs in bob-
bing, jerky motions that more realistically simulate those of running.

In paving the way for directions that expand the formal array of conventions within
the first-person shooter tradition, *Doom* is presenting nothing new with regard to the
principle of variation integral to generic process.[28] Working within the conventions of
many of its first-person shooter predecessors, *Doom* introduced enough new rules to
allow for a redirection of the aesthetics of the first-person shooter genre. Technologi-
cal advances allowed *Doom*'s creators to develop a filmic approach to special effects and
action. As a result, *Doom* cemented the break between platform games and first-person
shooters instigated by *Wolfenstein 3D*, making possible the player's more convincing
immersion in the game's narrative spaces. *Doom* was also pivotal in broadening the
conventions and expectations of the first-person shooter.[29]

The *Doom* games reflect a neo-baroque attitude in the level and extent of their ge-
neric exchange and in the ways they invite the audience to reflect on how they situate
their form within entertainment media.[30] In doing so, the games call upon the neo-
baroque principle of virtuosity. *Doom* and *Doom II* reflect a complexity of form that
reveals the extent to which examples across popular culture dynamically interact with
one another, abandoning concerns for an exchange and extension of rules from within
singular and closed generic borders. Discussing *Doom*'s influences, Jay Wilbur, the
chief executive officer of id Software, stated that id "wanted to make an *Alien*-like
game that captured the fast-paced action, brutality and fear of those movies. Another
fine influence was the movie *Evil Dead II*—chainsaws and shotguns are an unbeatable
combination!" ("Violence Is Golden," 1994, 43). When one plays *Doom* and *Doom II*,
Alien and *Evil Dead II* stand out as sources. The games are an amalgam of action,
science fiction, and horror film genres, with specific reference made to *Alien* (with its
hybrid science fiction, horror, combat, and action structure)[31] and to *Evil Dead II*
(a film that also meditates on the slippery nature of horror). In drawing on two films
that manipulate generic limits in different ways, id Software created games that
extended generic boundaries even further than the films by making the first-person
shooter system "more elastic at the borders" (Calabrese 1992, 65) by intertextually
connecting its form to cinematic examples.

In *Doom* and *Doom II* the visual references oscillate among an array of creatures,
each calling on the iconography of a variety of genres. The ability to access a chainsaw
as a weapon is an allusion to the Ash character from *Evil Dead II*, who maniacally chops
off one of his appendages and replaces it with a chainsaw. The player is thrust into

science fiction environments that consist of moon bases, technological gadgets, and teleporters that are coupled with an atmosphere dominated by dim lighting and eerie sound effects that recall the ghoulish backdrops that dominate horror films. Not only do the games' specters, imps, "cacodemons," "hell knights," "cyberdemons," and "arachnotrons" allude to science fiction and horror film conventions, but the games also self-consciously rework the Lovecraftian Cthulhu mythos, which has itself inspired an immense intertextual web of media examples,[32] including the *Evil Dead* films in their reference to the *Necronomicon*.[33] The characters Cthulhu, Azathoth, Dagon, Shub-Niggurath, Elder Beings, Hastur, and the Night-gaunts initiated the Cthulhu mythology by making appearances, initially in the 1928 story "The Call of Cthulhu" (published in *Weird Tales*), and later in other tales that included "The Temple," "Dreams of the Witch-House," "The Haunter in the Dark," "The Shadow out of Time," and "The Shadow over Innsmouth." These creatures, who once inhabited and ruled the Earth, "are imprisoned or sleeping in various parts of the Earth and the galaxy, waiting for the time 'when the stars are right' and they can reclaim their rule" (Davis 1995, n.p.). Like their demon cousins in the *Doom* games, they can gain access to our world through portals that teleport them to various locations. In fact, Sandy Petersen, who created the hugely successful "Call of Cthulhu" role-playing game, also worked with id Software on the *Doom* games and the equally successful id-produced *Quake* games (which included a creature taken directly from the Cthulhu mythology, the Shub-Niggurath).

The Labyrinth, Virtuosity, and Doom II

The neo-baroque and baroque may share the interpretative and visual motif of the multidirectional labyrinth, but through technological rather than technical means, the neo-baroque labyrinth is often more literal. Computer games are especially indicative of this transformation. Whereas the Barberini Ceiling relies on a multidirectional logic that is produced in the way the spectator's gaze accesses the work (and in turn deciphers its allegorical intent), in the case of *Doom II*, the game player is more interactively engaged with the system of the labyrinth. The interactive possibilities of computer technology produce an illusion of a more direct immersion into a labyrinth than was available to Cortona and other artists of seventeenth-century baroque.

The corridors of *Doom II*'s multiple levels are literally constructed as multidirectional labyrinths, and players must make choices between paths within each level, the aim being to destroy as many aliens as possible, then find the exit to the next level.

Unlike in the one-directional labyrinth, there is no single path that can be followed. Players wander through the confusing corridors, sometimes following dead-end paths, then retracing their steps in an effort to find the correct path to follow. A one-directional or hard-railed path is further denied to players in that they must often return recursively to prior locations to retrieve much-needed health supplies, weapons, and keys that access secured doors. The player must also return to previously traveled paths when he or she has missed "secret" passageways during the earlier stages of the journey. Guiding players along the way (accessed via the TAB key on the computer keyboard) is a map device that makes possible an aerial-plan view of the paths already traveled within the complex. Although the map reveals the corridors that the player has discovered, the puzzle of finding the "correct," unexplored path that leads to the exit still waits to be solved. Failing to discover a solution, the maze wanderer is trapped within the labyrinth, unable to complete the game.

The solution to *Doom II*'s interpretative puzzle is therefore interwoven with the game's more literal puzzle structure. As players wander the game's labyrinthine corridors, they are also engaged in a labyrinth logic that relates to *Doom II*'s eclectic transformation and reorganization of past generic signs into new and expanded configurations. Players are invited to synthesize into a coherent system intertextual allusions scattered throughout the game. The construction of this coherent system depends greatly on the player's media literacy in that the quite literal labyrinth-as-game is also concerned with *Doom II*'s intertextual connections to its history. In particular, *Doom II* engages in a clever virtuoso game with id Software predecessors *Wolfenstein 3D* and *Commander Keen* (1990).

Doom II consists of thirty levels (and two secret levels) located on Earth, Mars, and Hell. Having traveled through fourteen levels of gore and destruction, the hero arrives in the richly textured and layered settings of *Doom II*'s Industrial Zone (level 15). After undergoing some genuinely suspense-provoking moments fighting imps and demons (to the accompaniment of atmospheric music tracks, sound effects, and eerie lighting effects), the player enters not one but two secret levels hidden behind a secret doorway on this level. This secret doorway transports players back in time by placing the hero within the corridors of *Wolfenstein 3D*, id Software's predecessor to *Doom*. The first secret level (Wolfenstein) takes players to the first level of *Wolfenstein 3D*, and the second (Grosse) to the final level of *Wolfenstein 3D*. After the effects of *Doom II*, players find themselves in the rigidly angular, monotonously decorated and colored corridors of *Wolfenstein 3D*, where battles occur with two-dimensional images of soldiers who all look exactly the same. This shift of game experience is both a treat and

a disappointment. The atmospheric game play of *Doom II* is suddenly replaced by a dated type of game play that had, before the emergence of *Doom*, been quite innovative and exciting.[34]

One of the most disorienting experiences while in the *Wolfenstein 3D* levels occurs when touches of *Doom II* spill into this game predecessor, making the "3D" addition to the "Wolfenstein" title seem quite hollow when compared to changes that have been introduced into the genre since *Wolfenstein 3D*. Occasionally players encounter this spill as three-dimensional decor (in the textured, three-dimensional trees and skies) that invades the two-dimensional space of the *Wolfenstein 3D* world. Players are also continually reminded of *Doom II*'s presence through the "super"-weapons still at their disposal, which are in marked contrast to the limited and primitive weapons used in *Wolfenstein 3D*. One of the most suspenseful moments from the depths of *Doom II* that escapes into this secret Wolfenstein level occurs when a cyberdemon (the most awesome of the creatures from *Doom II*) suddenly appears, his intention being to stop the player from accessing the *Doom II* level again. In this instance, the past is not merely recalled through an allusion occurring in the present. Past and present literally collide, and players witness intertextuality literally playing out before them as signs of the past coexist with the present.

Doom II travels a journey into the past further still. The Grosse level (which is also the exit level from level 15) continues the intertextual game. If successful in destroying the cyberdemon, players can proceed to the Suburbs (level 16), where they again must find the exit room. When (and if) it is found, it is discovered that the exit room is inhabited by four identical cartoon-like figures hanging from nooses on a futuristic gallows. To complete this level the player must first shoot these characters down, releasing them from the nooses that keep their two-dimensional, cardboard cutout bodies swaying in midair. These cute additions to the level have some historical significance: They are clones of Commander Keen, the title character in another id Software product dating back to 1990. *Commander Keen* even predated *Wolfenstein 3D*, reigning back in the days when id was still making platform games. Again, *Doom II* makes a self-conscious reference to its sources—and to the revisions of those sources. It asks its audience to celebrate the advances made in extending the first-person shooter genre's rules. The solution to exiting the room is to shoot and destroy the Commander Keen simulacra, which originated in an earlier game, which initiated the transformation of the platform game into the corridor style first-person shooter format, which, in turn, paved the way for *Wolfenstein 3D*, *Doom*, and *Doom II*. To fail to

understand the significance of the iconography from *Commander Keen* and *Wolfenstein 3D* is to miss the deeper interpretative layers that are embedded in *Doom II*'s game play. Such an understanding leads to the revelation that the game is both paying homage to its predecessors and staking a claim for its superiority by literally having the (more skillful) players of the current game destroy its predecessors.

In an interview regarding *The Evil Dead*, Raimi discussed the issue of allusionism in the horror film. Discussing Wes Craven's allusion to *Jaws* (via a poster) in *The Hills Have Eyes* (1977), Raimi stated that in Craven's film the poster was included to make the point that *Jaws* was "pop" horror, whereas *The Hills Have Eyes* was "real" horror (Edwards and Jones 1983, 27). The subsequent appearance of a poster for *The Hills Have Eyes* in the basement in *The Evil Dead* undermines its predecessor by suggesting that, by 1983, it was Craven's film that produced "pop" horror and Raimi's that presented "real" horror. This is precisely the sentiment that the makers of *Doom II* are expressing with a neo-baroque flourish in their allusions to predecessor games *Wolfenstein 3D* and *Commander Keen*. The inclusion of the *Wolfenstein* level asks the player to ponder the differences between the "real" game horror of *Doom II* and the "pop" game horror of *Wolfenstein 3D*. The computer game as intertextual game draws on a "labyrinth lore" or prior examples, thus using images, iconography, characters, and the "metaphorical significance of the maze to shape and give meaning to a new work of complex artistry" (Doob 1990, 224).

The baroque and neo-baroque, therefore, share a concern for virtuosity. In laying out its film and game predecessors, the makers of *Doom II*, like the artist of the Barberini Ceiling, are telling players that they have improved upon on their predecessors.[35] Although intertextuality has always been integral to popular culture, the function and extent of intertextuality have become amplified in the post-1960s era. The neo-baroque eclecticism evident in *Doom II* leads to the construction of an "intertextual arena" that actively addresses the audience, inviting it to engage in a dialogic process about the arena's construction (Collins 1989, 60). As Collins has observed, in recent years "texts have appeared which thematize the very construction of intertextual arenas where *texts* become microcosms of the overall field of competing discourses" (1989, 60).

Relying on a game based on a labyrinth, players discover the "pleasure of becoming lost" in an array of intertextual signs that are not merely alluded to, but are actually present; this being lost is paralleled by a desire to rediscover order, to rediscover the "pleasure of discovering where we are. Both these pleasures consist of substituting

order by, in the first phase, annulment and, in the second, reconstruction" (Calabrese 1992, 133). Neo-baroque games challenge players to discover order within their intricate web of connections and allusions. While one is immersed in the turns of the *Doom II*'s corridors, as for the maze wanderer in Doob's scheme, "survival and escape may well depend not only of the maze-walker's intelligence, memory, and experience but also on guidance—Ariadne's thread, instructive principles, signposts, or advice along the way" (1990, 47). Functioning both literally and interpretatively, the game player's mastery and understanding of the labyrinthine structure that is *Doom II* depends on an Ariadne's thread that weaves and links its way back through a confusing maze of corridors and secret passageways and a vast array of *Doom II* predecessors and influences. If he or she fails to grab hold of the thread, the player is left confused in the computer game's labyrinthine turns to wonder at the implications and function of the strange figures and conventions that are brought back from the first-person shooter's past. In the solving of the puzzle of the maze, order may eventually emerge from chaos, and the progression from one to the other depends on the player's game-play skills and knowledge of conventions.

Having identified the paths of a successful journey, players who complete the game also have the opportunity to destroy the makers of the labyrinth. If players survive and find their way to level 30, they are confronted by a doorway that is decorated with a ram's head, a doorway that separates them from the exit to the entire game. Once beyond the door, players find themselves face to face with John Romero—or, rather, his head on a stake. Romero was one of the game's programmers and one of the individuals who made every *Doom II* player's life both joy and a nightmare for weeks and months of torturous game play. Having played (and suffered because of having played) the game, players can now symbolically destroy one of its makers. Computer games introduce a new dimension to the neo-baroque principle of virtuosity. The player's interaction and more active involvement with the game spaces suggests a role of creation. The unraveling of the maze of the computer game can, in a sense, exist only when the player plays it. In addition, players produce their own distinctive form of game play. Because of the complex programming, no game can be played the same way twice. Recognizing this, and having mastered the game by taking it to its conclusion, players are asked also to recognize their own virtuosity in outperforming and solving the riddle posed by the game designers—thus the destruction of one of the game's creators.

The technological nature of the computer game medium further complicates the open structures inherent to neo-baroque seriality and intertextuality. The success and

proliferation of computer games since the 1990s has introduced to contemporary entertainment media intricate polycentric motions that have expanded the scope of story formations and the serial process. As a result, the dynamism of the neo-baroque aesthetics that inform popular culture has become intensified, finding a new voice in a new medium. In particular, the computer game's inherent hypertextual form and articulation of alternate geographies creates a complex polycentrism that has ramifications for interpretative possibilities. It is to these new possibilities that I now turn.

3 Hypertexts, Mappings, and Colonized Spaces

Phantasmagoria *and Intertextual Journeys through Horror*

When we discuss the user's interface with the digital spaces of networked computers —the electronic-mail systems, mailing lists, newsgroups, chat rooms, multiplayer-game worlds, search engines—the words "space" and "navigation" recur in our efforts to conceptualize the nature of the interface between the human and the cyberspace engendered by the machine. As has been well noted, the term cyberspace, originating from the Greek word κύβερ, literally signifies a space that is navigated. All cyberspace environments provide users with "their own sense of place and space, their own geography" (Dodge and Kitchin 2001, 1). Spatial and navigation metaphors also extend into the virtual realm of computer games, and all the formats that support them, from computers to consoles such as PlayStation 2, Nintendo, and Xbox. Dodge and Kitchin observe that virtual-reality technologies comprise two forms: the first is the "totally immersive environment" that requires "goggles to view a stereoscopic virtual world that phenomenologically engulfs" the user, and the second "is screen-based and allows the user to interact with a responsive 'game space'" (2001, 5). In both forms, computer-generated environments are created that allow the user to move around in and explore artificial spaces, spaces that often attempt to reproduce (in virtual form) the geographical and gravitational laws of the material space that humans inhabit. Both forms are interactive, and the interaction occurs in real time (2001, 5).

The user's ability to interact in real time in the virtual space that is constructed partly explains the perceptual processes that collapse this ethereal (cyber)space into a material space similar to a geographical place.[1] The first part of this chapter investigates how the navigational properties of cyberspace affect traditional notions of spectatorship, particularly as theorized in film studies (the film medium being one of the

Figure 3.1 The "final girl" heroine, Adrienne, from Sierra's *Phantasmagoria* (1995). *Phantasmagoria*™ screen shots courtesy of Sierra Entertainment, Inc.

gaming medium's primary influences and competitors). The labyrinthine paths effected by digital technology offer multiple interpretative possibilities. The second part of the chapter focuses more directly on questions of space, colonization, and new geographies, especially in relation to the baroque mapping of newly discovered spaces and the neo-baroque mapping of expanding digital environments.

Horror has found a popular and lucrative home in the computer game industry, with horror film conventions migrating and mutating into computer games like *Phantasmagoria* (figure 3.1), *Phantasmagoria 2: A Puzzle of the Flesh*, *Harvester*, *Resident Evil Veronica: Code X*, and *Silent Hill 1 and 2*. *Phantasmagoria* (1995), created, written, and designed by Roberta Williams and directed by Peter Maris, proved to be one of the most controversial games ever on first release. The game's horror themes and gory displays of violence, while common to the world of horror cinema, were unprecedented in computer games. In terms of the new representational realism provided by the CD-ROM interactive movie—at that time a recently developed technology—*Phantasmagoria* was groundbreaking. In fact, it was the game's combination of realistic imagery and interactive technology that proved a controversial issue among critics.

As discussed in the previous chapter, many examples of contemporary entertainment media self-consciously engage with their history and sources, *Phantasmagoria* is no exception. The intertextual referencing within the game reveals the extent of a me-

dium steeped and saturated in the history of its own conventions. As with the *Doom* games, when one is tackling *Phantasmagoria*, an issue that must be considered is how this game positions itself within the array of conventions and traditions from which it emerges and upon which it consciously draws. As Collins states in regard to the current proliferation of "Batman" texts, one characteristic of popular culture is its increasing "hyperconsciousness about both the history of popular culture and the shifting status of popular culture in the current context" (1991, 165). An awareness of generic and stylistic antecedents is nothing new. The distinction for the neo-baroque emerges in the way contemporary examples of popular culture place themselves in what Collins calls an intricate "intertextual arena," inviting a paradigmatic level of engagement from the spectator. Not only do many examples of popular culture draw upon sources specific to their own genre in all stages of their historical development, but they also reconfigure and renegotiate the "already said" of popular culture, moving across different genres and different media and revealing the fluid nature of an array of sources and conventions.

An analysis of *Phantasmagoria* must take into account both the producers' and audience's complex intertextual frame (which is formed and informed by a series of diverse sources). Like the "Batman" texts that Collins writes about, *Phantasmagoria*'s meaning depends on its negotiation of a variety of traditions past and present, including literary, cinematic, and computer games. In addition to the stalker horror film tradition, by which it is heavily influenced, the game is steeped in a combination of intertextual and generic traditions firmly rooted in horror. *Phantasmagoria* shares many generic concerns, for example, with evil possession films like *The Shining* (Kubrick 1980) and *The Amityville Horror* (Rosenberg 1979). In the game, a couple, Adrienne Delaney and Don Gordon, arrive at their new Gothic-style home in the small town community of Nipawomsett. While exploring her new home, Adrienne discovers a secret chapel hidden behind the fireplace in the library. In the chapel, she unwittingly unleashes an evil demon who possesses her husband Don, and his frame of mind slowly shifts from testy, to unpredictable, to deranged. In attempting to unravel the secrets of the house, Adrienne discovers that a century earlier the house was inhabited by the magician Zoltan Carnovasch, otherwise known as Carno. Finding the trickeries of magic insufficient to quench his magician's thirst, Carno turned to the black arts in the hope of producing "real" magic. Purchasing a spell book that opened the way to the gates of hell, he summoned an evil being into our world. In unleashing this demon, Carno's spirit became possessed by it, with the result that, over the span of a decade, he married then brutally murdered five women. The last one, Marie, plotted with her

lover Gaston to murder Carno by luring him in one of his magician's traps. The result, however, was that all three died, finally putting an end to the evil in Carno's host body—that is, until the arrival of Don. Mimicking his nineteenth-century soul mate, Don proceeds on a bloody killing spree that puts an end to most of the supporting cast, including Adrienne's cat Spazz. Thrust unwillingly into states of horror and disbelief, Adrienne discovers, one by one, the dead bodies of Don's victims, while also witnessing the nineteenth-century phantom slayings and inventively gruesome disposal of Carno's five wives.

From a literary perspective, in addition to the impact of a Gothic sensibility, there are distinct echoes in *Phantasmagoria* of the works of Edgar Allan Poe, in particular, the haunting and eerie themes and atmosphere of tales like *The Fall of the House of Usher*. Similarly, the small-town familial crises that prevail in many of Stephen King's novels also find their way into the game. A precinematic heritage is also evident in the game title's reference to phantasmagoria. Phantasmagoria were especially popular in the late eighteenth and nineteenth centuries and were included in the magician's repertoire; they also revealed a predilection for themes of horror. The phantasmagoric device, which relied on magic lanterns for its effects, could conjure illusions and phantasms that lured the audience into its horrific and fantastic representations.[2] In addition, the success of phantasmagoria as a precinematic form of entertainment was further enhanced by the nineteenth-century love of things Gothic (Heard 1996, 27), and their special effects and themes influenced early photography and the cinema, both of which dabbled in effects trickery in presentation of fantastic and horror themes.[3] The game *Phantasmagoria* calls on this tradition not only through its title, but through Carnovasch, the demonically possessed first owner of the house in *Phantasmagoria*, who was himself a nineteenth-century magician versed in the "magic" of phantasmagoria. As such, *Phantasmagoria* is acknowledging its history, acknowledging the precinematic impact of phantasmagoria on horror cinema, and acknowledging its own place in redirecting the horror tradition that originated in phantasmagoria into new entertainment directions through the computer game format.[4]

Just as the *Doom* games made advances for their own genre and technological format, *Phantasmagoria* paved the way for advances in the interactive potential of horror games by abandoning the cartoonish environments (familiar to games like *Doom*, *Alone in the Dark*, and *Quake*), incorporating instead real actors (twenty of them), settings, cinematography, and stylistic devices traditionally associated with the cinema, including over five hundred camera angles. In the game, not only is it possible for characters to move around a realistic 3D environment (figures 3.2 and 3.3), the realism of which is enhanced by the incorporation of full-motion video[5] but also the character motiva-

Figure 3.2 An interior space from *Phantasmagoria* (Sierra, 1995). *Phantasmagoria*™ screen shots courtesy of Sierra Entertainment, Inc.

Figure 3.3 An exterior space from *Phantasmagoria* (Sierra, 1995). *Phantasmagoria*™ screen shots courtesy of Sierra Entertainment, Inc.

tion and character development are of a level and articulation that had seldom been seen in computer games prior to the game's release. The popularity of horror games like *Phantasmagoria* actually allows the game designers to showcase the new, creative atmospheric potential of computer games (Foster 1995, 32). As a result of the generic, stylistic, and intertextual experience shared by the two media, to a certain extent it is useful to consider horror games from the perspective of horror cinema. Nevertheless, as will be outlined below, more flexible interpretative models need to be developed—models that take into account film traditions that are being revised—in conjunction with the different interactive possibilities provided by digital technologies that present alternative manifestations of the neo-baroque.

In *The Raw and the Cooked* (1994), Claude Lévi-Strauss evaluates, through music, the formal structures of two cultural attitudes that he classifies as structural and serial thought; both, in fact, reveal the patterns of the classical and the (neo-)baroque. Quoting Boulez (1958–1961), Lévi-Strauss states: "Classical tonal thought is based on a world defined by gravitation and attraction, serial thought, on a world that is perpetually expanding" (1994, 23). The structural system is closed, and Lévi-Strauss views this system of signs as retaining the capacity to serve an unconscious, mythic function. This approach invites symptomatic modes of interpretation. Serial thought, however, is perceived as destroying "the simple organisation . . . [of conventions] passed on by tradition" (Lévi-Strauss 1994, 23). Not only do codes declare themselves self-consciously, they also become complex and multiple. The result is that the unveiling of the unconscious function of myth, which relies on formalist principles of fixed forms and repetitive formulas, becomes a difficult model to sustain. Although these observations are applicable to the open-endedness of the (neo-)baroque outlined in the previous chapter, questions of interpretation of contemporary entertainment media become even more problematic as a result of the digital medium.

Parts of *Phantasmagoria*, especially chapter introductions (of which there are seven), flashback fantasies, and nightmares, are articulated in a movie format (in full-motion video); it is not possible, in these parts, to manipulate the action unraveling before us. The rest of the game is, however, interactive, and by using a mouse, players direct Adrienne to make exploratory choices that slowly untangle the narrative web mapped out by the game designer. These two modes of representation contribute to the production of an interactive environment that allows players (who are responsible for guiding Adrienne through the game) to move around in the house, its gardens, and the town by clicking their mouse in the direction they want Adrienne to take. It is possible for players to have Adrienne examine and collect various objects along the way, which

Figure 3.4 Adrienne explores the kitchen area, from *Phantasmagoria* (Sierra, 1995). *Phantasmagoria*TM screen shots courtesy of Sierra Entertainment, Inc.

are saved in an inventory (figure 3.4), and put them to use at later a stages in the game. For example, a letter opener saved in the inventory can later be retrieved to remove a loose brick in the fireplace; this then provides Adrienne with access to a mysterious chapel that has suspiciously been sealed off from the rest of the house. A bone that Adrienne collects from the general store permits her to distract the ferocious dog guarding the house of another character, Malcolm, and therefore to gain crucial information about the history of the horrors that have befallen herself and Don. And a Christmas tree ornament, a snowman, plays a fundamental role in the demise of mad Don at the end of the game.

Stalker Film Meets the Stalker CD-ROM "Interactive Movie"

Although the game folds itself into numerous horror genre traditions, it is the game's links with the stalker tradition, as witnessed in films such as *Halloween* (Carpenter 1978), *Prom Night* (Lynch 1980), and *Friday the 13th* (Cunningham 1980) that remain a

primary concern here with respect to Lévi-Strauss's observations. Paradigmatic levels of interpretation aside, even following the syntagmatic path of the story, the player is confronted with multiple possibilities. The digital realm, particularly its hypertext structure, as vehicle of the neo-baroque places traditional forms of interpretation into crisis. The term "hypertext" (or, more specifically, "hypermedia")[6] refers to the new forms of linearity and textuality that inform computer-generated texts. Radically transforming traditional linearity, the hypertext consists of blocks of information that are connected by a network of paths or links (Snyder 1996, 49). Computer users can access links between blocks of information in multiple and varied sequences, with the result that multiple and diverse narrative possibilities can emerge. The hypertext nature of the digital medium lends itself to a neo-baroque form requiring similarly open forms of interpretation. To explore the significant transformations of interpretation introduced by hypertext structures, it is important to understand the function of more traditional forms of linearity and the interpretative frameworks that respond to such models.

Both Vera Dika and Carol Clover have outlined the basic formula of the horror film, and the analyses that unravel parallel Lévi-Strauss's observations regarding structural systems that conceal unconscious, mythic functions. In *Games of Terror* (1990), Dika offers an analysis of the stalker film that she suggests dominated in popularity between 1978 and 1981, with the most influential instigators of the stalker film formula being John Carpenter's *Halloween* and Sean Cunningham's *Friday the 13th*. The formula Dika identifies focuses specifically on a combination of plot, setting, character types, stylistic components, and production values that dominated and were obsessively repeated in the stalker film subgenre during this period. Clover, in *Men, Women and Chainsaws* (1992), dubs these films "slasher" films and extends Dika's temporal limits to include the earlier example *Texas Chainsaw Massacre* (1974) and the later example *Texas Chainsaw Massacre 2* (1986). Rather than focusing on Dika's more formalist concerns, Clover's "slasher" definition places emphasis on the dynamics revolving around the "slash" and the relationship that develops between the psycho-killer and what she calls the "final girl," who is the final survivor and hero of the films. Despite differences of opinion between the two writers, the fundamental logic of the stalker/slasher film remains the same in both of their analyses: It concerns shifts of power, and in particular, the narrative (and spectatorial) motivation behind the shifts of power from psycho-killer to final girl hero. Four elements present in this subgenre of horror are also applicable to *Phantasmagoria*: plot structure, character types, structures of the gaze, and the gore factor.

Dika locates a dominant pattern in the stalker film. The narrative divides into two separate temporal frameworks: one set in the past, and the other in the present. Yet both are linked in the way the killer (whose initial crime is depicted in the past) and the victim/hero (to whom we are introduced in the present) are to be brought together thematically in the film's present temporal frame (Dika 1990, 59–60). *Phantasmagoria* does operate on this past/present principle. Rather than demarcating abrupt structural separations between past (which frames the opening) and present (which constitutes the bulk of the narrative), however, the game intersperses the past throughout itself. The present scenario of Don and Adrienne is intermingled with the past, which consists of a series of flashbacks that appear to Adrienne as phantom visions of Carno's wives appearing to "retell/show" their gruesome deaths. Despite the manipulation of time and sequence of events, past crime still provides an answer of sorts to the heinous crimes taking place in the present.[7]

With regard to the spectator's investment in slasher films, Clover argues that these films are more victim-identified than traditional film theory has allowed for. Rather than watching with a voyeuristic gaze that is about control and mastery,[8] the spectator of the slasher film responds to and "identifies" with the main character, the final girl. In the process he (and it is the male spectator who interests Clover) becomes embroiled in a position that, for the majority of the film, thrusts him, via the female protagonist, into a state of powerlessness in the face of evil (1992, 8–9). Only in the final stage of the narrative does the powerlessness shift to a position of control through the female protagonist's transformation into hero and active instigator of narrative action.

Clover explores Yuri Lotman's analysis of character functions in myth, and she arrives at a similar conclusion: The character functions of the victim and hero are gendered (Lotman in Clover 1992, 12). Like myth, slasher films reveal only two character functions: society codes mobile, heroic functions as masculine and immobile, victim functions as feminine (1992, 13).[9] Arguing that the slasher film reflects an older tradition that saw the sexes not in terms of differences but in terms of sameness, Clover suggests that the main characters in slasher films (hero and killer) encapsulate a one-sex model.[10] Both sexes (and their accompanying character functions) are represented in the one body. *Phantasmagoria* fits quite neatly into this argument. Secondary characters, for example, exist in the game to be killed, their status as function remaining in the victim/feminized mode.

These feminized victim characters (which include the vagrants Harriet and Cyrus, the telephone repairman, and even the five murdered wives of Carno the magician)

serve a narrative purpose in highlighting Adrienne's heroic properties when they finally emerge. Unlike in the characters doomed to be victims, in the final girl and psycho-killer forms, both sexes (and their accompanying functions) are displayed. As the killer moves toward defeat, he becomes feminized, and as the final girl moves toward victory she shifts from the role of victim to that of masculine/hero (1992, 50). Dika reaches a similar conclusion, stating that both the killer and the heroine are masculine in their "dominance of the film's visual and narrative context" (1990, 55).[11] As Clover states, the complex processes of character empathy or identification[12] in the slasher film reveal a fluidity and theatricality of gender often ignored by traditional film spectatorship theories.[13]

The theatricality of gender is highlighted further in *Phantasmagoria*. Adrienne's victim status in the initial stages of the game is quite typical of the final girl. Her suffering at the hands of her victimizer is borne out, for example, in the final chase scene through the house and in the noninteractive rape scene that takes place in the bathroom in chapter 4. The absence of interactivity in the presentation of this scene further highlights Adrienne's passive victim status, and players also experience her passivity first-hand in their inability to interact with the dramatic action. But her passive elements are always countered (and finally overshadowed, if the game is played properly) with an assertiveness and refusal to slip unquestioningly into the role of victim. Despite Don's threatening ravings and growing violence, Adrienne remains inquisitive, assertive, and active, traits that allow her to take on the status of hero in the end. Likewise, in the final confrontation scene with Don, the full-motion video mode is abandoned; Adrienne's greater active, heroic function is asserted by the player's capacity to interact with the events.

The final girl is the "undisputed 'I' on which horror trades" (Clover 1992, 45), and her central role is reflected in the camera work that stalker/slasher films use to construct point-of-view shots. The construction of these shots is more crucial to the interactive environment of CD-ROM technology than to films. The stalker/slasher tradition favors combining more objective, third-person shots with the subjective points of view of both killer and hero, with the camera often representing the vision of these characters. As Clover points out, the "eye" of the camera is collapsed into the "I/eye" of these characters. Whereas the killer's point of view dominates in the first part of the film, in the latter part (when the final girl shifts from victim mode to that of hero), she gains control of the point of view or gaze. *Phantasmagoria* reflects a similar structure of gazes, in which the power of the gaze is unraveled and transferred as the narrative progresses. As will be discussed later, however, this unraveling need

not necessarily be strictly linear. The game presents the player with four structures of the gaze or look. The first two are more interactive modes involving first- and third-person views, usually in combined form. For example, Adrienne's examination of environments (seen in third-person, more objective mode) often also leads to a shift to a more subjective mode in which her vision merges with that of the camera/computer eye. For example, we look on as Adrienne moves toward the window in the tower room of her house, then our viewpoint is collapsed into Adrienne's/the camera's as she/we look through the window toward the greenhouse.

The two remaining structures of the look in *Phantasmagoria* are characterized by a movie-style (and therefore, noninteractive) cinematography that is again both objective and subjective in method. More objective, third-person camera work includes the opening scenes to each introduction. The more subjective shots, on the other hand, reveal the layered complexity of this array of intertextual references, including the so-called fly-by shots, which are rapid tracking shots (in which the camera reflects the player's/game character's vision) made popular in the computer game world by the mystery/horror game *The Seventh Guest*. Interestingly, the fly-by shot finds its most famous film parallel in the stalker film, particularly in the articulation of the killer's point-of-view shot as he (and sometimes she) stalks his (her) victims. *Phantasmagoria* acknowledges this cinematographic convention, which was initiated as a staple of the subgenre by *Halloween*, finding almost poetic expression in the film's villain, Michael Myers's stalking, invasive gaze. Later in the film, however, just prior to Laurie's discovery of the blood-fest (and as she crosses the street to the house of death), she too is associated with this viewpoint—and its accompanying associations with control of the gaze and narrative action.[14]

Phantasmagoria thus follows the structures of the look according to the stalker/slasher tradition, and ultimately it is Adrienne's gaze that remains prominent. Adrienne's own subjective shots are framed in two ways. The first is the tracking shot that reflects the operations of her mind's eye, the most powerful instance being the opening nightmare scene, which has the first-person eye/camera eye flying through a dark, atmospheric environment filled with torture instruments and various horrors. The tracking viewpoint travels restlessly past surreal, abominable images, then stops suddenly as viewpoints change and Adrienne looks on at her own torture, a foreboding of the chaos that lies ahead. The second is a point of view more traditionally associated with the stalker film; for example, the tracking shot that follows her gaze as she glances down the house's second-floor staircase. The speed of the tracking point-of-view shot, however, implies that it could in no way be associated with a character's

vision. As mentioned earlier, complex intertextual play entails the game's situating itself within the context of the horror tradition array. The result is that the structures of these looks may imply a direct point-of-view shot associated with the late-1970s stalker film, but the shot also extends itself, replacing character point of view with camera point of view. This subjective shot, characterized by the camera in frenzied motion, is a convention popularized by Sam Raimi in his *Evil Dead* (1983), a film that took to excessive, parodic limits the conventions of the stalker film. *Phantasmagoria* therefore creates links with aspects of the stalker film across its history (as well as with horror conventions of computer games like *The Seventh Guest*), and this further complicates the saturated quality of allusions and intertextual references present in the game.

The Hypertextual Array: A New Medium for the Neo-Baroque

Interpretations that draw upon traditions of film criticism and theory are important in placing games such as *Phantasmagoria* in the context of their intertextual filmic and generic traditions. It is also important, however, to consider the significance of the generic migration of horror into the realm of the computer, where the more classically aligned, traditional approach to interpretation (like Clover and Dika) is shattered as a result of the medium itself. Clearly Clover and Dika never intended their interpretations to be applied to games; the issues they raise, however, are significant given the interrelationship of two media forms bound by a similar generic heritage. When drawing upon critical models from film, critics of computer games need to transform their interpretations to accommodate the radically different narrative formations possible in games through digital technology. Interpretation itself must adopt a neo-baroque style that reflects the polycentric, hypertextual movements of game worlds. The digital realm is labyrinthine in the very fact of its technology, and the player's traversal of game spaces highlights precisely this point.

A convincing application of Clover's and Dika's approaches to *Phantasmagoria* would depend on the fixity of the game's text—a text that relies on a story progression that shifts in a linear fashion from problem to resolution. The static, linear structure of stalker/slasher films allows both of these writers to view these films' plot structures (and the stylistic codes that support the plot structures) as operating like a membrane. When one is delving below the surface, the symptomatic meaning of the text is exposed and along with it its social, psychological, or mythic significance.[15] In Clover's interpretation, for example, much is to be gained by a male spectator's identifying with a female hero. By the male spectator's "running identification through the

body of a woman" (who serves a dual function as victim/hero), castration anxieties associated with the loss of power and with "being feminized" find a safer outlet in the female hero. The final girl functions according to a "politics of displacement," and the woman is used as a "feint, a front through which the boy can simultaneously experience forbidden desires and disavow them on the grounds that the visible actor is a girl" (1992, 18). For Dika the repetitive, formulaic features of the stalker film—and the peak popularity of those films between 1978 and 1981—reveal a ritualistic logic. The films engage the audience in a game about genre and the conventions of the stalker film, the underlying intention being a social ritual that addresses a collective dream. For Dika, on a psychoanalytic level, the Oedipal conflict underlying the narratives of stalker films addresses the needs of adolescent spectators (1990, 16). On a broader social level, Dika views the films as providing an outlet for an audience's anxiety over social traumas such as post-Vietnam anxieties, inflation, and unemployment (Dika 1990, 131).

Indeed, the CD-ROM interactive movie has been criticized for its greater emphasis on a linear form, than an open form, especially when compared to games like *Quake* or *Duke Nukem 3D*. Unlike *Phantasmagoria*, the latter are not dependent on video imaging and a game design that requires the use of real actors, film cinematography, and a presentation that has more in common with television and the cinema than the computer game. The CD-ROM format is seen as limiting the player's interactive and participatory options. Gary Penn, for example, has complained that the detailed environments of CD-ROM interactive movies limit games' interactive potential, making them more closed and linear, and for Penn, "linear footage is not the way forward in creating detailed interactive environments" (1994, 86). As Keith Ferrell observes, however:

> On a purely pragmatic level, the creation of open-ended, wholly interactive, fully explorable worlds that still possess some sort of structured story and character content may be too much to ask. . . . How do you anticipate every possible scenario or player action? How do you ensure complete narrative consistency no matter what the actions are? How many millions of words of dialogue must you write in order to accommodate all the conceivable conversations? Add the creative, technological, and budgeting challenges and you're looking at an undertaking that dwarfs even the biggest of motion pictures. (1994, 30)

A more participatory and more interactive mode of presentation than the CD-ROM interactive movie encompasses a major creative and technological demand. Yet despite

the logistic limitations, a strict linear structure is nevertheless ruptured in computer games, presenting players with possibilities totally alien to the cinematic experience. Like most games that are digitally created, *Phantasmagoria* unsettles traditional modes of interpretation, operating instead according to the logic of interaction—specifically, interaction that depends on hypertext, weblike narrative forms that present multiple rather than singular narrative possibilities. Certainly, embedded within the game programming there is a singular, linear structure (a classical function) that follows a story progression that adheres closely to the stalker tradition. No matter how technically proficient they are, however, it is most likely that game players will follow through multiple story directions and actions to discover a "stalker" narrative that parallels that of the cinema. Players must continually make choices that then lead them into a variety of narrative scenarios, thus realizing the motif of the labyrinth. Rather than multilinearity's (or the labyrinth's) logic being the product of intertextual relationships and generic citations that lead player and text to other examples of popular culture, in *Phantasmagoria* the labyrinth emerges as a result of the medium itself. The hypertext nature of computer games involves an expansion of the neo-baroque aesthetic to incorporate a new technology.

Aarseth argues that the development of the computer as both cultural and aesthetic form of expression challenges the paradigms of cultural theory (1994, 51). When the shift is made from film experience to computer game experience, possibilities of the neo-baroque are further realized as a result of the game medium's capacity to produce multilinearity and interactivity. Interactivity is made possible by digital technology that calls into play alternative metaphors to those traditionally conceived for the film spectator. In technical terms, a hypertext system consists of a series of blocks or "lexias" that are connected "by a network of links or paths" (Snyder 1996, 49). The hypertext system recalls both the system of folds and that of the labyrinth, each of which relies on a complex array of interconnecting monads. Each lexia extends and connects with other paths that branch out in numerous directions. In the case of *Phantasmagoria* each block presents only one possibility of a narrative sequence. A variety of story possibilities branch off from the narrative in a networked pattern. The narrative is not limited to a static, spatial fixity. Instead, it is an open, dynamic structure that moves beyond the linear. According to Snyder, just as the technology itself abandons fixity through its hypertext links, so critical theory must follow suit, and the new metaphors that emerge must evoke the features of hypertext technology (1996, 35).

The three most familiar metaphors that conjure images of the new experience of narrativity are navigation, the labyrinth, and the Web, and games such as *Phan-*

tasmagoria realize all three metaphors. As discussed in chapter 2, Doob suggests that the two labyrinth forms—the unicursal (one-directional) and the multicursal (multidirectional)—are designs of "planned chaos" that possess a different structural logic from one another (1990, 52). The unicursal, which follows a singular, linear path, dominates in the visual arts and is "part of popular culture rather than an exclusively learned model" (1990, 48).[16] Unlike the one-directional model, which is closed in structure and reveals no divergent paths, in the multidirectional labyrinth, the wanderer needs to make choices when confronted with multiple path possibilities. The multidirectional labyrinth is viewed as deriving from the literary tradition (Doob 1990, 48). Eco characterizes the model of the multidirectional labyrinth as the maze: It "displays choices between alternative paths" (1984, 81). Eco, however, introduces a third labyrinth model: the net, whose "main feature is that every point can be confronted with every other point and, where connections are not yet designed, they are conceivable and designable" (1984, 81). This is the work in continual process: a multidirectional labyrinth that expands continuously and therefore remains forever unfinished.

Despite Doob's comments that popular culture and the visual arts lend themselves to the one-directional model, the other two models (the multidirectional and the net) best characterize the baroque and neo-baroque motions of seventeenth-century art and contemporary popular culture. Serials, for example, would be one-directional only if a single linear continuation extended from serial to serial in a forward temporal motion. As has been argued, however, contemporary serials are multidirectional in that they fold and expand toward multiple paths. In fact, although they may initiate a multidirectional structure, their expanding complexity often results in the collapse of the labyrinth's walls, which are then extended and transformed into Eco's third type of labyrinth, the net. The net, as an extension of the multidirectional labyrinth, encompasses the seriality and intertextual connections present in neo-baroque entertainment forms. Their folds are potentially infinite. With regard to computer game design, the labyrinth model similarly has the capacity to transform the multidirectional model (where the "walls" of the labyrinth remain limited and fixed through programming) into the net model in that players possessing technological know-how can redesign aspects of programming to produce new and expanding possibilities.

The open nature of computer games like *Phantasmagoria* is suggested in the way players literally traverse the virtual labyrinth through hypertext form. Because of the nature of hypertext story structures, interpretations of a symptomatic kind become difficult to sustain. In the labyrinth wanderer metaphor conjured in interpreting the

Barberini Ceiling, spectators have multiple choices in terms of which linear paths they choose to follow and of the sequence in which these paths will be taken. Movement along paths, however, involves a visual traversal, and despite the multilinearity inherent in the mode of engagement, the outcome at the end of each journey remains fixed. Even in experiencing the Apollo program in the gardens of Versailles, which involves the viewer's actual movement through the space of the gardens, the differences between the baroque and neo-baroque are highlighted. The digital capabilities of the neo-baroque widen the gap between serial and structural thought. As suggested in the previous chapter with regard to the Barberini Ceiling, allegory unifies and gives meaning to the fluid and open nature of the overall structure. The same may be argued for Versailles: As the spectator travels through the spaces of Versailles, he or she experiences the various Apollonian narratives, until finally, through accumulation, they become integrated into the allegory of Louis XIV's triumph. *Phantasmagoria* offers a virtual journey, like the interpretative journey offered by *Evil Dead II*, that literally makes apparent the unraveling and coexistence of compossible and incompossible paths (which, once traveled and experienced, become compossible). As was hinted through the example of *Doom II*, the digital realizes an addition to neo-baroque motion. The virtual traversal and entanglement in hypertext folds and narrative events produce different outcomes to narrative events depending on the paths players choose to navigate. As Aarseth suggests, "the cybertext *is* a game-world or world-game; it *is* possible to explore, get lost, and discover secret paths in these texts, not metaphorically, but through the topological structures of the textual machinery. This is not a difference between games and literature but rather between games and narratives" (1997, 4–5).

Players of *Phantasmagoria* are, for example, responsible for making decisions as to how and where to guide Adrienne. As navigators of the story, they select the sequence of events and the sequence in which the narrative unravels before them. In a reflection of the structure of the multidirectional labyrinth, some aspects of the narrative action are closed off until other paths have been explored. To a certain extent, the labyrinthine form also implies a linear attitude toward narrative form, reflecting the linear narrative hidden in the corridors. In fact, with the multidirectional labyrinth, there is always a "correct" linear path that may be taken to traverse the paths of the narrative maze; other paths, however, are introduced, thus complicating this stricter, more "correct" form of linearity. For example, it is not until chapter 5 of *Phantasmagoria*, after the séance held by Harriet in which Carno appears to Adrienne, that we can operate the dragon lantern in the conservatory in Adrienne's house. This, in turn, gives players access to a secret passageway in the room, which then leads to the pre-

viously out-of-bounds theater. The overall effect is the creation of a web of plot scenarios that undermine notions of singular, linear progression, replacing them with multilinearity. For example, while in the house's kitchen, Adrienne may trek off to explore Carno's bedroom. But to get to the bedroom, players may choose to go via the dining room, or first go outside and explore the gardens, or go through to the adjacent bedroom that belonged to Carno's last wife Marie, and so on. Each decision, of course, is accompanied by its own narrative implications—and conceivable interpretations.

If we choose to apply both Dika's and Clover's arguments to *Phantasmagoria*, interpretative conclusions based on film texts must be reevaluated. In the crucial shift in the relocation of power away from psycho-killer to the final girl, the shift from victimization and passivity to mastery and control can alter dramatically. Certainly, if players play the game "correctly," ensuring Adrienne's success in the end, it could be argued that the arguments of both Dika and Clover are still applicable. Regardless of the hypertextual structure, in one sense, there is still a core, binding narrative that players are required to play. There is a path that can lead them out of the game labyrinth. Chapter 7, the final chapter of the game, may unravel to reveal classic final-girl material. In chapter 7 Don corners Adrienne in the house's darkroom. She struggles with him, and then she (and the player) ingeniously chooses to throw drain cleaner on his face. Escaping to the nursery, she finds a shard of glass from a broken frame and hides behind the door waiting for Don to come. When he does, Adrienne plunges the broken glass into him, then runs downstairs to the theater dressing room. She finds Don's jacket on the floor, searches it, and discovers, in the pocket, a Christmas tree decoration (which has sentimental value because Don proposed to her on Christmas Eve). Hiding in the dressing-room closet, she waits out her fate. Don enters soon afterward, opens the door, and drags Adrienne to the chair of torture. He manacles Adrienne's right hand to the chair, and as he crouches down to manacle her feet, she/we select the snowman from the inventory and give it to Don, as Adrienne pleads with him to remember how things once were between them. As Don begins to lift himself from a crouching position, we make Adrienne pull, with her free left hand a lever and the giant blade strategically positioned above them—which was meant for Adrienne—plunges explosively and memorably through Don's upper body.

According to one of the hypertext paths, this narrative possibility and the interpretations that accompany it are still viable. It remains, however, only one of the narrative possibilities present in the game, a one amongst multiple ones. The game produces a seriality within a single structure. The narrative ending depicted above

depends on players' playing the game through without making mistakes and on making all of the above-mentioned choices that guide Adrienne safely to the end of the game. This narrative ending also depends on players' searching through environments properly, discovering all necessary bits of information to facilitate progression, and picking up all useful objects. The likelihood of the correct choices' being made in such a way that they produce such a linear sequence are, however, minimal. The unraveling of the game instead depends on "traversal functions" (Aarseth 1994, 61) that exist across blocks within the hypertext structure.

The game creates a formation and experience of multiple compossibles that branch outward, suggesting a multidirectional structure. With each additional unfolding or discovery of a path, critics, in a sense, must alter their interpretation to follow suit. Another variation to the game's ending, for example, may be as follows. Searching the theater dressing room in a different sequence, in which Don has not visited and left his jacket, results in Adrienne being strapped to the torture chair without the snowman. The snowman is the key to survival in *Phantasmagoria*. No snowman means she has no way of coaxing Don to position himself strategically in the line of the giant axe. No snowman also means the final girl becomes final in another sense: in the sense that she dies. The axe plunges mercilessly through Adrienne's body, narratively leaving her in the victim/feminized position.[17] When applied to such a game scenario, Dika's and Clover's assertions about mastery at the end no longer remain fixed, and their conclusions need to be reevaluated. Our critical models and methods of interpretation need to be as neo-baroque and dynamic as the narrative networks and possibilities that the games present.

Similarly, the game play of *Phantasmagoria*, developing along multilinear directions, can further unsettle the singular temporality of the text. For example, technologically savvy players can access video program files (.vmd, or "video and music data" files) from each of the game's seven CD-ROMs and copy them onto the computer hard drive. Through additional program manipulation, players may then view the game's scenes at different temporal points in the story. For example, Don's rape of Adrienne in chapter 4 can be shifted into an earlier chapter. This can radically affect questions of character motivation, especially if the rape takes place prior to Don's demonic possession (implying different kinds of story motivations that would suggest that the evil events that took place were reflections of a problematic relationship that existed between Don and Adrienne prior to the release of the demon). Likewise, those not interested in the narrative elements can copy all the .vmd files onto their hard disk. This option offers a special-effects fan's dream, because the scenes of gore and grueling

violence can then be accessed at will and removed from any narrative logic. In this instance, the game "meaning"—and the linear path players chose to create—focuses on the unraveling of special-effects spectacle. As a result, critical response to the effects divorced of narrative must follow suit, in that in this instance, narrativity is put to one side, and the spectacle of special effects dominates as source of meaning.

The multilinearity and open narrative form of *Phantasmagoria* can lead players in a variety of other directions. If linearity and character motivation traditionally associated with Hollywood cinema is not the player's predilection (or simply, if he or she is a bad player and cannot work out how to access all options present in the game design), it is possible to produce a narrative that has more in common with art cinema and avant-garde cinema forms of narration and nonnarration than linear narration. In the case of bad game play, not only is it possible to miss entire portions of narrative action, therefore creating narrative gaps, but it is also possible to focus on actions that are in no way concerned with unraveling a narrative. Players can make Adrienne wander aimlessly around the house and in town; they can make her eat in the kitchen or look at herself in the numerous mirrors littered around the house; she can go to the bathroom, comb her hair, put on makeup, and go to the toilet. In the last scenario, the usual procedure is that we click on the toilet seat, she shuts the door in our face, and then we hear the flushing sounds of the toilet, and water running in the hand basin before she opens the door. One of the "cheat tricks" aficionados of the game have discovered is that if they click their mouse seven times on the chair next to the toilet before clicking on the toilet, Adrienne shuts the door and players hear various gross sound effects—moans, groans, plunks and "aaahs"—coming from inside the bathroom as Adrienne goes about her business. All these actions, from the mundane to the comical, are more aligned with the "dead time" of art cinema than the economy of classical narration.[18] They are actions that are not concerned with moving narrative action forward, and many are reminiscent of the mundanity of everyday life represented in Sally Potter's avant-garde feminist film *Thriller* (1979). Although events such as these do unravel in a sequence that mimics the linear, they serve a nonnarrative function in the sense that they have no overall story function.

Unlike those of the cinema and baroque counterparts of the seventeenth century, *Phantasmagoria*'s intertextuality and potential narrative formations are closely connected to the technology that drives it. The multidirectional labyrinth teeters on being transformed into what Eco characterizes as the net. Other games such as the *Quake* series actually do erupt beyond their preprogrammed limits, developing programmable parameters that are as limitless as the capabilities of the fans that create them. *Star*

Wars Quake, for example, is a modification that allows art work, sound, and code elements of *Quake II* to be changed or replaced to coincide with the *Star Wars* universe (the story events occurring twenty years prior to *Star Wars: A New Hope*). In this case, relying on a group that exploits total-conversion modification packages (which allow players to alter the architecture, style, and mise-en-scène of a previous game and extend on player-devised game patches) players can download programs that rely on the base technology of preexisting games but modify details to create new variants. All that is required for the downloads to work is a version of id's *Quake II*. Additionally, players can then further modify files and create add-ons from an available-files section.

Landow has suggested that hypertext redefines the beginnings and endings of linear narratives in multilinear ways (1994, 57). In the case of computer games, not only are players confronted with multiple story avenues and choices within each game session, but patches and other programs can further open up the games and transform them into dynamic networks that organically continue (like the neo-baroque serials) to expand their limits. Depending on the game player's choices and interests, therefore, the possibilities are as labyrinthine as the hypertext structure that supports them. Each game player can alter the order and articulation of events in distinctive ways. Even if other games similar to *Phantasmagoria* were to emerge, following along similar slasher paths (for example, its sequel *Phantasmagoria 2: A Puzzle of the Flesh*), the neo-baroque aesthetics of the works evident in the intertextual array, interactive possibilities, and hypertext form would shift and change so dramatically that no theory or critical approach predicated upon homogeneity and stability could be applied in any sustained or beneficial manner. The hypertext "discounts any final version" (Snyder 1996, 57). The classical (or structural) becomes complicated and is multiplied, and closed form gives way to the open spatiality of the neo-baroque. Finding singular interpretations in a sea of hyperlinks becomes nearly impossible.

Not only are traditional conceptions of narrative and the "original" unsettled in computer games, but assumptions of authorial control are also undermined. Although a game's programmers are its creative voice in that they design the game structure and devise all possible hypertext scenarios, the game player also has an integral creative role to play in navigating and selecting the narrative (or nonnarrative) paths that give life to the game action in configurations specific to his or her methods of game play. In addition, players can also manipulate the game programming itself. As is the case with intertextuality, the game player becomes integral to the unraveling of ensuing game "meanings." An "original" version of a game is rewritten each time it is played, replayed, or reprogrammed. Aarseth observes that "[a]s long as we are able to imag-

ine or reconstruct an ideal version, everything appears to be fine, and our metaphysics remains intact. But what if the flawed version interferes so deeply with our sense of reception that it, in more than a manner of speaking, steals the show?" (1994, 56).

Unlike Leibniz's baroque model of a world of compossibles, which are chosen by God and allow no flaws, in the digital realm the player as god makes choices by journeying through spaces: The journey through a previously unseen space suddenly makes that space (and the narrative scenarios it contains) possible, and when that same space is reexperienced, the events that previously occurred there may also be rewritten, making multiple worlds possible, including the flawed. The neo-baroque does not embrace worlds that comprise one compossible and multiple incompossibles, but those that comprise multiple compossibles.

Colonizing Space: The Baroque Mapping of New Worlds

The neo-baroque spaces traversed in games such as *Phantasmagoria* are spaces of discovery. Around each corridor, hallway, or doorway, a new space of exploration appears, and each space invites the player to colonize its form, to become familiar with its "rules," and to manipulate and master those rules for the sake of game advantage. Like gods, programmers create the spatial parameters of the games that players explore. Although these virtual worlds exist prior to the player's engagement with them, it could be argued that on the level of perception, virtual spaces and geographies do not exist until the player has mapped them. Virtual geographies wait to be uncovered, and often they may never be claimed by the player, in which case (for the player as opposed to the programmer) they do not exist.

The metaphor of colonization is an appropriate one when one is immersed in virtual worlds. In our era of the neo-baroque, we have conquered and colonized all spaces on our planet, and although we have trekked out into the surrounding solar system (often with the aid of our technological extensions), outer space waits to be conquered physically by other generations. The new frontiers of the neo-baroque lie in virtual spaces, which embody new modes of perception, communication, and subjectivity. Like baroque spaces, neo-baroque spaces are dynamic and refuse fixity and closure, forcing their inhabitants to reconsider their relationship to the world and the universe. Before taking a journey into digital colonies, I will turn back to examine an earlier period of exploration and discovery.

Human colonization and mastery of material geography made itself felt with noted force during the sixteenth and seventeenth centuries. From the late fifteenth century,

the parameters of the known world were increasingly being rewritten. New races and new lands were discovered in the Americas, Africa, India, and later, Australia. Further, these discoveries led to the colonization of these lands, which empowered the colonizing European nations. Despite his mistaken belief that he had reached Asia, the success of Columbus's trip and discovery of the Americas in 1492 led to "a wave of voyages that was to expand Europe's comprehension of the known world" (Ferro 1997, 30). With settlement and trade came aggression and the assertion of national power structures.[19] Between 1509 and 1514 Columbus's son Diego and Diego Velasquez initiated and achieved the conquest of Cuba. Peru, Bolivia, Paraguay, and later the Philippines were invaded and conquered by Francisco Pizarro (Ferro 1997, 30–35). By 1521 the Iberian nation further expanded its power, and Mexico was also conquered and plundered for natural resources, followed by Chile, Brazil (which had previously been a Portuguese colony), Paraguay, and Argentina (Burkholder & Johnson 1998, 62). The French and English colonized parts of Canada in the sixteenth century—including Quebec, founded by the French in 1608—initiating competition between the two nations with regard to territorial control and expansion. Both nations also controlled other parts of North America, including the French-owned Louisiana and the English settlements in New England, Plymouth, and Cape Cod (Ferro 1997, 42–47).

Although Holland did not begin expanding and colonizing with full force until the seventeenth century, when areas including the Indian archipelago, Jakarta, Java, and regions of Africa were settled (Ferro 1997, 44), the Dutch concern with the possibilities of consumerism sealed the union between colonization and capitalism. As Thrower observes, it was during the seventeenth and eighteenth centuries and in the environment of "nationalism and colonialism" that mapping became an important instrument used for economic and political purposes—specifically, purposes that were adjusting to the new conditions of capitalism (1996, 92). The discovery of continents previously unknown resulted in a boom in cartography: Newly discovered places were mapped, then repeatedly remapped to include additional places.

During the baroque era, in particular, the search for, mapping of, and colonization of geographical space became potent vehicles for monarchs and for the emerging companies of the new capitalist era. In the latter half of the seventeenth century, France became a leader in topographic mapping (Thrower 1996, 108),[20] and Louis XIV emphasized his role as powerful conqueror in the interior of Versailles. The fresco *Escalier des Ambassedeurs* (1679), later redesigned under Louis XV, depicted the return of Louis XIV from the Dutch War of 1672–1678. In this fresco, Charles Le Brun

painted personifications of the continents of the four parts of the world (Europe, Asia, Africa, and the newly discovered America) who appear to peer down at individuals who travel the staircase (Berger 1985, 15–20). Louis XIV is represented as Hercules, his victory and power evident in the plunder that fills his chariot, plunder taken from some of the most powerful colonizing nations of Europe: Spain, Germany, and Holland.

During this Baroque period, national and capitalist powers alike were heavily dependent on the ownership of the most current maps, which would provide the most accurate and effective navigation routes to desired locations. As Miles Harvey explains in his thoroughly entertaining *The Island of Lost Maps: A True Story of Cartographic Crime* (2000), map theft ran rife during the period. In 1592, for example, the Dutch traders and navigators Cornelius and Frederick Houtman "were commissioned by a group of nine Amsterdam merchants to journey to Portugal to learn what they could about newly developed sea routes to the East Indies" (Harvey 2000, xi–xii).[21] As one of the dominant colonizers of the sixteenth century, Portugal possessed some of the most accurate navigational charts of newly discovered sea routes and lands. Competition and the drive of an emerging mass consumerism, however, soon altered the Portuguese domination of the power base, and as the seventeenth century progressed, the Dutch became a power to be reckoned with. As Harvey notes, "the Houtmans and their associates were the vanguard of the age of modern capitalism. . . . The merchants they represented were in the process of pooling their resources in an innovative enterprise called the Company of the Far East, one of the earliest modern examples of the joint stock company, or corporation . . . this company was the predecessor of the famous Dutch East India Company, which in turn gave rise to the Amsterdam stock market" (2000, xvi).

Globalization and capitalism were making themselves felt with full force, providing new financial incentives for exploration. With the backing of companies such as the Dutch East India Company, in the early seventeenth century, Holland was at the forefront of cartographic advances and the emergent era of capitalism.

Economic backdrop aside, the expanded understanding of the spatial parameters of the Earth and the cosmological parameters of the universe that developed during the seventeenth century was to have a dramatic cultural effect, one that often was considered a threat by the Church. Printing technology was to play a crucial role in disseminating more accurate images of the world, thus aiding in the altered state of perceptions of the Earth: "For the first time the whole world is able to see the world as a whole" (Harvey 2000, 101). Accompanying this new spatial conception, a new

rationalism also influenced the thought of the day (Lablaude 1995, 36). Scientific advancement during the baroque period led to the development and invention of new cartographic instruments, with the result that not only were newly discovered spaces made visible to Western vision, but these new geographies could be mapped empirically (or what was then considered to be empirically) and with greater precision and accuracy. Two important technological milestones in cartography included triangulation, which, through "the fixing of places by intersecting rays," not only made maps more exact but provided a more precise ability to navigate; likewise, the pendulum clock, first theorized by Galileo and later built by Christian Huygens in 1657, made possible a "more accurate determination of longitude at fixed points of observations" (Thrower 1996, 91). Additionally, the establishment of scientific academies, such as the Accademia dei Lincei in Rome and the Accademia del Cimento in Florence, in the early seventeenth century was followed by the founding of the Royal Society of London in 1662 and the Academie Royale des Sciences in Paris in 1666, concerned themselves with a wide variety of scientific problems, including mapping and charting the Earth and the heavens (Munck 1990, 296–297).

The translation of Claudius Ptolemy's *Geographia* (dated to the second century A.D.) into Latin in 1410, in conjunction with the European voyages to new lands, was to advance cartography for the next three centuries (Thrower 1996, 58).[22] Ptolemy's *Geographia* became an important cartographic blueprint that was rewritten and perfected for over two centuries. In his *Geographia*, not only did Ptolemy insist on drawing maps to scale, but he was one of the first cartographers to reconceptualize the spherical Earth onto a flat surface (Harvey 2000, 65). The work included instructions for making map projections of the world, suggestions for breaking down the world map into larger-scale sectional maps, a list of coordinates for approximately 8,000 places, and two new systems of pinpointing location, latitude and longitude, which have since become integral to navigation (Thrower 1996, 23). Printing technology allowed numerous versions of Ptolemy's world map (figure 3.5), including the famous Ulm woodcut print of 1486, to be disseminated throughout Europe. The addition of the Americas to Old World geography, however, necessitated the redrawing and radical revision of Ptolemy's template (Burkholder and Johnson 1998, 67) (figure 3.6). As Thrower observes, the "Old World" as perceived by Ptolemy dominated the Northern Hemisphere, "whereas in reality it covers only about three-eighths of this distance." Also, the Indian Ocean in Ptolemy's vision included no route around southern Africa to India, and there was no east Asian coast (1996, 60). With the discovery of new mapping techniques and seafaring explorations, maps soon improved

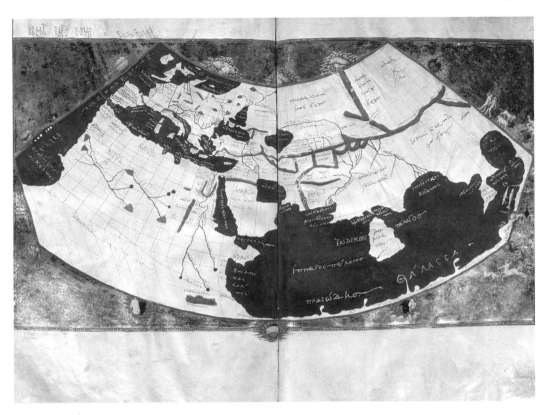

Figure 3.5 Fifteenth-century *mappa mundi* (map of the world) that relies on Claudius Ptolemy's *Geographicorum Libri*. By permission of The Art Archive/Biblioteca Nazionale Marciana Venice/Dagli Orti.

rapidly. According to Thrower, "As the Europeans extended their sphere of influence overseas, the conception of the Ptolemaic world was shortly to be radically altered" (Thrower 1996, 60). Armed with current maps, navigators provided crucial information that made possible the production of maps with greater geographical accuracy.

In 1506, Giovanni Contarini and his engraver, Francesco Rosselli, printed the first maps to show the New World discoveries (Thrower 1996, 69–70).[23] Soon after, Martin Waldseemuller's 1507 map included the northern and southern regions of the New World. The fame of Waldseemuller's map, which revealed the influence of Amerigo Vespucci's accounts of his 1499 voyage to the north coast of South America, is due particularly to its being the first to include the name "America."[24] Thus, to the three previously known continents of Europe, Africa, and Asia was added a fourth,

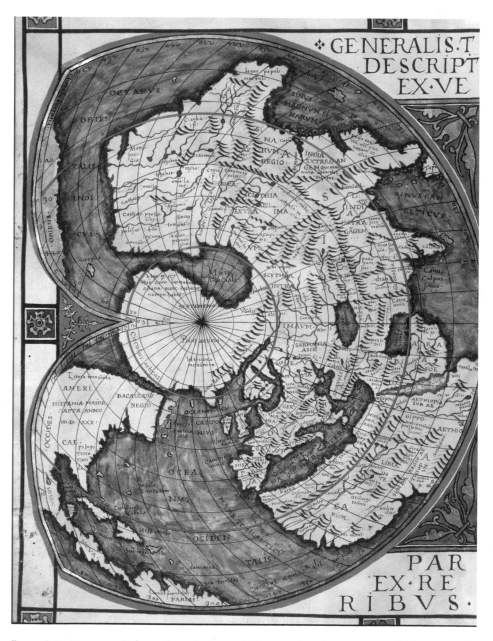

Figure 3.6 *Mappa mundi* from sixteenth-century Italian portolan. By permission of The Art Archive/ Biblioteca Nazionale Marciana Venice/Dagli Orti.

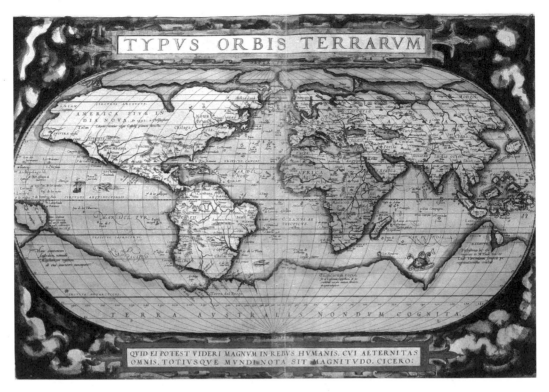

Figure 3.7 World map by Abraham Ortelius, in *Theatrum Orbis Terrarum* (1570). By permission of The Art Archive/Dagli Orti.

America. Despite Waldseemuller's additions to the Ptolemaic world map, his depiction of the Americas was nevertheless limited and failed to include the west coasts, which had not yet been explored (Thrower 1996, 71). Decades later, the 1570 maps of Abraham Ortelius (figure 3.7) and Gerardus Mercator's map of 1569 marked a new era in cartography. Not only did they include a more detailed depiction of the New World, but they inspired a tradition in which maps were more detailed and projected the three-dimensional world onto a flat plane[25]: The links to ancient cartography in the tradition of Ptolemy were beginning to come apart.[26] By the time Pieter Goos's world map (figure 3.8) was published between 1656 and 1666, almost the whole world had been mapped, and later cartographic advances, such as the *Libro dei Globi* of 1701 by Venetian Vincenzo Coronelli (who also founded the first geographical society, the Academia Cosmographica degli Argonauti, in 1684), introduced further accuracies

Figure 3.8 World map by Pieter Goos (between 1654 and 1666). By permission of The Art Archive/John Webb.

in depiction (Thrower 1996, 81–85, 123), including more exact cartography and more complete additions of North America and Australia.[27]

Despite these advances, the more that was discovered about the Earth's land mass, the greater was the uncertainty in terms of what lay beyond the parameters of the Old World. A Pandora's box had been opened, and geographically, the Earth was not to be definitively mapped for another two centuries. This uncertainty is evident partly in the instability and changeability of maps: although it acknowledges the presence of the New World, Mercator's map, for example, depicts it as an amorphous and expansive place; likewise, a southern continent is included, one inspired by myth rather than fact

(Harvey 2000, xii–xv). The unveiling of new worlds was accompanied as well by mythical overtones and mystical awe. Like the fantastical and mystical scenarios that contemporary science fiction conjures in its attempts to come to grips with the realities of virtual environments, many of the "empirically" mapped charts of newly discovered lands incorporated images and tales that belong to the realm of the fantastic. Harvey provides some pre-seventeenth-century examples:

> Hartmann Schedel's 1493 world map, for example, is accompanied by prints depicting a variety of human monstrosities, and one man whose feet point backward. . . . Schedel explained that in India some men have dog's heads, talk by barking, eat birds, and wear animal skins, while others have just one eye in the middle of their foreheads and eat only animals. Libya has a breed of people who are male on the right side of their bodies and female on the left. . . . Johannes Ruysch's 1507 map, one of the first to record the discoveries of the New World, shows a pair of islands off the coast of Newfoundland said to be inhabited by evil spirits. . . . Christopher Columbus reported that the New World contained one-eyed men, and others, with the snouts of dogs, who ate men, although he conceded he had not seen them himself. He did, however, claim to have spotted three mermaids on his historic 1492 journey but reported that they "were not as pretty as they are depicted, for somehow in the face look like men." (2000, 18–19)

The mysterious "othering" of beings who inhabited these strange, new countries persisted into the seventeenth century, particularly in the *wunderkammers*, which often housed collections of strange and wonderful artifacts brought to Europe from the New World.

These were changing times that shook the foundations of the known world and its dominant belief systems. The extent of the transitional nature of the times is perhaps most potently felt in cosmological and astrological advances of the seventeenth century. The mapping of "outer space" became a controversial science in the seventeenth century. Armed by the dissemination of knowledge that was made possible by the invention of printing, the publication of Nicholas Copernicus's *De Revolutionibus Orbium Coelestium Revolutionibus* in 1543 provoked the superstitious institutional responses to science (including Copernicus's condemnation by the Inquisition) that would continue into the seventeenth century. Refuting the Aristotelian-Ptolemaic[28]-Christian geocentric model of the universe and espousing a heliocentric and heliostatic theory,[29] Copernicus's beliefs opened up the possibility that Earth was merely one of many other planets in a vast universe (Guthke 1990, 33).[30] The increased adoption of heliocentrism by scientists resulted in new imaginings, such as the existence of a plurality of worlds, worlds that no longer held a special place for Earth as the center of the

universe. Although Copernicus's ideas were based more on reasoning than on empirical observation, his work ushered in the more radical observations and experimentation that gained impetus in the seventeenth century during the scientific revolution. As advances in cartography did for the terrestrial world, the invention of new instruments increased the accuracy with which celestial space could be mapped. The new sciences would add scientific credence to Copernicus's claims, further casting doubt on prior beliefs that placed humanity—and its earthly habitat—at the center of the universe. If humans lived on but one of many other planets, could one of those other planets also sustain life? If so, what were the ramifications for the teachings of the Bible? In the wake of the public execution of Giordano Bruno by fire in 1600, in 1616 the Holy Office declared the belief in the Copernican system to be heretical and placed *De Revolutionibus* on the Index of Forbidden Books (Easlea 1980, 78). Even so, old and new belief systems entered into a battle that would finally be won by the new.

The plurality-of-worlds concept proposed by Copernicus was granted further credence by Galileo Galilei's observations with the telescope. Working on advances in the recently invented telescopic lenses, Galileo had constructed his own telescopes by 1609, which included far more powerful lenses than were used previously. Thrower states that Galileo

> was the first scientist to employ the telescope for research purposes and, with . . . instruments, made what are presumably the first lunar charts by this means. Galileo's original maps were destroyed, along with many of his other works, but several engravings of his lunar drawings are found in his *Sidereus nuncias* (1610). . . . The lunar sketch map . . . though crude, was the first to show craters, which Galileo attempted to measure, and seas, . . . which he shortly realized were not water bodies. . . . [T]hrough a "remote sensing" device, Galileo first mapped a surface that humans would not explore directly for more than 350 years. Galileo discovered two of the moon's librations and initiated the serious study of selenography through his maps and writings. (1996, 92).[31]

Like Copernicus before him, Galileo, with his *Sidereus Nuncius* (Starry Messenger), further challenged the existence of a geocentric universe. Galileo observed the mountains and craters on the moon (disproving the belief that the moon was perfectly spherical); discovered four of Jupiter's moons (Io, Ganymede, Callisto, and Europa), suggesting that the Earth was not unique in having such a satellite; and saw stars that had not previously been visible to the human eye. In February 1616 the papacy declared the heliocentric theory "foolish and heretical because it contradicted the Holy Scriptures" (Munck 1990, 293), and on June 22, 1623, because of the publication of

his *The Assayer*, Galileo was condemned to house arrest for the rest of his life by the Roman Inquisition, charged with heretical beliefs: "stating in print and in person that the earth revolved around the sun" (Rowland 2000, 1). In 1632, however, Galileo published his *Dialogues Concerning Two New Sciences*, a book that was supposed to be an objective exchange for and against the Copernican model. The character Salviati (Galileo's mouthpiece), however, rather than the Aristotelian Sagredo, was granted the voice of reason. To ensure the wider dissemination of his ideas, Galileo began publishing in Italian, rather than Latin, "thereby making sure that his case would be heard well beyond a privileged Latin-reading minority" (Easlea 1980, 79). Soon after the release of *Dialogues*, the Holy Office ordered the confiscation of the book, but thanks to the emergence of a system that supported the new consumer ethic, "almost no copies remained unsold" (Easlea 1980, 79).

Despite resistance from the church, scientific discovery persisted in pushing the boundaries of knowledge. Through mathematics, in his *Astronomia Nova* of 1609, his *Epitome Astronomiae Copernicanae* of 1621, his 1621 revision of *Mysterium Cosmographicum* (originally published in 1595), and the *Rudolphine Tables* of 1630, Johannes Kepler outlined his support for a heliocentric system, arguing also that the planets moved in elliptical rather than perfect circular orbits; the falsity of the geocentric, Aristotelian-Ptolemaic-Christian universe was another step closer to being exposed (Munck 1990, 292). Reflecting the possibilities opened up by new optical technologies (a topic I will return to in chapter 4), in 1678 Edmond Halley, a fellow of the Royal Society of London, published a star chart of the constellations of the Southern Hemisphere (Thrower 1996, 95), thus making visible the previously invisible multiplicity and plurality of other worlds. Not only did the physicist and astrologer Christian Huygens develop the first scientific wave theory of light, but he located the rings of Saturn and discovered Saturn's moon, Titan (Gribbin 1998, 219). Then, in 1687, the physicist Isaac Newton provided conclusive proof of heliocentrism in his *Philosophiae Naturalis Principia Mathematica* (known as the *Principia*). Through calculus he revealed that the laws of physics are universal, "that it is the same law of gravity which makes an apple fall from a tree and holds the Moon in its orbit around the Earth and the Earth in its orbit around the Sun; that all these moving objects all obey the same laws of mechanics" (Gribbin 1998, 308; Easlea 1980, 162–178).

Like sea navigation, which remapped human understanding of the nature of the world, astronomy expanded the perception of the universe that surrounds the Earth. Geographical and celestial spaces became filled with mystery: an infinite universe lay in wait to be discovered. In the case of cyberspace, potential realms of discovery seem

equally infinite. The primary difference between these realms and those of the physical world and universe is that they are experienced virtually. As Harvey states, the "new breed" of computer navigator appropriates "Age of Discovery language to describe Age of Information concepts (Netscape Navigator, Microsoft Explorer)," but "[t]he new breed has no need for physical wilderness. It celebrates the fact that . . . very little remains that is real. The new breed dances on the grave of poor old Distance, believing that in cyberspace all vistas are endless" (2000, 130–131).

Colonizing Cyberspace: Neo-Baroque Mapping and Virtual Spaces

It has already been noted that, from an economic perspective, the logic of globalization aims at exploiting profit on a global scale, and digital technology has been instrumental in supporting the success of the new economy that has resulted from globalization. Embracing a combination of traditional telecommunications systems and entertainment media such as the telephone, the fax, television, video, fiber-optic cables, microwave links, and satellite links, the Internet has vastly expanded the global possibilities of communication. William Mitchell has noted that, although economic and cultural globalization predates the computer and the communications satellite, "the digital telecommunications infrastructure greatly increases the density of linkages within systems of cities, and can spread these systems worldwide" (1999, 21).[32] It is now part of the discourse of globalization to state that, as a result of the immediacy provided by the Internet and intranets, geographical distance no longer provides an impediment to capital growth; the "instantaneous communications" provided by cyberspace "have led to a collapse in spatial boundaries, leading to radical space-time compression which frees vital and capital relations from modernist spatial logic" (Dodge and Kitchin 2001, 13). Operating in modes analogous to "seaports and airports before them," says Mitchell, Internet and intranet technologies "serve as points of connection to a wider world and [as] potential generators of economic activity in their surrounding regions" (1999, 19). During our era, digital technology has become a powerful vehicle of a virtual colonization for financial, personal, and communal gains.

The conquest or visibility of old frontiers or of lands unknown relied on material presence within a specific geographical space. Communal interaction was similarly reliant on the physical interaction and exchange between people. User interface with the Web also invites a comparison with structures of community, but of a redefined kind. Videoconferencing, mailing lists, newsgroups, and chat rooms connect people from multiple geographical locations, inviting communality on the basis of common inter-

ests rather than geographic proximity. As David Porter explains, "what continues most powerfully to draw people to the Internet is its power and novelty as a medium of person-to-person communication. People log on to newsgroups, listservers, and the interactive role-playing sites known as MUDs (Multi-User Dimension) and MOOs (MUD Object Oriented) for the same reason they might hang out at a bar or on a street corner or at the coffee machine at work" (1997, xii). These sites, newsgroups, and listservs are, however, also virtual locations that wait to be uncovered and explored. Drawing attention to Howard Rheingold's significant study of virtual community, *The Virtual Community: Homesteading on the Electronic Frontier* (1993), Shawn P. Wilbur evokes the metaphor of the "electronic frontier" that includes the "home-steaders" and "pioneers" who participate "in virtual community-building" (1997, 8).[33] But the colonizers of these virtual places make their conquests, establish their friendships, and engage in a sense of community without having to leave the comfort of their own homes (or workplaces).

A great deal has been written about the relationship between technology and globalization; likewise, analyses of the virtual geographies articulated in cyberspace abound. To date, however, little attention has been devoted to cyberspace from the perspective of entertainment. Specifically, the immensely popular multiplayer network games and role-playing games (RPGs) continue to expand in number at an exponential rate, attracting players from all over the world. Innumerable Net communities have been constructed based on player interest in particular games, and through their avatars (virtual identities), players can break geographical boundaries by interacting with one another in virtual space and in real time. Distance is simultaneously expanded and collapsed.

In the words of Benedikt, the cyberspace we confront in the realm of the computer, no matter what its guise, suggests a "new universe, a parallel universe created and sustained by the world's computers and communication lines. A world in which . . . alter-human agency takes on form: sights, sounds, presences never seen on the surface of the earth blossoming in a vast electronic sight" (1991, 1). The spaces of this new universe are new frontiers that offer the user virtual geographies that wait to be mapped and discovered. Although it is possible to purchase and play games like those in the *Quake* series, *Unreal*, *Half-Life*, *Tomb Raider*, and *Halo* individually, in recent years an enormous on-line community has emerged that allows users to play their games in the comfort of their own homes while also logging onto network matches that allow them to interact with hundreds (at times, thousands) of other players in real time who are also logged onto the same game. Sites like GameSpy 3D, GameStorm,

Heat, Internet Gaming Zone, Multi-Player Games Network, and On-Line Entertainment provide servers through which players can access a multitude of games in multiplayer format. Games accessible in this format include *Quake II*, *Quake III Arena*, *Half-Life*, *Unreal*, *Baldur's Gate* and *Baldur's Gate II*, *Aliens vs. Predator*, *Blair Witch Trilogy*, *Buffy the Vampire Slayer*, *Carmageddon*, *Deus Ex*, *Duke Nukem 3D*, and *Diablo*.[34] Usually, these games are advertised as tournaments, and players who want to participate log on at designated times. Likewise, most games include additional chat rooms that allow players to regroup, discuss strategies, comment on game play, or just catch up with other player-companions.

Networked entertainment spaces differ from geographic locations: They can be accessed from anywhere in the physical world "and are centered on common interests and affinity rather than coincidence of location. Whereas social interaction, common ties and location are of importance in traditional notions of community in geographic place, in cyberspace it is suggested that personal intimacy, moral commitment and social cohesion come to the fore" (Dodge and Kitchin 2001, 17). In these spaces we become explorers, mapping out and discovering virtual geographies and confronting and conquering foes (or making allegiances with virtual beings) that have no substance in the "real" world.

Reflecting transformations in the game industry toward networked experiences, the *EverQuest* (989 Studios/Verant Interactive/Sony, 1999) phenomenon and its subsequent add-ons *EverQuest: The Ruins of Kunark* (figure 3.9) and *EverQuest: The Scars of Velious* reflect the phenomenal (and growing) success of on-line multiplayer RPGs. Unlike the above-mentioned multiplayer games, *EverQuest* ⟨www.EverQuest.com⟩ has no single-player mode and can be played only on-line via one of multiple servers that are situated worldwide.[35] The addictive potential of this MMORPG (Massively Multiplayer Online Role-Playing Game)—which has broken all records for on-line gaming, with over 150,000 players accessing its virtual-reality world on a daily basis—is evident in many a player's refusal to exit the virtual spaces evoked in this world and reenter the land of the flesh. As Adrian Carmody warns, if you play *EverQuest*, "prepare to lose touch with your real-life entirely, your dog, your garden, your partner (buy them a copy as well!) and you'll probably never notice that strange smell emanating from the fridge until it's too late" (1999, n.p.).

EverQuest confronts the player with a 3D environment that provides multiple camera viewpoints (first and third person, as well as an "objective camera" style). The player chooses his or her avatar or avatars (we can select up to eight characters for

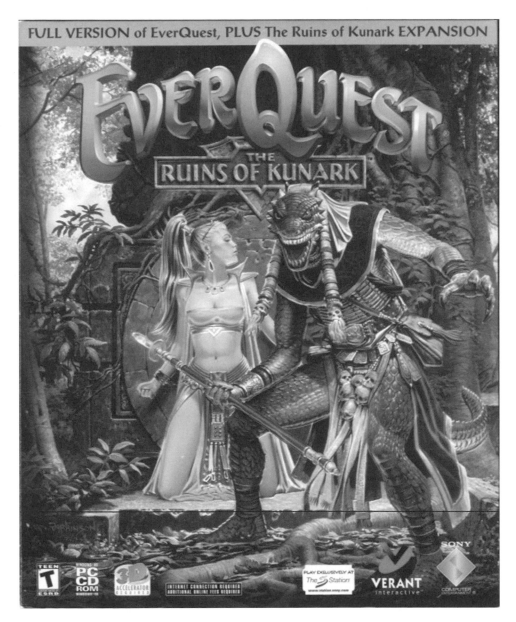

Figure 3.9 The cover to on-line game *EverQuest* and its expansion, *The Ruins of Kunark*. Sony/Verant Interactive. Screenshot of *EverQuest*® used with permission of Sony Online Entertainment. *EverQuest* and The Ruins of Kunark are registered trademarks of Sony Computer Entertainment America Inc. in the U.S. and/or other countries. Copyright 1999–2003 Sony Computer Entertainment America Inc. All rights reserved.

each game server), then selects his or her race (the possibilities for which include Barbarians, Dark Elves, Gnomes, Humans, and Iksars, each with their own unique talents); occupation or class (for example, bard, monk, rogue, cleric, magician, necromancer, or warrior); ability (his or her level of agility, charisma, dexterity, wisdom, intelligence, and stamina); facial appearance and name; and religion or deity (including Bertoxxulous, Brell Serilis, Bristlebane Fizzlethorpe, Innoruuk, and The Tribunal), each of whom embodies specific belief and morality systems. Following this, the player can enter a world called Norrath, which is inhabited by a number of races (to date, thirteen), each of which dominates specific regions of Norrath. In addition to having its own races, Norrath also has its own economic systems, alliances, and politics. So begins the player's quest through numerous cities that are scattered throughout several continents. Distinguishing itself from the baroque, however, this virtual realm is not reliant on physical and geographically present conquests and colonizations. Players can duplicate versions of themselves as avatars and send each identity off to experience alternate adventures. Players, in a sense, can become "serial-like" in creating and developing multiple personas that permit diverse interfaces with the *EverQuest* world.

With the aid of information Web sites like ⟨http://everquest.station.sony.com/guidebook/index.jsp⟩, ⟨http://www.eqvault.com⟩, and ⟨http://eq.stratics.com⟩, players find themselves in a strange and complex game space that is populated by thousands of other characters (who are avatars for their real-life alter egos) and also includes preprogrammed, nonplayer characters. Adopting a digital agent by taking on the identity of an avatar, in *EverQuest*, players colonize a realm whose indigenous people are not Indians but digital identities. Once in Norrath, the player can engage with others in communal activities and exchanges by speaking to them (by typing text messages); cast magic spells; attack and loot victims; send action messages called emoticons, which reveal the player's actions and emotional state; earn money by begging, healing, or casting magic spells or selling items to other players; bank his or her earnings; eat and drink to survive by purchasing or finding food (for example, fishing); travel by swimming, walking, running, taking a boat and (when appropriate experience has been accumulated) given the absence of the laws of physics, even teleporting between places. The communality of the game is highlighted not only within the game space, but in the multiple sites and activities that are devoted to *EverQuest* beyond the perimeters of the game space itself: chat rooms, listservers, on-line public forums,[36] and events organized in "real" space, such as the U.S. EverQuest Fan Faire held in Orlando, Florida, on October 19–20, 2000. And so the virtual geography continues to expand in a potentially limitless fashion.

For the player, one of *EverQuest*'s key attractions is the exploration of all of Norrath's cities.[37] Although players can explore their surroundings independently, in *EverQuest* strength is definitely found in numbers (solo travels often lead to danger and even death). Most players form parties with other adventurers; not only does this make for interesting group rapport, but individuals in the group can devise specific adventures or quests, which are publicized beyond the game space on chat boards, the Internet, or message boards. Players can also organize public events like marriages between characters, duels, lotteries and contests. Guilds allow players with similar ideas or goals to form groups. The official structure of guilds, which come complete with a charter, or a written set of intentions and purposes, takes the idea of the group mentality further still. The function of guilds is, in many respects, a social one: the sets of ideological beliefs and goals outlined in a guild's charter reflect the concerns of the guild in relation to Norrath. Succumbing to the logic of imperialism, guilds can also declare war on one another. Only unlike in real war, time limits that predetermine the beginning and closure of the war also come into effect. When the time expires, the war ends and peace ensues.

Chat rooms and Net surfing may not invoke terminology associated with the frontier spirit, but in *EverQuest*, players adopt a more literal frontier mentality as they discover cities, forests, and other races in the realm of Norrath. The world of Norrath is a space that is colonized by the player. We may initially emerge in the city associated with the race of our avatar, but we soon venture outward: establishing affiliations with groups, forming quests, venturing beyond our known world to discover new continents—and sometimes even attempting to conquer these newly discovered spaces through aggression.

The upgrade to *EverQuest, EverQuest: The Ruins of Kunark*, redefined the known world of Norrath and its three continents by introducing an entirely new continent called Kunark (figure 3.10). Traveling to Kunark by ship, the player can explore over twenty new zones created by programmers. In Kunark, they confront a new array of nonplayer characters and a new race, the Iksar (or Lizardmen). In another expansion, *EverQuest: The Scars of Velious*, the player explores the previously lost continent of Velious, where new and mysterious characters, including dragons, are again discovered. As the *EverQuest* Web site ⟨www.everquest.com⟩ states:

> The newly discovered frozen continent of Velious awaits hearty adventurers and expands the world of Norrath by over 20%. [There are] 19 perilous new zones including: ice caves, crystal caverns, crypts, dungeons and frozen towers. A new cast of visually

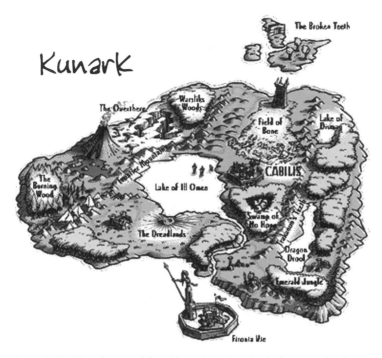

Figure 3.10 Kunark, one of the additional *EverQuest* lands that expanded the geographical boundaries of the world originally occupied only by the realm of Norrath. Sony/Verant Interactive. Screenshot of *EverQuest*® used with permission of Sony Online Entertainment. *EverQuest* and The Ruins of Kunark are registered trademarks of Sony Computer Entertainment America Inc. in the U.S. and/or other countries. Copyright 1999–2003 Sony Computer Entertainment America Inc. All rights reserved.

> stunning non-player characters including frost giants, ice dragons, snow orcs, cave bears, Snowfang gnolls, storm giants and vicious ottermen. . . . Hundreds of new magical items to discover, trade and sell.

Like the baroque counterparts of computer games, that which was invisible is, through discovery, made visible.

Vivian Sobchack has described QuickTime movies as a form that

> most frequently evokes from me the kind of temporal nostalgia and spatial mystery I feel not when I go to the movies, but when I try to "inhabit" the worlds of Joseph Cornell's boxed relics, or wander among the enigmatic exhibits in the Museum of Jurassic Technology in Culver City, California, or leaf through pictures of the personalized collection

of "curiosities" found in the *Wunderkammer* of the sixteenth and seventeenth centuries. (2000, n.p.)

Computer games like *EverQuest* and *Phantasmagoria* also remind me, as QuickTime does Sobchack, of little worlds in little boxes. In these games, programmers and players interface with micro—virtual realms that are reminiscent of our own but operate according to their own spatial and temporal rules. In the sixteenth century, Giulio Camillo in his *Theatrum Mundi* (1588) and Samuel Quiccheberg in his *Inscriptiones vel Tituli Theatri Amplissimi* of 1565 described the contents of the popular *wunderkammers* as "theaters of memory" and "theaters of the world," respectively. These treatises on early museum theory influenced the nature of seventeenth-century museum collections dramatically. Stafford is correct to characterize these encyclopedic museum collections, which included animal and plant specimens, minerals, coins, medals, books, machines, paintings, and "amazing toys," as "playhouses of the world" (2001, 6). The objects in these museum spaces performed for their audience, and the performance reflected a desire to bring knowledge and the world to the visitor. The *wunderschrank*, or cabinet of wonder, is especially interesting in the context of computer game spaces, for cabinets of wonder contained within them "performative devices full of secrets and surprises" that waited to be discovered and uncovered by the user's interaction with them (12). Stimulating "its users to become performers" by opening cabinet doors and drawers, and then discovering, touching, and smelling the contents within, the *wunderschrank* required the "senses to converge in a kind of synesthesia" (6). As in computer games, which rely on human vision, hearing, and touch (of control consoles or keyboards), objects that were unveiled in the *wunderschrank* conjured a sense of place and time (a spice from Chile, a mouse skeleton from Mexico, a coin from ancient Greece). Computer games offer radically different conceptions of space, place, and time to that presented by the *wunderschrank*. Our avatars may die, but they can defy temporality by being resurrected, returning to the same place and time, and beginning their journey anew. The objects experienced in the world of a computer game are creations of digital programming, not nature. They have no indexical relationship to the "real" world, yet despite the fact that cyberspace is a nonplace (and the fact that the dead can be resurrected there), humans persist in creating spaces that appear to have gravity and objects that have solidity and materiality. Ultimately, these digital worlds present, in macro form, a filtered and revised variation of our memory of the reality we inhabit beyond the computer.

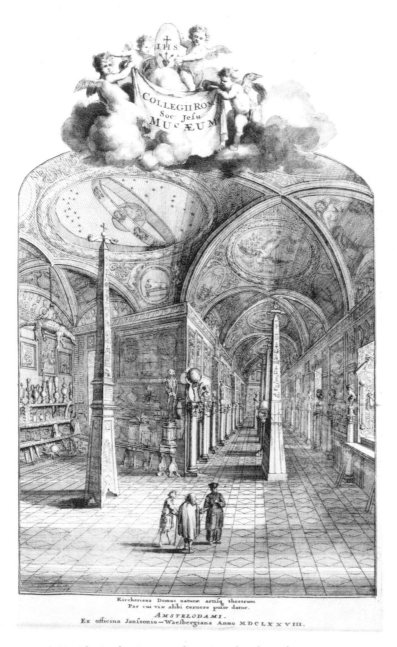

Figure 3.11 The Kircher Museum, from Georgibus de Sepibus, *Romani Collegii Societatis Jesu Musaeum Cele-berrimum*, first frontispiece (Amsterdam 1678). By permission of the University of Chicago Library, Special Collections Research Center.

Stafford explains that "[t]he cosmos as displayed in the *Kunstkammers* was not so much a static tableau to be contemplated as it was a drama of possible relationships to be explored" (2001, 6). Collections like those of the Jesuit priest Athanasius Kircher in Rome cultivated this conception of the *wunderkammer* as theater of the world (figure 3.11). Playing a central role in the support and progress of the new sciences, the Jesuits maintained the importance of knowledge and the advancement of the human intellect. Through his collection in the Roman College, Kircher became the Jesuit mediator to the cosmos. Within the walls of his museum it was possible to experience aspects of the New World: plant and animal specimens, spices, minerals, drawings of the local inhabitants—all were present within this space. Jesuit missionaries, on their return from distant places like China, India, Mexico, and the Philippines, would bring with them objects that embodied the memory of their originary homeland, objects that became part of this theater of memory. Kircher's collection, which also included detailed texts, images, and letters by visitors to these countries, was as encyclopedic as the World Wide Web. In both cases, information was (is) collated and stored within a complex database that did not (does not) succumb to the inconvenience and laws of space and distance. In Kircher's *wunderkammer*, visitors could access and experience a version of the world in microcosmic form.[38] Relying on the effects conjured by their spectacular residents, Kircher's microcosms rarely failed to evoke states of wonder in their audience. It is to the spectacles and states of wonder that I now turn.

4 Virtuosity, Special-Effects Spectacles, and Architectures of the Senses

(Neo-)Baroque Visuality

The last few decades have been host to a variety of entertainment media that are dependent on special-effects spectacle. With a seriality similar to that which underlies the logic of these entertainment forms, the effects illusions conjured are intent, through the employment of new technologies, on extending boundaries: either by applying techniques that blur the screen boundary by drawing us into the entertainment space, or by obfuscating the screen frame and creating the illusion that the contents of screen space have spilled into the space of the spectator. Computer games such as *Phantasmagoria* and *EverQuest* rely on digital programming that invites the player to engage in their spectacular spaces through immersive and interactive forms of interplay. As discussed in the previous chapter, the audience is lured into the characters, objects, and environments that are contained within the "box" of the computer or television screen: We emotionally, empathically, and perceptually enter the microcosmic worlds of virtual reality through our direct interaction with them. The cinema and theme park attractions (which often rely on film technology) present viewers with alternate neo-baroque effects. In films such as *Jurassic Park* (Spielberg 1992) and *The Matrix* (Wachowski and Wachowski 1999) and theme park attractions such as *Jurassic Park: The Ride* (1996) and *Terminator 2: 3D Battle across Time* (1996), special-effects technology is similarly intent on immersing the spectator in the fantasy induced by the effects by highlighting intense sensory experiences that often seek to collapse the representational frame perceptually. Unlike that of their small-screen companions, however, the sheer size of the cinema screen and theme park attraction invites the dual sensation of the audience's immersion *into* the alternate world and the impression of the entry of this world into the space of the audience.[1]

Integral to the (neo-)baroque is the principle of virtuosity. Like the playful (neo-)baroque attitude toward allusionism and intertextuality, virtuosity reveals itself through spectacular and auditory allusions—allusions that unveil a specifically technological virtuosity. Focusing on seventeenth-century *quadratura* and trompe l'oeil illusionistic painting and the post-1970s science fiction film, I compare here the technical and scientific advances of seventeenth-century spectacle and technological advances displayed in late-twentieth- and early-twenty-first-century spectacle to evaluate the (neo-)baroque nature of these forms. A dual impulse resulting from an alliance between artist and scientist is an important factor that manifests itself formally in the (neo-)baroque. First, in both the baroque and neo-baroque periods, scientific and technological advancement in optics pushes the boundaries of the understanding of human perception to new limits. Second, artists and filmmakers in both periods consciously produce works that exploit and often instigate scientific and technological developments by perceptually collapsing and testing the boundaries that separate representation from reality and confronting viewers with technological tours de force. In the virtuoso construction of represented realities, audiences are invited to engage self-reflexively with the works' technical and technological processes of construction. Furthermore, the (neo-)baroque constructs spectacles that strategically make ambiguous the boundaries that distinguish reality from illusion.

The (neo-)baroque complicates classical spatial relations through the suggestion of the collapse of the representational frame. Rather than relying on static, stable viewpoints controlled and enclosed by the limits of the frame, the (neo-)baroque highlights the theatrical, spatially invasive nature of representation, dynamically engaging the audience in what Deleuze has characterized as "architectures of vision." He suggests (via Michel Serres) that the baroque offers architectures of vision that situate the viewer in a spatial relationship to the representation (1993, 21). Rather than providing a statically ordered perspectival arrangement, the center continually shifts, the result being the articulation of complex spatial conditions.

The spatial attitude to vision required of (neo-)baroque spectacle instigates participatory spectatorial positions through dynamic compositional arrangements. With borders continually being rewritten, (neo-)baroque vision provides sensorial models of perception that suggest representational worlds that lose the sense of one center. Rather, the center is now to be found in the position of the spectator. Given that (neo-)baroque spectacle provides polycentricity and multiple shifting centers, the spectator, in a sense, is the only element in the image/viewer scenario that remains cen-

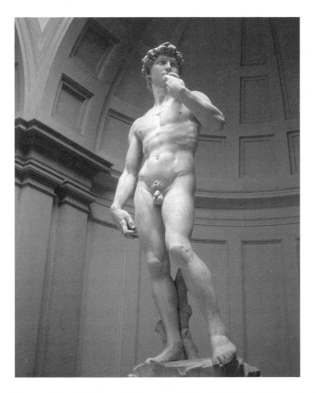

Figure 4.1 Michelangelo Buonarroti, *David*, Galleria dell'Accademia, Florence (1501–1504). By permission of The Art Archive/Galleria dell'Accademia Florence/Dagli Orti.

tered and stable. The audience's perception of and active engagement with the image orders the illusion.

A comparison of Michelangelo's *David* (figure 4.1) (1501–1504) with Bernini's sculpture of *David* (figure 4.2) (1623–1624) highlights the distinction between classical and baroque attitudes to point of view and perception. In Bernini's *David*, the sculptural narrative as self-contained piece dependent on a single, immobile viewpoint is transformed into a narrative that changes as a result of its three-dimensional capacity to engage the spectator actively in spatial terms. The Renaissance ideal of a perspectivally guided narrative representation is replaced by a baroque concern with complex, dynamic motion and multiple perspectives dependent on the position of the viewer in relation to the work. The spectator's view of Michelangelo's *David* is reliant on a frontal viewpoint that stresses David's contemplation of the arrival of his enemy

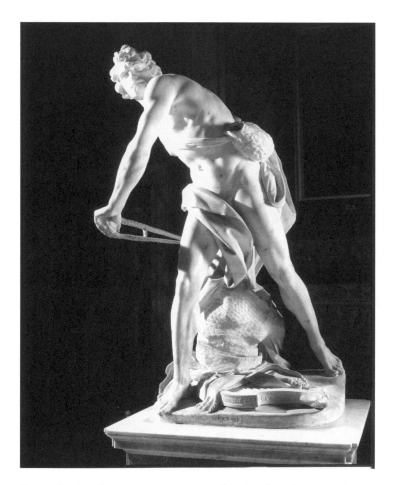

Figure 4.2 Gian Lorenzo Bernini, *David*, Galleria Borghese, Rome (1622–1624). By permission of The Art Archive/Galleria Borghese Rome/Dagli Orti.

Goliath. The impact and meaning of Bernini's *David*, however, depends on the interaction and combination of multiple, shifting viewpoints and narrative perspectives. The primary narrative action chosen—the point prior to David's release of his slingshot and stone to kill Goliath—and the formal means chosen to depict this action invite the spectator, through dynamism, to move around the statue, following the swerve of David's body. As Hibbard states, "the single twisting figure necessarily introduces a number of subordinate views" (1965, 55). As a result, other narrative perspectives are revealed that depend on the spatial relationship between the viewer and the sculpture.

For example, the intense concentration on David's face can be experienced fully only when the work is viewed from the left. From this perspective, the narrative focus is on the emotional climax to David's actions. Likewise, the stone about to be unleashed cannot be seen until the spectator moves to a frontal view, and from the right side, David's body becomes the focal point of the viewer's observation. From this perspective, neither the slingshot nor the intensity of facial expression are discernible. The result, in this instance, is that the sculpture elicits curiosity in the viewer, as he or she wonders what is happening. In this seventeenth-century sculpture, alternative perspectives emerge from the spatial relocation of the viewer in a way that reinforces Deleuze's articulation of the architectural dimension of sight: The revelation of David's actions requires our physical movement through the space that the *David* inhabits.

Like its baroque counterpart, neo-baroque spectacle articulates this experience of the architectural dimension through numerous methods. During my first viewing of *The Matrix* (Andy and Larry Wachowski 1999), for example, I found my senses bombarded by imagery, movements, and sounds that plunged me into a state of disorientation and overstimulation. Not only was an array of framing effects and camera movements employed (from high-velocity pans, tracks, and fast-paced edits to 360-degree camera somersaults), but there was motion, and there was lots of it! Bodies, cameras, sound, and visual effects—everything moved and moved fast (figure 4.3). Like so many contemporary action extravaganzas, *The Matrix* reflects a concern with the kinesthetic that once primarily belonged more exclusively to the realm of the theme park attraction. Rather than vision's remaining focused on specific sections of the screen, the speed of the images, and the accompanying sounds that animated these images, invited my eyes to scan the screen restlessly in its entirety, speedily searching for significant details that might appear and vanish before my eyes had captured them.

The spatial dimension of sight (and its accompanying shifting viewpoints) is manifested in movies not only in the action of scanning *across* the screen surface. Increasingly, science fiction films indulge in creating the perception of a spatial invasion into the (illusionistic) depth of the screen. Two recent examples suggest the extent to which this architecture of vision has become ingrained in Hollywood effects cinema, primarily as a result of computer-generated special effects. The opening scene of *Contact* (Zemeckis 1997) literally (at least in visual terms) makes the spectator become lost in space. Computer effects create the illusion of the longest zoom-out shot in the history of the cinema as the camera appears to travel ever outward through infinite space, continually relocating its center, from planet to planet, solar system to solar

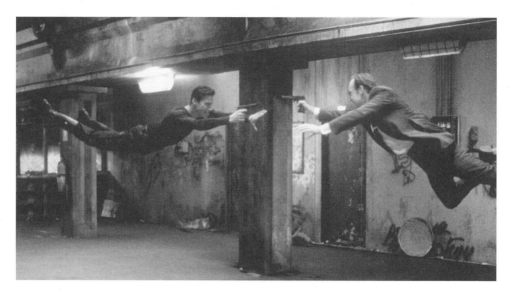

Figure 4.3 One of the many kinetically charged scenes from *The Matrix* (1999). By permission of The Kobal Collection.

system. This journey through the universe finally reveals its deceptiveness when the camera zooms out to reveal a human eye. The apparent vision of outer space is finally exposed as that of a character's inner space. In both instances, however, the concern with the infinite in retained. *Event Horizon* (Anderson 1997) again plunges the audience's vision into an infinite zoom-out. In one sequence, the camera (or the computer effect mimicking a camera motion) centers on the view of a figure through a window. The figure seems to be hanging upside down, but as the camera pulls out, it also rotates and recenters the spectator's view to one that encompasses a larger view of a space station that includes additional figures seen through windows and situated at angles different from that of the original figure. Again, the camera zooms out, and as it rotates, provides an even longer shot of the station. So it continues, until this dizzying architecture of vision reveals the massive polycentric and labyrinthine structure that is the space station, which is itself situated within a boundless space. All the while, it is the spectator's perspective, or more precisely, the spectator's sensorial engagement that becomes integral to the success of these cinematic spectacles.

According to Martin Jay and Christine Buci-Glucksman, baroque form is often associated with a delight in visual spectacle.[2] The baroque order calls upon systems of

the classical, as embodied, in particular, by the tradition of Renaissance perspective, to overturn, investigate, or complicate their rational, self-contained visual and narrative spaces. Above all, the baroque spectacle contests classical notions of "realism," opting instead for a redefined representational reality, one driven by an enigma that opens up a space of ambiguity rather than mastered clarity. Both the classical and the redefined realities offer systems that present the spectator with alternate versions of represented realities, although (extending on Jay's and Buci-Glucksman's perceptions of the baroque as an inherently visual order), as I will argue below, the neo-baroque also relies on the auditory equivalent of spectacle. In fact, in recent years, entertainment media such as theme park attractions have called into play all the senses in their efforts to create their technologically new immersive spaces. Not only does the inherent audio-visuality of entertainment structures create common ground for contemporary entertainment, allowing for the serial flow of images across media and across a global level of distribution, but audio technology also advances the spatial possibilities of the neo-baroque obsession with collapsing the representational frame.

Art history has understood the classicism of Renaissance art of the fifteenth and sixteenth centuries in relation to its reliance on the representational frame, whereby the observer is provided with a view into a parallel reality that does not acknowledge the presence of the spectator in the world in front of the frame. In his influential *Della Pittura* of 1435, Leon Battista Alberti outlined the Renaissance system's capacity to "rationalize vision through mathematics"; the mathematical clarity of the 'one point perspective' was employed to "produce the illusion of a three-dimensional world on a two-dimensional surface" (Ackerman 1991, 60). The spectator looks at this space, which effaces its construction through rational means, as if looking through a window or frame beyond which another world exists, oblivious of its voyeuristic observer.

As Damisch has argued, however, one of the most "imprecise definitions . . . [and] crude simplifications, not to mention . . . outright errors and misunderstandings" is that which perceives the one-point system of perspective (which functions to "contain" its representation within the frame) as unproblematically reproducing the dominant ideology of the "bourgeois" system (1994, xiv). He especially points the finger at the discipline of cinema studies, which drew upon painting traditions and transferred the metaphor of the enframed representational space to the cinema.[3] The camera now served the function of "framing," projecting onto the screen a world that (through one-point perspective) also reproduced dominant ideologies. Damisch states that "[t]he assertion that the camera, by its very structure, exudes ideology can lead to two

disparate interpretations. It is one thing to regard it, its mechanics, as an ideological contrivance. It is quite another to claim that it is such because it is regulated by the perspectival 'code' and, through this, by an acquired ideology" (1994, xv).

To quote Damisch, "This debate is now an old story" (xv), especially when considered in relation to interpretations of class and ideology as they are represented in Hollywood cinema. Expanding on a model first applied to Hollywood cinema by André Bazin (1967, 29),[4] in the seminal study *The Classical Hollywood Cinema* (1985) Bordwell, Staiger, and Thompson defined pre-1960s Hollywood cinema according to classical forms related to the Renaissance model. Classical aesthetic norms dominated the industry of this period, norms that reflect a closed attitude to form through centered framing, narrative progression, and resolution, a visual and auditory style that remains at the service of narrative unity and a refusal to exceed the purposes required of story action (1985, 384–386). The causal narrative structure and centered compositions create the effect of an enclosed story world, one that rationally frames a visual, auditory, and narrative representation that the spectator passively observes. Combining Renaissance art's reliance on one-point perspective with the more powerful mimetic system of photographic realism, classical Hollywood cinema has been viewed as producing a representational space that attempts to be transparent, "like a window onto the real" (Docker 1994, 65). Writers such as Laura Mulvey, Stephen Heath, Colin MacCabe, and Kaja Silverman have developed this formal and spectatorial observation further from an ideological perspective.[5] The historical development of the theoretical tradition these writers represent is, by now, well rehearsed, and the question of whether the spectator of classical cinema remains unaware of the status of representation as representation is a highly problematic issue of debate that I do not intend to rehearse further.[6] That which *is* significant for the purpose of the immediate analysis is the fact that classical form favored a framing device that remained intact.

Embracing the classical, the (neo-)baroque often draws attention to the framing device to reflexively complicate or reject its function. The convention of frame or window onto which a parallel reality is painted or projected is taken to extreme, and the representational reality no longer seeks to frame a world of resemblance. Rather, the (neo-)baroque is intent on simultaneously blurring and drawing attention to the frame that separates reality from representation. Drawing on advances in optics, the technical bravura of the *quadratura* and trompe l'oeil seventeenth-century tradition and the technological bravura of computer-generated effects (especially as witnessed in science fiction cinema) seek to invade the space of the audience with illusions that are best characterized as representational spaces. Through this complication of the rela-

tionship between reality and representation, a (neo-)baroque ambivalence emerges. The baroque and neo-baroque create the illusion of the merging of an artificial reality into the phenomenological space of the audience while simultaneously inviting the spectator to recognize this deception to marvel at the methods employed to construct it.

Discussing the shift from a Renaissance to a baroque order, Foucault states that during the seventeenth-century baroque,

> thought ceases to move in the element of resemblance. . . . The age of resemblance is drawing to a close. It is leaving nothing behind it but games. Games whose powers of enchantment grow out of a new kinship between resemblance and illusion; the chimeras of similitude loom up on all sides, but they are recognized as chimeras; it is the privileged age of trompe l'oeil painting, of comic illusion, of the play that duplicates itself by representing another play, of the quid pro quo, of dreams and visions; it is the age of deceiving the senses . . . the restrictive figures of similitude were to be forgotten. And the signs that designated them were to be thought of as the fantasies and charms of a knowledge that had not yet attained the age of reason. (1986, 51)

Like that of the baroque, the illusion of neo-baroque spectacle is not concerned with similitude and the reproduction of a parallel reality: a window that looks onto another world that is like our own. As Tuve has explained, for the seventeenth-century artist, "imitation" was not about the relationship between art and reality; the issue of representation was not significant in the sense of art's capacity to reproduce material reality (1947, 13). Rather, imitation and representation evoked alternate "realities" that reflected the ability of the image to capture a "sense impression" or to "reproduce the emotions." As will be outlined further in the following chapter, in the (neo-)baroque, existing reality is devalued in favor of an effects space that postpones the narrative and instead invokes the experience of transcendence or heightened emotions. To "represent" does not mean to "stand for the reality or concept behind" (Tuve 1947, 12); its ultimate concern is with the abstract nature of the senses, for those "single moments of consciousness" (Tuve 1947, 14) and experiences that are "seized and carefully represented for their own interestingness" (Tuve 1947, 14). (Neo-)baroque spectacle conjures "chimeras" that deceive the senses in playful ways that ask, eventually, to be recognized as chimeras. An awareness of the construction of the illusionistic deception is often one of the *conditions* of audience/spectacle relations in the (neo)baroque. Crucial to an understanding of the aesthetic differences between the classical and the baroque, therefore, is a grasp of the way each formal

system depicts and defines its represented reality and, in turn, relates this reality to the spectator.

The Quadratura Spectacle of S. Ignazio and the Digital Spectacle of Jurassic Park

Andrea Pozzo's *quadratura* ceiling decoration for the Church of S. Ignazio in Rome, completed between 1691 and 1694, and Steven Spielberg's *Jurassic Park* of 1993 convey the idea of the (neo-)baroque fold that weaves its way between malleable borders, revealing the open rapport that exists between spectator and spectacle, between media, between disciplines, between eras. Both of these works invite the spectator to test the nature of his or her own reality through the works' construction of alternative realities that actively invade real space. The concern in both is with a (neo-)baroque interplay between an illusionistic representation and reality that appear to meld into one another. Driving the various dimensions of the optic fold are virtuoso displays.

Andrea Pozzo's ceiling painting on the nave vault of S. Ignazio, *The Glory of S. Ignazio* (figure 4.4), brings to a dramatic crescendo baroque concerns with collapsing the boundary between illusion and reality, fictive space and real space, architecture and painting, spectator and spectacle. Using one-point perspective, the architectural framework illusionistically extends the nave toward the heavens, which are inhabited by Saint Ignatius of Loyola, an integral figure in the founding of the Society of Jesus. The actual architecture of the church vault appears to rupture and extend itself infinitely into the heavens, while S. Ignazio floats on a cloud above the head of the viewer. Architecture folds into painting, which, in turn, appears to dissolve the solidity of the church vault, replacing it instead with ethereal, spiritual apparitions. Wittkower has argued that "[w]hat distinguishes the Baroque from earlier periods . . . is that the beholder is stimulated to participate actively in the supra-natural manifestations of the mystical art rather than to look at it 'from outside'" (Wittkower 1985, 139). What emerges through *quadratura* and trompe l'oeil effects is an architectural sense of engaging the spectator in the illusionistic construction of the experience of an infinite, other-worldly space. The focus is on dynamism and active audience involvement that encourages movement and therefore provides an alternate attitude to classically oriented models.

A comparison with Raphael's *School of Athens* (1509–1511) (figure 4.5), a paradigm of High Renaissance art, effectively conveys the difference in spectator responses.[7]

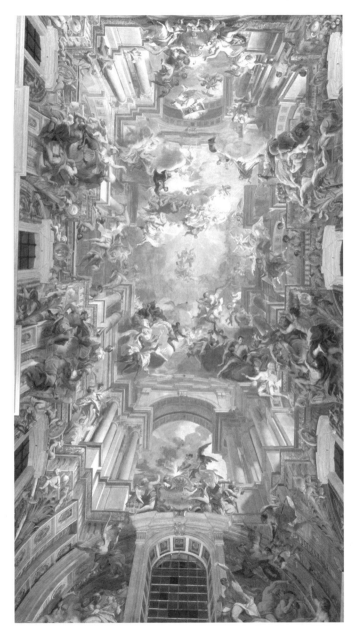

Figure 4.4 Andrea Pozzo, *The Glory of S. Ignazio*, Church of S. Ignazio, Rome, 1691–1694. Copyright Photo Vasari, Rome.

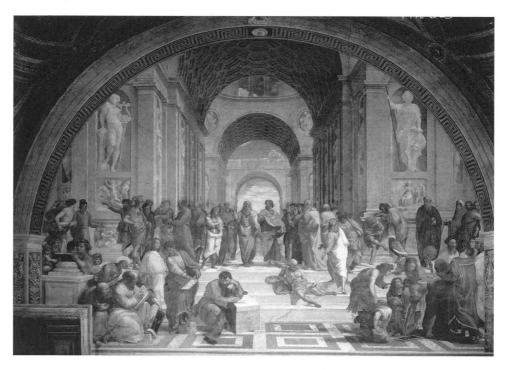

Figure 4.5 Raphael, *The School of Athens* (1509–1511), Stanze della Segnatura, Vatican. By permission of The Art Archive/Vatican Museum Rome/Album/Joseph Martin.

Classical systems are characterized by closure, with the systems' borders functioning as a membrane that allows exterior elements to enter, provided they become part of the system contained by the narrative frame (Calabrese 1992, 66). Closed systems remain centered, ensuring narrative clarity and symmetry of organization. In *School of Athens*, the architectural arrangement recedes into the background, centering the two key figures, Aristotle and Plato, while a series of other philosophers flank them on either side. The fresco is dedicated to philosophy, and although the other philosophers are depicted in unified groups, "each group is tied to the whole by some detail that serves as a hyphen that relates the details, through compositional arrangement" to the central narrative concern focused on the figures of Aristotle and Plato (Murray 1986, 41). Raphael's painting adheres closely to the principles presented in Leon Battista Alberti's treatise *Della Pittura* (1435–1436), in which Alberti stresses the significance of "istoria," a term that carries with it notions of history and story. Reflecting concerns that were some centuries later remanifested in the classical Hollywood para-

digm, Alberti stresses the importance of a centered pictorial composition that supports clarity of narrative presentation. Above all, Alberti emphasizes the need to "avoid excesses" (Spencer 1966, 23).

Open systems, typical of the baroque, permit a greater flow between the inside and outside and operate according to a polycentric logic. Rather than reflecting a classical concern for the static, closed, and centralized, the baroque system is dependent on dynamic forces that expand and often rupture borders (Calabrese 1992, 66). Differentiation, polycentrism, and rhythm are central to neo-baroque storytelling strategies (Calabrese 1992, 44). Whereas Raphael contains his imagery and narrative by framing it within a hemispherical border that rigidly encloses the composition (and the narrative that it contains), Baroque artists like Cortona and Pozzo avoided this by suggesting the redundancy of the frame. The frame is included in the composition so that its limits can be complicated, contested, or escaped. The intent is the production of a dynamic space and open attitude to narrative form, one that aims at and produces a potentially infinite space continuum. Baroque virtuosity is integral to the principle of coextensive space, a space that can appear to extend *both* into the material confines of the two-dimensional surface *and* into the space of the audience.

In this respect Pozzo's work is typical of the baroque. Having written a treatise on perspective that was originally published in Rome as *Perspectiva Pictorum et Architectorum* (1693–1700), Pozzo had, like many artists of the seventeenth century, also put his theories into practice. During the final decades of the seventeenth century, Pozzo became an exponent of the "inviolability of perspectival laws," and his *quadratura* spectacles supported a monofocal system that emphasized a construction of space based on one viewpoint (the repercussions of which are outlined later in this chapter) (Sjöström 1977, 66). Following the *quadratura* tradition, in *The Glory of S. Ignazio*, Pozzo employs the "open-wall principle," which served to destroy illusionistically the space of the real architectural wall by fictively constructing architectural views that extend beyond it (Sjöström 1977, 14–15). In this technical bravura performance, Pozzo takes Renaissance concerns with the laws of perspective to their absolute limit by illusionistically conjuring a space in the vault that appears to puncture solid architecture. The artificially and mathematically generated fictional world of the architectural and heavenly vision appears to extend beyond the vault and lead to infinite heights above. The Renaissance metaphor of a frame or window onto a parallel universe contained and limited by that frame is dissolved, and the parallel reality is now one that illusionistically extends beyond while remaining connected with our own.

On one level, the border that traditionally demarcates a difference between the painting and the real world via a representational frame is broken, and the aim appears to be to invite the viewer to embrace this illusion. But the illusion is not purely concerned with total immersion or the acceptance of this fictive space as a logically ordered representational reality. Sjöström has explained how the effect of the three-dimensionality of *The Glory of S. Ignazio*'s painted architecture achieves its point of greatest impact in the middle of the nave (the "classical" point), which is the point at which the viewer witnesses the *Glory of God*, depicting a God who sends his rays of light down to pierce S. Ignazio. The viewer is also encouraged, however, to traverse the space of the church, and when he or she moves away from the painting's midpoint, a distortion effect is achieved in the fictive architecture and figural arrangement. This perspectival distortion (which is partially due to the physical structure of the vault) severs the smooth transition between illusion and reality (Sjöström 1977, 66). The effect reestablishes the ruptured barrier between representation and reality, producing a "distorted chaos of shapes" (Kemp 1990, 139). The coextensive, three-dimensional space also exposes the two-dimensional surface, with the result that a spatial complexity emerges.[8]

Within the architectural and painting framework of *S. Ignazio*, the viewer is not required to prioritize the center, occupied by the *Glory of God*, as the central or "correct" viewpoint, one aligned with a Renaissance or classical order of vision. The viewer is instead invited to traverse and interact with the architectural representation in far more fluid terms, engaging in the transformation of the three-dimensional into the two-dimensional, and of the two-dimensional into the three-dimensional. In the words of Jay: "Resistant to any totalizing vision from above, the baroque explored what Buci-Glucksman calls 'the madness of vision,'[9] the overloading of the visual apparatus with a surplus of images in a plurality of spatial planes. As a result, it dazzles and distorts rather than presents a clear and tranquil perspective on the truth of the external world" (Jay 1994, 47–48).

For Jay and Buci-Glucksman, the "baroque ocular regime" (as found, especially, in the baroque reliance on perspective and optical technologies such as the camera obscura) subverts the dominant visual order of scientific reason associated with the Renaissance. Grounding his analysis within the historical context of the seventeenth century, John Martin, however, associates baroque spectacle with the scientific advances of the era (Martin 1977, 15). Further examination of the intent of baroque virtuosity resolves the contradiction that emerges when these statements are considered

in tandem: I would suggest that this "madness of vision" is, itself, a symptom of the baroque concern with the scientific.

The painted architectural effect in the fresco of S. Ignazio is concerned with "providing a touch of artistry in the entertainment, a performance given not at the appointed time but at the appointed place" (Sjöström 1977, 22). Central to the principle of coextensive space and the baroque architectural manipulation of space is the artist's ability to display a certain virtuosity. The "illusion has the double aim of first momentarily deceiving the observer and then, after the truth has been revealed, of amusing, surprising and impressing him" (Sjöström 1977, 113). In his perspectival treatise, Pozzo outlines the reasons behind his use of the monofocal system, a system renowned for its failure to sustain the illusion of infinite space when viewed from certain vantage points within the real architectural environment. With regard to his strategic choice of that system, Pozzo states that "the distortions which arise when one moves away from the intended stationpoint should in no way be regarded as errors or disadvantages; on the contrary, they constitute a positive factor.[10] They emphasise the difficulties through which the artist, through his skill has been able to overcome" (in Sjöström 1977, 64). Furthermore, he suggests that "the painter is not obliged to make it appear real when seen from every part . . . far from being a fault, . . . I look on it as an excellency in the work" (Pozzo in Kemp 1990, 139). The "faults" should "evoke admiration for the skill of the artist in making it work at all and should stimulate the spectator's delight in the optical game being undertaken" (Kemp 1990, 332). The spectator, in other words, should recognize the way science has been placed at the service of artistic skill.

The spectator is drawn into an active relationship with the spectacle through his or her participation in a game of vision that is about artistic virtuosity. In the case of Pozzo specifically, the artist reveals not only his capacity for mastering complex mathematical systems that inform the laws of perspective, thus "improving" on the Renaissance tradition that revived these ancient laws, but also his mathematical adeptness in being able to transform this capacity into a form of visual game play. Within this system of virtuosity, total illusionism on its own would have no purpose without being accompanied by the revelation of the constructed nature of the illusion, a critical point to which I will return below.

The baroque concern with technical bravura in Pozzo's S. Ignazio *quadratura* painting becomes, in Spielberg's *Jurassic Park*, a neo-baroque concern with technological bravura. Similar concerns with games of perception are in operation in both Pozzo's

painting and Spielberg's movie. *Jurassic Park* is a film that, through the technological capabilities of computer graphics (rather than the mathematical and scientific advances that affected perspective and *quadratura* illusion), brought to cinematic life the extinct dinosaur. *Jurassic Park* introduced changes to special-effects technology that marked a further revolution in the post-1970s Hollywood film industry. As a result of *Jurassic Park*'s success—both as a film and with regard to the film's technology—the old matte painting department at Industrial Light & Magic has been replaced by computer hardware and painting software. Old motion control cameras have been superseded by computer graphics workstations, and the optical-printing department has been almost entirely supplanted by scanners and digital systems. *Jurassic Park*'s effects advances "allowed filmmakers to produce seamless invisible effects that ranged from the creation of synthetic (or "virtual") sets to the replication of a dozen extras into a cast of hundreds" (Cotta Vaz 1996, 239).

As an example of science fiction effects films of the last decade, *Jurassic Park* is but one of many films that are the culmination of changes introduced into the industry in the 1970s as a result of the incorporation of digital technologies into the cinema. In particular, the computer graphics effects employed in the film serve a central role in the film's narrative structure. The plot deals with the construction of a theme park presenting dinosaurs that have been genetically engineered and brought back to life to entertain park visitors. In many respects, it is not the genetically engineered dinosaurs of the film's diegesis, but the computer engineered dinosaur effects (figure 4.6), that are the film's primary attraction. Through such effects, Spielberg orchestrates a complex scenario around the play between reality and illusion, engaging the spectator in a game of perception that is also about an understood *deception*: a revelation of chimeras.

In one of the many suspense-filled scenes dominated by one of the aforementioned dinosaurs, a *Tyrannosaurus rex*, Dr. Sattler (Laura Dern), Dr. Malcolm (Jeff Goldblum), and Jurassic Park's resident safari hunter Muldoon (Bob Peck) escape from the tyrannosaurus in a jeep (figure 4.7). At one stage during the chase, one of the characters looks in the rearview mirror, and the image of the tyrannosaurus that is reflected gives the impression that it is moving toward its intended prey at breakneck speed. In the excitement of the hunt, however, the audience is given only a few seconds to notice a particular detail (one common to many new cars)—a line of text on the mirror reading: "Objects in mirror are closer than they appear." This detail is extraneous to the film's concerns, and the text is not meant for anyone within the narrative space,

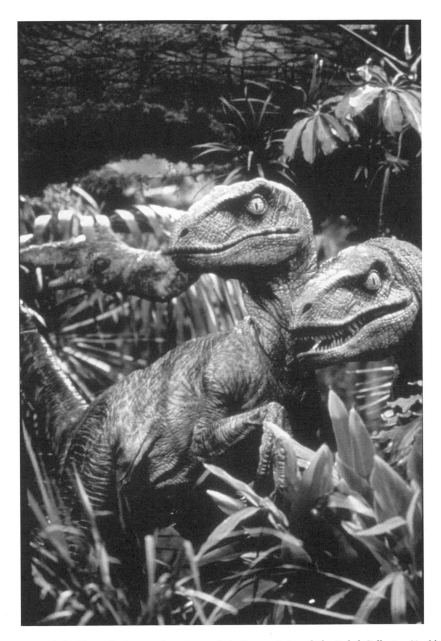

Figure 4.6 Two velociraptors from *Jurassic Park*. By permission of The Kobal Collection/Amblin/Universal.

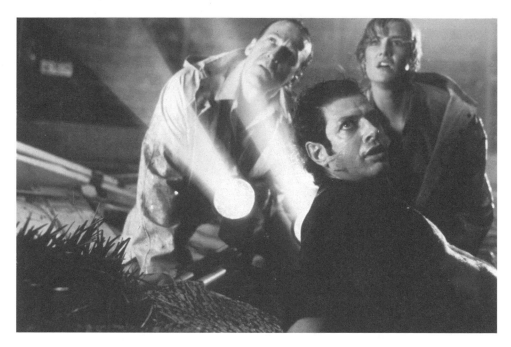

Figure 4.7 Dr. Malcolm and his colleagues ready themselves for the oncoming attack from the *T. rex* in Spielberg's *Jurassic Park*. By permission of The Kobal Collection/Amblin/Universal.

Instead it is a play on words that addresses us, the audience. The words say, "Objects in mirror are closer than they appear," but in fact, the opposite is true. The computer graphics have constructed such a convincing tyrannosaurus that, in conjunction with the editing, acting, sound effects, and special effects, the suspense heightens to a point at which, for the audience, the tyrannosaurus *appears* to be closer than it is. This proximity is but an illusion, and these words become a sort of in-joke that speaks of a cinema that lures us into embracing its representation of a simulated, fantastic illusion *as* reality. This point is further highlighted in the way the screaming survivors in the jeep actually reflect the real audience's horrified response as it watches this cinematic simulation.

The mirroring effect takes on an additional layer when the audience considers that the "real" actors within the set were also responding to an object in their presence that was not actually there: namely, a computer-generated dinosaur that existed in a different type of reality than that of the space on the set occupied by the actors. While one is captivated by the seductive motions of spectacle and special effects, this fact is

easy to forget. The eventual moment of recognition, however, speaks of the message delivered in the mirror, a message that asks the audience to marvel at the methods employed to construct this technical extravaganza that gives an impression of closeness to something that is actually not even there.[11]

Stephen Prince suggests that the fundamental paradox of digitally dependent cinema is its ability to create "credible photographic images of things which cannot be photographed." Computer images challenge traditional film theory's grounding in a model of realism. Realism in the cinema has been tied to "concepts of indexicality," with film viewed in photographic terms (1996, 28). Computer-generated images force a reevaluation of this tradition in that they have no profilmic referent or source of origin in the real world. With respect to such computer-generated images as the dinosaurs in *Jurassic Park*, the morphed creatures in *Terminator 2* and *Terminator 2: 3D*, and the alien bugs in *Starship Troopers*, "no profilmic event exists to ground the indexicality of its image" (Prince 1996, 29). Contemporary entertainment media open up a new relationship between the spectator and the entertainment image. In light of the transition to digital, Prince suggests that film theory itself must undergo a metamorphosis, one that accounts for and responds to digital imagery and addresses the increased obfuscation of the barriers that separate reality from illusion. More importantly, he suggests that film theory "has construed realism solely as a matter of reference rather than as a matter of perception as well" (28), and given this stage in the cinema, when "unreal images have never before seemed so real" (34), this position, he argues, needs to be reevaluated:

> Before we can subject digitally animated cinema and processed images, like the velociraptors stalking the children through the kitchens of *Jurassic Park*, to extended meta-critiques of their discursive or ideological inflections [and these critiques are necessary], we first need to develop a precise understanding of how these images work in securing for the viewer a perceptually valid experience which may even invoke . . . now historically superseded assumptions about indexical referencing as the basis of credibility that photographic images seem to possess. (36)

Film theory fails to account for the paradox that, although images may be *perceptually* realistic, they are *referentially* unreal (Prince 1996, 36). A great many contemporary science fiction films playfully allude to and depend on this paradox, a paradox steeped in a neo-baroque logic. Since the beginning of the film era, cinematic technology has aimed at producing perceptually convincing environments. Like their animated cousins, Bugs Bunny, Snow White, and the digitally produced Buzz Lightyear, the

dinosaurs in *Jurassic Park* have no analogous basis in our reality. The difference between the dinosaurs and their animated cousins, however, emerges in the way the animated dinosaurs *appear* convincingly to inhabit the fictional "reality" that the humans of *Jurassic Park* also inhabit. In a variety of different ways, many contemporary films and related entertainment media perform games of vision around this notion of constituting illusions as convincing alternate realities that move us. To recall Tuve, the chimeric allure of these "imitations" lies in their ability to affect our emotions and senses, in the process often overpowering our powers of cognition.

These games flaunt film's capacity for seeming to make a reality out of an illusion and for leaving the audience in a state of awe in light of the cinema's ability to present visually and aurally constructions that have no parallel basis in the real world, yet to confront us temporarily with the possibility that the cinematic *T. rex* will escape the limits of the screen and rage toward us in the space of the cinema. In this instance, the coextensive space is achieved through mathematics and the laws of perspective as applied to the virtual realm of the computer, which, like the S. Ignazio Ceiling, make the audience aware of the "distortion" that redirects the audience's perception to the two-dimensional plane that is the film screen. Neo-baroque virtuosity manifests itself again, operating in conjunction with the spectacle. In a way that parallels the syntactic avenues open to baroque seriality and intertextuality, the viewer who has noticed the text in the mirror may follow an alternative path to the one provided by the narrative action, a path that leads to the film's digital production.

Viewers of *Jurassic Park* find themselves immersed in ambiguous relationships with regard to the technologically produced spectacle similar to those evoked by the technical mastery informing the S. Ignazio Ceiling. Crucial to these relationships is the recognition that the construction of the convincing on-screen illusion is a performance that lures the audience into a game of perception, a game that invites the audience to marvel at the realistic portrayal of living, breathing screen dinosaurs. Hayward and Wollen have suggested that the "development of audiovisual technologies has been driven not so much by a realist project as by an *illusionary* one" (1993, 2)—in this instance, the illusion of dinosaurs that appear to be phenomenologically "real" *within* the narrative space of the film. Contemporary effects films like *Jurassic Park* center their games of vision precisely on this notion of making illusions into realities in ways that recall Pozzo's dynamic structure. Within the (neo-)baroque system, however, total illusionism has no purpose if not accompanied by the revelation of the constructed nature of the illusion. The S. Ignazio fresco and *Jurassic Park* aesthetically reflect their respective eras' concerns with new perceptions.

Significantly, the virtuosity evident in *Jurassic Park* and the S. Ignazio Ceiling relies on the same aesthetic of repetition and variation that makes its presence felt in (neo-)baroque attitudes to intertextuality. In the case of (neo-)baroque effects, however, "perfection" is targeted through technological rather than artistic means. Virtuosity, claims Calabrese, is found in flight from a central organizing principle. It shifts away from a "closely knit network of rules towards a vast polycentric combination and system based on transformations" (Calabrese 1992, 40). Each technologically produced illusion of reality attempts to outdo its predecessor. Depending on connections with examples that have preceded it, each variation introduced expands the boundaries of spectacle production, redefining predecessors' efforts and claiming new territories in illusionistic effects. In this respect, the recognition of the virtuoso performance also requires an understanding of the technological virtuosity underlying the artistry.

Optics, Virtuosity, and Seventeenth-Century Illusionistic Ceiling Paintings

The "art of spectacle," which in the seventeenth century had not yet come to be seen as a tainted form, was "an art which did not pretend to anything beyond pure spectacle and pleasure . . . it was precisely this love of illusion, of the pleasure of surprise, of enchantment, coupled with a blurring of the distinction between illusion and reality, which was essentially baroque" (Saisselin 1992, 46). The seventeenth-century baroque era gave voice to the association of art with pleasure, divertissement, and entertainment. Whereas the eighteenth-century Enlightenment viewed art as an aesthetic distinct from luxury and pleasure (luxury being seen as a symptom of corrupt society), according to a baroque ocular regime, the aesthetic lay precisely in luxury and pleasure communicated by art (Saisselin 1992, 21, 27).[12]

Although they stand primarily as monuments to their patrons, baroque ceiling paintings were also monuments to spectacle itself, and in particular, to spectacle as emblematic of the magnificence of the artist who can evoke such wonders through illusionistic means. Each new example that entered the array of illusionistic conventions competed with and was intent upon "improving" the spectacular capabilities of its predecessors. The technical virtuosity of seventeenth-century spectacle is related, in part, to advances in optics that resulted in radically new perceptions of reality. In their technical bravura, seventeenth-century illusionistic ceiling decorations stand out as icons of the baroque that showcase the century's fascination with optics through deceptive illusions. Like the new sciences, these grand-scale illusionistic

ceiling paintings pushed to new limits the illusions of represented realities that the painting medium, mathematics, and technological machinery (including cameras obscuras and perspective machines) were capable of constructing or revealing. The visual delight in spectacle that was found in painting, theater, and the construction of public and private buildings was linked specifically to a transformed social infrastructure, one in which new media and technologies flourished with new confidence. Fleming has argued that the machine is what distinguishes modern civilization from all others, and it was during the baroque era that individuals began thinking in terms of machines and mechanical aspects of motion and vision (1946, 121–122).

Assuming that certain cultures are ocular-centric (Jay 1994, 3), then both the seventeenth and the late twentieth and twenty-first centuries are like-minded in that they are dominated by new optical developments that promote and unveil new perceptions of reality to such an extent that they have radical philosophical and phenomenological ramifications. Scientific and technological advances in optics merge with the arts in ways that test prior conceptions of "reality" from philosophical, artistic, scientific, and mathematical perspectives. The seventeenth-century baroque's fascination with the operations of the eye was revealed in numerous ways.

No other era prior to the seventeenth century had witnessed a comparable proliferation of scientific and philosophical writings about vision and optics. Some of the most influential seventeenth-century texts in this area were written by Giovanni Battista della Porta, Galileo Galilei, René Descartes, Athanasius Kircher, Jean-François Niceron, John Locke, and Isaac Newton.[13] In addition, as Stafford has explained, multiple optical machines were developed, ranging from the scientific to the entertaining and often both simultaneously (1994, 2001). For example, Athanasius Kircher's famous museum in Rome housed numerous "marvelous toys" that revealed the instructive possibilities of optics, hydraulics, automation, and acoustics through entertaining methods of display (Stafford 1994, 39). In turn, as in Pozzo's S. Ignazio ceiling, the "art of visual illusion" was displayed in Kircher's museum so that the rational, scientific principles behind it could eventually be unveiled (Stafford 1994, 45). Kircher's *wunderkammer* became an attraction throughout Europe, drawing scholars and royalty through its doors. Not only did the collection, because of its encyclopedic nature, include the works of philosophers, scientists, and scholars past and present, but as Kircher claimed, within the collection's space, reputations could be made. As Findlen explains, "Writing to Duke August . . . in 1659, Kircher affirmed that 'my Gallery or Museum is visited by all the nations of the world and a prince cannot become better known "in this theater of the world" than have his likeness herein'" (1995, 641).[14]

This "theater" became known as a virtuoso performance par excellence, because its microcosm included wonders of nature from all over the world, the scientific and technological wonders of "man," and the artificially conjured illusions of painters. As orchestrator of the contents of this space, Kircher became a virtuoso who inspired awe. Like other collectors of the era, virtuosos like Kircher became famous for displaying the rationality of science through the wonder of human artifice.

In the catalogue to Kircher's museum (figure 3.11), *Musaeum Kircherianum*, published in 1709 after Kircher's death, Philippo Bonanni provided descriptions of some of the automata housed there, like the following:

> Another small machine placed on the table attracts no less amusement for the eyes than for the ears: it is a Monkey dressed in the uniform of a Drummer boy. When you lightly touch a small toothed iron key placed on its side, the little machine seems to suddenly go into a rage, and starts to beat the little drum with all its might, striking with great precision the rhythm of beats usually used to incite soldiers to battle. In the meantime, it rolls its head, moves its eyes all around and, opening its mouth, shows its teeth ready to bite. (quoted in Hanafi 2000, 78)

Bonnani goes on to explain that the "affect it provokes is only mock terror," reflecting a concern with using "entertaining machines for the purposes of scientific demonstrations" (quoted in Hanafi 2000, 79). Machines that generate illusions and deceptions were typical of the seventeenth century, and although twentieth-century historians like Jurgis Baltrusaitis[15] understand the "intersection of exact science and depraved, fairy visions" as contradictory, no such contradictions were apparent to the seventeenth-century creator or viewer (Hanafi 2000, 75).[15] As in the vision on the S. Ignazio Ceiling, the fantastic becomes a vehicle for displaying technical, technological, and scientific virtuosity.

According to Walter Houghton, the virtuoso stops at the point where the "genuine scientist" begins: "The virtuoso sensibility found satisfaction in mechanics at the moment of history when its achievements were still sufficiently unfamiliar, in fact and theory, to retain the aura of magic" (1942, 203–204). In the case of baroque and neobaroque spectacle, an ambivalence is set in place: Virtuosity thrives in the spectator's delight, wonder, and admiration for the strange and incredible, a strange and incredible dependent upon the scientific and the technological (193). Houghton views this appetite for states of wonder as existing in transitional periods such as the seventeenth century. Special effects, especially those evoked in the science fiction film genre, similarly invoke advances in computer and other effects technology while also retaining

"the aura of magic": The "required action of wonder is produced not merely by inge-
nuity, but by the mystery that shrouds the creation of the machine or its action. The
effect is magical" (199).

Stafford explains that "the automaton was the machine as virtuoso. . . . Its anthro-
pomorphic physiology of concealed pipes and pulsating liquids established a metaphor-
ical connection between animated artifice and live audience" (1994, 121). For the
audience, the virtuosity of the automaton manifested itself in the ways it appeared to
animate its own form, but ultimately, the spectator was required to acknowledge the
true virtuoso: the designer of the mechanical wonder, who was the "dazzling producer
of incantatory effects that magically captivated and controlled others by their showi-
ness" (121). The machine as virtuoso was therefore eventually exposed as the creation
of human virtuosity. Above all, this entertaining visual wonder provided insight into
the laws of mathematics and their application (Bredekamp 1995, 48). The automaton,
a creation to which I will return to in the final chapter, was but one of many enter-
taining devices that, through wonder, promoted science.

Optical machines such as the magic lantern and the anamorphic lens, which were
common displays in collections like Kircher's, were used to exploit the deceptive and
fantastic possibilities of perception. Dominant belief systems were rocked, and ad-
vances in optical technologies merely supported the belief that nothing was as it
appeared to be on the surface. As explained in the previous chapter, the telescope
made the previously inaccessible and distant visible. The microscope made the minus-
cule perceptible to human vision. The panorama added a new scope and movement to
sight. New boundaries were drawn, boundaries that offered what appeared to be fan-
tastic revisions of prior perceptions of the universe and humanity's place in it, and the
advances in science, mathematics, and technology had a dramatic impact on the aes-
thetics of the period. Stafford explains that the "destabilized world order ushered in by
the New Science" compromised and undermined prior knowledge systems: "The
earth, apparently, was a mere speck of dust whirling in an immensity. The telescope
and microscope probed untold galaxies filled with a chaos of competing particles that
the viewer had to labor to reconcile. The ever-expanding solar system gradually
inspired humanity both to think about life on other planets and to question prevailing
concepts of the unity of God, man, and the universe" (2001, 5).

Expanding further, Stafford draws parallels with our own times and our own para-
digm shifts: Cyberspace and virtual reality also "require us to remap the relationship
between synthetic worlds and the holistic sphere of our body" (5).

Contemporary society tends to understand works of art as distinct from technolog-ical inventions, but the neo-baroque reiterates the importance of "[u]nderstanding that instruments belong to a broader technological system and are integral to connective theories and practices of visual communication. . . . [This] allows us to situate them within more inclusive endeavors where art and science do not so much rival each other as intermingle and branch" (Stafford 2001, 1).[16] Significantly, the themes of vastness, spectacle, and alternate worlds of wonder that we discover in the media of both periods reflect strongly these transforming cultural, scientific and technological conditions.

One of the optical inventions that was especially influential for northern artists was the camera obscura, which allowed light to pass through a lens and reflect the image being captured on a flat surface. The camera obscura betrayed an "ambition to invent a machine that could perfectly reproduce nature" (Kemp 1990, 167).[17] The scientist Johannes Kepler, in fact, understood the eye as operating according to the mechanics of the camera obscura: Human vision and machine collapsed into one an-other in perfect unison (Kemp 1990, 167).[18] The seventeenth-century concern with optics and optical machines such as the camera obscura, the perspectograph, the pan-tograph, the camera lucida, and the anamorphic lens reveals a fascination with the reproduction of convincing alternative realities, or with the revelation of previously imperceptible realities. Seventeenth-century perspective machines, which included Cigoli's perspectograph and Scheiner's pantograph, made possible the transfer of objects from the "real world" onto a two-dimensional picture plane while giving the impression of three-dimensionality. Thus, mathematically driven optical machines allowed for the presentation of a representational world in convincingly realistic terms. The seventeenth-century fascination with optical devices, which were used as tools for painting but were also instruments of entertainment and curiosity in their own right, informed the format of the dioramas, panoramas, and phantasmagoria of later centuries, all of which have been noted as ancestors of the cinema.[19]

In addition to optical devices, mathematics (especially mastering and surpassing mathematics as outlined in ancient Greek and Latin texts) was central to the seventeenth-century scientific revolution and became an equally essential tool for the representational arts. It played a crucial role in the new sciences and was especially important in the development of three-dimensional geometry, which had a great impact on the way the seventeenth-century artist embraced geometrical perspective. Although the Renaissance nourished the rise of the mathematical laws of perspective,

it was baroque artists who, in the context of the scientific revolution, explored and exploited the illusionistic potential of perspectively arranged pictorial spaces. In the seventeenth century, numerous artists published treatises on the use of perspective in art including Cigoli's *Prospettiva Pratica* (Practical Perspective) of the early 1600s, Pietro Accolti's *Lo Inganno de gl'occhi*, *Prospettiva Pratica* (The Deception of the Eye, Practical Perspective) of 1625, and Andrea Pozzo's *Perspectiva Pictorum et Architectorum* (Pictorial and Architectural Perspective) of 1693–1700. The Renaissance established the importance of an artist's mastering the "science of art" (Kemp 1990), but it was in the seventeenth century that this mastery reached an obsessive peak.

The principles of mathematics, especially as applied to geometry and perspective, became an important means of understanding and "seeing" the suddenly expanded universe and for exploring the properties of space within the realms of science and art. In his *Astronomia Nova* (1609), the *Rudolphine Tables* (1617), and *Epitome Astronomiae Copernicanae* (1621), Kepler advanced Galileo's assertion that the universe was governed by a heliocentric logic, and through mathematics, proved that planets do not have circular orbits but circle the sun in elliptical motions (Easlea 1980, 72–73). In *Principia Mathematica* (1687) Isaac Newton outlined his three laws of motion[20] and calculated the gravitational properties of the universe, confirming that "falling stones and the moon are constantly accelerating towards the centre of the earth in the same way that each planet (including the earth) is constantly accelerating towards the sun" (Easlea 1980, 162–167).

The crucial function served by the mathematical principles of perspective in *quadratura* painting was closely linked to advances in the new sciences. As outlined in the previous chapter, Galileo's experiments with the telescope and his study of the solar system were to have ramifications of grand proportions, resulting in a new perception of the universe "into realms of expanse and minuteness inaccessible to scientists of classical antiquity" (Kemp 1990, 167). Galileo's experiments gave scientific credence to Copernicus's assertion that the cosmos is "a vast uniform system of interconnected parts" (Martin 1977, 155). The scientific revolution gave validity to the conception of an infinite universe, and one manifestation of the infinite was found in the baroque interest in space, especially as articulated in *quadratura* painting, with its emphasis on perspective. As Martin states:

> The awareness of the physical unity of the universe is reflected in the new attitude adopted by many Baroque artists toward the problem of space. Their *aim* . . . is to break down the barrier between the work of art and the real world; their *method* is to con-

ceive of the subject represented as existing in a space co-extensive with that of the observer. Implicit in this unification of space, in which everything forms part of a continuous and unbroken totality, is a concept of infinity analogous to that framed by some of the greatest thinkers of the period. (1977, 155)

Through *quadratura*, the illusionistic depiction of alternative realities was taken to new limits. The principle of coextensive space was of fundamental significance to baroque art, and it is in the adept manipulation of space that baroque virtuosity lies: Science made visible the previously invisible, boundless space, and art explored similar concerns in its articulation of infinite hyperworlds. This parallelism and alliance in the fields of art and science is further echoed in the fact that it was during the seventeenth century that new academies of science and art flourished, academies that often included scientists, mathematicians, and artists. The Accademia del Disegno, for example, which included many popular artists of the period also included the mathematician Ostilio Ricci and the scientist Galileo Galilei; likewise, while functioning as an art academy the Accademia di San Luca was founded by the mathematician Federigo Zuccaro (Kemp 1990, 92–93).

A brief survey of some of the most influential illusionistic ceiling paintings of the period reflects a concern with variation and virtuosity as well as painting's alliance with science and mathematics. Annibale Carracci's Farnese Ceiling of 1597–1608, previously considered (figure 2.6), is often viewed as the work that initiated the seventeenth century's fascination with illusionistic painting. Perspectival manipulation (and other deceptive means such as trompe l'oeil) aimed at extending real architecture into a fictive space. Although illusionistic painting had been popular in earlier times, in the seventeenth century it became a central feature of decoration, taking to new limits the requirements for an "intimate knowledge" of theories of perspective (Wittkower 1985, 65). In the Farnese Ceiling we discover a combination of the old and the new: Carracci combines the method of *quadri riportati* (trompe l'oeil contained within framed paintings) with a *quadratura* framework (one reliant on perspective). The Farnese Ceiling ushered in a new age of baroque illusionistic ceiling painting through its dynamism and its attitude to space, and ceiling paintings that followed were increasingly driven toward illusionistic spatial extensions through a reliance on perspective.

In the wake of the Farnese Ceiling, greater emphasis was placed in the field of painting on mathematical principles of perspective. In 1610–1613 Ludovico Cigoli completed his fresco *The Virgin of the Immaculate Conception* on the dome of Sta. Maria

Maggiore in Rome. The painting depicts the Virgin Mary standing on a Galilean moon, a moon no longer conventionally smooth, but instead showing surface irregularities as recorded by Cigoli's friend Galileo. In addition to this shift in perspective, the method of foreshortening chosen by Cigoli created distortions in the painted figures situated around the base of the dome. The perspectival distortions proved controversial, because they were viewed as having no place in the classical tradition of the Renaissance. However, the perspectival system Cigoli chose was informed by a seventeenth-century viewpoint, in particular, that of the perspective theories he developed on the basis of Galileo's study of sunspots. Galileo noted that the length of sunspots on the sun's spherical surface altered in size according to the rules of perspective: Those near the center appeared greater, whereas those near the edges, which succumbed to greater foreshortening (like the figures on the periphery of Cigoli's dome), appeared thinner (Kemp 1990, 95–98).[21]

Although examples of ceiling painting that followed may not have been scientifically informed as directly as Cigoli's, the competition was nevertheless on. Artists combined the laws of perspective with artistry to outperform (while also paying homage to) the works that had preceded theirs. In 1621–1623, Guercino painted his *Aurora* in the Casino Ludovisi in Rome; in 1624–1625, Giovanni Lanfranco completed an illusionistic painted architecture and open-sky design on a ceiling in the Villa Borghese; then Lanfranco outperformed his own work in 1625–1627 with his dome of S. Andrea della Valle, initiating a new phase in baroque painting; as outlined in chapter 2, Cortona's Barberini Ceiling combined trompe l'oeil and *quadratura* traditions, achieving an illusionistic spectacle of undisputed technical bravura; and at the end of the century, Pozzo completed his virtuoso representation of coextensive space in the S. Ignazio Ceiling, marking what has been viewed as a redirection from the "old" embodied in classicism (Wittkower 1985, 88). Throughout the century, each new illusionistic example attempted to equal, if not radically extend, the illusionistic possibilities of mathematical systems. Grand-scale illusionistic ceiling painting pushed to new limits the representation of alternative realities that the painting medium, mathematics, and technological machinery were capable of producing. As in Bach's fugues, similar themes are intricately interwoven, varied, and rearranged into new formations. It is important to recognize that, as the aesthetic of repetition performs for the viewer, claiming its originality with virtuosic flair, for each illusion to achieve its purpose, it must be understood in relation to the whole. Like Earth in its new role (in the heliocentric model) as but one of many planets in a vast universe, each virtuoso display is but one of a network of monads.

Optics, Virtuosity, and Digital Effects in Science Fiction Cinema

Our times are marked by radical transitions similar to those in the seventeenth century: Advances in optical technology have both aided in making the previously invisible visible and constructed alternate realities that build digital environments that offer sensorially authentic experiences. In the realm of inner space, computer imaging has expanded the field of neuroscience by making possible the "spatialization and visualization of the brain's concealed terrain in a kind of neural photography" that not only captures images of the structure of the brain itself, but also provides three-dimensional images that relate brain functions to their location in the brain (Stafford 1996, 24). In physics, computer imaging has provided access to the interior viewpoint of atoms (25).[22] By donning virtual-reality "eyephones" and "datagloves" that are connected to a computer, we can enter a simulated virtual realm that greets us with images, textures, and a three-dimensional space; and with companies such as SensAble Technologies and CyberGrasp expanding research in the field of haptics (the ability to experience virtual touch), and DigiScents producing olfactory technologies, the potential for "authentically" experiencing an alternative existence in a virtual realm is not far away. Currently, the Integrated Media Systems Center at the University of Southern California is merging multiple technologies (3D facial modeling, animation, and spatially placed sound) to create a virtual world that brings "virtual people together for lifelike encounters" (Ignatius 2001, 39). The Mobile Assistant IV, produced by Xybernaut, allows the user to wear a computer: with the 233 MHz Pentium chip processor and a 3 GB hard drive strapped around the waist, a keyboard on the wrist, and a full-color VGA screen the size of a postage stamp suspended in front of one eye, the user can interact with reality and cyberspace simultaneously—and the mass market version made by Hitachi is available and being updated as I write these words (Ghosh 2001). In September 2001, using a combination of laparoscopy, computer technology, and robotic surgery, Jacques Marescaux and Michael Gagner from the Mount Sinai Medical Center in New York removed the gallbladder of a sixty-eight-year-old woman in Strasbourg, France, 3,900 miles away (Selim 2002). Most dramatically, our optical technologies have made visible the human genome, in the process granting humanity the key to the mysteries of DNA.

In the realm of outer space, astronomers have been able to study the ionized gases of the Milky Way through the use of high-sensitivity spectrometers (Reynolds 2002).[23] The Hubble Space Telescope has revealed to human view parts of the galaxy never seen before, including a planet outside our solar system, discovered in 1995 by Italian

astronomers, and a brown dwarf sighted by U.S. scientists in the same year. In February 2001, on Mauna Kea in Hawaii, astronomers looked through the Japanese Subaru Telescope (at twenty-seven feet wide, the world's largest) and detected a distant starforming region (Wright 2002, 29). In September 2002, the Hubble Space Telescope captured on film the birth of a galaxy known as Hoag's Object (Pountney 2002). And recently, an international group of astronomers in the Côte d'Azur observatory in France used multiple telescopes with silicon light detectors to survey Saturn, discovering twelve previously unseen satellites in the process (taking the number of Saturn's known moons up to thirty) (Weinstock 2002, 64).

The growth of multiple media entertainment forms in the last decade of the twentieth century and the initial years of the twenty-first reflects the transformation of our own conceptions of reality through advances in science and technology. Rather than providing visibility to preexisting realities, entertainment technologies have developed the capacity to *create* alternative realities in convincingly visible ways. Via the vehicle of the entertainment industry, computer technology is leading optical advances by producing radically new effects spectacles particularly compared to effects reliant on film imaging. The computer has expanded our conception of reality, providing us with cybernetic technologies of vision that are now playing an integral role in the articulation of cinematic spaces. By paralleling advances in, and often initiating new, optical technologies, entertainment spectacles are acclimatizing audiences to a new order of vision. Rather than exploring the infinite through *quadratura* illusion, special-effects films often invite the spectator to explore the ways in which the world is expanding to incorporate the infinite realm of the virtual. Spielberg's *Jurassic Park*, in fact, has a great deal to inform the audience about in terms of the way contemporary culture is grappling with the issue of changing realities. This concern about changing realities is evident both within the diegetic space (in the plot's concerns with the implications of genetic engineering, computer technology, and the simulated experiences of high-tech theme parks), as well as in the film's employment of special effects (which reveal a level of technological advancement that allows for the construction of illusionistically convincing depictions of a new dinosaur age).

As has been established earlier in this chapter, one of the most successful vehicles of technological display is the science fiction film, a genre that asks its audience to contemplate the effects of optical technology while simultaneously displaying the latest advances in that technology. In their own way, science fiction films attempt to come to grips with the radically changing conceptions of the world around us and our identity within it. As such, in their reliance on special effects, the "meaning of science fiction

films is often to be found in their visual organization and in their inevitable attention to the act of seeing" (Bukatman 1998, 250). Whereas the seventeenth century witnessed the alliance between science, technology, and art in the form of new academies that espoused the new sciences, in the late twentieth and early twenty-first centuries, the production of big-budget science fiction films has resulted in a new union between computer engineers and filmmakers in the form of special-effects companies such as Digital Domain, DreamWorks, Industrial Light & Magic (ILM), and Rhythm & Hues.

It is no coincidence that genres such as science fiction, fantasy, and horror have undergone a boom period since the 1980s.[24] The revival of popularity in these genres coincided with the growth in special-effects companies, which themselves relied on advances in optical technology made possible by the computer revolution. Given the genre's capacity for embracing both horror and the fantastic, science fiction films like the *Jurassic Park* trilogy, *Starship Troopers*, and *The Matrix* have proven especially popular because, while on the narrative level, these films engage in examination of the cultural ramifications of advances in science and technology, they also exploit the potential of such advances through special effects. As Brooks Landon (1992) has stated, contemporary science fiction coincides with the cinema's incorporation of new media. An "aesthetic of ambivalence" emerges: Whereas the themes of science fiction movies often warn about the negative implications of new technologies and scientific advancement *within* the film narrative, science fiction themes also manifest themselves in the advanced (science fiction) technologies used to construct the film's effects.

Science fiction cinema, especially its current manifestation, has always reveled in displaying the technological capabilities of the film medium, while thematically deliberating on the future effects of such technology. Having emerged during a period when the cinema was more concerned with the spectacle of film technology rather than narrative, the science fiction film genre has its roots in films such as Méliès's *A Trip to the Moon* (1902). This early "trick film" used its science fiction premise as an excuse to exhibit the "magic" of new film technology:[25] The cinema's technological capabilities were presented in the form of elaborate special effects barely tethered to narrative.

Despite their embracing technology never previously seen in cinema, blockbuster effects films of the 1990s and today share many features with films from earlier phases in the history of the cinema. Inherent in the "aesthetics of astonishment" that Tom Gunning has argued is central to pre-1907 cinema is a baroque concern with exhibitionism, virtuosity, spectacle, and active audience engagement. Although it offers a more intense manifestation of a baroque visual order, contemporary effects cinema has much in common with earlier periods of film history, in particular the tradition

Gunning has characterized (via Sergei Eisenstein) as the "cinema of attractions."[26] In the cinema of attractions, narrative concerns and characterizations compete with, and are often overpowered by, spectacle and performance. This is a cinema that, rather than centering the action solely on a story, emphasizes display, exhibitionism, performance, and spectacle. In fact, the attractions tradition draws on a neo-baroque ocular regime that delights in opening up spaces that invite the spectator to marvel at the films' illusionistic methods of construction.

As was outlined in the Introduction, the cinema has been especially susceptible to baroque aesthetics, as is evident in the cinema-of-attractions tradition[27] and the grand historical spectacles of the 1910s and 1920s. As John Belton explains, since the 1920s, many attempts have been made to enlarge the standard 1.33:1 aspect screen ratio: In December 1926, Paramount installed a temporary forty-foot-wide screen in the Rivoli Theater for the sequences of the naval spectacle *Old Ironsides*; the Magnascope lens (developed in 1924) was used in the screening of this film and for segments of Merian C. Cooper's *Chang* of 1927; Polyvision, which relied on a three-camera system, was used to create the three-screen panoramic effects of *Napoleon* (Gance 1927); and in 1929 Fox Studios projected *Happy Days* and *The Big Trail* on 70 mm film rather than the standard 35 mm (Belton 1992, 34–43). Such new technologies could not survive, however, in the midst of a film industry concerned with retaining the standardization of its successful production and exhibition practices. These new technologies lacked the stability of norms of practice and were often used in films, according to Belton, "largely as a novelty—as a special effect that was underscored by its isolation within the film as a whole" (39); in addition, the economic constraints imposed by the conversion to sound and the limited number of theaters equipped to show wide-screen formats ensured the maintenance of the standard 35 mm, small-screen format (51).

Although wide-screen technology, and the more participatory forms of spectatorship it entails, had been present from the silent era, only in the 1950s did more radical experiments in film technology and film spectacle flourish.[28] It was in the 1950s that audiences finally experienced the successful implementation of wide-screen technology and more spatially invasive spectacles in the form of Cinerama,[29] CinemaScope (figure 4.8), Ultra Panavision, 3D, cycloramas, advances in 65 and 70 mm format, surround sound, and new color technology. As Belton argues, the 1950s were more conducive to these technological changes than previous periods had been. The suburban boom, the arrival of television, the emergence of the theme park in the form of Disneyland, and a new leisure culture are just a few manifestations of the altered social conditions and changed forms of audience reception in the 1950s. Likewise, the previously suc-

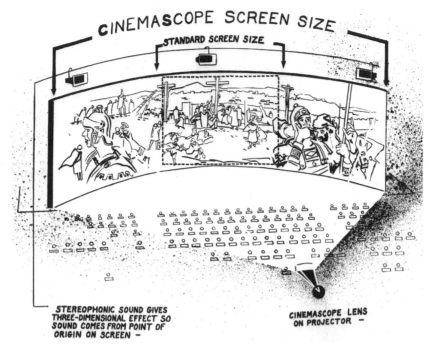

Figure 4.8 A 1950s drawing of Cinemascope screen ratio and stereophonic surround-sound system. By permission of The Kobal Collection.

cessful classical Hollywood model was no longer as popular in the 1950s as it had been in its 1920s–1940s heyday. The industry was undergoing economic strife, exacerbated by the 1948 Supreme Court decision in a case involving Paramount that forced the film majors to sell off their exhibition and distribution rights. The changing times were conducive to changing technologies and altered viewing experiences. Although the new variety of spectacle attractions was successful with audiences in the 1950s, however, the success was short-lived. The financial instability of the film industry along, with new audience expectations in the 1960s, made a cinema of spectacle financially nonviable. The turn toward a cinema verité–style realism, as well as on-location filming, discouraged further developments of film technology.[30]

Whereas Kubrick and Trumbull had experimented with and revised 1950s technology for the effects in *2001: A Space Odyssey* (1968), not until the 1970s and the release of the films *Close Encounters* and *Star Wars* did the wide-screen, surround sound, invasive experience of cinematic spectacle become a norm within the film industry.

Reimplementing and reinventing the technologies of cinematic spectacle characteristic of the 1950s and nurtured by a culture experiencing grand-scale paradigm shifts, contemporary effects cinema, along with its audience, embraced the immersion into and experience of a cinema that speaks of technological wonder. Not only have spectacle extravaganzas become a successful and dominant component of the entertainment industry, but they have revived and improved on 1950s technology that had lain dormant for almost two decades,[31] taking it along new, digital paths.

Much like the pioneering examples of the science fiction genre at the turn of the century, contemporary science fiction cinema has provided a venue for innovative developments in film technology—developments that have been depicted on-screen in fantastic terms and on a grander, blockbuster scale—one more aligned with the grand-scale technological upheaval of the late twentieth and early twenty-first centuries. As examples of the genre, films such as *2001: A Space Odyssey* (Kubrick 1968), *Close Encounters of the Third Kind* (Spielberg 1977), *Star Wars* (Lucas 1977), *The Abyss* (Cameron 1989), *Terminator 2: Judgment Day* (Cameron 1991), *Jurassic Park* (Spielberg 1993), and *Terminator 2: 3D* (Cameron 1996) were at the forefront of new developments in contemporary entertainment, pushing technology to new limits, and for the first time in its history, showcasing science fiction and the science fiction aspects of film technology in the multimillion-dollar blockbuster format.

Like the Barberini and S. Ignazio Ceilings, with their illusionistic spectacles and the effects they produced, contemporary science fiction cinema reflects, among other dramatic transformations, radical technological, perceptual, and artistic advances that are conveyed through an intense-emphasis on the special-effects spectacle. Both the seventeenth and twentieth/twenty-first centuries share a fascination with expanding the boundaries of the artificial capacity to create alternative realities or to view previously imperceptible realities. Although it uses different technological means to convey illusion than seventeenth-century ceiling painting, the contemporary science fiction film draws on film technology's capacity to convincingly represent parallel realities that are made possible as a result of computer technology. The advances and capabilities of technology are displayed through visually (and auditorily) overwhelming illusions.[32]

Artistic virtuosity through new technological means has been integral to the formal components of contemporary science fiction cinema. Like Pozzo's frescoed ceiling, *Jurassic Park* is no exception in this respect. The film's effects involve the audience in a game about artistic and technological virtuosity, therefore situating the film in relation to current effects technology and within the context of the history of cinematic effects. From the minute we pass through the gates to the Jurassic Park theme park depicted

in the film, another gate opens that takes spectators back to 1933 and *King Kong* (Cooper), and even before then to 1925 and *The Lost World* (Hoyt) (an allusion made even more obvious in the title of the sequel to *Jurassic Park—The Lost World: Jurassic Park* [1997]). Both films were effects movie milestones of another era in the history of the cinema, exhibiting the effects expert Willis O'Brien's experiments with stop-motion animation. In the hands of O'Brien, it was the dinosaurs and the giant prehistoric ape who were the stars. When *The Lost World* was released at New York's Astor Theatre in 1925, "nothing like it had ever been seen before, nor would anything be seen until *King Kong* in 1933" (Miller 1991).

When *King Kong* first appeared on the screen, (with a fanfare comparable to that accompanying the release of Spielberg's sequel, *The Lost World: Jurassic Park*), the film's effects announced themselves as attractions intent on outperforming the technological and illusory feats of their predecessors. Similarly, by alluding to *King Kong*, in *Jurassic Park* Spielberg pays homage to early effects technology that has inspired ongoing fantastic constructions throughout the history of the cinema.[33] Spielberg is also paying homage, however, to himself and to current film technology. Although *Jurassic Park* still has a connection to stop-motion effects, the film was also revolutionary in cementing a shift in cinematic special effects away from photographically conceived effects toward digitally conceived images that have their origin in computer reality which have become integral to late-twentieth- and early-twenty-first-century spectacle. *Jurassic Park* heralded a major transformation in the film industry toward the digital, thus signaling a turning point away from the cinema's one-hundred-year reliance on photo-realistic methods of illusionistic representation. Largely because of the success of *Jurassic Park*, by 1994, the old photochemical optical process was increasingly being replaced by the digital. Implementing the flair of neo-baroque variation, *Jurassic Park* directed film technology into enough new territory to warrant its entry into a new system of representation.[34]

Beyond the playful intertextual referencing discussed in chapter 2, neo-baroque virtuosity is manifested in cinema in the self-conscious allusion to film technology: Beyond their narrative function, special effects in science fiction films also become the means of unveiling technological advances. Embracing a baroque theatricality, each new addition to the stream of science fiction extravaganzas competes with its predecessor on the level of the technological. Each virtuoso performance attempts to outshine that of its predecessors. The development of morphing effects and the technology that drives them is a case in point. Morphing software was created by ILM for the effects in *Willow* (Howard 1988),[35] which initiated a shift toward computers'

digitally duplicating processes previously achieved by the photochemical techniques of traditional optics. In *The Abyss* (Cameron 1989), cutting-edge *Photoshop* software developed by Adobe was first put to extensive use for the creation of the morphing pseudopod alien.[36] Not only did morphing software replace traditional stop-motion animation, but the possibilities and requirements engendered by the Photoshop technology resulted in the expansion of ILM's computer graphics department.[37] Specific technological means (morphing) were required to create a specific effect, and in turn, this fantastic transformation within the film's fictional realm led to the production of a new technology, new special-effects departments, and a multibillion-dollar industry.[38] Pushing the limits further still, *Terminator 2: Judgment Day* (Cameron 1991) introduced the first digital main character on whom the plot depended in the form of the liquid terminator T-1000. In combination with the *Morph* program, the creation of more powerful computers, digital scanners, and software like *Photoshop* heightened the photorealistic capacity of the illusion.[39] The T-1000's liquid-metal, shape-shifting cyborg was able to transform itself into both animate and inanimate objects: from policeman to floor, and from metallic spike to fluid blob. Again, the effects the film required provided an opportunity to take computer technology to new limits. Dennis Muren, the ILM effects supervisor who worked on the film, viewed the creation of the T-1000 as an "opportunity to develop new tools and achieve the next level of digital imaging" (quoted in Cotta Vaz 1996, 201). Reflecting the union of art and technology, the T-1000's metamorphic nature resulted in the creation of new hardware and software programs.[40] Additionally, as in the case of *Star Wars* before it (whose effects requirements necessitated the establishment of ILM), the success of *Terminator 2*'s effects triggered the successful expansion of numerous effects production houses, including director James Cameron's own Digital Domain.

In the effects entertainment cinema tradition that followed in the 1980s, 1990s and first decade of the twenty-first century, the "fantastic" and science fiction have become the means through which to explore and push to new limits the technological and illusionistic capabilities of the cinema. With each of the major effects-innovative films released in the last decade, each journey into the fantastic and science fiction not only has used computer effects but has also expanded the limits of computer technology. With each change, the door to past film technology and to classical Hollywood form shuts ever more firmly, and the perceptual gap between illusion and reality closes.[41] Each fantastic film effect owes its chimeric impact to new developments in computer software and hardware; and in this union of art and technology, each fantas

tic special effect improves on and advances the technology that preceded it, making the fantastic appear more realistic through technological means. Digital technology has necessitated a metamorphosis of the film industry.

The technology that allows cinematic effects to be produced puts on an illusionistic display so that it may show off the auto-eros of its own technology. In the process, the seemingly divergent terms "magic" and "technology" often merge. For example, discussing the morphing effects in *The Abyss*, James Cameron made the following comments:

> Arthur Clarke had a theorem which stated that any sufficiently advanced technology is indistinguishable from magic. And that's how it's supposed to be—for the audience. . . . The audience response to the [pseudopod morphing] sequence was overwhelming. They got the joke; they understood intuitively what was magical about the scene. They were seeing something which was impossible, and yet looked completely photorealistic. It defied their power to explain how it was being done and returned them to a childlike state of entertainment. The sufficiently advanced technology had become magic to them. (Cameron 1992, 6–7)

In addition to explicitly acknowledging *The Abyss*'s place within an attractions tradition in the way the audience is granted active engagement with the special effect ("They got the joke"), Cameron also suggests that an understanding of the "magical" elements of a scene simultaneously implies an understanding (or at least recognition) of the technology that implements it. Spectators are placed in an ambiguous relationship with the screen in that they are invited to understand and be immersed *both* in the illusion as a reality (the magic) *and* in the methods used to construct that illusion (which ruptures that reality). To repeat Houghton's statement, the transitional nature of the baroque era is reflected in the way the scientific and the fantastic collapse into one another, resulting in an unabashed virtuosity. Reflecting an increased cultural concern regarding the nature of reality, fabricated digital and filmic spaces increasingly strive toward making the illusion and the real indistinguishable.

Certainly, the affective power of the effect that is so integral to the culture of baroque spectacle may be understood as "mobiliz[ing] senses to bring about a commitment of masses to absolute monarchies" (Turne, quoted in Maravall 1983, 23). The "monarchies" of the contemporary era have metamorphosed into the conglomerates that control the entertainment industries. According to Maravall, the seventeenth-century baroque attempted to guide human beings grouped together in masses, acting

upon their will and psychologically motivating them by means of the technology of attraction, whose aim was to capture (1983, 78). Church architecture, palaces, paintings, sculpture, the theater—all were produced on a massive scale that invoked wonder in spectators when they were confronted with such virtuosic displays. One factor underlying baroque spectacle's evocation of states of wonder is its capacity to combat competition. During the seventeenth century, baroque spectacle became the Catholic Church's response to the competition of Protestantism and the scientific revolution. The Catholic Church's attempts to reassert its power over Protestantism in the wake of the Counter-Reformation, and its efforts to attract a burgeoning (and largely illiterate) mass culture, had a pronounced impact on the form of art that emerged in the seventeenth century. "Sensual seduction" through spectacle became a powerful means of attracting the masses (Jay 1994, 45).

Sensual seduction through spectacle also brought the masses back to the cinema in the 1970s. The previously ailing film industry underwent a successful transformation in the hands of new conglomerate management. A new generation of directors like Spielberg, Lucas, Cameron, and Raimi (especially since his *Spider-Man* fame), in whose films special-effects technology plays a crucial role, established conventions that manifest a strong neo-baroque attitude toward spectacle. Rather than a way of competing with other powerful families, religious groups, or new sciences, as it was for the Catholic Church and its leaders in the seventeenth century, entertainment spectacle became an important means for competing with other film companies and new media competitors.[42] More than in any other period in its history, cinema of the post-1976 era has been confronted with the conflicting demands of other media for its audience. Additionally, conglomerates with multimedia interests and investments rely on the spectacular possibilities inherent in the development of new media technologies and on each media example's ability to define its difference according to its media-specific spectacle and form of audience engagement.[43]

Indisputably, the "monarchical" and conglomerate glorification that underlies the imagery of illusionistic paintings such as the S. Ignazio Ceiling (which stresses the glorification of the Jesuit leader and his movement), Cortona's Barberini Ceiling painting (which is a monument to the godliness of the Barberini), or Lucas's *Star Wars* and Spielberg's *Jurassic Park* (which are testimonies to the successful establishment of Lucas's effects company ILM) has strong ideological connotations. Again, however, another layer of baroque and neo-baroque spectacle lies in formal concerns that affect viewers in more immediate, sensory terms. Such spectacle is, above all, concerned with the fetishization of the technology that drives it.

Star Wars *and the Architecture of Vision*

Contemporary special-effects technology and audience experiences mark a radical turning point in the history of the cinema, one that follows a series of changes in film technology introduced in the late 1970s. These changes were, of course, aided by the institutional transformation of the film industry along conglomerate lines. An important transition year was 1977, and the two films that sealed the dominance of a new baroque era in cinema were *Star Wars* and *Close Encounters of the Third Kind* (which will be the focus of the final chapter).[44] Neither film introduced any new kinds of special effects, with both owing a great deal to the effects innovations Trumbull produced for *2001: A Space Odyssey* (Kubrick 1968) and *Silent Running* (Trumbull 1971). The originality comes instead from their spatial organization and their depiction of objects in space in a way that produces a neo-baroque relationship between spectator and image. Both films introduced a new sensibility into the film experience. Traditional perceptions of film space were on their way to being dramatically altered, and since the release of these two films, particularly since the 1980s, computer-generated spectacle has been integral to these new perceptions.

Star Wars, in particular, breathed new life into film technology that had lain dormant since the early 1960s. In reviving the effects spectacle, George Lucas turned to film technology that had dominated in the 1950s, another period in the history of the cinema informed by baroque sensibilities in its attitude toward spectacle, though not to the extent of the post-1970s. Lucas's effects unit revived 1950s wide-screen technology (employing old VistaVision cameras that had remained unused since the early 1960s), the matte painting tradition, stop-motion photography, and surround sound, as well as the art of combining models and miniatures with paintings (Cotta Vaz 1996, 9, 91). Turning to prior points in the history of the cinema when technologically produced spectacle had dominated, Lucas shaped such spectacle to suit contemporary needs. Despite its use of primitive (by today's standards) computer technology,[45] *Star Wars* (which is to the contemporary blockbuster what Annibale Carracci's Farnese Ceiling was to the seventeenth-century illusionistic ceiling painting) also anticipated the era of computer graphics, standing as a transition point between the old and the new.[46] Furthermore, within the space of twenty years, *Star Wars* serves as its own reference point and dramatizes the extent of technological advancement, in the rerelease of *Star Wars* as a 1997 newly digitized and "enhanced" version. *Star Wars* 1997 is both a homage to the changes that have occurred in computer graphics over the twenty years since (and due to) *Star Wars* 1977, and a virtuoso performance that takes a bow

for the digital "improvements" in special effects that the "revised edition" has introduced, thus "improving" on the effects technology (which still relied on photochemical systems) of the original *Star Wars* trilogy. Just as *Star Wars: A New Hope* 1977 marked a transitional moment in Hollywood cinema, so *Star Wars: A New Hope* 1997 marks a new step into the cinema of the next century.

All the while, in these examples from the *Star Wars* franchise, films perform for an audience, and the performance centers on special-effects technology and its illusionistic potential. As in the displays in Kircher's museum, the ultimate virtuosi are the directors and the technicians of the film studios and effects houses who orchestrate these "theaters of the world" for the delight of the audience.

Star Wars was one of the first contemporary effects films to explore the cinema's potential as architectural event. Marking a major turning point in spectator and screen relations,[47] the film introduced new visual, audio, and kinesthetic experiences to the cinema that heightened the effect of immersion and sensorial engagement. After the film's famous opening textual narration, which relates events that occurred prior to the film's beginning, the viewer is confronted with an image of a dark, infinite space that is speckled with an equally infinite number of stars. The camera pans down to reveal first one planet in the distance, then another in the middle distance, then, framing the bottom of the screen, the tip of a third planet in the foreground. The pan shot stops, and a static image of three planets progressively receding into space greets the spectator, thus neatly evoking the laws of one-point perspective. A small spaceship enters the screen from off-screen on the right, and the perspectively organized planetary alignments remain intact. With stable framing relations having been established that place the audience in a classical relationship to a space that adheres to the closed-frame principle of one-point perspective, the framing is shattered by the entry of an enormous spaceship that erupts onto the screen from the top of the frame. In this respect, the classical within the baroque is introduced and then manipulated with virtuosic grandiosity.

The opening minutes in *Star Wars* remove any point of location, and the audience is "lost in space" (Gabilondo 1991, 99). It is an unlimited space, because a vanishing point cannot be located anywhere within it (Gabilondo 1991, 100). The sequence's rearticulation of spatial relations becomes especially apparent when the spaceship enters the scene, plunging into the film space from the upper part of the film frame. The sudden dwarfing of the dark, starlit solar system by the enormous spaceship further affirms the extension of space by producing a spillage of spectacle into (or in this instance, out of) the realm of the audience. To quote the special-effects television

series *Movie Magic*: "[T]he cinematic impact may never be greater than when a small model spaceship photographed with John Dykstra's motion control camera rumbled over our heads and changed the landscape of movies forever."[48] Off-screen cinematic space has always been an integral feature of the cinema. In classical Hollywood cinema, however, off-screen space was grounded and emphasized a "world within a frame." Off-screen space is generally used as a device that suggests a space that lies off-screen but *within* the diegesis. The entry of the spaceship in *Star Wars* preserves this classical function[49] in its adherence to the traditional use of off-screen space (the ship arrives on-screen from a space that belongs to the diegetic space). A neo-baroque logic also pervades the scene, however. The monumental spaceship in its spectacular entry also perceptually appears to invade the screen from the space of the auditorium. The frame dissolves, as the spaceship appears to move from the real space of the auditorium into the representational space within the screen.

This effect is aided by John Williams's soundtrack in all its surround-sound glory. Williams's composition, a fuguelike variation on the theme music to the opening of *Flash Gordon* serials,[50] blares not out of the single-speaker system typical of movie theaters of the time but out of the new Dolby stereo system. As Altman outlines in his historical account of sound development in the cinema, following the attempts at stereo sound in the 1950s, by the 1960s

> [s]urround channels were so seldom used that surround speakers fell into disrepair. . . . However, the late Seventies application of the new Dolby optical reduction to *Star Wars* and *Close Encounters of the Third Kind*, and other fantasy blockbusters initiated a new era in speaker usage . . . a new generation of sound specialists labored mightily to employ the surround sound speakers to enhance spatial fidelity. (1995, 70)

Like the serials and sequels that explode from the confines of *Star Wars*, the film, into other media, here the special effects create an alternate form of explosion: an explosion of the screen that is felt with an audiovisual intensity. *Star Wars* initiated the blockbuster success of computer-generated special effects in contemporary science fiction cinema, in the process redefining the relationship between the audience and film experience. In this redefinition, the conception of the passive viewer collapses, and although spectators remain in their seats, new audience/screen relations suggest an active participation that implies that the viewer's relationship with the screen representation is no longer "invisible" (Belton 1992, 187).[51]

The continual relocation of the center is an even greater issue in the climactic scene near the end of the film when the rebels attempt to destroy the Empire's Death Star

base. In this scene, X-Wing pilots pirouette through space in their fighters, defending themselves against enemy spaceships that attempt to halt their mission. A combination of techniques that emphasize kinetic motion creates spatial disorientation in this scene. X-Wing fighters fly across the screen repeatedly and in a variety of directions: left to right, up to down, diagonally, and toward the camera. The camera also engages in similar kinetic movements. At times, the camera pans in the direction of the fighters. At other points, it moves in a direction opposite to the fighters, creating disorientation in the viewer. Multiple edits offer additional perspectives that further highlight a multidirectional system of spatial motions. Character point-of-view shots also add to the spatial dynamics. The multiple-directional focus of the X-Wing fighters produces a confusing sense of objects in motion and a spatial relation that is continually being redefined relative to character or camera viewpoint. Fighter pilot characters look forward, downward, upward, and to their left and right as they respond to the chaotic events that spatially surround them.

At still other points, the viewer is thrust into the kinetic motions, his or her view being collapsed both into characters' points-of-view, as they weave their X-Wings through space, and into the view provided by the restless camera and suddenly shifting viewpoints via editing. As the X-Wing pilots move into the narrow channels of the Death Star, they turn to their computers to aid in targeting the Death Star's vulnerable core. The image that the computers target provides a geometric system that frames the pilot's line of view according to the laws of one-point perspective, yet the actual space these characters occupy is anything but monodirectional. Luke Skywalker, in fact, finally succeeds in destroying the Death Star only when he abandons the computer's one-point perspective schema, opting, instead, for his instincts and the guidance of the Force. With the spectator's sight thrust into the viewpoint of the camera, his or her experience is highly kinetic, and a multifocal perspective replaces the unifocal.

Once the representational frame illusionistically collapses, traditional perspective, which relies on the frame and a static viewpoint, also collapses. An illusion of limitless space itself is placed before the spectator, and an invitation is extended to engage with the spectacle in spatially and architecturally disorienting terms. Belton suggests that the linear perspective that informed pre-wide-screen and "deep-focus" cinema of the classical era encouraged the audience to "explore the depth of the frame"; widescreen technology popularized in the 1950s, however, combined the exploration of the depth of the frame with a scanning of the screen in its entirety (1992, 198).[52] In *Star Wars*, the combination of wide-screen, 70 mm film technology, the kinetic motions of

the camera, and the spatial dimensions of the sound encourage what Martin Kemp, in another context, has called the "turning-eye" (1990, 212).

Recent effects technology embraces the "all-around" nature of the audiovisual world, creating the impression of the "step-in" spectacle. The resulting (neo-)baroque aesthetic overcomes "the limitations of classic . . . traditions and that of the static eye" (Kemp 1990, 212–215). The audience's visual and aural senses actively engage with the spectacle, and audience members are invited to imagine that they are being enveloped by the architectural dimensions of the screen events. Scanning the entire surface of the 70 mm projected image, the spectator's gaze, in the opening scene of *Star Wars*, follows the length of the spaceship as it (and the rumbling sound that accompanies it) deceptively arrives from space of the audience. Enhanced by sound that emits from speakers throughout the cinema, the audience's vision and hearing actively absorb the kinetic frenzy depicted in the Death Star destruction. Throughout the process, the spectator's focus shifts continually. As in *quadratura* painting, which invites the spectator to engage with the image in architectural terms by altering his or her focus and viewpoint, all privileged, singular focal points are abandoned to encompass the enormity and spatial complexity inherent in the spectacle. As was mentioned earlier, this new spatial organization no longer centers the viewer. The viewer is now the center.

The shifting perceptions characteristic of the baroque are well expressed by Leibniz, whose writings reflect the dissipation of the privileged omniscient viewpoint that understood classical systems as a system controlled by a single viewpoint within a self-contained universe (Crary 1994, 50). Leibniz's perception of the world suggested that the central, omniscient viewpoint was replaced, in the baroque, by a world of multiple viewpoints. As Crary notes, "The monad became for Leibniz an expression of a fragmented and decentred world, of the absence of an omniscient point of view, of the fact that every position implied a fundamental relativity" (1994, 50).[53] As mentioned earlier in this book, each fragment in a monad is conceived as being connected to a larger whole. The spectator becomes integral to this system, being one of multiple monads that comprise the entire experience.

Remediation, Spectacle, and the Assault on the Sensorium

Neo-baroque entertainment spectacles may provide alternative technological and multimedia dimensions to audience encounters, but the essence of the experience of the neo-baroque relies on familiar media and technological forms. As the song goes, "Everything old is new again." In *Remediation: Understanding New Media* (1999), Jay

Bolter and Richard Grusin suggest that all media, no matter how "new," rely on a media history. New media always retain a connection with the past in a continual effort to remediate, redefine, and revitalize their own form by drawing on other media. Bolter and Grusin state that "[b]oth new and old media are invoking the twin logics of immediacy and hypermediacy in their efforts to remake themselves and each other" (1999, 5). Like painting, architecture, and sculpture, which have a longer history of traditions to draw on, contemporary media forms such as the cinema and theme park attractions "remediate" or refashion other media forms, adapting these other forms to their own media-specific formal and cultural needs. In short, "No medium today, and certainly no single media event, seems to do its cultural work in isolation from other media" (1999, 15). The fascinating formal and experiential facets of many contemporary media examples, however, are found in the *way* they remediate and merge media forms, the outcome being the production of a neo-baroque aesthetic. The multiplication of remediated forms, merging the "new" and the "old," that are experienced in the theme park environment heightens the emphasis that the neo-baroque places on the involvement of multiple senses.

The theme park ride *Star Tours* (1987), produced by Disney and Lucasfilm, an attraction at Disneyland (Anaheim, California) and Walt Disney World (Orlando, Florida), further expanded the potential for realizing Deleuze's "architecture of vision." The ride initiated the "popularity of 'ride-the-movies' theme park attractions" (Cotta Vaz 1996, 80). In developing the ride, the Disney and Lucasfilm crew merged hydraulically powered motion simulators devised for commercial and military pilots with film technology.[54] The ride's motion simulator is programmed (via computer) to correlate with motions on the screen. The combination produces convincing sensations in ride participants of acceleration, deceleration, and movements left and right and up and down. The ride offers participants tourist trips to locations in the *Star Wars* universe. Its motion effects are initiated when a rookie robot pilot commandeers the spaceship "and gives its unwitting passengers a runaway ride through space" (Pourroy 1991, 32). The success of the ride, which reproduces the camera motions that accompany Luke Skywalker's flight in the X-Wing in the Death Star destruction scene of *Star Wars*, depends on a kinetic and spatially invasive form. The difference between the films and the ride, however, is that *Star Tours* combines a forty-passenger simulation ride with 70 mm film projection, and as the rookie pilot takes flight through space, the simulator moves, thrusting the audience around in motions that mimic those being depicted on the screen. The kinetic, dynamic visual effects produced appear to collapse the frame of the filmed image, perceptually plunging the audience into the representa-

tional space. Whereas in the Death Star scene in *Star Wars*, the spectator was only occasionally plunged into a character's point of view, in *Star Tours*, the entire ride thrusts the participant into a first-person viewpoint. The participatory and invasive nature of the spectacle (and the audience's relationship to it) produces such an intense architecture of vision that many an audience member literally suffers the effects in the form of nausea.

In her discussion of contemporary science fiction cinema, Sobchack suggests that Jameson's (1984) articulation of postmodernist space finds expression in post-1977 science fiction films. Special-effects spaces, according to Sobchack, present themselves as "total spaces" that "stand for, and replace all other space"; the special-effects environments of science fiction cinema also "celebrate hybrid expression, complexity, eclecticism, and 'variable space with surprises'" (1987, 255). Above all, the special-effects spaces of science fiction cinema play on the neo-baroque concept of "great theatre of the world" and of "theatre as embodiments of illusion" (Baur-Heinhold 1967, 7). *Star Wars* brought neo-baroque scope to the "space opera" science fiction tradition from which the film emerges. Through its effects and cross-media variations, however, *Star Wars* transformed Baur-Heinhold's "theatre of the world" into a "theatre of the universe."

The sensorial assault invoked by the neo-baroque is but one aspect of the theme of the theater of the world, where the world and theater, reality and performance blur. *Star Wars* and *Star Tours* greatly expand upon techniques and technologies of coextensive space that drive the ceiling of S. Ignazio. The fantastic and the real appear to merge. In the case of the seventeenth-century baroque, the illusion of coextensive space was perhaps observed in most invasive terms in the theater. Theater, and the genre of opera that emerged from the baroque conception of theater, began to flourish in the seventeenth century in spectacular terms, on both public and private levels.[55] The seventeenth century was a turning point in advances in the theater medium, especially with regard to technological apparatuses and more skillful application of perspective to set design. Multiple media—art, architecture, painting, sculpture, hydraulics, engineering, pyrotechnics, and music—were remediated and placed within a new context, with the result that the seventeenth-century multimedia spectacle invades the senses from multiple perspectives. One of the centers initiating a baroque attitude to set design and theatrical presentation was the Medici court in Florence. In particular, the reign of Cosimo II, between 1608 and 1621, witnessed the production of theatrical displays that influenced theater design and performances throughout Europe in the seventeenth century and into later centuries. Although narrative had a

place in the Medici theatrical extravaganzas, just as it does in grand-scale special-effects cinema, these extravaganzas were associated above all with an excess of spectacular experiences.

Technological advances in the theater and a flourishing of the arts laid the scene for displays of spectacle within an expanded arena of reception. New theatrical technological marvels were particularly influenced by the rediscovered writings of the Roman author Hero. In his *Pneumatics*, Hero outlined the theatrical possibilities of spectacular effects through automata, hydraulics, and automatic scene changes (Strong 1984, 37). In addition to the winches, pullies, and trap doors he recommended, Hero's system of hydraulics became crucial to baroque theater. New mechanical inventions informed by hydraulics introduced a new dynamism into the theater, making possible the swift transformation of stage wings into new settings, the sudden appearance and disappearance of fantastic, demonic figures from trap doors, and the miraculous arrival of flying chariots or heavenly beings. These magical apparitions were accompanied by stunning fire displays, explosions, water effects, and sound effects, all of which gave rise to theatrical spectacles not witnessed before, spectacles that engaged the senses on multiple levels. In addition to displaying the power of the patron, another intention of these sensorial experiences was to keep the audience continually astounded at the extent of theatrical advances. Driven by the era's fascination with motion and space, the theater that emerged was, much like *quadratura* painting (whose theatrical influences we saw in the work of Cortona), concerned with escaping the limitations of two-dimensional space. In the words of Baur-Heinhold, "space had broken its bounds and become indeterminate" (1967, 123). Underlying the interplay between illusion and reality is a key concern that reflects the instability of the times: What is reality and what is illusion?

Theatrical intermezzi began as a series of interludes between sections of the main play. By the early seventeenth century, however, they had become focal points that showcased musical and ballet performances, and in particular, mechanical devices and spectacular effects.[56] The intermezzi were often nothing more than excuses that permitted the display of exuberant sets, advanced technological displays, and magnificent musical performances. As a result of this exhibitionist concern, one of the most popular intermezzo performances repeated throughout the seventeenth century was the hell scene. Much like our own era's science fiction and horror genres, the hell scene allowed scenographers and effects designers to astonish the audience with their level of expertise and with the technologies' ability to produce convincing illusions.

Giulio Parigi worked as the chief architect and set designer in the court of the Medici between 1608 and 1635, his set designs influencing theatrical productions throughout Europe. All of the numerous productions in Parigi's lifetime an infernal scene. One of the most popular and influential of these was the hell scene for an intermezzo in the Medici's production of *Il Giudizio di Paride* (1608), a theatrical celebration (which ran for nine days) for the wedding of Cosimo II and the Archduchess Maria Magdalena. The end of the fourth act of the play was followed by the fifth intermezzo, "The Forge of Vulcan." The infernal interlude called up the "miracle machines" (Nagler 1964, 104), taking them to the limits of fantastic and illusionistic possibilities and suggesting to spectators that the realm of Hades had entered their real space.

An etching of the Parigi set by Remigio Cantagallina reveals the baroque virtuosity that drives the spectacle. The changing of the sets themselves from act to act and from intermezzo to intermezzo revealed the sets' impressive perspectival arrangement: they appeared to extend from the space of the auditorium. Another interesting effect is recorded in Cantagallina's etching of "The Forge of Vulcan." Below the stage itself, where Vulcan, Mars, and Cyclops orchestrate the selection of the Duke of Tuscany's armor, a trap door is visible, revealing the trap machines and the stagehands operating them. Nagler views this as a coup de théâtre, with Parigi intent on showing off his talents by partially revealing the process of construction (1964, 104). Settimani, recording the Medici theater productions between 1596 and 1608, wrote that the intermezzi were "stupenda per la magnificenza, e maraviglia delle machine,"[57] and as with *Star Wars* and *Star Tours*, the new technological contraptions became the stars of the performance, in turn displaying the craft and skill of their virtuoso creators.

Technology and artistry made possible the illusionistic manipulation of space, inviting the perceptual demise of the frame. For example, in the final scene in *Star Wars*, the audience is actively acknowledged as part of the performance—a point doubly echoed in the film's diegetic audience within the scene. As Belton argues, wide-screen cinema of the 1950s exploited the cinema's alliance with traditions of the theater (and the active audience engagement this entails).[58] *Star Wars* not only acknowledges these theatrical traditions through the traditional motif of cinema as theater, but it takes these traditions further through the theatricalization of space made possible by the film's effects and the audience responses they invoke. A similar statement may be made regarding the seventeenth-century theater spectator. Not only did diverse media and technologies merge in baroque theater spectacle—including painting, theater

design, sculpture, music, ballet, pyrotechnics, and hydraulics—but theater met life and life met theater, as performance and reality folded into one another.

Seventeenth-century baroque vision understood "the gap between theatre and social life [to be] disappear[ing]", according to Molinari, who says that Bernini, in particular, exploited this theme, being intent on the "abolition of the distinction between life and theatre" (1968, 149). One of Bernini's theatrical presentations, of which we have few records, suggests that he portrayed an audience on stage, watching the performance. But the baroque sense for spectacle as theater also invites the entry of theater into the social realm. The production of Gian Lorenzo Bernini's *Mars and Mercury* that inaugurated the Teatro Farnese in Parma in 1628 included a theater that spilled off the stage and into the pit. In addition to including jousts, the "whole performance concluded with the most terrific coup de théâtre Baroque theatre had ever dreamed of—the pit was completely flooded," and the combat between soldiers ruptured the stage boundaries to enter the space of the pit (Molinari 1968, 153).

Likewise, in the case of the 1608 festivities that accompanied the wedding of Cosimo II, the theatrical spectacle even ruptured the boundary of the theater auditorium itself. One day of the festivities consisted of the performance of a sea battle called *Argonauts on the Arno*. Theater spilled over into the city of Florence, in this case onto the river Arno and its banks and bridges. The performance involved a massive naval battle spectacle held together by the narrative excuse of Jason's search for the Golden Fleece (with Cosimo II in the role of Jason). To the accompaniment of pyrotechnics, music, and songs, the theatre spectacle included elaborately decorated barges on the river with astonishing ships, such as that of Hercules, whose bow consisted of the heads of the hydra, complete with flames emitting from each of the hydra's nine heads. Other ships were apparently drawn by sea horses, and yet another took the form of a giant lobster that magically transformed into a magnificent barge, to the recorded amazement of the audience lining the river banks.[59]

This is the realm of baroque spectacle as theater of the world: Once the viewer is invited beyond the proscenium and beyond the frame, the frame perceptually disintegrates, embroiling the viewer in a series of baroque folds that present the possibility of a limitless scope of vision. The outside becomes inside and the inside out (Deleuze 1993, 35). The shifting nature of the world endows it with an ephemeral, fluid quality: Illusion can reveal itself as reality, and reality as illusion. The baroque phenomenon of border crossing is best expressed by Deleuze in his articulation of the baroque "unity of the arts" (a topic to which I will return in the final chapter):

If the Baroque establishes a total art or a unity of the arts, it does so first of all in extension, each art tending to be prolonged and even to be prolonged into the next art, which exceeds the one before. We have remarked that the Baroque often confines painting to retables, but it does so because the painting exceeds its frame and is realized in polychrome marble sculpture; and sculpture goes beyond itself by being achieved in architecture; and in turn, architecture discovers a frame in a façade, but the frame itself becomes detached from the inside, and establishes relations with the surroundings. . . . We witness the prodigious development of a continuity in the arts, in breadth or in extension: an interlocking of frames of which each is exceeded by a matter that moves through it. (1993, 123)

Theme park attractions (which stand at the center of the most cutting-edge developments in entertainment) take "unity of the arts" to new limits. Although they are played out overtly in contemporary blockbuster effects films, the polycentrism and multimedia mergings inherent in the neo-baroque find their most literal form of expression in contemporary theme park attractions. Where blockbuster effects cinema interweaves the represented frames of computer-generated, filmic, and architectural realities, theme park attractions often take the ambiguity of the frame further still. Insides and outsides are continually rewritten, and multiple media and lived realities are continually reframed. The proscenium that demarcates audience space from the performance is blurred, and the audience becomes a participant in an enveloping entertainment spectacle. Within the theme park, we need to reconsider Deleuze's "architectures of vision" as "architectures of the senses."

Terminator 2: 3D Battle across Time, *the Unity of the Arts, and Architectures of the Senses*

In *Terminator 2: 3D Battle across Time*, a multimedia attraction at Universal Studios, Orlando, Florida, and Los Angeles, California, Arnold Schwarzenegger, Linda Hamilton, Edward Furlong and Robert Patrick reprise their roles under the direction of James Cameron. Screen action using computer, video, and film technology combines with live action within the theater to produce an exhilarating, participatory entertainment experience. An unsuspecting group of adventurers enters the "Cyberdyne complex" at Universal Studios, and the tour of the installation begins. The audience is to be present at the unveiling of the latest Cyberdyne innovation: the T-70 cyborg (a primitive 1997 version of the T-800). As the Cyberdyne host introduces the crowd to the company's "cybotic" vision through a video being projected on multiple television

screens, the video control room is invaded by Sarah and John Connor, the mother and son from the *Terminator* films, who warn the audience (via video screens) of the dire need to escape. After Sarah refreshes the group's memories about the events that took place in *Terminator 2* by narrating and showing them brief scenes from the film (and as the reality of the audience's presence at Universal melds with the fiction of the *Terminator* universe), Cyberdyne once again takes control of transmission, and an embarrassed host warns everyone to ignore the wild ramblings of the Connor rebels. The audience is then ushered into an auditorium, and the presentation continues. Sitting dumbstruck and surrounded by "live" T-70s (who flank the audience on either side of the auditorium), the audience is treated to the sight of Sarah and John's invasion of the auditorium, this time as "real" actors in the audience's space. Suddenly the audience finds itself thrust into the center of a live action battleground.

Meanwhile, behind the Cyberdyne representative on stage, the Cyberdyne logo appears, projected onto a 23 × 50 foot screen. Amidst the battle chaos (and armed with 3D glasses), the attraction participants are seemingly caught in the cross fire of bullets fired at the Connors by the T-70s; some of the bullet shots fired in the auditorium hit the Cyberdyne logo on the screen. With appropriate sound effects booming out of the auditorium's 159 speakers, the audience looks on in horror as the bullet holes embedded in the logo melt and morph into the T-1000 the shape shifting cyborg antagonist from *Terminator 2*. As his liquid, blob-shape morphs into "chrome man" guise, the T-1000's head begins to fill the screen, then lunges forward, seemingly escaping the confines of the screen space as he thrusts in the direction of the audience, some members of which react to the motion by screaming and reaching out to protect their faces from the coming onslaught. The T-1000 then "moves back" into screen space (his three-dimensional form flattening back into the two-dimensional format of the screen), morphing into liquid metal form and slipping down to the lower part of the screen where, in search of his prey (figure 4.9), he then transforms into a live actor (as a policeman form of the T-1000) on stage. Moments later, a time portal opens up in the screen, and a "live" T-800 (a Schwarzenegger look-alike) arrives on stage on a Harley-Davidson Fatboy, calling out a repeat performance of Schwarzenegger's famous one-liner to John in *Terminator 2: Judgment Day*: "Come with me if you want to live." Both then enter the screen reality (leaving Sarah behind to deal with our present reality), and the next stage of the story begins: a seven-minute film that dramatizes John and the T-800 trying to destroy the Cyberdyne computer mainframe in the year 2029.

Like many of the effects films and attractions that preceded it, the *Terminator 2: 3D* attraction has pushed film technology and computer graphics to new limits, while

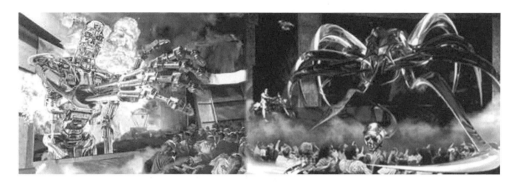

Figure 4.9 The T-Meg from the *Terminator 2: 3D* attraction at Universal Studios. By permission of Universal.

simultaneously acknowledging its dependence on film technology of the past—in this instance, that of the 1950s. At one stage in the film, the screen expands to 180 degrees and is flanked by two additional screens of identical size, expanding the dimensions of the screen to 23 × 150 feet of enveloping spectacle. True to baroque virtuosity, however, while harking back to the 1950s era of Cinerama (figure 4.10), as well as to 3D cinema, Cameron and the effects crew of Digital Domain also take these technologies further. The projection from the 70 mm film used in *Terminator 2: 3D* no longer reveals the graininess of 1950s Cinerama; film quality combines with digital effects to produce a crystal clear depiction of an alternative reality that invades the reality of the audience. Digital technology also rejuvenates 1950s 3D cinema, as does the updated screen, coated with high-gain material allowing for the best possible 3D imagery ("*Terminator 2: 3D* Fact Sheet" 1997). Morphed beings are now placed within a 3D context, and the illusionistic outcome is not only technologically groundbreaking but also phenomenologically new. Audience members sit mesmerized by the world that spills into their space, all the while wondering how the illusions that create that world are possible. Likewise, the surround-sound systems that wide-screen cinema first introduced as a five-speaker format in the 1950s (figure 4.8) (which were given new life with the release of *Star Wars* and the era of surround-sound entertainment cinema that followed) are now replaced with new digital audio effects by Soundelux that comprise 45,620 watts of sound blaring through 159 speakers.[60] The "spectacle" of sound is taken to new limits. Explaining the transformations in surround-sound technology of the 1980s, with the development of THX and other surround-sound systems, Altman explains that surrounds and speakers "were liberated from the demands of spatial fidelity or narrative relevance . . . the Eighties ushered in a new kind of visceral

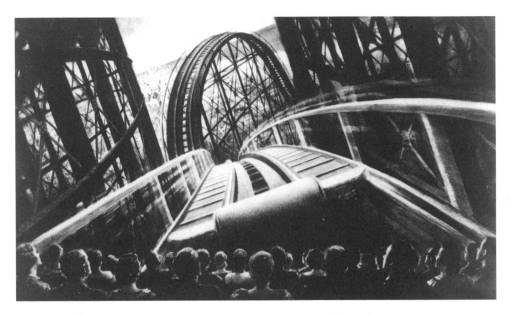

Figure 4.10 Still from the 1950s film *This Is Cinerama!* By permission of The Kobal Collection.

identification, dependent on the sound system's overt ability . . . to cause spectators to vibrate—quite literally—with the entire narrative space" (Altman 1995, 70).[61] Surrounds were increasingly used for spectacular effects that appeared, in audio form, to explode out of the space of the screen. This effect is felt with a vibrating intensity in the sound system devised for *Terminator 2: 3D*: The spectator's entire body vibrates as the booming sonic effects make their attack not only from the sides, but also from below.

Furthermore, simulation ride technology works on a grand scale in this attraction: The norm of six to forty seats per ride found in attractions such as *Back to the Future* (Universal Studios) and *Star Tours* (Walt Disney World) is now expanded to accommodate approximately seven hundred vibrating seats. At one point during the attraction, the auditorium floor moves, and the audience has the sensation of going down an elevator into the depths of Cyberdyne with Schwarzenegger and Furlong.[62] These innovative effects combine to make the experience seem real, and the audience feels as if they are placed in the middle of the action. Adding to the sensation of a collapse of illusion into reality is the theatrical addition of sprays of water and smoke that integrate us with the action on the screen and in the auditorium. State-of-the-art digital effects, the digital sound system, and simulation ride technology combine with older

technologies of wide-screen and 3D cinema to produce an immersive and sensorially entertaining experience.

The "total unity of the arts" that Deleuze discusses occurs through extension, invoking the motion of the fold: As in the fluid media and figural transformations of Cortona's Barberini Ceiling, one space extends into another, one medium into the next, the spectator into the spectacle, and the spectacle into the spectator. Extending the baroque spatial dimension of sight, the neo-baroque employs computer and film technology to produce virtual trompe l'oeil effects. Introducing motion, sound, and other sensorial experiences to visual spectacle, the neo-baroque articulates the perceptual collapse of the frame more powerfully than before, and in ways not witnessed before. In the words of Schwarzenegger: "The topography of motion pictures continues to change at the speed of light, becoming more and more interactive with audiences across the globe. . . . What we have created with *Terminator 2: 3D* is the quintessential sight and sound experience for the 21st century, and that's why I'm back" ("*Terminator 2: 3D* Fact Sheet" 1997). The effects illusions in *Terminator 2: 3D* are indicative of the accelerated pace at which entertainment industries are transforming as a result of new computer technologies.

Entertainment forms like the *Terminator 2: 3D* theme park attraction engage in such a complex and excessive level of interaction and remediation that it becomes increasingly difficult to untangle one media form from another. Does *Terminator 2: 3D*, for example, belong to the realm of the cinema, to that of television, of computer technology, sculpture, architecture, the theater, robotics, the simulation ride, or the theme park attraction? A neo-baroque fold informs the logic of remediated theme park attraction spectacles: Multiple multimedia "realities" intermingle with and fold into one another; characters from within the screen appear to enter the space of the audience; and the space of the audience appears to become one with the space of the screen. Three-dimensional images, theatrical effects, computer graphics, animation, wide-screen technologies, digital sound, and simulation ride engineering combine to construct the illusion of a breakdown of spatial boundaries that separate the audience's reality from the representation: The end result is that while the spectator is immersed in the exhilarating kinetics and illusions of the "ride," it becomes difficult to fix the boundaries that frame the illusion and distinguish it from the space of reality. With the "new" added to the "old" media experiences, the multiplication of remediated forms—which stand as paradigm to the baroque unity of the arts—also serves to heighten the emphasis that the neo-baroque places on the involvement of multiple senses.

The combined effort of all of the different innovative effects makes the *Terminator 2: 3D* experience seem and feel real. For example, when the T-70 cybots fire above our heads, we see and hear the sparks as their weapons fire. When the explosion erupts on the screen, we see, smell, and taste the smoke that fills the space of the auditorium. And when the T-Meg is shattered to smithereens at the end of the attraction, we touch and taste the sprays of liquid that dampen our bodies. State-of-the-art digital effects, the digital sound system, roller-coaster technology, and revamped widescreen and 3D cinema formats combine with theatrical effects such as fire and smoke to produce an immersive and sensorially entertaining experience that engages all our senses—from the haptic, the gustatory, and the olfactory to the auditory and the visual. Revealing the dynamic nature of form, our own era has taken baroque games of perception to new limits, necessitating a rearticulation of Gilles Deleuze's concept of a baroque "architecture of *vision*" and Martin Jay's "baroque *ocular* regime." When discussing the neo-baroque, we also need to consider an experience that engages the sensorium.

The tricks have always been there, but the technology has now changed. Contemporary entertainment forms employ a variety of technological means to achieve this shift in perception. In the process, current effects cinema and theme park attractions also perform and compete with prior effects traditions, continually attempting to technically outperform previous effects technology—and along with it, the perceptions of reality these technologies delivered. Indeed, underlying Bolter and Grusin's statement regarding the baroque's concern for immediacy and hypermediacy lies the possibility for a baroque logic: in "their efforts to remake themselves," according to Bolter and Grusin, current entertainment media often display a baroque obsession with virtuosity and the grand theatricality of illusionism. By seeking to remove the proscenium arch, current entertainment spectacles like *Terminator 2: 3D* also insist on the eventual revelation of the process of mediation.

Underlying *Terminator 2: 3D*, which frames itself within its own media history, is a virtuoso concern, therefore, one that results from its flawless articulation of an illusion that invades the audience's space in deceptively real and immediately experiential ways. Throughout the entire attraction, the spectacle maintains an undeniable sense that the convincing representational space it offers is being displayed so that the audience may admire it as a multitechnological feat of illusionism. The visual and sensory games that entertainment technologies articulate flaunt their capacity for making a reality out of an illusion—or, rather, for making the fantastic enter our world in such immediate and sensorially invasive ways. Increasingly, and through their own media-

specific methods, entertainment media strive to obliterate the frame that demarcates the distance between reality and fantasy.

Terminator 2: 3D lures the audience into various levels of represented realities by displaying a variety of technologically conjured effects, setting itself up in the process as a new kind of techno-spatial experience. Participatory techniques are taken to excess. Not only does it boast wider screens, greater digital surround-sound systems, state-of-the-art digital effects, and a 3D technology never witnessed before, but all these technologies combine to produce an assaultive sensation that integrates the audience into the illusion. *Terminator 2: 3D* lures the spectator-as-participant into its levels of reality, plunging him or her into a realm of spatial ambiguity both through an illusory invasion of the audience's space (through 3D) and through an illusion that plunges the audience into the spectacle's space (through wide screen). Unlike its 1950s spectacle counterpart, in the 1990s, *Terminator 2: 3D* is controlled at every level of production by computer graphics, ensuring the successful articulation of illusion as reality. Throughout the entire attraction, the audience's sense of their reality "morphs" to accommodate the various games of perception that envelop them in their illusionistic spaces.

When the T-1000 makes his first morphed, 3D appearance, not only does his screen form, as the Cyberdyne logo, morph into that of the chrome man, but the digital metamorphosis parallels a theatrical metamorphosis: liquid metal, computer-generated effect on the screen, slides into a live theatrical effect involving a live actor on stage, then back again to digital film effect on the screen. The audience is taken on a journey through different possibilities of illusions of reality. The theatrical space of the audience/Cyberdyne complex, the actors, and T-70 cybots performing live in the auditorium is interweaved with the filmed, videoed, and digitized realities of wide-screen, 3D, television, and computer images. Furthermore, the filmed realities contain within them further layers that reflect on different constructions of perceived realities. The result is an interplay between film and digital traditions, one that suggests that the incorporation of the digital into film has "improved" or "advanced" the audience's understanding of a perceptual reality (especially in relation to the perceptions provided by traditional film viewing experiences).

The attempted concealment of the paradox inherent in the interplay between perceptual and referential realities returns us to the principle of neo-baroque virtuosity. Underlying *Terminator 2: 3D* is a virtuoso concern, one that results from its flawless articulation of an illusion that invades the audience's space in such deceptively real terms. Like other neo-baroque examples, *Terminator 2: 3D* calls upon past sources that

influenced its form. The single screen (which suggests more conventional cinematic viewing) initially presented to the audience transforms to display also the morphing effects of the T-1000. For the first time in film history, 3D technology integrates with computer technology to expand the audience's perception of screen space's collapsing into theater space. The screen expands to triple its length, but the traditional wide-screen, Cinerama experience also introduces another computer-generated spectacle: the T-Meg. This liquid metal, insect-like creature fills the 180-degree space generated by the screen's expansion (which encompasses the spectator's peripheral vision, thus creating the illusion that we have entered representational space), then lunges at the audience to further invade the auditorium space.

The neo-baroque fold informs the logic of the spectacle as all of these multimedia "realities" intermingle with one another: actors from within the screen enter into the space of the audience; the space of the audience appears to become one with the space of the screen; effects on the screen thrust themselves forcefully into the audience's space (because of the combination of 3D and morphing effects, and through theatrical effects such as the sprays of water that hit the crowd when the T-Meg splatters into millions of pieces as it comes straight at us). 3D, computer graphics, and wide-screen technologies combine to construct the illusion of a breakdown of spatial boundaries that separate the audience's reality from the representation, perceptually collapsing the theatrical frame of the stage.

Throughout the entire *Terminator 2: 3D* attraction, the spectacle maintains an undeniable sense that the convincingly real representational space it is creating is also being displayed in order that the audience may admire it as a multitechnological feat of illusionism. But unlike the competition 3D attractions at Walt Disney World (*Honey I Shrunk the Audience* and *Jim Henson's Muppet Vision 3D*), *Terminator 2: 3D* does not round off its performance with the theatrical closure of the stage curtains. This attraction signals its difference from others by presenting a performance that is about the *removal* of the curtain: the removal of the barrier that separates the audience from the special-effects fabrication. Yet the fact that it achieves this so masterfully sets up an invisible curtain, one that is drawn to signal closure in the minds of the audience—a closure experienced during those moments of stunned silence and amazement that accompany the literally explosive end of the performance. The attraction literally ends with a bang as the T-800 blasts the Cyberdyne Complex of 2029 to smithereens. The effects of this explosion are not merely felt perceptually (while remaining contained by the frame of the screen); they are also felt in quite real (yet theatrical) terms through the vibrations under the audience's seats, through the heat that warms their bodies, and through the

sea of smoke that veils their vision as it drifts through the auditorium. The silence that follows is soon followed by the audience's tumultuous applause as the technological performance is acknowledged.

The visual and sensory games that entertainment technologies articulate flaunt their capacity for making a reality out of an illusion. Increasingly, and through their own media-specific methods, entertainment spectacles strive to obliterate the frame that demarcates a distance between reality and representation. The cinema relies on wide-screen formats, computer-generated special effects, and surround-sound experiences. Computer games immerse the player into their representational spaces through audience interaction. Theme park attractions draw upon a variety of methods, including Imax and Omnimax screen formats, wide-screen images, simulation rides, and theatrical experiences, to assault spectators sensorially, inviting them to believe that the illusion they witness is perceptually real. As Gunning observes in relation to pre-cinema: "These optical entertainments exemplify the state of suspended disbelief that Octave Mannoni describes as 'I know very well, and all the same. . . .' In a new realm of visual entertainment this psychic state might best be described as 'I know very well, and yet I see. . . .'" (Gunning 1995b, 471).

Again, fantastic effect paves the way for technological advancement. The special-effects companies employed to construct the spectacles within science fiction films and theme park attractions display a virtuosity not only with regard to advances in cinematic effects illusions, but also with regard to developments in optical and other sensory technologies. The final chapter will explore further the issue of virtuosity through the (neo-)baroque evocation of technical and technological transcendence.

5 Special-Effects Magic and the Spiritual Presence of the Technological

Sensual Seduction and (Neo-)Baroque Transcendence

Jurassic Park brings to maturity, in addition to the principle of virtuosity, two interrelated and inseparable features of neo-baroque visuality. The first is an innovative attitude toward the spectacle's construction of a spatial perception that emphasizes scientific principles. The second involves a seemingly contrary response that seeks to evoke states of amazement in the audience that have little to do with rationality. A relationship is sealed between representation and spectator, one intent on leaving the spectator in a state of wonder both at the "hyperrealistic" status of the representation, and at the skill and technical mastery that lies behind the construction of the represented spectacle. In the words of Deleuze, "the essence of the Baroque entails neither falling into nor emerging from illusion but rather *realizing* something in illusion itself, or of tying it to a spiritual presence" (1993, 124). Drawing on examples that highlight the union between technology and art, this chapter examines the nature of the "spiritual presence" that (neo-)baroque illusions elicit.

The relationship of the (neo-)baroque to precinematic traditions of magic performances and magic lantern illusions is also explored. The magic illusions conjured by magicians of the eighteenth and nineteenth centuries relied on optical technologies that were aligned with the reason of science—of man's attempts at ordering and understanding the world through rational means. In the employment of these optical technologies, however, the rational, scientific systems on which they were based often found expression in an antithetical form: in the fantastic effects illusions that invoked states of amazement in the viewer. Such eighteenth and nineteenth century magic traditions share a concern with perception and effect illusions, although, as will be discussed below, they are not concerned with the states of euphoric transcendence, the spirituality and wonder that is evident in the baroque and the neo-baroque.

Unlike their science fiction literary counterparts, which rely on the reader's imagining the effects of future science and technology as conveyed through the written word, the creators of science fiction cinema rely on visual spectacles that themselves embody the possibilities of new science. As seen in the previous chapter, the effects technologies that articulate the spectacles of contemporary science fiction films are examples of cutting-edge technological inventions (and the scientific principles that drive them). The neo-baroque nature of science fiction cinema resides partly in the magical wonder and "spiritual presence" effected by scientifically and technologically created effects illusions, and it is precisely such a wondrous state that is evoked in Steven Spielberg's *Close Encounters of the Third Kind* (1977).

The plot of *Close Encounters of the Third Kind* centers on a group of characters—the protagonist being Roy Neary (Richard Dreyfuss)—who, like Moses's chosen people, are driven by an almost religious fervor and mystical drive to congregate at a site in Moorcroft, Wyoming. In the film's climax it is not a vision of God they experience at Moorcroft, but rather a vision of transcendental wonder that accompanies the visitation of alien beings from another world. Scientists and government officials also congregate at the site, and through high-tech synthesizers that make communication with the aliens possible, they transmit musical harmonies to the heavens—harmonies that sound more like hymns than an alien communication system. In the sky, the clouds mass together ominously, then part to reveal colorful rays of light that usher in alien spaceship scouts that descend to the earth like messenger angels. Then there is a sudden lull and a portentous silence, soon to be replaced by an audibly increasing rumble from the sky, a rumble whose source is eventually revealed to be a monumental spaceship. The faithful onlookers stand frozen in states of awe and astonishment as they look upon the descending form, remaining transfixed by its multicolored, hypnotic beams of light (figure 5.1).

As the ship lands, the synthesizers continue to transmit their melodic tones in an effort to make contact with the supreme alien beings. The spaceship doors open, and beams of an other-worldly light emit from the ship, lighting up the scene in an ethereal glow from which pour a series of dreamlike figures, lost human souls who have returned to earth after years of absence. Cherub-like aliens emerge from the ship, soon followed by a spindly alien creature who, bathed in the rays of light, extends his arms to the onlookers in a pose reminiscent of centuries of depictions of the figure of Jesus Christ. Appropriately, a church service is held in preparation for the departure of the Chosen Ones. This group of humans, which includes Roy Neary, are led on board

Figure 5.1 The arrival of the alien spaceship in *Close Encounters of the Third Kind* (Spielberg 1977). By permission of The Kobal Collection/Columbia.

the ship (figure 5.2). Once inside, Neary looks around in wonder at the alien environment, his state of stupor accompanied by John Williams's nondiegetic melodies that further amplify his emotions. Looking up from the vast space that opens up within the ship and engulfs him. Holding back his emotions, Neary stares at a circular object surrounded by celestial golden lights that then erupt, invading the space with millions of shards with starlike brilliance. The spaceship takes off and ascends to the heavens from which it came, and the film's end credits roll.

This scene, depicting the much-awaited alien visitation, uses its "alien carousel of a spaceship" to induce states of euphoria and transcendence (Sobchack 1987, 284), both in Roy Neary and in the audience, which is similarly affected by the spectacular effects produced by the special-effects designer Douglas Trumbull. The film's special-effects technology appears to make dreams and fantasies come true: to make illusions seem to metamorphose into reality, this point being echoed in the nondiegetic inclusion of the Disney tune "When You Wish upon a Star" as Neary enters the spaceship.[1] But it is no longer Jiminy Cricket who opens the way to the transformation of fantasies into reality; rather, it is the effects technology. Within the diegesis it is the alien technology

Figure 5.2 Roy Neary (Richard Dreyfuss) is escorted on board the alien spaceship by cherubic aliens in *Close Encounters of the Third Kind* (Spielberg 1977). By permission of The Kobal Collection/Columbia.

that promises to fulfill Neary's dreams, but within the space of the spectator, it is both Steven Spielberg and Douglas Trumbull who perform the role of Jiminy Cricket as impresarios of wonderment.

The film's special effects relocate its focus away from the narrative toward the visual and auditory, and this denarrativization aids in the feeling of transcendence. A neo-baroque interaction between affect and effect, and their accompanying states of wonder, comes into play. In the special director's cut release, from the moment when the spaceship lands and up until the closing credits, over half an hour of screen time elapses. Half an hour of pure spectacle—with hardly a word spoken—accompanied by a highly emotive music track (composed by John Williams) invites the audience within the film to ponder the other-worldly experience of the arrival of alien technology within the diegesis, and the audience beyond the diegesis to wonder over the special-effects technology that constructs the film's spectacle. This is an example of

cinema that is aware of setting up a performance for its spectator. Like *Terminator 2: 3D*, *Close Encounters* acknowledges our presence, so that we can celebrate the nature of the performance that each offers. As Bukatman states, "the effect is designed to be seen, and frequently the narrative pauses to permit the audience to appreciate . . . the technologies on display (what, in a somewhat different context, Laura Mulvey once referred to as 'erotic contemplation')" (1995, 271).

The climax of the film reveals a new attitude toward cinematic spectacle, one that has now become commonplace in contemporary cinema. Sobchack argues that contemporary science fiction films are "literally and thematically connected to intense and transcendent states of feeling" that are intent on producing states of euphoria and "intoxicatory or hallucinogenic intensity" (1987, 284). *Close Encounters* is viewed as one of the earliest New Hollywood films to call upon this state of wonder, connecting affect to effect. Displaying its neo-baroque virtuosity, the film relies on its historical sources to achieve its effect. The overt religious overtones, both narrative and spectacle, that imbue the final scene deliberately aim at paralleling both alien visitation and technological spectacle with Christian traditions. The religious fervor that drives characters like Neary, and the allusion to Moses and his chosen people are made explicit in the film. Early in the film, as Neary argues with his wife in the family home, one of his children watches *The Ten Commandments* (the 1956 Cecil B. DeMille blockbuster) on television. By alluding to *The Ten Commandments*, Spielberg is not only proffering a parallel between Moses and the Word of God and the aliens and the Word of the Extraterrestrial. Spielberg is also acknowledging a technological parallel shared between the cinema of today and that of the 1950s. Both cinemas opened the way to spectacle of baroque proportions. In referring to the 1950s spectacle tradition through *The Ten Commandments*, Spielberg is paying homage to an influential effects tradition gone by, while also making a claim for the advances in technological spectacle that he and Trumbull introduced in 1977 with *Close Encounters*, a spectacle that no longer needed religious themes and narratives to create a sense of awe. This sense of awe was now to be found in the effects technology itself. Once we are overpowered by the effects experience, however, such self-reflexive touches that remind us of an *effects* tradition are placed on hold. Within the film's narrative, it is the aliens who invoke a state of transcendent transformation. But for the audience, it is the effects technology that evokes a state akin to this rapturous state of other-worldliness.

As suggested in chapter 4, the spectator has an ambiguous relationship with this spectacle. Crucial to this relationship is the simultaneous acceptance of the fantastic illusion

both as a technological achievement and as an alternative reality. As in the mathematical organization of Pozzo's S. Ignazio Ceiling or the reflection of the computer-generated dinosaur in the mirror in Spielberg's *Jurassic Park*, the effects technology is both exposed and disguised. Embodied in this ambivalence for spectacle is a clash of opposites that connect the rational and technological with the irrational and emotional in a union configured by special effects.

Albert La Valley has characterized special effects as being used to "show us things which are immediately known to be untrue, but show them to us with such conviction that we believe them to be real" (1985, 144). As he correctly notes, it may be argued that all cinema is a technologically produced special effect. The baroque dimension of the special effect, however, emerges when the fantastic "comes to life." Within this state of ambivalence the spectator is asked to be astonished at the technology that magically produces the impossible in such photo-realistic terms. The combination of the irrational with the rational is experienced in the ambivalent tension that tugs at the spectator: the oscillation not only between emotion and reason, but also between the sensory and the logical, between three-dimensional and two-dimensional space. As Sobchack states, the "special effects [which] have always been a central feature of the SF [science fiction] film . . . now carry a particularly new affective charge and value" (1987, 282). A new "emotional ground tone" aesthetically transforms the spectacle, shifting the spectator's engagement from "deep and private affect" to the "representation of superficial and visual special effect" (258). Neo-baroque ambiguity pervades audience perception. On the one hand, the affective response denies or disguises technology's technological nature. Yet on the other, it is the technological effect that makes possible the affect. The concern for evoking states of amazement goes hand in hand, therefore, with the crafted manipulation of spatial perceptions, and with the active negotiation of the spectator in relation to this environment.

Although Bernini's artistic *tour de forces* definitely display the relationship between spectacle and powerful patronage, another significant dimension of their address centers on the ways his art is often motivated by a mystical desire to thrust the spectator into the work by inducing states of transcendence through amazement, delight, and wonder. In its address to the spectator, the multimedia arrangement of Bernini's *The Ecstasy of St. Teresa of Avila* (figure 5.3) in the Cornaro Chapel in Santa Maria della Vittoria in Rome (1644–1652) startlingly parallels that of the final effects extravaganza of films like *Close Encounters*, and the numerous special-effects films that followed in its wake.

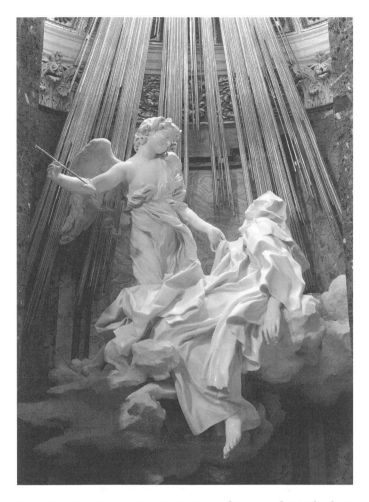

Figure 5.3 Gian Lorenzo Bernini, *The Ecstasy of St. Teresa of Avila* (detail), Cornaro Chapel, Santa Maria della Vittoria, Rome (1645–1652). By permission of The Art Archive/Album/Joseph Martin.

The Ecstasy of St. Teresa merges a variety of media—painting, sculpture, and architecture—into a unified composition that perceptually spills into the church space. It is frequently claimed that Bernini's work often aimed to seduce the senses through the theatricalization of spectacle, yet as Careri has observed, comparisons to the theater reduce the composition to "mere spectacle" and ignore the integral function served by the combination of multiple media in inducing the effect of that spectacle (1995, 3). The *St. Teresa*'s overall effect is reliant on its monadic structure. Chromatic marble, architectural detail, gold, painting, stucco—all fold fluidly into one another, luring the viewer into an architecture of vision that embraces the polycentric nature of the composition. In turn, Bernini's skillful creation of surface, texture, and motion evokes shifting sensations and thoughts in the spectator. Bernini has been, during his time and since, heralded as the master of the "unity of the arts." The *bel composto*[2]—the beautiful union of multiple media—that he conjures with such ability is not only concerned with the production of a harmonious composition. Instead, in Bernini's work, the diverse media materials of the three arts of painting, art, and architecture maintain their differences, so that they can "surpass their own limits, transcending one into another" (Careri 1995, 8). Importantly, the movement between media directly elicits responses in the viewer. In the *St. Teresa*, the viewer looks on at a sculpted angel who descends on metallic rods representing rays of other-worldly light that spill out from the painted skies above. As the rays descend into the space of the chapel, they transform from painted form to the sculptural form of gilt rods, while merging with the natural atmospheric light that also illuminates the chapel. The viewer is engrossed in what appears to be a first-hand experience of the vision of the mystic St. Teresa: as the angel prepares to pierce her heart (a symbol of Teresa's willingness to serve God), she writhes, anticipating the ecstatic reverie that awaits her (Teresa of Avila 1949).

The special effects of this composition initially stir the senses on the level of the materiality of the *bel composto*. The solidity of marble is defied: Its density and weight are re-created and transformed into a weightless cloud that floats in the space of the chapel, the masses of flowing fabric that drape themselves over Teresa and the angel, and the soft, pliable flesh that allows Teresa to convey her orgasmic pleasure. Gold appears to dematerialize as it erupts into the chapel background, continuing the rays of ethereal light that pour in through the chapel windows above. The column and pediment that frame the vision buckle and bulge, threatening to escape the limits ascribed to architecture. And the painted angels and clouds visible in the vault spill beyond the limits of the flat, hard surface on which they are painted, escaping the architecture and seeming to merge with and share the very space and air of the chapel.

Careri argues that the effect of the *bel composto* on the viewer results from the creation of a "montage consisting of a series of progressions or leaps from one component of the *composto* to another" (1995, 2). Each shift between media forms that transcend their nature creates a similar shift in the sensory perception of the viewer; the viewer's senses are assaulted as the viewpoint leaps from medium to medium, leaving him or her to marvel at the textural effects and the motion of matter that Bernini creates. Although the virtuosity of the effects is an important aspect of the response, the polycentric and dynamic nature of the diverse elements of the *composto*, with each medium taken to its limits, finally culminate in "an explosion . . . at which point another element comes to the fore and carries on" (75). At this next level, when each monadic component interrelates with the others and creates a unified whole, the spiritual comes into play, and the viewer experiences a state akin to transcendence.

Reproducing Deleuze's dual-level baroque house, the *composto* of special effects also finally unveils a cosmological logic that distinguishes the celestial and earthly realms, so that they may ultimately be united. As outlined by Deleuze, the idea of the dual-level house proposes that existence involves a complex interplay between the material (the lower part of the house) and the immaterial, or cosmological (the upper part of the house), as aspects of "being." In the *St. Teresa*, the spirituality embodied by the heavens is conveyed through an ethereal quality created by light, colorful and fluid forms conjured by the medium of paint; additionally, the natural light provided by the window seems to puncture the solid architectural space and fill it with a mystical, diaphanous brilliance. As Careri explains in regard to Bernini's Fonesca Chapel in San Lorenzo in Lucina, Italy, (1665–1675), "the 'tectonic' value of the interior architecture is diminished and its very nature as an impermeable 'container' of enclosed space challenged" (1995, 24). Although the two realms—the celestial and the earthly—are kept separate by the horizontal, decorative border that runs across the midpoint of the chapel wall, the two worlds are finally united at the point where the vision appears: The divine light from above punctures the pediment and columns that frame St. Teresa and the angel, warping the architectural feature (and denying it the solidity of its matter) while also filling the earthly space with a heavenly light that enters St. Teresa, making her body vibrate with its divine power.

These *composto* effects therefore produce powerful affects. It is not the representation of the illuminated objects that is significant, however, but the illumination itself. St. Teresa's ecstasy is an abstraction: The effect of the ecstasy is unrepresentable by definition. Reflecting the allegorical nature of the baroque, the *composto* effects make possible the representation of something—faith and the love of God—that is

unrepresentable. As St. Teresa describes in her *Relazione Spirituale*, faith, the desire of God, and the state of the soul cannot be made visible. To give such concepts form, it is necessary to make "comparisons" that give the inner realm and soul a material substance. So, for St. Teresa, the love of God feels "as if someone had plunged an arrow into the heart or into the soul. One experiences a pain so intense that one cries out, but at the same time it is so delightful that one wishes it would never end. It is not a pain of the body or a physical wound. It has nothing of the body; it is all within the soul" (quoted in Careri 1995, 60).

What viewers of the *St. Teresa* see before them, therefore, is nothing of material substance, but a vision existing in St. Teresa's imagination, a vision that attempts to seduce the viewer, making him or her an active participant in the affective aspects of St. Teresa's vision and moving him or her to a supernatural plane through sensorial engagement.

I find Michael Heim's definition of cyberspace fascinating in this respect. Highlighting William Gibson's depiction of "cyber entities" as "the sign of Eros," Heim notes that, in Gibson's novel, *Neuromancer*, characters experience cyberspace "as a place of rapture and erotic intensity, of powerful desire and even self-submission" (1991, 62). Compared to the experience of the matrix of cyberspace, "Ordinary experience seems dull and unreal by comparison" (62). Heim's description of the raptures of cyberspace could easily be applied to the hallucinogenic effects of *Close Encounters* and the mystical experience of *St. Teresa*. It is interesting that it is to the sixteenth-century Spanish mystics, John of the Cross and Theresa of Avila (Bernini's subject) that Heim (and Gibson) turn to in order to find the words that most closely evoke the experience of cyberspace. Heim notes that in searching for ways to define spiritual divinity in their writings, like Gibson, these mystics "reached for the language of sexual ecstasy" (62). As St. Teresa noted with regard to the soul, the state of cyberspace—the realm of the digital—cannot be represented. Instead, the intensity of both the divine and the fantastic is given concrete form through erotic imagery.

The *effect*, which is representable, provokes the *affect*, which is unrepresentable. Via Vivian Sobchack, Brooks Landon (1992) has argued that, in contemporary science fiction, an interplay between affect and effect is in operation, one that initiates an "aesthetic of ambivalence." The main focus of neo-baroque spectacle is the conjuring of the sublime embodied in the vision that is made possible through effects illusions. The spectator of *St. Teresa* is enveloped in an almost mystical experience. Much like the response Spielberg and Trumbull intend to invoke in the audience of *Close Encounters*. Virtuosity reigns supreme as the performance of special effects envelops and plunges

the spectator into the space of the visionary-like spectacle, involving him or her more directly in the transcendental events taking place before him or her. A self-reflexive form of address is highlighted in the way audiences are doubled.

In the sides of the chapel are relief sculpture images, set within an illusionistic architecture, of members of the Cornaro family, who commissioned the work. The receding space is linked perceptually with the space that viewers inhabit in the aisle of the church. As with the doubling of the audience in *Close Encounters*, sculptural diegetic and actual nondiegetic viewers in the *St. Teresa*, look on marveling at the vision that is taking place before them. On the level of affect, through spectacle, we are invited to share the transcendent ecstasy of St. Teresa, while on the level of effect, we marvel at the level of skill required to produce this vision of her martyrdom. As with *Close Encounters* it is both the spectacle and technical mastery as performance that produce the state of affect. The (neo-)baroque "seduces the viewer who in the end is its true material" (Damisch 1995, ix). The teachings of St. Ignatius of Loyola were especially influential in regard to sensory perception, and in the seventeenth century, the Society of Jesus continued his teachings, as outlined in his *Spiritual Exercises*, placing particular emphasis on the emotions and the "application of the senses in contemplation" to develop spiritual awareness (Careri 1995, 38–39).

In the Fonesca Chapel, Fonesca, Bernini's patron, is depicted, like the Cornaro family in their chapel, at the side of the chapel, as if looking onto the main sculptural composition of the altarpiece, the *Annunciation*. Careri makes the point that the *bel composto* is fundamentally motivated by Jesuit beliefs, the Annunciation being a representation of "an imaginary picture in Fonseca's mind" as he contemplates the religious scene to make contact with his soul (1995, 45). Fonesca's placement at the side of the chapel, however, suggests that he is not the individual that the image directly addresses: The viewer who enters the space of the church and has a frontal view of the chapel. Viewing the scene in its entirety, the worshipper can connect the monadic elements of the *composto* and understand the significance of the contemplation in which Fonesca is involved. A similar argument may be made with regard to the fictional audience in the Cornaro Chapel: Their presence strengthens the centrality of the external viewer, who is thereby provided with the means to transcend the material realm and attain spiritual understanding, thus becoming part of the *composto*.

One of the repeated concerns of the baroque era, even beyond the Jesuits, was that the individual be "moved from within" through an expression in art. Unlike the Renaissance artist, who sought serenity, clarity, and order the Baroque artist was intent on stirring and impressing "directly and immediately" (Maravall 1983, 75). This

intention was supported and influenced by philosophical and religious writings of the era. The goal of "amazement" is voiced in these writings in diverse and dynamic ways, and it was during the Renaissance that the humanist movement initiated an interest in Aristotelian theory on the role of wonder in art. As Maravall explains, however, although Aristotelian theory was read in the Renaissance, it was Baroque artists who redefined the function of the term "wonder," striving to stir emotive sensations in the viewer. According to the logic of baroque spectacle, audiences "must be moved by acting with calculation upon the extrarational workings of their affective forces," with the "efficacy of affecting," of awakening and moving the affections, being one of the founding motives of the baroque (1983, 75).

In addition to painting and sculpture, music especially came to be admired in the baroque era for its capacity to engage the emotions: Relying on the "doctrine of affections," music written and performed with appropriate technical skill was considered to be the embodiment of the ability to stimulate both the senses and reason or intellect. Expanding on music theory from antiquity, baroque music theory expounded the "affective qualities of each mode or key," which expressed various states of mind and soul (Bukofzer 1947, 365).[3] As in the representational arts, the realm of the senses and that of reason and intellect folded logically into one another. Affections were intimately bound up with the technical elements of the music craft: Music was, for the baroque composer, as exact a science as mathematics. As Bukofzer explains, the wide dramatic range of affections required of monumental forms such as opera—and the keys necessary to produce them—"would make well-nigh superhuman demands on musical understanding" (1947, 366). In his *Musurgia Universalis* of 1650, Kircher reflected the view of other music theorists in associating musical acoustical laws with mathematics and sciences like geometry and astrology. Music came to represent the harmony of the universe itself. As Bukofzer states,

> The works of Bacon, Descartes, and Leibniz testify to the fact that music held an important place in the philosophical treatises of the baroque era. In accordance with his metaphysical system Leibniz defined music as "the unconscious counting of the soul," convinced that the unconscious realization of mathematical proportions was the ultimate cause of the sensuous effect of music. In this manner Leibniz, and with him many music theorists, reconciled the senses and the intellect, the audible and the inaudible. *Sensus* and *ratio* were the two basic factors in the judgment and evaluation of music, and, for that matter of all other baroque arts. The two factors complemented each other. . . . The aspect of *ratio* . . . revolutionized the science of music and led to the substitution of the physical properties of sound for mathematical or purely speculative rationalizations. (1947, 392)

The baroque arts aimed at overwhelming the audience on sensory levels. Narrative purpose and instruction were overpowered by sensory purpose. Reason was replaced by the senses. In the words of Alewyn: "The baroque illusion is always conscious and intentional: it refuses to seduce the soul or even to deceive reason; it wishes to seduce the senses" (Alewyn 1965, quoted in Buci-Glucksman 1994, 60).

The attitude of Bernini, as an exponent of the baroque delight in the senses, parallels that of Pietro da Cortona. Although in his treatise on painting, Cortona insisted on the moral function of art via narrative focus, his work is above all characteristic of a tendency of the century that approached art as "pure form without an extraneous raison d'être" (Wittkower 1985, 24).[4] While serving an ideological purpose, the work can also undermine this function by asking to be experienced as pure form in the sense that the delight evoked results from the formal properties that make possible the special effects. As Jay claims, baroque reason is "[r]esistant to any totalizing vision from above, the baroque explored what Buci-Glucksman called 'the madness' of vision, the overloading of the visual apparatus with a surplus of images in a plurality of spatial planes. As a result, it dazzles and distorts rather than presents a clear and tranquil perspective on the truth of the external world" (1994, 47–48).

In playful ways, baroque spectacle speaks directly to viewers through the "seduction of their senses." The prioritization of spectacle over narration—and often its audio equivalent—results in the "denarrativization of the ocular" (1994, 51). According to Jay, this denarrativization of the ocular, which was finally realized in nonrepresentational abstract art in the twentieth century, is also present in the baroque; the baroque ocular regime overloads the narrative signs of paintings, producing a "bewildering excess of symbolic meaning," with the result that "in the relationship between the visual signifier and the textual signified, images were increasingly liberated from their storytelling function" (Jay 1994, 51).[5] Foucault has also argued that, rather than the baroque's focusing on "resemblance," which is supported by narrative structures, for the baroque "similitudes have become deceptive and verge upon the visionary or madness . . . they are no longer anything but what they are" (1986, 47–48).

Aliens and the Second Coming: The Spiritual Presence of the Technological

Through technical skill and an understanding of the mathematical principles of perspective, Bernini's *St. Teresa* transports the viewer to another realm: a spiritual realm that functions as a liminal space that provides insight into a heavenly vision according to Catholic teachings. Responding to a different cultural moment, *Close Encounters*

constructs its vision by interacting with 1970s technologies and belief systems. It is no coincidence that in this film, Spielberg transforms the Christian focus of *The Ten Commandments* into a New Age variation. Reflecting its times, *Close Encounters* not only embraces the spirituality of New Age religion, but it especially invokes the technological obsessions associated with New Age movements. In *Children of Ezekiel* (1998), Michael Lieb provides a fascinating account of the ways in which cultures at different times transform biblical prophecies, such as the visionary prophecies of Ezekiel and John (from *Revelation*), making them applicable to specific cultural contexts. Significantly, reflecting the transitional nature of the late 1970s, it was end-time prophecies that captured the imagination of the New Agers.

Ezekiel's vision of God arriving on a gold chariot during the end time, surrounded by rays of divine light, is especially significant from a New Age perspective. Anticipating the Rapture that will follow during the Second Coming, when Christ will take the worthy up to heaven, in *Close Encounters*, Spielberg deliberately revisits Ezekiel's prophecy:

> Now it came to pass . . . that the heavens were opened, and I saw visions of God. . . . And I looked, and, behold, a whirlwind came out of the north, a great cloud, and a fire infolding itself, and a brightness was about it, and out of the midst thereof as the colour of amber, out of the midst of the fire. . . . As for the likeness of the living creatures, their appearance was like burning coals of fire, and like the appearance of lamps: it went up and down among the living creatures; and the fire was bright, and out of the fire went forth lightning. . . . Now as I beheld the living creatures, behold one wheel upon the earth by the living creatures, with his four faces. . . . And when they went, I heard the noise of their wings, like the voice of great waters, as the voice of the Almighty. (Ezekiel 1:1–24)

As in Ezekiel, during the final minutes of *Close Encounters*, an audiovisual extravaganza confronts the protagonists: Great clouds appear in the sky, emitting great brightness and flashes of lightning; creatures and spirits soon follow, each on "wheels" that come down to the earth, then fly back up toward the heavenly light. Neary and Ezekiel (1:26–28) then sight a being who has the appearance of man but is surrounded by such brightness that it is as if he is lit by fire. Following the revelation that he is confronted by the image of the Lord, Ezekiel falls to the ground. Although Neary stands and faces the being that confronts him, his facial expression reveals a similar sense of emotional fullness as he realizes he is standing in the presence of divinity.

Since the 1970s, Ezekiel's vision of God has represented "an impulse through which the will to power finds expression in the wonders of technology that define the

modern world" (Lieb 1998, 4). Increasingly, "the ineffable, the inexpressible, the unknowable" embodied in this visionary tale of the approach of the Second Coming has been "technologized" to meet the needs of contemporary culture (4).[6] As Lieb explains, in an effort to control and understand the mystery of the second coming, the details of the vision underwent an act of "technomorphosis" (8), and the most significant for our purposes is that which interpreted the Rapture and Second Coming as an event involving alien visitation. With respect to *Close Encounters*, Lieb suggests that by associating the ineffable with the machine, Spielberg "transforms the technological into a science of the divine. In that act of transformation, Spielberg brings into play his delight in the 'scientific' dimensions of ineffability" (46).

In the 1960s Jacques Vallée (whose fictional double Spielberg inserted into the film as scientist Claude Lacombe, played by Jacques Truffaut)[7] captured popular imagination and altered belief systems by publishing his *Anatomy of a Phenomenon* (1965), a book about UFOlogy (the study of unidentified flying objects, or UFOs). Numerous other books followed: Morris K. Jessup's *UFO and the Bible* (1956), W. Raymond Drake's *Gods and Spacemen in the Ancient East* (1974a) and *Gods and Spacemen of the Ancient Past* (1974b), Erik von Daniken's *Chariots of the Gods* (1969), Josef F. Blumrich's *The Spaceships of Ezekiel* (1974),[8] Raël's *The Book Which Tells the Truth* (1974) and *Extraterrestrials Took Me to Their Planet* (1976) (see ⟨www.rael.org⟩), and Gerhard Steinhauser's *Jesus Christ: Heir to the Astronauts* (1976). Many of these texts reconsidered the vision of Ezekiel in light of alien visitation (Lieb 1998, 50–51). For von Daniken, representations of past god worship revealed that "God" was "an ancient astronaut" and that what Ezekiel saw was "a spacecraft of momentous proportions piloted by ancient astronauts who have since been worshiped as divine beings" (Lieb 1998, 53). Clearly influenced by the increased number of alien abduction and UFO-sighting reports, *Close Encounters* also reflects (often consciously) on an extensive body of texts (such as those cited above) that gave "scientific credence" to religion and alien visitation (Lieb 1998, 4). Since *Close Encounters* integrated the lessons of the New Age movements, popular culture from *Independence Day* (I am thinking here of the believers who set up vigil on a skyscraper rooftop as they await alien saviors) to the *X-Files* has "technomorphosed" the Second Coming. An important distinction, however, needs to be made between the baroque and neo-baroque in relation to representation and spirituality. Whereas the baroque seeks to make concrete or give representation to that which is unrepresentable (the spiritual), the neo-baroque seeks to make the concrete (the technological) unrepresentable by imbuing it with a spiritual quality. Many New Age groups, especially the fringe groups obsessed with science fiction, engage in precisely such a neo-baroque transformation.

These spiritual beliefs have persisted, and many New Age groups base their belief systems on the understanding that the savior will arrive not from the abstract realm of heaven, but from the literal heavens. The Raëlian religion, founded in 1973 when the group's leader, Raël, (much like Ezekiel) was "visited" by an alien. As is explained on the group's Web site ⟨www.rael.org⟩:

> The Raëlian Religion ... is an international, non-profit making organisation whose prime goal is to establish an official embassy for extra-terrestrials. . . . It should be made clear at this point that the original stimulus for founding such an embassy was a request made to a journalist called Raël by an extra-terrestrial, during an extraordinary encounter in the volcanoes of central France on the 13th December 1973. The extra-terrestrial explained that:
>
> • It was they who created all life on earth.
> • Humans in the beginning mystified them and adored them as gods.
> • It was they who started the world religions as a way of progressively educating humanity.
> • Now that we can understand them, they wish us to establish an embassy for them.
>
> The embassy, they explained, could become a source of great benefit to mankind and could greatly accelerate human progress in many fields. They explained that their name "Elohim" which has been mistakenly translated as "god" in the Torah and Bible, originally means "Those who came from the sky" in ancient Hebrew. Now that mankind has started creating life in laboratories itself, they judged that we are finally capable of understanding how they created us and how yesterdays religions and tomorrows science are simply two ends of the same string. ("The Raëlian Religion" 2002)[9]

Like numerous New Age movements, the Raëlians (who have over 55,000 members in eighty-four countries) embrace the technological with an obsessive passion, their "prophet" Raël insisting that the technological and scientific capabilities of humans must advance so that we may be worthy of greeting the master race of Elohim beings from other worlds. The Raëlians have added a series of amendments to their Declaration of Human Rights to create a new version that the Web site refers to as "the Raëlian Movement's new version of the Universal Declaration of Human Rights." Article 14 of the Raëlian version, as posted on the Web site, reads: "Everything must be in place to stimulate the development of Sciences. Scientific discoveries must be designed and oriented toward the improvement of every human being's life conditions, so that everyone can benefit from them without being discriminated against and so that everyone's happiness is improved." Considering scientific and technological

advancement to be integral to human evolution, Raël has invested millions of dollars in cloning technology. The Web site entry explains the rationale for this investment most coherently:

> Welcome to CLONAID™—the first human cloning company! CLONAID™ was founded in February 1997 by Raël who is the leader of the Raëlian Movement, an international religious organization which claims that life on Earth was created scientifically through DNA and genetic engineering by a human extraterrestrial race whose name, Elohim, is found in the Hebrew Bible and was mistranslated by the word "God." The Raelian Movement also claims that Jesus was resurrected through an advanced cloning technique performed by the Elohim. Raël has handed over the CLONAID™ project one year ago to Dr Brigitte Boisselier, Raëlian Bishop, who is now CLONAID's™ Managing Director. Dr. Brigitte Boisselier has founded a new company that is now carrying out the CLONAID™ projects as well as other projects presented herein. The name and the location of this company are currently kept secret for obvious security reasons.

Raël, the man who has himself offered up his DNA for cloning purposes, clarifies: "Cloning will enable mankind to reach eternal life. The next step, like the Elohim do with their 25,000 years of scientific advance, will be to directly clone an adult person without having to go through the growth process and to transfer memory and personality in this person. Then, we wake up after death in a brand new body just like after a good night sleep!"

Beyond advancing the UFO mythology of the divine alien, the last two decades have continued to imbue the alien nature of our new technologies with a spiritual quality. In recent times, cyberspace in particular has captured the popular imagination, its ethereal space embodying the awesome powers of the technological. For Benedikt, and many since him, the spiritual qualities of cyberspace lie in its ability to transcend the material limitations of reality. Cyberspace is, he says, "[a] new universe, a parallel universe created and sustained by the world's computers and communication lines. A world in which the global traffic of knowledge, secrets, measurements, indicators, entertainments, and alter-human agency takes on form: sights, sounds, presences never seen on the surface of the earth blossoming in a vast electronic night" (1991, 1).

Virtual reality, especially as it came to be theorized and imagined in the 1980s and early 1990s, was akin to "a religious vision of cyberspace" that adopted the role of "Heavenly City" (16). Embracing technology and the prophetic "wisdom" of New Age belief systems, Spielberg's *Close Encounters*, in turn, adopted the role of prophet. For Stenger, for example, *Close Encounters* is transformed by New Age philosophy into

a prophetic vision that anticipates, in the fervor of the followers who await the technologically enhanced sublime aliens, the technology of the computer, and the cyberspace vision it would contain: "a wavelength of well-being where we would encounter the second half of ourselves" (1991, 50). Through the union of cyberspace, dream, hallucination, and mysticism, "the imaginary might become a reasonable subject of science," and while immersed in this space, "We will all become angels, and for eternity! Highly unstable, hermaphrodite angels, unforgettable in terms of computer memory. In this cubic fortress of pixels that is cyberspace, we will be, as in dreams, everything: the Dragon, the Princess, and the Sword" (52).

Stenger further explores the nature of cyberspace and the technological via Mircea Eliade's (1961) work on the sacred. According to Eliade, despite the desacralization of the world through modern science, the sacred finds a way to make its presence felt: "Man cannot get completely away with his religious behavior. For the Sacred is a dimension of consciousness" (quoted in Stenger 1991, 54). Distinguishing itself from material reality, cyberspace exists on another level of reality. As such, cyberspace, like the heavens, becomes an ideal target for a "hierophany: an irruption of the Sacred that results in detaching a territory from the surrounding cosmic milieu and making it qualitatively different" (Eliade, quoted in Stenger 1991, 55). Conditions are ripe, therefore, for religion to re-create the experience of transcendence within this new, digital heaven. The cinema can create and maintain a deceptive perception that collapses the proscenium and weaves the spectator (even if briefly) into its magical worlds, but cyberspace promises a more powerful merging of reality and illusion. The very identity of the "spectator" can be folded into this ethereal space through interaction, in the process undergoing transformations and transcending to places that are the stuff of both magic and the divine, as has been argued strongly by Erik Davis (1998) and Margaret Wertheim (1999). And as in Ezekiel's vision, the vehicle that takes individuals on this glorious journey is technology. Such mystical possibilities also contain within them an aura of magic.

The Magic of Spectacle

In *Artful Science: Enlightenment Entertainment and the Eclipse of the Visual Education* (1994), Stafford draws attention to the "intelligence of sight" (xxii). There is much to be learned from our technologies in the context of entertainment, for often they speak of the times that found use for them. Historicizing entertainment and the visual component of the eighteenth-century leisure culture in relation to the Enlightenment, Staf-

ford observes that there was a cultural transition from a dominant visual baroque order in the seventeenth century to a dominant textual order initiated by the Enlightenment (a transition that is again manifested during our times, highlighting a move to a dominant audiovisual order). The transition period of the eighteenth century combined both orders: the delight of the visual and the reason of the textual. Stafford also suggests that the technological upheavals manifest in the late twentieth century have resulted in similar states of flux to that of the eighteenth century, as new technologies such as computers attempt to integrate the visual into the textual. Various mathematical and scientific re-creations of the eighteenth century involved "ways of doing science by stimulating the eyes." The previous baroque delight in the ocular was reshaped by technologies of the eighteenth century (1994, xxii). As the new era of reason and as upholder of the classical, the Enlightenment sought an "instructive purpose" to visual delights (1994, 1). It was, above all, the figure of the magician, who, operating as quasi scientist and having in his repertoire the magic lantern, acted as a medium between a baroque order of vision and Enlightenment concerns with the rational. The "artful scientists" (who included the magicians) flourished at a time when visual culture associated with the baroque was moving toward a "text-based structure," and magicians played an important role in the transition period (1994, xxv). Exposing charlatans intent on the deception of illusions, magicians revealed that scientific reason lay behind fantastic illusion.

The magical properties of the cinema have been acknowledged from its beginnings and reveal the cinema's reliance on and remediation of the rich audiovisual heritage that preceded it. Like its predecessors, the cinema (particularly through genres like science fiction) has retained an ambivalent relationship between the magical manifestations of fantastic visions and the scientific, as well as the affect-effect relationship this entails. The ambivalence present in film technology's ability to produce "movie magic" is expressed effectively by Martin Scorsese:

> There has always been a magic to the movies. We all know, of course, that movies are the product of science and technology. But an aura of magic has enveloped them right from the beginning. The men who invented movies—Edison, Lumière, and Méliès—were scientists with the spirit of showmen: rather than simply analyze motion, they transferred it into a spectacle. In their own way, they were visionaries who attempted to convert science into a magical form of entertainment. (quoted in Robinson 1996, xi)

The association between cinema and a magic created through science is not surprising given the cinema's early connections with magic traditions, and it is an association

that has persisted throughout the history of the cinema. It may be seen, for example, in the Industrial Light & Magic logo, which was created in 1975 to accompany the special-effects house established to produce the effects for *Star Wars*. The logo depicts a magician coming out of an industrial gear.[10] In many respects, although today's film technology may be transforming at a dramatic rate toward the digital, in that sense being radically different from that of early cinema, its fundamental concern with constructing magical illusions out of new technologies that are associated with the rational and scientific remains similar to that of early cinema.

Although their underlying concern may have been to use spectacle to reveal the greater reason of science, the magic illusions produced by magicians of the eighteenth and nineteenth centuries relied on distinctly baroque ambiguities. Optical technologies such as the magic lantern, which was in the magician's repertoire, revealed a tradition preoccupied with the magical power of images. As with the seventeenth-century effects of *St. Teresa* and the contemporary effects of *Close Encounters*, audience responses wavered between the rational and the irrational, the scientific and the magical. The visual effects of the "artful scientists" who are the subject of Stafford's book (1994) may have progressed along a singular path that aimed at unveiling the "reason" of science, but the optical illusions conjured by magicians invoked a more complex and ambivalent state in the spectator, one relying on a baroque duality: The delights of magic and science were not antithetical.

The initial popularity of the magic lantern (a technological device later used by magicians) as visual entertainment has its origins in the seventeenth century. Athanasius Kircher, the individual often (incorrectly) credited with its invention, discusses the function of the magic lantern in his *Ars Magna Lucis et Umbrae* of 1671. Kircher's magic lantern contained a candle and a concave mirror (figure 5.4). The light falling onto the mirror was reflected onto an image that was painted on glass. Through the magnification provided by projection lenses attached to the lantern, the image (which usually depicted a fantastic theme) could be magnified and projected onto a wall or screen (Castle 1988, 31–33).[11] Magic lanterns transcended the "limitations of standard forms of pictorial illusionism," expressing in concrete form the ways in which contemporary "science" had altered perceptions of the universe. The panorama (a form that later influenced wide-screen cinema), for example, expressed this concern with perception by extending the notion of coextensive space, creating spectacles that engulfed the viewer, and the system of binocular illusion found in the stereoscope (which became the model for 3D cinema) attempted to create an even more "realistic" perception of a three-dimensional representational environment that invades the viewer's own.[12]

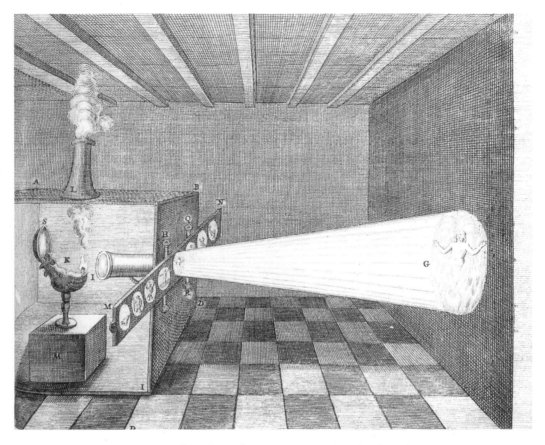

Figure 5.4 Magic lantern projection from the Kircher Museum. From Georgibus de Sepibus, *Romani Collegii Societatis Jesu Musaeum Celeberrimum* (Amsterdam 1678, 39). By permission of the University of Chicago Library, Special Collections Research Center.

Giambattista Della Porta's merging of magic and science in his important work *Magiae Naturalis* (1558–1589) reflected attitudes that developed in the seventeenth century toward a science that persisted in retaining links with magic and mysticism. Kemp, in fact, suggests that it is incorrect to make rigid separations between the "ingenious deceits" provided by optical instruments and magic. The scientific function of optical instruments such as the camera obscura, the magic lantern, the ana-morphic lens, and the telescope are also related to traditions of two kinds of "magic": natural and artificial (1990, 191). In the case of natural magic, instruments such as the camera obscura were used to exploit natural phenomena with the intent of

astonishing viewers. Artificial magic was based on the inventor's capacity to create painted, drawn, and sculpted illusions "that achieve astonishing effects when viewed under specific circumstances" (203). The production of artificial magic involved the union of the scientific and technological with "elements of sheer entertainment" (210), and the optical devices of artificial magic were ancestors of the cinema.

Kemp emphasizes the importance of understanding these magical illusions and sensory experiences not within a Cartesian framework, but through that of natural and artificial magic.[13] Despite the fact that perspective has been considered "normal rather than bizarrely magical" (Kemp 1990, 203), its achievement through illusion belongs to a seventeenth-century understanding of artificial magic. Like the digital technologies of the contemporary era, perspective became the embodiment of a baroque concern with ordering and representing the world through artificial means. Through natural and artificial magic, it was possible to create worlds in a way that paralleled God's creation of the universe. Findlen, in fact, argues that the theater of illusions established by Kircher in his museum in Rome sought, through magic lantern effects, to blur "the boundaries between inside and outside, between museum and the world that created it" (1994, 46–47). The intention underlying the exhibition and use of magic lanterns was to demonstrate the "ability to contain and produce wonder," specifically, that of the natural world (47).[14]

Nineteenth-century magicians inherited the ambivalence inherent in the baroque tradition of artificial magic. As mentioned above, during the nineteenth century magic performances often served the dual function of extracting an affective response of wonder from the audience and of also stressing a more rational concern for unveiling these magical illusions as outcomes of science. Despite, or because of, the drive for reason, the magician journeyed into the realm of baroque logic. As discussed in chapter 3 in relation to the computer game *Phantasmagoria*, one of the most popular magic lantern effects in the magician's repertoire was the ghost or apparition show, which involved phantoms suddenly appearing out of nowhere—an effect that influenced early photography and cinema. The most famous and most duplicated magic lantern show was the *Fantasmagorie* by Étienne Gaspard Robert (known as Robertson). Robertson was a Belgian inventor, physicist and student of optics who improved the technology of the magic lantern, including its capacity to enlarge and shrink images (Castle 1988, 31).[15] In 1797, Robertson performed the *Fantasmagorie* in Paris in an abandoned chapel surrounded by tombs. Crowds flocked to the dimly lit chapel to see magic lantern effects that included skulls, atmospheric lighting, sound effects, and the appearance of

ghostly apparitions in a display concerned with an "optical explosion of the senses" (Castle 1988, 31):

> Coal burned in braziers. Robertson gave a preliminary discourse, denouncing charlatans and their bogus apparitions. . . . He tossed some chemicals on the braziers, causing columns of smoke to rise. The single lamp flickered out, putting the audience in almost total darkness. Then, onto the smoke arising from the braziers, images were projected from concealed magic lanterns. They included human forms and unearthly spectral shapes. . . . Some spectators sank to their knees, convinced they were in the presence of the supernatural. (Barnow 1981, 19)

Despite the centrality of illusionism and the theatrical emphasis on the fantastic in his *Fantasmagorie*, Robertson's intentions were also scientifically motivated. His aim was to expose impostors who claimed they were capable of conjuring "real" spirits and to make people who believed in ghosts realize that the fantastic was a deception controlled by technological means. For magicians, there was nothing science and technology could not explain or achieve. Upholding an inherently seventeenth-century heritage, magicians emphasized magic as a science, and much as with science fiction's relationship to effects technology, the skill of the magician's "science" was displayed through his conjuring magical or supernatural illusions. As with contemporary special-effects films like *Close Encounters* and *Jurassic Park*, it was necessary to the effect that the technology be both disguised and visible[16]—the visibility of the effect being further evident in *The Making of Jurassic Park* and *The Making of Star Wars: The New Edition* films that accompanied these effects films, along with many other *Making of . . .* films along the same lines. Yet although the motivation behind such enlightenment spectacles was to lay claim to scientific reason, a baroque complexity overpowers them. As Castle states, "even as it supposedly explained apparitions away, the spectral technology of the phantasmagoria mysteriously re-created the emotional aura of the supernatural" (1988, 30). The "purveyors of magical illusions learned that attributing their tricks to explainable scientific processes did not make them any less astounding, because the visual illusion still loomed before the viewer, however demystified by rational knowledge it might be" (Octave Mannoni, quoted in Gunning 1995b, 471).

Magicians also played an important role in the early period of film. The illusions of magicians found their way onto the early cinema screen in numerous ways. In addition to film screenings shown during magic performances and the production of films depicting magicians' performances,[17] tricks of illusionism central to the magic

performance were given new expression in "trick films," which used the film medium to produce "magic" through means specific to the film medium (for example, through effects such as editing and double exposures). Magic was also transplanted into film, however, in more direct ways. The transformations, beheadings, disappearances, and ghostly apparitions so popular in trick films owed a great deal to the optical illusions that nineteenth-century magicians had achieved previously with magic lanterns.

The effect of metamorphosis (paralleling current morphing effects in cinema, although through photochemical rather than digital means) had, in the nineteenth century, been produced by a magic lantern optical effect, usually as part of the magician's performance. At the turn of the twentieth century, metamorphosis as a filmic optical effect became an important part of the film magician's repertoire (see Barnow 1981, 16). Many of the metamorphosis trick films exploited the cinema's inherently contradictory nature: its capacity to produce the irrational and the magical as real terms through rational and empirical technological means. Indeed, a series of such transformation films produced at the turn of the century have a great deal in common with morphing effects in contemporary cinema. These films included *The Startled Lover* (1898), in which a girl transforms into a skeleton in her lover's arms, then back to her original form; *The Barber's Queer Customer* (1900), which involved the customer's face's undergoing a series of transformations; and *Pierrot and His Wives* (1900), in which Pierrot's well-endowed wife is suddenly changed into two lean ones (Barnow 1981, 91).

It was Georges Mél?ès in particular who integrated film and magic by transforming the magician's illusionism with the magic lantern into the trick film. Thus began the tradition of the magic of cinematic special effects. Mél?ès, himself a magician, in 1888 purchased the famous Theatre Robert-Houdin[18] and soon after produced a series of transformation films, including *The Spiritualist Photographer* (1903), which showed a girl in front of a canvas who was transformed into a painting, then back again. In *The Man with the Rubber Head* (1902), an experimenter (played by Mél?ès) inflated a copy of his own head with a hose; the illusion of the head's inflating was achieved through a series of superimposed images. Barnow views the primary concern of this film not as the fantasy of the transforming head, but rather as a technical challenge (97) that asks the audience to be astounded at the technological prowess that makes possible the morphing of the inflated head and its realistic appearance. The scenes of fantastic transformations portrayed in these films were simply an impressive means of allowing film technology to perform. As Gunning states, true to the attractions tradition, Mél?ès's films addressed and acknowledged the audience by setting themselves up as a

technological performance; hence, claims to the supernatural were undercut because "Méliès invites technical amazement at a new trick rather than awe at a mystery" (1995a, 63–64). The magic lantern and the magician heritage of this technology of vision has persisted throughout the history of the cinema. Despite periods of classical ordering, as has been mentioned, the cinema frequently returns to a more baroque-aligned visuality intent on the wondrous possibilities of spectacle achieved through technological means.

The magic of special effects, however, has reemerged with a new baroque force. The cinema has frequently returned to a baroque-aligned visuality intent on producing wondrous spectacles through technological means. Early film traditions (and the magic performances that preceded them), however, lacked the concerns with evoking states of transcendence and affection to an intensity that parallels the seventeenth-century period—or our current examples. Although early cinema inherited the legacy of the magician and his technology, the conjuring of an illusion that attained a supernatural status was dissipated. In addition to having no interest in the symbolic and allegorical function inherent in a more full-blown baroque logic, early cinema also lacked the economic and cultural infrastructure integral to a more pervasive baroque aesthetic—an infrastructure whose presence, in contrast, we experience with great force today. Our entertainment forms have expanded our experience of the baroque in less filtered and more far-reaching ways, revealing an intensity of baroque culture that was more familiar to the seventeenth century than to early cinema. Drawing on alternative technologies, scientific developments, and cultural and economic transformations, our own time has given voice to a new and more profound articulation of the baroque.

The Aesthetics of Rare Experiences

The relationship between the scientific and fantastic or magical is first given voice in the seventeenth century. According to Gunning, the "confluence of an ancient magical imagistic tradition and a nascent scientific enlightenment seesaws between a desire to produce thaumaturgic wonder and an equally novel interest in dissolving the superstitious mystification of charlatans via demonstration of science" (1995b, 469). Giambattista Della Porta's popular *Magiae Naturalis* describes an experiment with the magical properties of images and optics that includes a plan for an optical theater using a camera obscura, a device that allowed painters to produce visions that could delude spectators. As Gunning notes, the optical theater created visual entertainments "whose magical effects were due to the laws of optics" (1995b, 470). Such magical

illusions that had their basis in science profoundly affected the form taken by baroque spectacle.

Even scientific writings of the seventeenth century reflect the blurring of boundaries between science and the fantastic. In an effort to explore the implications of contemporary scientific thought, states of wonder and astonishment were evoked through the avenue of science fiction. One of the most influential scientific writings of the seventeenth century in the later collision of science and fantasy in the form of science fiction was Galileo's *Sidericus Nuncius* of 1610. As noted in the previous chapter, Galileo's telescopic observations of the moon supported Copernicus's theory that the Earth was part of an infinite, heliocentric universe. This discovery cast doubt on the medieval assumption that the stars and heavenly bodies were a mystical realm that was the "aetherial abode of departed spirits" (Remnant and Bennett 1996, lxxix).

Seventeenth-century "heretics" like Galileo threatened to unleash chaos with their new ideas. For example, Guthke describes the inner turmoil that the poet (and later the priest) John Donne experienced as a result of Galileo's writings (1990, 113–117). In the poem "First Anniversarie: An Anatomy of the World" of 1611, Donne states:

> And new Philosophy cals all in doubt,
> The Element of fire is quite put out;
> The Sunne is lost, and th'earth, and no mans wit
> Can well direct him, where to looke for it.
> When in the Planets and the Firmament
> They seeke so many new; they see that this
> Is crumbled out againe to his Atomis.
> 'Tis all in pieces, all cohaerence gone;
> (Donne 1967, 207, lines 205–212)

Donne's ruminations continue, and although this poem mourns the death of the daughter of his patron, Sir Robert Drury, the theme of mourning becomes an excuse to depict a world that is coming to an end. Pascal expressed similar concerns about the new cosmology. In his *Pensées* he lamented that "the eternal silence of those infinite spaces strikes me with terror" (quoted in Guthke 1990, 117). Combined with other events (including mass famines, poverty, peasant rebellions, plagues and diseases, wars, changes in power structures and ruling orders, the challenge to the Catholic Church, the rise of atheism, and cults such as the followers of Paracelsus, the Rosicrucians, and the Hermetics) the new cosmology led to a flourishing belief that the times were unstable, so much so that that there was growing conviction throughout the late sixteenth and seventeenth centuries that the apocalypse would soon come (Easlea 1980, 2, 131). Prophecies spread throughout Europe that Christ would soon

return. The Puritan preacher John Dove presented a sermon in 1594 that proclaimed "the Second Coming of Christ and the Disclosing of Antichrist," and in 1617, six years after Galileo's *Starry Messenger* was published, the chaplain Godfrey Goodman voiced an opinion that was popular during the early years of the seventeenth century: Nature and the universe were in decay, and it was "the last age of the world"; one specific belief was that Satan's thousand-year imprisonment as foretold in the *Book of Revelation* was to end in 1666 (Easlea 1980, 76).

The alternate response to understanding the revelations of the new sciences came from a more positive (or at times, ironic) perspective. Remnant and Bennett make the point that Galileo's discoveries stressed that the moon was an earthly body similar to Earth. As such, Galileo's scientific study (and other discoveries in astronomy and the new sciences) inspired other writers to imagine that the moon was "perhaps inhabited by living beings and in principle accessible to explorers from our planet" (1996, lxxix). The fantastic possibilities of space travel and life beyond the planet Earth that resulted from scientific endeavors were often reflected through science fiction themes.

Although they tried to support scientific fact, the writings of famous scientists of the era, including Johannes Kepler and Christiaan Huygens, were imbued with science fiction concerns. Kepler's *Somnium* of 1634, for example, provided an account of moon travel. The book's protagonist is transported to the moon through sorcery, and this magical journey permits him then to sustain seventeenth-century scientific observations concerning the moon. Huygens's *Cosmotheoros* of 1698 and Bernard le Bovier de Fontanelle's *Entriens sur la pluralité des mondes* of 1686 (figure 5.5) invoke the idea of space travel by asking readers to imagine themselves voyaging through the solar system and inhabiting the sun, the moon, and planets other than Earth. In fact, the publication of texts dealing with the plurality issue so increased that satires like Charles Sorel's *Vraie histoire comique de Francion* (1623–1626) also began to appear. Taking, like his "straight" scientific works, a cynical attitude toward the notion of a heliocentric system, Sorel's serial novels include two imaginary journeys into space, the possibility of manlike inhabitants on the moon, and although it is introduced, as Guthke points out, as a "ridiculous notion," an idea that is now commonplace in science fiction: the invasion of the Earth from outer space (1990, 122).

In addition to "scientific" writings that relied on science fiction to deliver their message, the seventeenth century also ushered in more fantastic ruminations on the possibilities of space travel (Remnant and Bennett 1996, lxxix). Further adventures of lunar travelers included Ben Jonson's *News from the New World Discovered in the Moon* (1621), Fatouville's *Arlequin, Empereur dans la lune* (1683) and Cyrano de Bergerac's

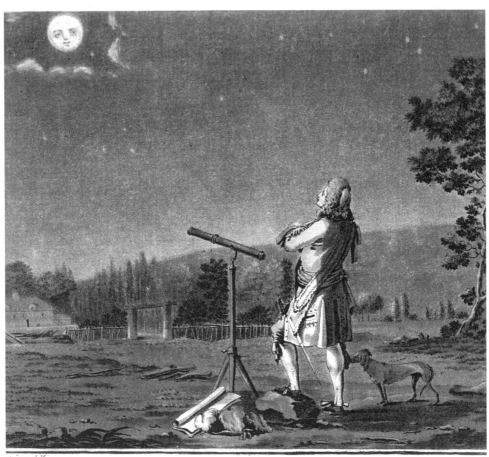

Figure 5.5 Bernard le Bovier de Fontanelle (1657–1757), French scientist and man of letters, reflecting on the plurality of worlds. French engraving, cover page of *Méditant sur la pluralité des mondes*, Musée Carnavalet, Paris (1791). By permission of The Art Archive/Musée Carnavalet Paris/Dagli Orti.

États et empires de la lune (1657) and *États et empires du soleil* (1662).[19] Even arguments against the new cosmology were framed within the context of the fantastic. Athanasius Kircher's *Ecstatic Journey* of 1656 (which Huygens was to criticize for its lack of scientific observation in his *Cosmotheoros*) relates a journey to the moon, sun, and other planets. When Kircher asks his guardian spirit, Cosmiel, whether life can exist on these other bodies, Cosmiel replies: "God in his inscrutable wisdom destined only the Earth to be the abode of life and of man" (Guthke 1990, 124).

The church could not escape the debates about new cosmology and many in the church, like the Jesuit priest Kircher, entered the space travel discourse. In 1638, braving the possibility of being attacked as heretic, Bishop John Wilkins (anonymously) published *Discovery of a World in the Moone: Or, A Discourse Tending to Probe, that 'tis Probable there May Be Another Habitable World in that Planet* (figure 5.6).[20] Wilkins noted that the Catholic Church and others had been "mistaken about the antipodeans" and proclaimed, "Let another Columbus, then, discover a new world on the moon." In his account of this new world, he "discusses the physical possibility of various forces of interplanetary transport" (Guthke 1990, 147–152). As the church later came to embrace the possibility that the Earth was not unique in the universe, so this very fact became the proof of God's miraculous and wondrous abilities in that He fashioned not one world, but an entire universe. In the same year as Wilkins published his book, Wilkins's fellow Englishman, Bishop Francis Goodwin published, also anonymously, the immensely successful *The Man in the Moone: Or a Discourse of a Voyage Thither*. In Goodwin's book, the hero, Domingo Gonsales (who later crossed over into Cyrano de Bergerac's 1657 book), relates his journey to the moon in a vehicle he attaches to a flock of migrating swans; there he discovers a "lunarian utopia." With direct reference made to Galileo (and descriptions that include Galileo's observations of the moon) Godwin's human hero makes contact with alien life. During his travels, Gonsales debunks the Aristotelian belief that the Earth is center of the universe and home to all life. On the moon he discovers a paradise inhabited by human-like beings, who are presented as being superior to the human race. In fact, Guthke suggests that Godwin considers the "possibility of a different kind of humanity in the context of the universe revealed by the new science" and, in turn, the new science raised questions that shook the foundations of religious belief: "Why is there no original sin here? Is one to assume a second Creation? Are the moon dwellers the chosen people of God?" (1990, 158).

The scientific observations that gave rise to speculation about the new cosmology were so alien to and different from past belief systems and scientific thought that their fundamental ideas could best be expressed in the realm of the fantastic—a fantastic

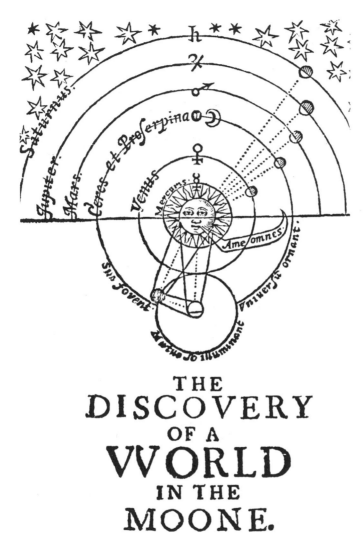

Figure 5.6 Frontispiece to John Wilkins' *Discovery of a World on the Moone* (1638). By permission of the Houghton Library, Harvard University.

that evoked wonder through science. Again, the effect of scientific discovery could be understood only in conjunction with the affective responses aroused in science fiction writings. More significantly, the focus turns to the heavens and alien life forms in ways that recall our own times. In the seventeenth century, the possibility of a heliocentric universe inhabited by planets that could support other life forms threatened the basic belief system of the church. In our own times, New Age thinking has accommodated in religious and mystic doctrine the outer space of the universe and the inner space of the computer.

In his thought-provoking book *Wonder, the Rainbow, and the Aesthetics of Rare Experiences* (1998), Philip Fisher explores the wonder-evoking capacity of modernist art from Claude Monet to Jackson Pollock. In doing so, he travels a journey back to the seventeenth century—a period filled with "rare experiences"—and to the writings of Descartes and Pascal. Drawing an important distinction between wonder and the sublime, Fisher explains that experiences of both are reliant on the visual and on the "aesthetics of rare experiences" that are not common to the everyday (1). The sublime engages the senses in surprise, power, and danger in the ultimate production of "the aestheticization of fear," whereas wonder is involved in the aestheticization of delight and pleasure (2). Furthermore, for Fisher, the "aesthetics of wonder has to do with a border between sensation and thought, between aesthetics and science" (6).

Confronted with a work of art or a discovery of science, the viewer is drawn into a problem-solving experience that can lead to a wonder-inducing journey. Fisher explains that the English definitions of the word "wonder" signify both *interrogation* ("I wonder why?"), making up "the activity of sciences in so far as science is the power to notice and put in question, rather than the power to answer," and *exclamation*, which retains the connection with curiosity but adds "the aesthetic sense of admiration, delight in the qualities of a thing" (11). In both instances, Fisher draws attention to the thaumatological associations of the word, referring specifically to the "science of wonders and miracles" that populated *wunderkammers* and collections during the sixteenth and seventeenth centuries.

Relying on Rene Descartes's conclusions in *The Principles of Philosophy* (1644/1988), Fisher observes that Galileo's telescopic observations of the moon and stars, Kepler's conclusions regarding the elliptical motions of the planets, the optical work of Huygens, and Descartes's own studies of the properties of the rainbow all brought more "new wonders into experience than any discovery in human history" (15). The infinite, unknowable, and invisible were suddenly made visible and, eventually, comprehensible to human vision and experience. The initial response to these new phenomena

was wonder, but their mysteries were soon understood through the interrogations of science, mathematics, and philosophical thought. Whereas prior to Descartes, the soul had been reduced to two primary passions, anger and desire, Descartes made wonder the first of the passions, throwing light on the claim that "philosophy begins in wonder" (Fisher 1998, 41–42). Fisher states:

> The aesthetic state is, only by a modern error, taken to be a passive one, a state of spectatorship rather than action. The activity is, of course, intellectual.... Wonder begins with something imposed on us for thought. The drive within wonder toward curiosity, questioning, and the search for explanation seems to involve no less than the religious move toward sign, history, memory, and meaning, a move away from the aesthetic experience itself, a passage from wonder to thinking. (1998, 40)

As Descartes had claimed in his *Discourse on Method* (1637/1999), wonder (*l'admiration*) emerges through our "relation to the visible world," where an "object must be unexpectedly, instantaneously seen for the first time" (Fisher 1998, 17). Devaluing memory in favor of the pleasure of being confronted with the rare experience and of feeling its impact sensorially, the viewer shifts to an intellectual plane as a seemingly wondrous and quasi-mystical experience is placed under scrutiny until its mystery is revealed. Thought "leads us to the feeling of familiarity that is aligned to what we call 'getting it' " (7). Mystification progresses to explanation (26).

Like divine miracles, wonder plunges the viewer into a state of pleasure that is made possible through a unique experience, one that is eventually placed under intellectual scrutiny (47–48). Seeking to avoid the potential fear and horror that such an experience may provoke, the viewer embraces the newness of the experience of the extraordinary with a combination of pleasure and curiosity that makes it familiar to everyday reality.

For writers like John Donne, and in particular, Blaise Pascal, the aesthetics of wonder evoked by the newly perceived universe instigated, instead of wonder, a new aesthetic of the terrifying. Indulging in the sublime qualities of the infinite and (seemingly) unknowable nature of the universe (and God's plan for it), Pascal replaced Descartes's "wonder" with the "abyss" (*une abîme*), stating that "[t]he eternal silence of these infinite spaces fills me with dread" (Fisher 1998, 50). For Pascal, refusing to travel the path of wonder and curiosity and seeking to inspire terror in those who claimed to comprehend the operations of the universe, the discoveries of the new sciences were "reabsorbed back into the religious sensibility" (52), becoming part of a sublime narrative of God's and nature's mysterious plan.

Following the path of wonder outlined by Descartes (and reflecting the affect-effect duality) the intent of many of the above-mentioned scientists and writers was to lead the reader, eventually, to the experience of interrogation. The scientific/science fiction hybrids of these scientist-writers produce the affect-effect duality in the sense that the capabilities of science incite astonishment in the audience through the fantastic and magical vehicle of science fiction. The previously unperceived realities opened up by the new sciences and technology during the seventeenth century embodied a rationality that could be perceived only in fantastic terms, thus providing a connection with the tradition of artificial magic. The effects of contemporary cinema visualize this rational/fantastic relationship in redefined neo-baroque terms by using science fiction as a tool that permits the exploration of technological, scientific, and perceptual transformations. Like the new sciences of the seventeenth century, new computer technology and digital effects remain in a transitional state, being strange enough and so radically new as to evoke not only curiosity and wonder, but an aura of the mystical. The virtuosity of science and technology is, in the hands of the virtuoso artist and filmmaker, transformed into something that is both magical and akin to the spiritual.

From their beginnings, science fiction films, via their narratives, have explored issues of technological and scientific progress, especially in relation to how they affect the nature of what it means to be human. In *Close Encounters* Trumbull's visionary-like effects are placed within the context of 1970s New Age thinking. *Close Encounters* transfers the possibility of alien cultures and technologies onto the film's effects technology, visualizing the process in transcendent imagery that evokes affective states in both the diegetic and film audiences. *The Matrix* (Wachowski and Wachowski 1999) similarly operates according to the dualism of affect and effect. *The Matrix*, however, projects current concerns regarding technological advancement into the future. The film's science fiction narrative explores the possible catastrophic effects that technology and our computer systems may have on our subjective and material selves. Again, a wondrous technological effect is explored through the more immaterial realm of the senses. And again, technology is understood through a spiritual presence, one that eventually leads to enlightenment.

In *The Matrix*, a group of rebels (who have discovered that computers have taken over the world and are keeping humans captive in cubicles that link them to a technology that induces in them illusions that they are living normal lives) search for a Chosen One, their savior, who turns out to be Neo, played by Keanu Reeves (figure 5.7). In one of the scenes near the end of the movie, Neo, like *St. Teresa*, recognizes his visionary status and is transported to another plane of reality, and we, through the

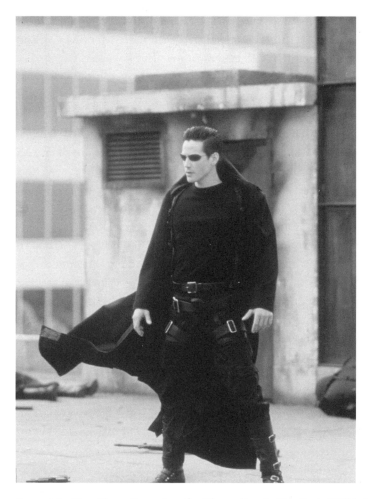

Figure 5.7 Neo (Keanu Reeves) as the Chosen One in *The Matrix* (1999). By permission of The Kobal Collection.

film's effects technology, go along for the journey. In the final minutes of the film, a virtual Neo confronts an agent of his computer nemesis with lethal consequences: Neo is shot. While his virtual self dies, his material self also experiences the wounding of his ephemeral other. Aware of cyber-Neo's destruction, Trinity (whose name underscores the film's revamped Holy Trinity in the form of Morpheus, Trinity, and Neo) plants a kiss on "real" Neo's lips, and miraculously, in cyberspace, cyber-Neo is resurrected. Raising himself from the ground that had previously been his deathbed, he looks at the three digital agents and he finally *sees*. In an experience of Descartes's aesthetics of wonder, his initial ominous, sensory-driven response to the illusory space created by the computer is transformed into a rational and cognitive one. The questioning that Morpheus has imprinted in Neo's mind has finally resulted in the unveiling of answers.

Within this narrative, through the eyes of Neo, technology induces a transcendent state. Neo, in fact, is literally deified in this final scene: He dies and is then resurrected. Neo's deification now allows him to see the world in a way that no other human has: as a system of rational, scientific codes that reveal the computer programs and binary systems used to create the illusory life that humans have inhabited—a technology that has created subjective realities (figure 5.8). This apocalyptic revelation, in fact, is transformed into a celebratory one as the source of wonder is finally exposed and understood in rational terms. In turn, the revelation of reason is conveyed in highly spiritual terms. Again, reflecting New Age beliefs and postmodern theories, technology is celebrated as the means to a new humanity, one that embraces computer technology. This narrative point is affirmed by the audience, which embraces the effects technology that is used to present the new human state of being depicted in the film. Again the aesthetic of ambivalence dominates in this scene: Just as the technological is exposed to Neo (in the shape of data and binaries), he is simultaneously overwhelmed and transformed by the product of this rational system in reverential ways.

The Game of Creation: Automata, Cyborgs, and Animated Statues

Relying as it does on technical mastery and mathematical principles of perspective, Bernini's *St. Teresa* would, at first, appear to lack a more direct concern with the technological in the sense that films like *Close Encounters* and *The Matrix* do. Yet, *St. Teresa* emerged during a climate that witnessed dramatic transformations on the level of the cultural and scientific. Responding to a complex cultural dynamic, one that gave

Figure 5.8 Neo's view of the Matrix as a system of binary codes, from *The Matrix* (1999). By permission of The Kobal Collection.

rise to the scientific revolution and to a new fascination with optics and spectacle, Bernini's *St. Teresa* has as much to tell us about transforming cultural systems as do films like *The Matrix*.

The technical virtuosity of seventeenth-century spectacle is related, in part, to advances in optics that resulted in radically new perceptions of reality. The fantastic— the spiritual presence as displayed in allegorical and symbolic form—became an important means of contemplating, displaying, and celebrating technical and technological virtuosity and advances. As I have argued previously, this appetite for states of wonder as outlined by Fisher and Houghton is manifest in transitional periods such as the seventeenth century—and, I would add, the late twentieth and early twenty-first centuries. Special effects, especially those produced in the science fiction film genre, similarly provoke advances (and are often at the forefront of the creation of advances) in computer and other effects technologies, while also retaining their magical wonder.

To a certain extent, this form of baroque spectacle may be seen as integral to the process of acclimatization to new technologies and sciences. In their technical and technological bravura, projects such as the *St. Teresa* stand out as icons of the baroque, showcasing the fascination with optics of the time period that produced them. The grand-scale illusionistic ceiling paintings and sculptural and architectural depictions of the seventeenth century pushed to new limits illusions of represented realities that the painting and sculptural media, mathematics, and technological machinery (including camera obscuras and perspective machines) were capable of constructing.

In her fascinating *The Monster in the Machine: Magic, Medicine, and the Marvelous in the Time of the Scientific Revolution* (2000), Zakiya Hanafi traces what she calls "the accelerated process of desacralization" of the monster that occurred in the seventeenth century in the context of the scientific revolution (x). Increasingly in this period, the category of the monstrous (as evident, for example, in "natural" genetic mutations) was no longer associated with the sacred. Scientific observation and empirical analysis of the natural world (and its collection in museums) now suggested that monsters were products of the natural world and, therefore, part of God's divine plan for the universe. As such, these creatures could no longer be understood as abominations. Interestingly, Hanafi suggests that during the seventeenth century, the monster (as abomination of nature) "became visible only by means of man's own creations: by means of his own machines and . . . new sciences" (x). "During the period 1550 to 1750," Hanafi suggests, ". . . the sacred characteristics attributed to monsters shifted to products of . . . [human] technologies. The monster became a machine" (ix). Art and nature began to merge through the virtuosic mastery of the human creator. Most famously (or infamously) it is the era's fascination with automata that reveals the extent of this merging. The automaton became an embodiment of the aesthetics of wonder.

Filippo Bonanni, curator of Athanasius Kircher's museum, described Kircher's collection of automata as "instruments composed through art" that "move by their own will" (Hanafi 2000, 78). These machines included a water-powered organ with moving figures (figure 5.9); a wind organ figured with a Cyclops and singing birds; a monkey dressed in the uniform of a drummer boy that beats a drum with all its might, while rolling its head, moving its eyes around, and opening its mouth to show its teeth as if ready to bite; and, numerous talking statues. Pietro Francesco Scarabelli, who provided the Italian translation for the 1667 catalogue to Manfredo Settala's famous museum, wrote that the movement of such machines (which included deforming mirrors that metamorphosed the observer into hideous forms) provoked "extraordinary

Figure 5.9 Athanasius Kircher, "Automata Theatre," from *Musurgia Universalis*, vol. 2 (1650, 347) (ms. no. 59.e.19). By Permission of The British Library.

wonder in whoever observe[d]" them. They were, he said, "delightful" and "pleasingly deceptive" and offered "an invitation to the spectator's eye to curiously submerge itself in a sea of wonders" (Hanafi 2000, 85).

Such are the *affects* evoked by these artificially produced technological *effects*. Repeatedly, these machines and the emotions they incite in the spectator recall the terms conjured to explain the effects of baroque art examples such as the *St. Teresa*. Emanuele Tesauro remarked that spectators of these marvelous automata became frozen in astonishment. He observed that "[a] passer-by is hard put to tell who is the petrified human and who the animated statue" (quoted in Hanafi 2000, 76). Likewise, explaining audience responses to his talking automata, in his *Musurgia Universalis*, Kircher stated that members of the audience "admire the agility of the lips and the tongue, and they will look with stupor at this structure whose whole body breathes life; yet nobody will be able to understand with what artifice . . . or from what hidden machinery it has its motion" (quoted in Hanafi 2000, 90). An ambivalent relationship between the rational and the irrational is again sealed: The effect of motion incites the affective state of wonder: "How did they do that?"

A contemporary of Kircher's, Thomas Browne, explained that "all things are artificial for Nature is the Art Of God" (quoted in Hanafi 2000, 5). Therefore, in their roles as creators, the artist and scientist (as artificial beings created by God), in turn, mimic the role of God. Within this role of human as creator lay the potential for mechanical monstrosity. In *De Monstrorum* (1634), Fortunio Liceti warned that "intervention into nature's productions through human skill and inventiveness [i.e., artificial means] . . . when applied to the production of monstrous human beings, is branded as entirely abominable" (quoted in Hanafi 2000, 36). As Hanafi suggests, "The main reason such a practice was perceived as contrary to the normal functioning of the world is because, at least since Aristotle's time, art had been defined as imitating nature, and not the other way around" (37).

Aristotle stated that "art partly completes what nature cannot bring to a finish, and partly imitates her" (quoted in Hanafi 2000, 37). The baroque artist and scientist was obsessed with "inverting this equation," delighting instead in the "mixing and blurring of the distinction between" the natural and the artificial, an inversion also found in many science fiction films (like Spielberg's *A.I.*), which also endow the machine/cyborg with the "nature" of the human. Hanafi suggests that two of the most important defining features of the baroque are its exuberance and its play with trickery and deception (37). In most instances, however, "nature was unquestionably believed to be the primary term, and human art, [was] relegated to completing or imitating nature's works." Human art, therefore, was "unquestionably believed to be the secondary term" (37). The play and the fun for the baroque artist "lay in simulating an illusion of [the] reversal of these two terms": The *secondary* human creator often *aspired* to adopting the role of *primary* creator. The demonic and heretical nature of such manipulation lay in the extent of the "mastery of illusion and trickery," for it was here that illicit magic came into play. Crucial to crossing the boundary was the "relation between spirit, matter and form" (52). Such technological monsters as the automaton were inanimate yet moved of their own accord (figure 5.10). Or as Hanafi argues, "whenever spirit is called into or forcibly inhabits formed matter there is a danger of monstrosity arising": The automaton is monstrous in that it is artificially created and "moving of its own volition would seem to be endowed with spirit," and here lies its association with the sacred (54).

I would go so far as to suggest that the evocation of wonder in Bernini's *St. Teresa* is deeply integrated into seventeenth-century beliefs and writings on natural and artificial magic. What is *St. Teresa* if not "matter formed by artificial means" that appears to move of its own volition—matter that also seems to be endowed with spirit or a soul? In *Witch Hunting, Magic and the New Philosophy* (1980), Easlea refers to Etienne Bonnot

Figure 5.10 A clockwork-operated eighteenth-century female automaton playing a Gluck. Made by Kintzing for Marie Antoinette (1785). The Musée du Conservatoire Arts et Metiers. By permission of The Art Archive/ Musée du Conservatoire Arts et Metiers.

de Condillac's *Traite des Sensations*, published in 1754. As Easlea explains, the protagonist in this treatise is a statue "that is cut off from its environment by its cold marble skin. Devoid of memory and experience and with an empty brain, the statue possesses neither knowledge nor moral concepts; when endowed with sensory perception, in particular the sense of touch, however, it begins to acquire a soul" (1980, 6).

Reflecting beliefs that had dominated in the seventeenth century, through its capacity to develop the use of its senses, Condillac's statue is transformed into a human being with a soul (Easlea 1980, 7). Merging the ancient myths of Pygmalion, in which a statue is brought to life, and Prometheus, who fashioned artificial creations out of nature, Condillac's treatise "is about giving life to mechanical beings who are capable of learning on their own through independent movement" (7), a tale that is all too

familiar to contemporary science fiction audiences. Belonging to the realm of natural magic because they were composed of natural materials (marble, stone), sculptures had much in common with automata, which were the products of artificial magic: Both were creations of man. Easlea explains:

> Occupying an intermediate position between sculpture and machine, Condillac's statue can be regarded as a recurrent theme. Though diametrically opposed to one another, androids and ancient statues shared the fact that both existed within the realm lying between the natural state and human creativity and were considered expressions of an effort to use the shaping of natural materials to explain the relationship between human beings and their natural surroundings. (7)

Automatons and sculptures played an important role in explaining the relationship between nature and culture. Much as in our own era, the adeptness of the creation reflected back on the scientific and technological capabilities of the culture in which it was created. Furthermore, artistry and technology also radiated a sense of the divine in the very fact that they were the creations of humanity, a humanity that sought to mimic the grand Creator. Depictions of our automata (the robots, animatronics, cyborgs) and technologies of our science fiction likewise conjure the divine in their efforts to articulate the pace of technological advancement: the death and resurrection imagery associated with Murphy/Robocop in *Robocop*; the revelation of Neo's divine nature in *The Matrix*; the refashioning of Christ's birth in the form of John Connor (J.C.) in *Terminator*; the mystical prophet quality of the psychics in *Minority Report*.

During the seventeenth century, the creation of art was an example of artificial magic (as, I might add, is the cinema, which also creates motion out of inanimate matter). It was the context of the institutionally sanctioned space of the church that allowed art such as Bernini's to be viewed from the perspective of the divine and the transcendent, therefore bypassing the debates that raged in the world of science regarding the diabolical potential of artificial magic. Whereas, in Bernini's work, the technical and technological became the means to a religious narrative, transporting the viewer into a state of religious reverie, automata confronted the viewer with productions that "threatened to transgress the 'laws of nature'" (Hanafi 2000, 74). Their danger lay in the fact that they potentially embodied the flip side of the divine: the diabolical. A fine line separates Descartes's "aesthetics of wonder" and Pascal's "aesthetics of the sublime": The failure to interrogate and apply reason to objects of astonishment could easily lead the viewer into the fearful and unknowable realm of the sublime.

Automata were entertaining and inspired wonder *because* they ran such a high risk, *because* they teetered on the fine edge between licit and illicit magic (74). The "godly" (as experienced in *St. Teresa*) and the "diabolical" (as witnessed in the automata) are flip sides of the same coin (74). In both instances, though in different ways in each, marvelous machines are used to induce "sacred wonder." Heeding the warnings of writers like Campanella, unlike the mad scientists and corrupt corporations of science fiction, artists like Bernini and scientists (and I use the term in its seventeenth-century context) did not cross the boundary delineated by Aristotle. The "figure of the *Artificer as God*" was kept intact, despite the fact that this order often came close to being threatened. Examples of artificial magic such as automata were emblems of scientific and technological advances of the seventeenth century, an era that ushered in a paradigm shift on many cultural levels.

Now we find ourselves in the midst of another paradigm shift. During the seventeenth-century baroque, the artist/scientist as creator threatened to overthrow God the Creator. In our neo-baroque times, the creation (which has been granted motion and a spirit by the computer) threatens to overthrow the human as Creator: The creation may become Creator. This is the fear that is narrativized in *The Matrix*; but ultimately, the human in the machine embraces this scientific technology: in the guise of Neo, it interfaces with the technology in order to master it. The result is that a new being, the technological human, is born, becoming a sacred monster in the process.

During the neo-baroque, the ultimate *composto* has been created. Human has merged with the machine; we have folded into technology and it has folded into us. Beyond the overt image of human-machine interface in the cyborg of science fiction, society requires our increased interaction with technologies. When we access our computers, use our mobile phones, switch on our televisions, or play games on our PlayStation 2 or Xbox units, we participate in the process of evoking the sacred monster. Beyond this, we exist during a transitional period in which *our* technologies allow us to create artificial life forms in the name of entertainment. Artificial intelligences are generated within the realm of the computer in order that they may, in turn, reproduce other digital life forms that are then transformed into a film's or computer game's effects (the use of artificial-intelligence engines in the construction of games like the *Quake* series, *Starship Troopers*, and *Black & White* is now a given).

For many seventeenth-century writers, monsters were produced when the human creator flouted the laws of nature and attempted to animate inanimate matter. During our times, our *fear of* and *fascination with* monstrosity stems from "our too perfect

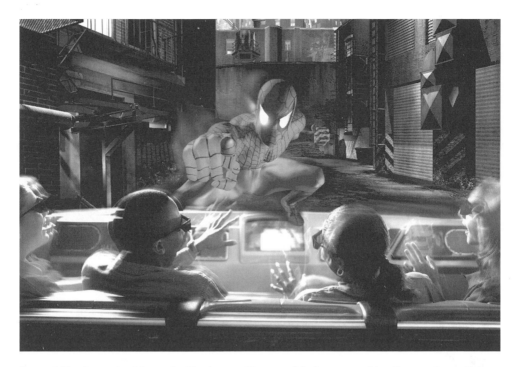

Figure 5.11 Promotional image for *The Amazing Adventures of Spiderman*, a multimedia attraction at Universal's Islands of Adventure. By permission of Universal.

mastery of nature": We have granted the inanimate machine its own volition. We have reached a point at which we can give life to mechanical beings who, in turn, can give life to their own kind. In the fictional space of *The Matrix*, the sacred resurfaces in the form of the divine retribution that the resurrected Neo inflicts on the creations of the machine—and in the way he reasserts the human presence in the machine.

The Amazing Adventures of Spiderman *and the* Bel Composto

If motion and senses give life to the machine, *The Amazing Adventures of Spiderman* (figure 5.11), a multimedia attraction at Universal Studios' Islands of Adventure in Orlando, Florida, becomes emblematic of the "monster in the machine." Typifying the unity of the arts that populates current entertainment forms, multiple machine forms merge, embrace us in their motions, and make our senses reel with the experiences they have to offer. Screen action using computer, video, and film technology combines with live action in the form of a roller coaster to produce an exhilarating,

participatory entertainment experience. The *bel composto* that Careri discusses finds a perfect home in this environment, for the spectator experiences a technological *composto*, one that no longer asks us to *visualize* our immersion with the experience depicted. Rather, we participate in an *actual* immersion when we enter the machine. For me, at least, the sensation was akin to confronting a sacred monster—one that was, in fact, doubly sacred in incorporating an icon of the contemporary divine: the superhero in the guise of Spiderman.

On the Marvel Superhero Island, one of five islands that make up the Islands of Adventure,[21] groups of adventurers enter the complex of the *Daily Bugle*, the newspaper that is the workplace of Peter Parker, alias Spiderman. Once inside, and as we pass through the room that displays a portrait of J. Jonah Jameson (the *Bugle* boss) we walk through the bowels of the newsroom. The offices of Peter Parker and other reporters are experienced both as architectural environment and as sculptural space where objects like desks, newspapers, computer terminals, photographs, discarded food, and clothing appear as if frozen in time as a three-dimensional realization of a comic-book world (figure 5.12). With the exception of the attraction adventurers who file through the offices, the workstations are abandoned, and television screens overhead provide a clue as to the reason for the en masse exit: Reporters (in animation form) inform us of catastrophic events that have occurred in New York City. Dr. Octopus—Spiderman's archenemy—and his group of villainous accomplices are wreaking havoc on the city and have stolen the Statue of Liberty, holding it for ransom. We are thus primed for the next space, a larger auditorium where Jameson himself—as mediated through a large screen—greets us (figure 5.12). Jameson informs us that Dr. Octopus and his group of wild hoons, including Electro, Mysterio, and Hobgoblin (all of whom we're introduced to on-screen), are at large. It's our job, says Jameson, to act as stand-in reporters and bear witness to the chaotic events occurring in the city. With our mission clear, we move into the next room, a "subway station" in which we enter a "scoop" (a roller-coaster buggy) and head off on our reporting job.

Our journey in the scoop takes us, armed with our protective goggles (3D glasses), through the streets of New York (á la Marvel Universe), which appear as architecture, painted sets, and sculptured environments. As we move through the city—at times being swirled around in multiple 360-degree spins (a fact that disturbs the centered vision associated with classical form)—at various intervals we're strategically placed in front of 3D filmed animations projected onto wide, domed screens. These larger-than-life animations place us further in the middle of the action. Spiderman, for example,

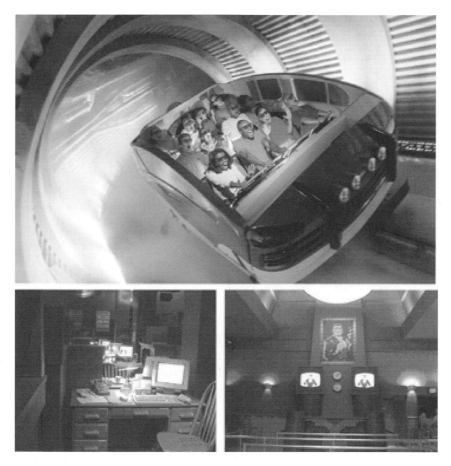

Figure 5.12 The "scoop" and interiors of *The Amazing Adventures of Spiderman* at Universal's Islands of Adventure, Orlando. By permission of Universal Studios.

introduces himself by "leaping" onto our scoop car (causing our car to rock) then somersaulting back into one of the film screens. Informing us he will be our protector, he nevertheless fails to spare us the shocking sensations of being electrocuted by Electro or torched by Dr. Octopus. Likewise, he's nowhere in sight when our scoop-mobile plunges downward at a 45-degree angle and we appear to fall from skyscraper height into an IMAX-constructed illusion of a New York sidewalk as it speedily approaches us. Admittedly, in this particular case, Spidey does save us from the fate that awaits us by setting up one of his trademark webs below us, but this only sends us rocketing back upward. With barely enough time to check out the status of our

innards we continue on our ride, witnessing the Statue of Liberty (in sculptural form) being hoisted above us and experiencing numerous other villain attacks (in 3D animated, wide-screen form), until finally Spiderman saves the day by battling the supervillains and trapping them in his web.

In this attraction, the reality of the audience's presence within Universal's Islands of Adventure melds with the fiction of the *Spiderman* comic book universe. Like many of the effects films and attractions that preceded it, the *Amazing Adventures of Spiderman* attraction has pushed film technology and amusement park rides to new limits by unifying previously self-contained media forms. In this attractions and others that preceded it, the aesthetics of wonder are multiplied. Confronted with the wonder of each technological marvel, we no longer ask, "How did they do that?" but "How did they do that, and that, and that . . . ?"

Likewise, operating according to the logic of the "unity of the arts," attractions such as *The Amazing Adventures of Spiderman* not only draw upon the formal aspects of other media, but they actually incorporate multiple media formats into their structure—in the process, engaging with as many senses as possible to heighten the illusion of the collapsing frame. Superheroes and supervillains are now placed within a 3D context, and the illusionistic outcome is technologically astounding.[22] All the while, audience members sit in their seats, their emotions vacillating between a childlike joy and a state of reverie that rivals that of Roy Neary in *Close Encounters of the Third Kind*.

The combined effort of all of the innovative effects employed in *The Amazing Adventures of Spiderman* makes the experience seem and feel "real." This multimedia automaton comes to life and thrusts the human forcefully into the effects it creates. All our senses are engaged, and the collapse of the frame is powerfully evoked. For example, when the animated version of Dr. Octopus blasts the audience with fire, the animated fire ruptures its film boundary and enters the architectural interior that we inhabit, appearing as "real" fire whose heat we feel and whose smoke effects we smell—and even taste. A neo-baroque "fold" informs the logic of *The Amazing Adventures of Spiderman* and other remediated spectacles of the same kind. Just as in the experience offered in *Terminator 2: 3D*, all of the many multimedia "realities" intermingle with and fold into one another; characters from within the screen appear to enter the space of the audience; the space of the audience appears to become one with the space of the screen. 3D images, theatrical effects, computer graphics, animation, wide-screen technologies, digital sound, and roller-coaster engineering combine to construct the illusion of a breakdown of spatial boundaries that separate the audience's reality from the representation: The end result is that while we are immersed in the exhilarating

kinetics and illusions of the ride, it becomes difficult to fix the boundaries that frame the illusion and distinguish it from the space of reality.

As is the case with Bernini's *St. Teresa*, the diverse media of *The Amazing Adventures of Spiderman* fluidly meld into one another, often denying their media reality in the process: The projected illusion of a New York street appears to generate a solidity that threatens to splatter our bodies if we plummet into it; computer-generated 3D illusions appear to have solidity despite their ethereal nature; and "spectators" feel as if their bodies have undergone radical transformations. The fluid and the rigid, the solid and the ephemeral fold into one another. As Careri explains with regard to Bernini's use of *bel composto*, the juxtaposition of textural and material elements does not create a separation between the diverse media: "On the contrary this juxtaposition defines an architectural space modulated by the movement of the body of the worshipper inhabiting it" (1995, 64). And like worshippers, the attraction riders embrace the experience when, after exiting, they (in many instances) run immediately to the entrance to reexperience the sensorial shocks that this illusion has to offer.

During a period when new technologies are transforming the parameters of reality and identity, entertainment experiences like *The Amazing Adventures of Spiderman* highlight a sacred monster that is indicative of our cultural concerns. Technological wonders like the building that houses the *Amazing Adventures of Spiderman* attraction are the new churches. These are the very technologies that have the potential for evoking Pascal's sublime aesthetics in that they threaten to alienate us by creating uncertainty with regard to our technologically altered states of being. Yet comprehending such entertainment forms from the perspective of Descartes's "aesthetics of wonder," it is possible also to understand that new technologies, no matter how advanced, need not rob us of our humanity. Unlike the baroque churches and the artworks they housed, such neo-baroque spaces, like theme-park attractions, are concerned with affirming not the soul, but the body. The conflict between the soul and the body is rearticulated and adjusted to our cultural needs. In the late twentieth and early twenty-first centuries, we increasingly experience the world through multiple and new technological mediations. Like other entertainment media, though in different ways, theme park technologies reaffirm our connection with the basics of our being: our ability to scream hysterically, to feel intense joy and exhilaration, to suffer nausea or terror, and to experience danger to our material selves. With regard to the work of Bernini, Careri states that the *bel composto* "is an aesthetic operation in which the heterogeneous multiplicity of the ensemble is taken apart and recomposed by the viewer himself" (1995, 5). In the case of attractions such as *The Amazing Adventures of Spiderman* and the *Jurassic Park* ride example that this book began with (figure 5.13), we recompose the multi-

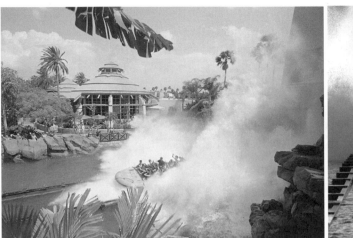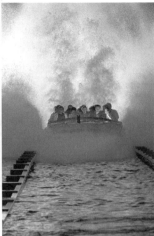

Figure 5.13 *Jurassic Park: The Ride* at Universal Studios in Orlando, Florida. By permission of Universal Studios.

media components and they, in turn, recompose us by reconfirming our ability to feel intensely. The technologies employed are integral to this reconfirmation. Again the ambivalent relationship between affect and effect asserts itself. The affect of intense sensory experiences is attained through the mediation of technological effects.

The visual and sensory games that entertainment technologies articulate flaunt their capacity for making a reality out of an illusion—or, rather, for making the fantastic enter our world in such immediate and sensorially invasive ways. Increasingly, and through their own media-specific methods, entertainment media strive to obliterate the frame that demarcates a distance between reality and fantasy. The cinema relies on wide-screen formats, computer-generated special effects, and surround-sound experiences. Computer games immerse us in virtual spaces that invite us to interact with them. Theme park attractions draw on a variety of methods, including IMAX and OMNIMAX screen formats, wide-screen images, 3D, simulation rides, and theatrical experiences. The future experiences that neo-baroque spectacles will provide will be limited only by the technologies that drive them. Where these journeys will take us, one can only guess. If, however, as Fisher states, "True wonder is a phase of the alert mind, of the mind in its process of learning" (1998, 56), then one thing is certain: I will definitely go along for the ride.

Notes

Introduction: The Baroque and the Neo-Baroque

1. The actual sequence of this fairytale scenario was *Jurassic Park* (the film), Universal Studios and Amblin Entertainment, 1993; *Jurassic Park: The Ride*, Universal Studios, Los Angeles, 1996, and Orlando, 1999; *The Lost World: Jurassic Park* (PlayStation console game), Dreamworks Interactive 1997. There have, of course, been other media offshoots, including the film sequels *The Lost World: Jurassic Park* and *Jurassic Park III*, Universal Studios and Amblin Entertainment, 1997 and 2000, and Japanese version of the ride at Universal Studios, Osaka.

2. Throughout this book I use the term "computer games" to refer to games for personal computers, network games, arcade games, and console games.

3. For an in-depth overview of the conventions of the classical Hollywood paradigm, see Thompson 1999 and Bordwell and Thompson 2001.

4. References to film "exceptions" that begin to break up classical forms of narration are not considered examples of how classical narration is being transformed; rather, they are dismissed because of their failure to adopt classical conventions correctly. In the case of *Armageddon* (Bay 1998), for example, Thompson draws on Todd McCarthy's critical review of the film as evidence of the film's failure to utilize classical forms of narration correctly: The focus on action and special effects result in a lack of depth with regard to character development and their motivation of "causal action" (14). The critic Thompson cites and Thompson herself may see the film as a "failed" or "incorrect" attempt at classical form, but audiences recorded their belief in the film's "correctness" through their contribution to box office returns. Likewise, *Speed* "suffers," according to Thompson, because it "uses up too much narrative energy in the bus episode without leaving any dangling cause at the end" (26). The end of the film (in the train) is viewed as an isolated episode that lacks concrete connection (in a classical sense) with the cause-and-effect patterns of the rest of the film. In other words, the film ignores the pattern of classical storytelling that Thompson identifies and instead succumbs to spectacle and action that ride on minimal story causation.

5. In *High Concept: Movies and Marketing in Hollywood* (1994), a highly significant contribution to the analysis of the dominant industrial and formal practices of contemporary Hollywood cinema, Justin Wyatt stresses the fundamental relationship that exists in Hollywood between "economics and aesthetics."

6. The classical era of Hollywood movie storytelling was dominated by the "Big Five" studios (Warner Brothers, Metro-Goldwyn-Mayer [MGM], Paramount, Radio-Keith-Orpheum [RKO], and Twentieth Century Fox [C20th]) and the "Little Three" (Columbia, Universal, and United Artists). The industry was vertically integrated, with the Big Five controlling all areas of film production, exhibition, and distribution (and with the Little Three controlling production and distribution). Because of financial difficulties that were partially the result of 1948 antitrust proceedings against Paramount Studios that saw the dissolution of the oligopoly of the major studios, film studios began to merge with larger conglomerates whose concern with the film industry was but a minor part of their economic structure (see Wyatt 1994, chap. 3). Thompson acknowledges the structural transformations of the industry following the Paramount case, including the shift in 1968 away from the old production code of censorship, which was a system based on self-regulation, toward a rating system; the increased conglomeration of the industry from the 1960s; the emergence of a new generation of "auteur"-driven film school directors (Spielberg, Lucas, de Palma, Scorsese et al.); and the development of the "high-concept" film. Thompson refuses to conclude, however, that these and other structural changes have resulted in systemic transformations across the entertainment industry. For further information about these industrial, economic, and historical changes, see Schatz 1981; Ray 1985; Corrigan 1991; Hillier 1992; Wyatt 1994; and Wasko 1994.

7. The economic rationale for this strategy was the "reduction of risk which could be obtained through control of affiliated and connected markets" (Wyatt 1994, 81).

8. Although she acknowledges Justin Wyatt's important research on the economic and aesthetic changes that the contemporary Hollywood film industry has undergone, Thompson ultimately dismisses his location of the effects of the high-concept look and increased synergy across media, which she states have not changed the approach to filmmaking but rather have led to "intensifications of Hollywood's traditional practices" (1999, 3).

9. On this etymological issue, see Fleming 1946 (122); Palisca 1968 (2); Wölfflin 1932; Overesch 1981 (37); Calabrese 1992 (chap. 1); Calloway 1994 (7). According to Palisca (1968, 2), French philosopher Noel-Antoine Pluche (1770, 129) used the term "baroque" in 1746 to distinguish between two violinists (Jean Pierre Guigonon and Jean Baptiste Anet) working in Paris at the time. Guigonon was concerned with the display of his abilities, whereas Anet was considered to keep display under control, because not to do so "is to wrest laboriously from the bottom of the sea baroque pearls, when diamonds are found on the surface of the earth" (Pluche 1770, 129, in Palisca 1968, 2). Zatlin also states that the French used the term "baroque" as "a pejorative way of distinguishing Spanish artistic

style from their own Neo-classicism" (1994, 25). Also see Fleming for an overview of the pejorative associations of the baroque (1946, 122).

10. Palisca (1968) and Bukofzer (1947) are typical of music historians in dating the baroque music period between the mid-sixteenth century and the eighteenth century.

11. On the dates, see Burkholder and Johnson 1998 (237), which notes that the Latin American baroque extended into the eighteenth century, as did baroque music.

12. The dualisms outlined by Wölfflin were especially developed in his *Principles of Art History*. The five oppositions that distinguish classical from the baroque, according to Wölfflin, are linear versus pictorial, plane versus depth, closed form versus open form, form that is weighed down versus form that takes flight, and unity versus multiplicity.

13. As the twentieth century progressed, studies on the historical baroque extended into the arts including literature, theater, architecture, garden design, music, and the new sciences. Key early-twentieth-century historians and theoretical protagonists of the baroque included the Englishman Satcherverell Sitwell and the Spaniard Eugenio d'Ors.

14. Dominant baroque themes such as understanding the world as a dream, life as theater, and the "play within a play" motif also invite comparisons to the baroque. Cro, for example, understands Fellini's concern with these motifs as revealing a baroque sensibility (1995, 162). Turning its back on neorealism's concerns with social conditions and material reality, Fellini's neo-baroque vision is conveyed in his play on the blurring of illusion and reality in films such as *La dolce vita* (1960), *Satyricon* (1969), *$8\frac{1}{2}$* (1963), and *Roma* (1972). Calloway (1994, 172–173) also points to the operatic theatricality of Fellini's *La dolce vita* (1960) and *Casanova* (1976) and the "visually obsessive" films *Satyricon*, *Roma*, and *Amarcord* (1973).

15. On the baroque mise-en-scène of Tim Burton's *Edward Scissorhands*, see Desneux 2000 and Calloway 1994 (229).

16. On Powell and Pressberger, see Calloway 1994 (139) and Berard and Cannière 1982. Berard and Cannière use the term "baroque" quite sweepingly and loosely. The baroque is subsumed into every aspect of Curtiz's films: in his lack of concern with norms; in his focus on transgressive themes and characters; in his use of extravagant styles, lighting, and mise-en-scène, and in his preference for virtuoso actors such as Bette Davis, Errol Flynn, Humphrey Bogart, and Boris Karloff. Berard and Cannière also refer to the films of Tod Browning and James Whale as "gothic baroque" (83).

17. See, in particular, Christine Buci-Glucksman and Fabrice Revault D'Allonnes' book on Ruiz (1987); Strauss also states that Ruiz's *Dark at Noon / La terreur de midi* (1992) is "l'histoire de fantômes et de miracles baroques imaginé par Ruiz" (1992, 12); Martin briefly mentions the "high baroque style" for which Ruiz is known for films he directed in the 1980s, in particular, *City of Pirates* (1983) and *Three Crowns of a Sailor* (1982) (1993, 47).

18. On Greenaway's more conscious use of a baroque style and setting in films like *Prospero's Books* (1991), see Calloway 1994 (229), Bornhofen 1995 (274–288), and Degli-Esposti 1996a. Both Bornhofen and Degli-Esposti refer to Greenaway's adoption of a neo-baroque form.

19. Roelens states that "le film, dans son thème comme dans son esthéthique, reflète et illustre cette religion du spectacle et ce spectacle de la religion" (1979, 176).

20. Gibson provides an interesting, though limited, analysis of *Mad Max: Beyond Thunderdome* based on Germain Bazin's articulation of the seventeenth-century baroque. Reflecting a "corporate aesthetic" akin to the postmodern era, baroque court and Church culture is understood as engendering a transcendental art that speaks of power and creativity. For Gibson, "the baroque configurations, the plastic exuberance, and the stylistic effervescence of *Beyond Thunderdome*" are expressions of "the telling of a new myth of origin" (1992, 171).

21. See Degli-Esposti 1996b. Of all the above-mentioned writers on the baroque nature of particular films or directors, Degli-Esposti is the most consistent and detailed in her efforts to locate traits of the baroque and the neo-baroque.

22. On the impact of baroque logic (especially the work of Caravaggio) on contemporary artists, see Bal 1999. In addition to providing overviews of 1990s exhibitions on the contemporary baroque, Bal covers a number of artists in her analysis, including Ana Mendieta, Andrea Serrano, Dotty Attle, Ken Aptekar, David Reed, Ann Veronica Janssens, Amalia Mesa-Bains, George Deem, Jackie Brookner, Edwin Ianssen, Jeannette Christensen, Lili Dujourie, Stijn Peeters, Mona Hatoum, and Carrie Mae Weems.

23. In France, the neo-baroque was also in vogue. In particular, the shops of Parisian decorators like Jean-Michel Frank became the meeting point of individuals who were victims of Parisian chic. The Louis XIVth style was especially in vogue. As Calloway points out, contemporaneous to the austere modernism of the period was a neo-baroque style that undermined the concerns of modernist values (Calloway 1994, 61–62).

24. The baroque fashion of the period was also reflected in films like Busby Berkeley's *Fashion of 1934*, which included the central character couturier Monsieur Baroque (Calloway 1994, 81).

25. The stage productions of John Gielgud's *Hamlet* (1934) and C. B. Cochran's *Helen!* (1932) also followed the neo-baroque trend. See Calloway 1994 (101).

26. It was the world of fashion that retained its admiration of the baroque in the intervening years. Between the 1920s and the 1990s, Chanel, Dior, Balenciaga, Schiaparelli, Lacroix, Lagerfield, Westwood, and Versace persisted in experimenting with baroque styles. See Calloway 1994 (145, 192). Also see the catalogue for the Gianni Versace exhibition (Martin 1997) held at the Metropolitan Museum of Art between December 11, 1997, and March 22, 1998, which included a number of the designer's baroque-inspired designs.

27. On the neo-baroque and contemporary Latin American art, see Wollen 1993.

28. For detailed overviews of the historical and aesthetic concerns that gave rise to the Latin American neo-baroque, see Cabanillas 1992; Bornhofen 1995; Wollen 1993.

29. Thomas (1995) refers to Sarduy's essay republished in *Latin America and Its Literature* (1978). The original was published in 1973 as "Barroco y neobarroco" in *America Latina en su literatura* and was republished as chapter 5, "Supplement," of Sarduy's *Barroco* (1975).

30. On the neo-baroque movement in Spanish literature, see Overesch 1981.

31. Overesch makes the important point that, although "neo-baroque" and "baroque" have become common terms for defining techniques employed in the Spanish novel, there is little consensus as to the precise features that characterize this "barroquism." In addition, there is much debate as to which authors typify a baroque sensibility (1981, 35).

32. Overesch argues that where the Latin American neo-baroque was closely concerned with reclaiming history in an effort to understand the present, the emergence of the neo-baroque in 1960s and 1970s Spanish literature, especially the emphasis on the illusory nature of identity and existence, related to cultural transformation and, in particular, to the increased impact of technology and foreign interests on Latin American culture, which are reflections of the new age of globalization. The new wave of Latin American authors, she states, reflect the way "artistic creation is the working out in formal terms of what culture cannot solve concretely" (1981, 80).

33. Although it is not the concern of this book to explore the Spanish manifestation of the neo-baroque, it is worth noting that little has been made of the relationship between post-1970s Spanish cinema and the neo-baroque literary tradition. Given the recurrent and shared themes and techniques that concern both neo-baroque writers and filmmakers like Pedro Almodovar, it is evident that the literary Spanish neo-baroque form has infiltrated the cinema of the period.

34. Peter Wollen, for example, has explored the avant-garde potential of Latin American, and especially Mexican, art of the 1950s. This art embraced a neo-baroque approach that strengthened in the 1960s and became "irresistible with the advent of post-modernism" in the post-1960s, and its formal strategies contained a more radical potential for subversion, for Wollen, especially when compared to the postmodern variation articulated in mainstream culture (1993, 13). Similar approaches that view the (neo-)baroque as a form that belongs in the margins may be found in Buci-Glucksman 1994, Jay 1994, and Degli-Esposti 1996a and 1996b.

35. For a detailed overview of the historical development and transformation of postmodern theoretical positions from the 1960s to the 1990s, see Best and Kellner 1997 and Anderson 1998. These works provide succinct summations of the divergent, and often conflicting, views present in postmodern theory.

36. Perry observes that one of Venturi's initial steps toward resisting and, in fact, attacking modernist architecture was to embrace traditionally less "purist" forms, including mannerism, the baroque, and rococo (1998, 20).

37. Although it was actually the fourth segment in the story sequence, *Star Wars* was the first of the films produced. *The Phantom Menace* (1999), the first segment of the narrative sequence, initiated the release of the much-awaited prequel trilogy. *Attack of the Clones* (the second segment) was released in 2002, and the third segment in the sequence is scheduled for release in 2004.

Chapter 1. Polycentrism and Seriality: (Neo-)Baroque Narrative Formations

1. See, for example, Don Quixote's exchange with a shepherdess who recognizes him on the basis of her familiarity with the false Quixote in the false sequel (1999, II:58, 1003).

2. Given the intertextual nature of popular culture in the 1980s and 1990s, a variety of media have become engaged in what Collins calls a competition for the "same overlapping functions" (1989, 112).

3. The *series* (which is often associated with television) is a sequence of independent episodes with self-contained stories that have in common recurring characters and basic diegetic situations, but not an overall narrative situation (Hagedorn 1988, 8). The *serial*, which consists of sets of episodes, weaves and extends its story across each episode, thus creating an expanding narrative structure. The *sequel* (which tends to dominate in the domain of the cinema) is a development of the series and sequel and, as such, can contain features common to both forms. Some sequels, such as *Batman and Robin* (Schumacher 1996), ignore narrative events that occurred in the original film, thus reproducing features of the series. Others, such as *Star Wars: Attack of the Clones* (Lucas 2002), continue story events of the original in a movement that mimics the serial. In the last two decades, a distinction between the series, the serial, and the sequel has become more and more difficult to sustain. The entertainment industry now supports media examples that can contain elements of all three.

4. The impetus for transnational corporatism and globalization has been in place since the 1980s. American government incentives favored the increased privatization of industry, and corporations shifted their attention to an international scale and away from insular national concerns. While the logic of globalization is an economic one, the "export and import of culture" is also a feature of it. The culture of the United States, as the current global leader, has infiltrated foreign domestic spheres through its mass-culture forms and commodities. In this expansionist move, it is not commodities alone (films, television shows, music) that move beyond the geographical borders of the United States, but the cultural content contained within them. See Jameson 1998b, 54–77.

5. I will capitalize the term "Alien" when it refers to Alien characters in the *Alien* films and other media crossovers.

6. Contemporary entertainment media's tendency to open its narrative form through the production of the sequel flourished in the post-1960s era. The film sequel is no longer limited to its most-favored genre: the horror film. In recent years a range of film genres have expanded their form to accommodate the sequel, including the cop film (*Die Hard* [McTiernan 1988], *Lethal Weapon* [Donner 1987], *Rush Hour* [Ratner 1998]), action-adventure (*Raiders of the Lost Ark* [Spielberg 1981]), the comic-book genre (*Batman* [Burton 1989], *X-Men* [Singer 2000]), and comedy (*Austin Powers* [Roach 1997]). Many film stories have also made sequel journeys into other media. *Raiders of the Lost Ark* has developed sequels in the computer game medium, as have the *Die Hard* films. The narrative of John Carpenter's film *The Thing* (1982) was continued in the comic books *The Thing from Another World* and *The Climate of Fear* (1993) and in PlayStation 2 format (2002). Likewise, the *Star Wars*, *Batman*, *Lethal Weapon*, and *Terminator* films have all extended their stories into the medium of the amusement ride, and television shows such as *The X-Files* and all of the *Star Trek* series (the "original," *The Next Generation*, *Deep Space Nine*, and *Voyager*) have been serialized into films, computer games, and comic books.

7. In the pre-1960s period the film studio system was an industry concerned primarily with film production, distribution, and exhibition. The classical Hollywood studio system based itself on stable, closed production practices that began to break up only after the 1940s for various complex reasons, which included the 1948 Supreme Court decision in the antitrust litigation involving Paramount (see note 6 in the Introduction chapter; see also Belton 1992 on the changed audience needs, needs that were more aligned with a growing leisure culture).

8. In *Hollywood in the Information Age* (1994), Janet Wasko traces the effects of globalization, transnational corporatism, and new technologies on Hollywood industry, stressing that historically (although not to the current degree), Hollywood has always been interested in other media and commodities beyond film.

9. For a detailed analysis of industry transformations in the post-1970s period, see Wasko 1994 (esp. 42–70). On the conglomeration of the industry, also see Ray 1985, Hillier 1992, and Wyatt 1994. The diversification of interests meant that companies no longer faced the problem of financial ruin when blockbuster films failed to attract box office sales. If a film proved to be a box office hit, crossovers into other media owned by the same conglomerate could similarly reap further economic successes.

10. On the Time Warner/America Online merger, see *Variety*, May 15, 2000; *Broadcasting & Cable*, September 25, 2000; *PR Newswire*, April 7, 2000; and *Business Wire*, January 10, 2000. Also see Wasko 1994 (chap. 4).

11. Other major corporations show similar diversification interests across the entertainment industry. Viacom, for example, owns or has interests in Paramount Pictures and the

United Paramount Network; United International Pictures; the CBS television network; cable stations including MTV, the Comedy Channel, Showtime, and The Movie Channel; Blockbuster and Paramount Home Video; Paramount Parks theme parks and the Nickelodeon and Universal Studios in Florida; the Simon & Schuster publishing house; and the Internet companies CBS.com and Country.com (*Los Angeles Business Journal*, January 3, 2000; *Broadcasting & Cable*, September 20, 1999). Typifying Hollywood's concerns with the potential of the Internet as a media form that can reach multiple consumers, the Walt Disney Corporation recently purchased the Infoseek Corporation, and News Corporation—which owns Fox Studios and Fox cable and television stations—has also established Fox Interactive, ChinaByte, and e-partners (*Los Angeles Business Journal*, January 3, 2000).

12. In sports, Time Warner also owns the Atlanta Braves (major-league baseball), the Atlanta Hawks (National Basketball Association), World Championship Wrestling, and the Atlanta Thrashers (National Hockey League). For detailed accounts of the Time Warner conglomerate and investments, see *Broadcasting & Cable*, September 2000; *Variety*, May 15, 2000; and *Variety*, July 19, 1999.

13. In 1998, for example, a joint venture between Marvel Comics and Universal Studios saw the construction of Marvel Mania, an entertainment-themed restaurant at Universal City that includes special effects, video systems, and interactive technologies built around Marvel characters. In the same year, McDonald's joined forces with the Disney Corporation, producing tie-ins based on Disney's film *Armageddon*; Taco Bell's tie-ins that same year promoted Columbia TriStar's *Godzilla*. For further information, see *Nation's Restaurant News*, January 3, 2000, and *Entertainment Marketing Letter*, June 1, 1998.

14. The postwar model (associated with Fordism) initiated a new stage of capitalist development, the first stage of global transformation. The 1973 recession, which was caused by a crisis in international competition, a slump in corporate profits, and high inflation (Anderson 1998, 79) initiated the second phase of global transformation. The third and current stage of the transformation has brought the "deregulation of financial operations," resulting in the emergence of a more flexible and single global market. See also Harvey 1982.

15. Dussel has made explicit the two dominant turning points that characterize modernity: the Eurocentric and planetary paradigms (1998, 3–4). From the Renaissance era and, in particular, with Spain's discovery and colonization of the New World, Europe's impact on the world was sealed spatially, intellectually, and socially. Charles V's attempts in the sixteenth century at establishing a world empire (by conquering areas of Europe, including Flanders, Hungary, Austria, Milan, and the two kingdoms of Sicily), although initially successful, failed as a result of economic crisis.

16. The Spanish colonies throughout Latin and Central America were controlled by viceroys, and the Spanish Crown also reaped monetary benefits in the form of imposed taxes. The Crown's bankruptcy in 1557 (as a result of wars and excessive royal expenses) led Philip II

to sell appointments for treasury posts, tribunals of accounts, administrative positions, and later even the office of the viceroy in the colonies to raise revenue (Burkholder and Johnson 1998, 83–86).

17. The Crown suffered repeated financial crises in 1598–1648, and available resources were devoted to the wars with the Dutch and, later, the French. During the seventeenth century, the "demise of Spain as European hegemon would become clear along with its reliance on colonial silver" (Stein and Stein 1999, 58).

18. Dutch control of many of the shipping routes caused problems for the English, especially in terms of trying to access areas of the Atlantic, Mediterranean, the Indian Ocean, and the Baltic Sea (Ferro 1997, 55).

19. Interestingly, the Catholic Church became an enormous power in Spanish America, exerting itself in "nearly every dimension of colonial life" (Burkholder and Johnson 1998, 92). By the beginning of the seventeenth century, the church was the most financially stable group in the colonies, with orders such as the Jesuits not only founding convents and colleges but also becoming successful landowners who rented their residential and commercial properties for monetary gains. The presence of the Society of Jesus in Spanish America was particularly pronounced, and its members established themselves as the leading educators in many major cities of Brazil, Peru, Mexico, and Paraguay and played a major role in converting the Indian population to Christianity (Burkholder and Johnson 1998, 96).

20. Munck explains that "seigneurial control exerted over the countryside . . . often gave . . . [the cities] a large degree of independence in town government, administration, law and taxation" (1990, 165).

21. Godzich and Spadacchini state that as early as 1521, twenty-nine towns in Spain had publishing presses (1986, 49–50).

22. In 1657, De Rossi received his first commission for a work, *Effigies*, a series of prints of portraits of cardinals alive at the time of publication. This privilege allowed De Rossi dominance over the printing industry. In fact, he became the leading print publisher in Rome between 1664 and 1674. Alexander's sanction attracted some of the best scholars, artists, and printmakers in Rome to collaborate with De Rossi. As Consagra has pointed out, papal privileges that protected all the publications of a single publisher for an extended period of time were extremely rare during this period and usually covered only specific publications. Clearly, De Rossi's strategic decision to publicize the Pope's accomplishments in the public realm through his publication aided in his obtaining Alexander VII's support (Consagra 1995, 197).

23. Further, the dissemination of plays, novels, biblical texts, and printed books proliferated. The migration of the English, French, and Iberian colonizers to the Americas resulted in the migration not only of books such as the Bible, chivalric romances, novels, and poetry

but also of the technology of the printing press as well. From the 1500s onward, "New World editions of Old World classics" and the writings of local writers were more easily accessible to the colonizers (Burkholder and Johnson 1998, 236).

24. The first and second parts of *Don Quixote* were written during a period of transition when, according to Cascardi, "the 'heroic' that had been idealized in ballads and romances of chivalry was replaced by a newer, more mobile order oriented around the values of social class." The novel reveals a new social order and class structure to be in the process of development. As Cascardi states, in *Don Quixote* this new order and structure is played out through the conflict between the old and the new: The lords, ladies, and knights in the novel are often contrasted with the new classes on the rise (such as the printer in Barcelona) who rely on the new capitalist business economy and the possibility of upward mobility (as reflected in Teresa Panza, who desires the economic means to rise above her status) (1997, 184).

25. On the impact of seventeenth-century print culture on the dissemination of books of natural magic, see Eamon 1994.

26. In chapter 32 of part I, occupants of an inn convince a priest to read *The Novel of the Curious Impertinent*, and the tale ruptures Quixote's own narrative for chapters 33, 34, and 35. Likewise, in chapter 38, a stranger at an inn decides to relate his own story, which continues (complete with sonnets) in chapters 39 to 41. Two more of many other story digressions include chapters 25, 26, and 27, which recount the adventures of a puppeteer and his ape, and chapters 38, 39, and 40, which tell the story of Madam Trifaldi.

27. The etchings of Dürer, who produced work early in the sixteenth century, mark a beginning in the evolving demand for image copies. Although the etching was not to attain greater popularity until the seventeenth century, Dürer recognized its potential, not only with regard to freedom of artistic handling, but also in terms of its reproducibility.

28. Burkholder and Johnson also stress the New World manifestation of seriality in the form of copies and reproductions: "The elites in major administrative centers tried to replicate Iberian cultural institutions and practices. The movement of officials, churchmen, merchants, and others to and from the colony and metropolis resulted in an ongoing transfer of Iberian high culture—European books and ideas, music, and art—to the major colonial cities" (1998, 232). Similarly, mural paintings in Latin American churches and private residences were often adapted from European print sources (Grizzard 1986, 26). Numerous paintings in Latin America and Mexico were based on print copies of the works of Martin de Vos, Sadeler, Rubens, Murillo, and Zurbarán. For example, the painting in the sacristy of the Cathedral of Puebla in Puebla, Mexico, includes the *Triumph of the Church* and *Triumph of Religion*, both derived from Rubens (Grizzard 1986, 31).

29. On the transformation of painting markets in the seventeenth century, see Haskell 1980.

30. Amabile (1891, 58–64) also includes transcripts of the Inquisition documents: *Contra Magistrum Jacobum svvánen pictorem. Jo: Dom.eus de And.a actuaries. Die 19 mensis novembris*

1608 neapoli; Die 20 mensis 9bris 1608 In palatio Archiep.ii neap.no coram Ill.mo et R.mo D.no generali locumente; and *Die 28 mensis novembris 1608 in palatio Archiepiscopali neap.no coram D.Advocato fiscale*. All three documents record the Inquisition process, the charges, and the questions addressed to Swanenburgh, as well as the artist's responses.

31. Amabile also makes the point that another likely source for Swanenburgh was a painting in the nearby Chiesa di Monteoliveto (today called the Santa Anna de' Lombardi). The painting, by Baldassare Aldivisi, depicts S.ta Francesca in the desert accompanied by an angel and threatened by a devil with a stick. The painting is in the second chapel on the right, which is dedicated to S.ta Francesca Romana. See Amabile 1891 (19, n. 1).

32. Often, opera theaters were maintained through the leasing of boxes to families as well as the sale of admissions (Palisca 1968, 119). Despite the fact that the aristocracy frequented the opera, in these commercial theaters, the aristocracy did not commission performances to coincide with important family events such as marriages or coronations. See also Munck 1990 (314).

33. The theater was an important source of entertainment in the colonies. In the early seventeenth century, theaters like the Corral de las Comedias, which opened in 1604 in Lima, Peru, were built throughout the colonies for performances of plays (often religious in theme) that were attended by locals (Burkholder and Johnson 1998, 243).

34. The glorification of the king went hand in hand with the subjugation of nature. The extent of this subjugation is revealed in the fact that more than 36,000 people were employed in taming nature into man-made gardens during Louis XIV's reign (Lablaude 1995, 38).

35. Hammond has noted that even before his accession to the papacy, more than thirty images were publicly associated with Maffeo Barberini, of which the most important were the bees of the Barberini arms, the lyre of Apollo and the Muses, the laurel wreath of virtue, poetry, and strength, and the sun, "which could denote everything from secular beneficence to the Crucifixion and Resurrection" (1994, 46).

36. Rosasco also draws attention to the fact that Apollo shows great self-control amid the group of women around him in the *Grotto of Tethys*, refusing to look at them while they bathe him. "Here", she states, "Apollo's gaze into the distance and expression of self-possession are indications of a godly (or godlike) serenity" (1991, 8). Rosasco argues that the statue group was imbued with further symbolic function for the seventeenth-century viewer: Specifically, Apollo's restraint and "ability to master his senses" also addressed rumors regarding Louis XIV's scandalous liaisons (1991, 13).

37. And in the very title of an early (c. 1675) manuscript poem on Versailles, the chateau is referred to as the "maison du soleil": the house of the sun (Berger 1985, 67).

38. For a detailed account of the Apollo theme at Versailles, see Berger 1985.

39. Other, now destroyed, Apollo-themed scenes in the royal suites included a ceiling painting by Gilbert de Sive depicting *Apollo with the Hours and the Four Parts of the World*, and the

fresco of *Apollo Dispersing Storms* occupied the center of the ceiling of Cabinet des Mois in the Salon Octogone. See Berger 1985 (67–68).

40. Berger, in fact, views the sequence of the rooms as an ad hoc arrangement that lacks the guidance of scientific advisers. Despite the advancement of scientific research in France during this period, which included the construction of the Paris Observatory in 1667–1671 and the arrival in Paris of the renowned Italian astronomer Gian Domenico Cassini in 1669, in 1670 (when the rooms were designed) there was little support for the Copernican system. See, in particular, Berger 1985 (42–47).

41. The fictional adventures of Louis XIV depicted in these narratives were all part of the Enveloppe, the new chateau built between 1668 and 1674. In 1678 the Enveloppe was modified by the creation a monumental long gallery: the Galerie des Glaces. See Berger 1985 (68).

42. This essay was first published in 1984 as "Postmodernism: The Cultural Logic of Late Capitalism." In the earlier version Jameson links postmodernism with "the new moment of multi-national capitalism" and the technological innovations that are driven by capital.

43. See part I, chap. 6, in particular: the priest and the barber, fearing for Don Quixote's health, peruse his library and list and make commentary on numerous texts. Also in part I, Don Quixote imitates figures from the epic, including the Cid; fictional heroes of chivalric romance, such as Amadis de Gaula, figures from Moorish novels by Rodrigo de Narváez and Abindarráez, and heroes of the ballad tradition like the Marqués de Mantua. See Cascardi 1997 (198).

44. As Bakhtin (1984) has argued, such dialogic processes are typical of the carnivalesque, especially as displayed in the novels of Rabelais. Although a discussion of them is beyond the scope of this study, the parallels between the strategies of the carnivalesque, the (neo-)baroque, and the postmodern are worth noting. On the parallels between postmodernism and the carnivalesque, see Docker 1994.

45. Don Quixote is also greeted by a citizen of Barcelona offering an alternate view as follows: "Welcome to our city, the mirror, the beacon, and polar star of knighte errantry in its greatest extent! Welcome, I say, the valorious Don Quixote de la Mancha; not the spurious, the fictitious, the apocryphal, lately exhibited among us in lying histories, but the true, the legitimate, the genuine, described to us by Cid Hamet Ben Engeli, the flower of historians" (Cervantes 1999, II:61, 1029).

46. Asked whether he has ever met witches like those that appear in his paintings, Swanenburgh responded: "Never have I known or seen sorcerers or witches, and if I met such women I would run away. I painted this subject because dealing with capricious themes *(di capriccio)* pleases all painters" [my translation] (Amabile 1891, 62).

47. The complex strands of postmodern practice and theory are evident in one (of many other) oppositions that are often referred to. As Best and Kellner outline, writers like

Teresa Ebert (1996) and Hal Foster (1983) distinguish ludic postmodernism (which "indulges in aesthetic play for its own sake while distancing itself from a politically troubled world") from a "postmodernism of resistance" (which "questions and deconstructs rather than exploits cultural codes" and relies on self-referentiality to initiate social change) (1997, 137). The ludic tradition of ludic postmodernism "indulges in aesthetic play for its own sake" while also abandoning "modernist pretensions to novelty, originality, purity, innovation" (137). The ludic postmodernist generally resists postmodern theories that insist that this transition period marks the "the end of history" (Baudrillard 1986). Where Collins and Docker are more engaging than ludic postmodernists in their collapsing of such oppositions: The postmodern fascination with "playing with the pieces of the past" can both imply a bolder political stance against social norms and be concerned with a form of aesthetic play. Focus on the latter need not suggest a "bad," ideologically problematic form of postmodernism.

48. Spectatorship theories centering on the "gaze" were first institutionalized by Jean-Louis Baudry (1981) and Christian Metz (1974). The model that developed depended on psychoanalytic and Althusserian theories of subject construction and was applied especially to forms of spectatorship aligned with Hollywood cinema. For an account and critique of this 1970s film theory tradition, see Carroll 1988 and Mayne 1993. For an account of television viewing and theories of the glance, see Flitterman-Lewis 1987.

49. The sense of nostalgia and elitism manifests itself despite Corrigan's claim that he is not mourning the "loss of good Aristotelian cinema" that knows "how to tell stories" (1991, 162).

50. Stallabrass also assumes a stable, unitary postmodern theory when, in actuality, no such unified theory exists. In this respect, see Best and Kellner 1991.

51. Ironically, the metaphor that Stallabrass uses to articulate the insatiable appetite of mass culture is the figure of Rabelais's Gargantua. Popular culture is "a massive heir to the throne [of Gargantua] whose wants are awesome and unbridled. He is an animated fantasy about greed, strength, and sheer, unstoppable corporeality. . . . We can recognize in the old giant's size, ubiquity, gluttony, vast knowledge and warlike nature qualities of our contemporary culture" (1996, 1–3). For Bakhtin, Rabelais's Gargantua expressed the unbridled, reflexive and grotesque powers of the carnivalesque—features that could counter the dominant power structures.

52. Anderson explains that "[m]odernity gave rise to two myths or forms of grand narrative. The first (which originated from the French Revolution) understood humanity as capable of its own liberation through heroic agency, and the second (derived from German Idealism) views the spirit as 'the progressive unfolding of truth'" (1998, 25). In response to Lyotard's mourning (in his The Postmodern Condition) (1984) of the loss of all grand narratives, including that of Christian redemption, Anderson makes the convincing observation that the problem with this argument lies in the fact that the 1980s, which witnessed the

"euphoria of the Reagan boom" and the collapse of the Soviet Union, also saw the estab-lishment of "what appeared to be one of the most grandiose grand narratives of all," a narrative that established itself as a "single universal story of liberty and prosperity, the global victory of the market" (1998, 32).

53. For an analysis of the assumptions that emerge as a result of the commerce/art binary, see Wyatt 1994, chap. 1.

54. The negative responses to current developments of visual forms such as the cinema have been counterbalanced recently by the more positive analyses of writers such as John Docker (1994) and Jim Collins (1989, 1995). Although they are aware of the malleable nature of term "postmodern," Docker and Collins have imposed their own definitions on the postmodern label. In doing so, they have taken steps toward articulating postmodern approaches that provide complex analyses that test negative theoretical assumptions applied to popular culture. They correctly query the supposedly homogeneous nature of contemporary cinema and refuse to perpetuate myths that propagate the denigratory aspects of the visual as ideologically problematic.

55. It would be convenient to extend a negative postmodern analysis to media examples such as the "Alien" cross-media serials in that their production is motivated by financial imperatives concerned with the dispersal and reproduction of the "Alien" signs across a diverse range of commercially profitable media variants. If we are to believe Baudrillard, "It has all been done . . . [postmodern culture] has deconstructed its entire universe. So all that are left are pieces" (1984b, 24). A neo-baroque model, however, offers an alterna-tive, less apocalyptic or dismissive understanding of these pieces. If a reader or viewer were to access only one example from within the larger serial structure, it is likely he or she would be confronted with narrative gaps and a sense of story fragmentation. It would appear that he or she has been left with superficial signs of unity and coherence that are present in basic iconographic and narrative signs that remain shared across the serial, sequel, and series system—only the allegorical sign "Alien" remains stable, its relevance echoing its status as commodity. Because of this, the open narrative structures so charac-teristic of the 1990s (particularly exemplified by contemporary mainstream media) have been viewed as one of the negative products of our postmodern age.

56. In the comic books, the Aliens and Predators are mortal enemies.

57. The character Ash Parnall was introduced in an earlier two-part comic-book story, *Rene-gade* (Dark Horse Comics, 1992).

58. Throughout the series Caryn visits Structures, a salon for genetic engineering that permits her to change her appearance, making possible her transformation not only into any other human form, but also into any other species form.

59. In the *Renegade* episodes, however, Ash Parnall was revealed to be a cyborg rather than a clone.

60. Collins observes: "Like their forebears, popular texts in the eighties acknowledge the force of what Umberto Eco (1987) calls 'the already said,' but rather than simply rework conventions within the confines of a specific genre, texts . . . re-configure that 'already said' by moving across genres, mixing different forms of discourse as well as different media, which by extension alters their traditional modes of circulation" (1991, 164).

61. Although Collins makes the following statement in relation to the "Batman" myth, his comments are just as applicable to *Aliens/Predator*: "The array presented multiple narrativizations of the same figure produced over a [twenty]-year period, appearing as simultaneous options, a simultaneity made more complicated by the fact that these narratives were not just continuations of an UR (original) text but . . . very ambitious attempts to re-construct the beginning of the [Alien] story, re-inventing, as it were, the point of origin for the seemingly endless re-articulations" (1991, 164).

62. Bach wrote *Kunst der Fugue* (Art of Fugue) during the last years of his life. He was in the process of revising an earlier version known as *Berlin Autograph* for publication, but he died in 1750 with the revision incomplete, leaving behind an unfinished fugue that was published by Bach's sons in 1750–1751. The recording of *Art of Fugue* studied for the purposes of this analysis was the version by Gustav Leonhardt, originally recorded in May 1953 in Vienna (New York: Vanguard Classics/Omega Record Group, 1993).

63. On the fugue, Bach and conventions of baroque music, see Bukofzer 1947 and Palisca 1968.

Chapter 2. Intertextuality, Labyrinths, and the (Neo-)Baroque

1. The narrative premise of *Batman/Judge Dredd* involves the two superheroes teaming up against a range of villains, including characters who resemble the cyberdemon from *Doom II*, the evil other-world ruler from *Mortal Kombat*, and ED209 from *Robocop*. A hybrid dinosaur/alien even makes an appearance, collapsing the villains of *Jurassic Park* and the *Alien* films.

2. For a detailed analysis of Verhoeven's use of intertextual referencing as a strategy for social critique, see Ndalianis 2001.

3. The baroque excess that typifies the *Evil Dead* films is also typical of the television shows *Xena: Warrior Princess* and *Hercules: the Legendary Journeys*, both produced by Raimi's Renaissance Pictures.

4. The gore in the film often, through its excess, crosses the boundary of horror and enters the space of comedy. In one scene, Ash's hand becomes possessed. The solution? First he stabs it, trapping it onto the floor. Then he saws it off with a chainsaw, which results in more blood-spraying effects, with the blood gushing over Ash's face as he victoriously cries out, "Who's laughing now?" As the hand attempts to escape, Ash traps it in a box,

securing the box's top with the weight of a book, *A Farewell to Arms*. The excess that informs such scenes often forces horror conventions to exceed the limits of the horror genre and, instead, enter the realm of comedy. Raimi's interest in pushing horror beyond its boundaries and into comedy is especially evident in allusions made to the Three Stooges. Besides the innumerable Curly chuckles heard on the soundtrack, in the infamous possessed-hand scene, as Ash fends off attacks from his possessed hand, the hand movements often allude to the Stooges' standard slapstick routines.

5. The reference to *Necronomicon* is an allusion to the book *Necronomicon*, whose title appears in the works of Lovecraft. Some would have it that this greatly feared and fearful book, the stuff of legend, really exists.

6. Similarly, on this issue of variation, the tracking shot may duplicate the ending of the first film, but the two holes present in the cabin door in the tracking shot of the first film (damage caused when Ash was attacked by a demon who thrust his hand through the door) are no longer present.

7. This question of original or copy is further complicated by the fact that the film reveals the impossibility of the existence of such a thing as "the original," especially as far as genre is concerned. Although the use and assimilation of conventions may reveal originality and may instigate new directions in a genre, genre films depend greatly on that which has gone before, even if only to contest or reject a previous form. As an example, although *Evil Dead II*'s absurd, darkly hysterical and over-the-top nature may appear original and new within the context of the horror genre, this morbid humor owes a great deal to the tradition of EC (Eastern Color) Comics, which influenced the deconstructive tendencies of contemporary horror cinema. For more information on the comic book/horror film connections, see Newman 1988 (18, 207), Anwar 1990 (347), and Brophy 1986 (12).

8. Written in the last decades of the seventeenth century for Nicolas Remond, counselor to the Duke d'Orleans, the text of *Elucidation Concerning Monads* was never sent to Remond and was finally translated from the French into German in 1720. For an account of the background and theoretical premises of Leibniz's *Monadology*, see Savile 2000.

9. Or, as Deleuze states, "God (or the creator of the folds may) play tricks but he also furnishes the rules of the game" (1993, 63).

10. As Deleuze makes clear, "monad" is the term that "Leibniz ascribes to the soul or to the subject as a metaphysical point" (1993, 23); drawing on the Neoplatonic tradition, in many of his writings, including his *Monadology*, Leibniz tackled the immense task of comprehending the interrelationship between the material nature of the everyday and the immaterial nature of the supernatural (as embodied in the soul and God). For Leibniz, matter and soul comprise a unity that also envelops multiplicity.

11. Leibniz's narrative of multiple possibilities is especially developed in his *Theodocie*. For example, the life of Sextus is presented as following multiple paths: "Leaving Jupiter's

abode, one Sextus will go to Corinth and become a famous man, while another Sextus will go to Horace and become king, instead of returning to Rome and raping Lucretia. . . . All these singularities diverge from each other, and each converges with the first. . . . All these Sextuses are possible, but they are part of incompossible worlds" (Deleuze 1993, 62).

12. Deleuze relates that "a continuous labyrinth is not a line dissolving into independent points, as dissolving sand might dissolve into grains, but resembles a sheet of paper divided into infinite folds or separated into bending movements, each one determined by the consistent or conspiring surroundings" (1993, 6).

13. The first, *Minerva and the Fall of the Giants*, symbolizes Urban's battle against heresy; in *Silenus and the Satyrs*, Urban's piety is seen as overcoming "lust and intemperance"; *Hercules Driving out the Harpies* is an allegory for Urban's justice; and in *The Temple of Janus*, Urban's prudence ensures peace (Wittkower 1985, 253).

14. See Scott 1991, Appendix F, for a reproduction of Rosichino's *Dichiaratione delle pitture della Sala de' Signor Barberini*.

15. For an account of the Farnese Ceiling's iconographic program and historical influences, see Scott 1991 (chaps. 9–13).

16. On seventeenth-century debates and disputes over whether the classical or the baroque was the most appropriate stylistic language, see Mahon 1971. As Mahon states, in the seventeenth century there was a discrepancy between art and the theory held to govern it. While "the prevailing artistic language was the baroque, the predominant trend in art theory was strongly accentuated in the opposite direction, towards the classical" (Mahon 1971, 3). Carracci's art became a model embraced by both camps. For classicists he epitomized the symmetry of classical sensibilities and simplicity of style and narrative presentation, and for "eclectics" like Cortona, Carracci's work embodied the open possibilities of baroque forms.

17. The competition between the two families culminated in the War of Castro (1641–1644). Castro was a fief in the papal states owned by the Farnese. The Barberini attempted to control these states through a marriage alliance with Duke Odoardo Farnese but were "informed that the Duke had no intention of marrying his family into the vulgar classes." The Barberini then attempted to take control coercively. The ensuing war eventually led to the demise of the Barberini with their expulsion from Rome. See Scott 1991 (6).

18. In addition to Cortona's allusions to and reliance on the epic poem *L'elettione di Urbano Papa VIII* (1628) by Francesco Bracciolini, which dealt with the theme of the intervention of Divine Providence in the election of the Barberini Pope (Paul 1997, 79), other complex allusions and mergings come into play in the Barberini Ceiling. By creating a hybrid relationship that conflated history painting, allegory, and mythological painting, Cortona perpetuated the tradition of the *genere misto*, or "mixed genre" (Paul 1997, 84).

19. Beverley (1988) states that, in Golden Age Spain, 80 percent of the population was illiterate. Even so, Maravall notes that as early as 1548 the Cortes of Madrid requested lower prices for the cost of primers, thus making their purchase affordable for children by parents from a working class background (Maravall 1986, 15).

20. Outlining Lima's argument, Godzich and Spadacchini explain that an auditive form of reception seeks to leave the audience dumbfounded, with their "*boca apierta*" (1986a, 47). This "flow of rhetoric" reflects what Lima suggests is a "seductive persuasion, given to theatricality" that "lends itself to manipulation" (Lima 1981, 16; Godzich and Spadacchini 1986a, 47). But as Godzich and Spadacchini point out, there are other possibilities besides viewing this as a manipulative and uncritical form of reception. The first is to view it as a critical form of reception in which the audience recognizes the nature of the manipulation and may agree with the arguments presented. The second is to see it as a critical form of reception in which audiences reject the rhetoric or ideology being espoused yet reappropriate its form for the purposes of popular culture (1986a, 48–49). The issue of auditive and visual "persuasion" through astonishment will be considered later.

21. The classical Hollywood era included hybrids like *Abbott and Costello Meet Frankenstein* (Barton 1948), which combined the horror and comedy genres; *The Thing from Another World* (Nyby 1951), which employed one the most repeated combinations: science fiction and horror; and *Calamity Jane* (Butler 1953). The New Hollywood era of the 1960s and 1970s relied more heavily on generic combinations. Drawing partly on art cinema aesthetics, films like *Bonnie and Clyde* (Penn 1967) and *Easy Rider* (Hopper 1969) combined the gangster film and road film, respectively, with the western in an attempt to produce a revisionist and deconstructive response to the traditional western genre. On New Hollywood responses to genre, see Ray 1985 and Schatz 1983.

22. For the discussion that follows, see Collins 1989, and in particular, Collins 1995 (chap. 3), "When the Legend Becomes Hyperconscious Print the. . . ."

23. In the film production and viewing process of the classical Hollywood era, film genres were generally more containable and standardized. Pre-1960s films were limited to exhibition in cinemas on first or second releases and for limited amounts of time. Access to films (and, more importantly to their conventions) was therefore limited. The recall of conventions, narrative elements, and iconographic details were reliant on the viewer's memory of past viewings. During the 1960s and 1970s television viewing and film industry restructuring resulted in the greater circulation of media images. Exposure to past film examples was made possible by the televising of old Hollywood films. When current film releases were viewed at cinemas, older generic conventions were also accessible to the audience through the replaying of earlier examples on television. In addition, film genres such as westerns, science fiction, and spy films found a home in the younger television medium. As Robert Ray (1985) explains, television's weekly screening of series such as *Gunsmoke*, *Peter Gunn*, and *The Untouchables* resulted in an increased familiarity with generic

and film conventions, to the extent that genre parodies like *Maverick*, *The Man from U.N.C.L.E.*, and *Get Smart* emerged. These parodies relied heavily on intertextual reading formations. For the first time in the history of the cinema, mass audiences were able to access the past directly.

24. The generic categories used to define computer games are applied both by the computer game industry and computer game magazines like *Edge*, *PC Power*, and *PC Zone* that review the games. More recently, academic articles discussing the games have also drawn on the same generic terminology.

25. For example, not only do games such as *The X-Files* and *Max Payne* depend on mise-en-scènes and cinematography that owe a great deal to filmic modes of production, but their structures are influenced by film genres. *The X-Files* bases its game premise on the popular science fiction television series, and *Max Payne* is a virtuosic elaboration and combination of the cop film tradition and the science fiction classic *The Matrix* (not only in the hero's Neo-style calf length jacket, but also in the way the player is permitted to perform slow-motion movements).

26. The recent resurgence of films such as *Mortal Kombat*, *Mortal Kombat: Annihilation*, and *Tomb Raider* testify to this fluid exchange among media. The emphasis on action and spectacle at the expense of tighter, more literary-oriented narratives common in contemporary blockbuster movies is no new phenomenon to the cinema. It is, however, an aesthetic that has become more pronounced in recent years because of the exchange with computer and arcade game formats. The chase and action scenes that take place in corridor-like spaces in films like *Die Hard with a Vengeance: Die Hard 3* and *Under Siege 2*, for example, reflect a certain first-person shooter sensibility.

27. The same may be said now of the *Doom* games in comparison to new generations of first-person shooter games released since *Doom II*, like *Duke Nukem 3D* and *Quake* in 1996.

28. On the complex debates surrounding issues of generic process and evolution, see Neale 1980, Schatz 1981, Gallagher 1995, and Altman 1999.

29. *Doom* became the form to which all first-person shooters would aspire and was compared to other "classic" examples of other genres from other media. To quote from one review: "To describe *Doom* as a first-person perspective action adventure would be like calling *Blade Runner* 'a film about robots'" ("Doom: Evil Unleashed" 1994, 30). The two *Doom* games triggered a craze in *Doom*like first-person shooters. Variations included games that repeated conventions formulaically, such as *Alien vs. Predator* (this game also being an off-shoot of the Dark Horse comics); *In Extremis* (which borrows heavily from the film *Aliens*) and *Terminator Rampage* (also influenced by the *Terminator* films). However, innovative additions such as *Dark Forces*, *System Shock*, *Duke Nukem 3D*, and *Quake* have expanded the boundaries of the genre by incorporating new features, adding an even greater realism and more intensive form of game play. Graphics and sound effects have become even more

detailed and three-dimensional, and the range of character movement available allows greater mobility: Aside from walking, running, and turning, heroes can now also look up and down, jump, swim, and crouch.

30. Crossover between and intermingling of genres is, of course, nothing new. In recent years this trend has become more pronounced and self-conscious. Not only have generic borders become more malleable, but works consciously engage in generic hybridity.

31. The action elements of *Doom* and *Doom II* had enough in common with film action forms to allow for the possibility of a direct flow back to action cinema. For some time Universal Studios was considering producing a film version of *Doom*, with Arnold Schwarzenegger as favorite for the lead role ("Doom the Movie!" 1994). Jay Wilbur envisioned such a film as following the game's lead in providing "mainly, just non-stop seat-of-your-pant sweat-of-your-brow action" ("Natural Born Killers" 1994, 42).

32. Lovecraft's Cthulhu stories have, for example, inspired the creation of the Internet role-playing game (RPG) *Call of Cthulhu*, which takes place in Lovecraft's 1920s America. Players "become 'investigators' who track down dark rumors or heinous occult crimes that gradually open up the reality of the monsters" (Davis 1995). See the RPG site available at ⟨http://members.tripod.com/~Tiras/deity010.html⟩. Other sites provide suggestions to players that include suggestions for actors to imagine as playing the various characters and for appropriate background music to play while involved in the game. See "Castings for Characters in Call of Cthulhu RPG," available at ⟨http://www.toddalan.com/~berglund/casting.html⟩. In addition to influencing numerous *X-Files* stories, the Lovecraft tradition has had a dramatic impact on computer games, including *The Lurking Horror* (1987), *The Hound of Shadow* (1989), the *Alone in the Dark* series (1992–2002), *Daughter of Serpents* (1992), *Blood* (1995), *Castlevania 64* (1999), and the popular *Quake* series. Lovecraftian music has inspired bands such as Black Sabbath, Blue Oyster Cult, The Fall, H. P. Lovecraft, Iron Maiden, Marillion, Metallica, and Necronomicon. See "Music for Call of Cthulhu," available at ⟨http://www.toddalan.com//~berglund/Cthulhu.Music.html⟩. Other examples of contemporary entertainment inspired by the Lovecraft tradition include Internet newsgroups like ⟨alt.necromicon⟩ [*sic*] and ⟨alt.satanism⟩, Chaosium's collectible Lovecraft-universe card game, and the board game *Necronomicon*. Also see "The Necronomicon and Other Grimoires," available at ⟨http://www.hplovecraft.com/creation/tomes.htm⟩.

33. Lovecraft often made reference to invented "authentic" texts in his stories. The most (in)famous was the *Necronomicon*, which becomes the narrative premise of Raimi's *Evil Dead* films. According to Lovecraft, who constructs a complex history around this book of the dead, it was written by an Arab, Abdul Alhazred. For years, fans believed (and, possibly, still do) that the book existed, and Eric Davis (1995) explains that, in the 1930s, index cards for the book started appearing in library catalogs. The propagation of this mythology has persisted, and in 1973, a small-press edition of Al Azif's book appeared, "consisting of eight pages of simulated Syrian script." See Davis 1995 for a fascinating

account of the impact of Lovecraft's Cthulhu mythos. As Davis correctly explains, Lovecraft's books "owe their life not to their individual contents but to the larger intertextual webwork of reference and citation" that has been perpetuated by fans.

34. To quote one reviewer who grappled with the differences in the game-play experience between *Doom* and *Wolfenstein 3D*, "Next to the horrors of *Doom*, *Wolfenstein* is a front seat at a Johnny Mathis concert" ("Doom: Evil Unleashed" 1994, 31).

35. The game play on the *Wolfenstein 3D* secret levels reveals an awareness of an audience familiar with the generic conventions of first-person shooter games and the filmic tradition being referred to. Brophy has observed that the contemporary horror film "mimics itself mercilessly" and exposes a "violent awareness of itself as a saturated genre." The same point may be made of the first-person shooter genre in the wake of the *Doom* games, which are to the first-person shooter what the *Evil Dead* films are to the splatter film. As Brophy argues in regard to the horror film, *Doom II*, in particular, is designed with an awareness of its place within the first-person shooter genre historical development. It "knows that you've seen it before. It knows that you know it knows you know" (Brophy 1986, 5).

Chapter 3. Hypertexts, Mappings, and Colonized Spaces

1. Dodge and Kitchin suggest that the aim of virtual reality "is to create a sophisticated conceptual space" in which experiences occur as they do "in the real world" (5). The intent is to make "cyberspace into a place" (Lajoie, cited in Dodge and Kitchin 2001, 5). They state: "Although, at present, both forms are mainly visual, developers are working on including total sound effects and, in the case of immersive environments, touch" (Dodge and Kitchin, 5). Also see the sites ⟨http://www.MappingCyberspace.com/⟩ and ⟨http://www.cybergeography.org/atlas/⟩.

2. Philipstal's *Phantasmagoria*, shown in Edinburgh in 1802, included the fantastic horror effects that revealed the sudden apparition of ghosts and skeletons (see McGrath 1996, 15). The most famous presentation of the phantasmagoria was the *Fantasmagorie* by Étienne Gaspard Robert (known as Robertson). In 1797, Robertson performed the *Fantasmagorie* in Paris in an abandoned chapel surrounded by tombs. Crowds flocked to the dimly lit tombs to see magic lantern effects that included skulls, atmospheric lighting, sound effects, and the appearance of ghostly apparitions. See Barnow 1981 (19).

3. On early photography and cinema's relationship to ghostly imagery, see Gunning 1995a.

4. Traveling through diverse media such as print, the precinema, and the cinema, the game also produces meaning by interacting with its computer game heritage. Rather than being influenced by horror games alone among computer games, however, *Phantasmagoria* turns to other CD-ROM games like *The Seventh Guest* (1992), *Critical Path* (1993), *Return to Zork* (1993), *Under a Killing Moon* (1994), and *Gabriel Knight* (1994) for its interface, its use of

full-motion video, the ability it offers players to maneuver the characters, and its filmic presentation of events; and to games such as *Myst* (1994) for its depiction of dazzling and haunting computer-generated environments. The game therefore engages its players in a metaphoric labyrinthicity, one drawing on a neo-baroque concern with virtuosity. By having the game interact self-reflexively with generic predecessors from a variety of media, the producers of *Phantasmagoria* also emphasize its significance as a new interactive medium's rearticulation of past generic codes.

5. *Full-motion video* is a term usually applied to a technique favored by the CD-ROM format. Interrupting the interactive possibilities of the computer game format, full-motion video reproduces the qualities of the cinema in providing uninterrupted sequences of events with which game players cannot interact. In *Phantasmagoria* the chapter beginnings are depicted in full-motion video. "Filmed" scenes are displayed that establish the narrative action that initiates each scene. In chapter 1, for example, the player is introduced to the characters, Adrienne and Don. Don, who is a photographer, is seen taking photographs of the landscape when he notices a house for sale in the distance. The couple buy the house and a series of sequences (which include Adrienne being tortured) follow. The player soon discovers that the torture scenes were actually a nightmare experienced by Adrienne. In the opening minutes of the chapter, although the player can bypass the full-motion-video effects, he or she cannot interact with them. Actual game play and interaction commences after the full-motion-video effects have finished.

6. Although the term "hypermedia" embraces the multilayered presentations found in games—text, sound, visuals—I have focused, instead, on "hypertext" because of the rich theoretical tradition that accompanies the term. Both terms, however, succumb to the similar principle of "lexia" that are linked.

7. *Phantasmagoria*'s other point of contact with the stalker film is in its attitude to gory special effects, and in this respect, it has connections with the *Doom* games and the *Evil Dead* films. The stalker/slasher tradition parallels the birth of gore conventions in contemporary horror cinema. It was the stalker killer's murderous acts that sparked horror's infatuation with a "splatter" attitude to special effects. In the many moments of bloody destruction in stalker/slasher films, gore effects often compete with narrative progression and character motivation, and *Phantasmagoria*, as inheritor of this tradition, is no exception. Hortencia, Carno's first wife, dies in her greenhouse: Players look on with Adrienne as Carno thrusts a garden trowel into her mouth, slitting her lips further apart into a joker grin, and continue to watch as he stuffs her morbidly wide-grinning mouth with soil. Victoria, his second wife, had a predilection for vino bianco—and Adrienne looks on aghast, intent on every gory detail, as Carno ruthlessly plunges a wine bottle into her eye socket. Such scenes of vivid, horrific violence would find themselves right in their niche in splatter classics like *Friday the 13th, Happy Birthday to Me* (1981), and *Slumber Party Massacre* (1982). During those minutes of splatter effects, narrative concerns are put to one side, and the focus becomes the display of special effects themselves.

8. On the theorization of the spectator along the lines of gendered identification and male mastery, see Mayne 1993 (chaps. 1 and 2).

9. Clover admits that some slasher films do have male protagonist heroes, however, in these rare instances—*The Evil Dead* being one case—the male character retains elements of both masculine and feminine traits.

10. The model is based on Thomas Laquer's study of one-sex theory. See Laquer 1990.

11. There are, of course, problems in this almost essentialist correlation of masculinity with the active and heroic. For the sake of argument, Dika's and Clover's frameworks will be interpreted as functions imposed by social convention.

12. The question of identification in the cinema is a complex and problematic process. Rather than using the term according to the psychoanalytic model of identification as posed by post-1960s film theorists like Christian Metz and Laura Mulvey, Clover uses the term to suggest that the films (and games) present their final girls as characters to identify or empathize with, in the sense that they remain the primary narrative focus and viewers (and players) are invited to invest their interest in her. For a fresh perspective on empathy and film spectatorship, see Plantinga and Smith (1999).

13. See especially "Introduction: Carrie and the Boys" and chapter 1, "Her Body, Himself." Laura Mulvey would, of course, be the most influential proponent of more traditionally aligned spectatorship models, arguing for the hierarchization of gendered looks and power structures; the male spectator is placed in a position of spectatorial control that allows him to identify with the dominant, diegetic male characters—and thus reaffirm the passive nature of the female character (see Mulvey 1975). Even Mulvey's revision of same-sex identification reinstated this power structure. Although the female spectator was acknowledged in the revision, Mulvey argued that she was often forced into cross-gendered forms of identification as the only option that allowed her narrative control akin to that of the male spectator (see Mulvey 1981). Mulvey did not consider the possibility of the male spectator's opting for similar cross-gendered form of identification, and as Clover argues, the fascinating feature of the slasher film is that it invites the male spectator to identify with characters that fail to submit to Mulvey's formula.

14. *Phantasmagoria* also permits us access to Don's and Adrienne's visions through this type of more subjective camera work, although interestingly, the game tends to favor Adrienne's gaze. True to the stalker/slasher subgenre, Don's gaze is privileged when the game emphasizes Adrienne's impending victim status. For example, in chapter 3, after Adrienne returns home from a trip to town (and after Don has undergone the early stages of his nasty transformation), she arrives in the couple's BMW, parks the car, gets out, and a fly-by tracking shot begins, quickly and menacingly making its way toward her. Adrienne's viewpoint then takes over, and we discover that the owner of the menacing gaze, which (true to the *Halloween* tradition) had been collapsed into our own, had been Don's.

15. A number of writers have, in fact, questioned the viability of what David Bordwell (1989) characterizes as symptomatic forms of interpretation. Scott McQuire, for example, has expressed concern about the way critics and theorists have prioritized thematic readings that obscure any sense of difference among examples of horror. Film examples are mapped out through ahistorical approaches in which the methodology consists of "mapping the surface elements of different discrete texts onto an underlying meta-narrative which is then presented as the real meaning of the various symbolic and iconographic devices" (1987, 24). Eileen Meehan has similarly stated that the kinds of cause-and-effect approaches to which McQuire refers require "an assumptive leap that reduces consciousness, culture, and media to reflections of each other" (1991, 48). In many ways, the neo-baroque nature of computer games highlights a problem already inherent in film theory and criticism.

16. Bonitzer (1981) applies the labyrinth motif to an analysis of the cinema. For Bonitzer, stylistic devices such as subjective camera viewpoints, different shot sizes, and depth-of-field shots thrust the spectator (perceptually, at least) into the film in a way that recalls the unicursal motif discussed by Doob. Through cinematographic and editing features, paths created are prolonged yet linear. The multicursality of the neo-baroque, however, complicates the singular paths of unicursality.

17. Horror cinema is renowned for its obsession with rupturing the closed, linear structures of its film spaces, particularly through endings that refuse the closure of many Hollywood films, and *Phantasmagoria* is clearly aware of this convention. For example, after one possible stalker/slasher ending (and assuming Adrienne's successful destruction of Don), Adrienne can move on to another possible ending, one that addresses itself to the possession/evil spirit tradition of horror. When she kills Don, the spirit that possesses him drifts from his body in a green mist, then solidifies into an enormous blue monster who hunts her down through the house. Again, Adrienne's success depends on how players play the game. If the player directs Adrienne to run to the chapel and use the spell book (which players should have picked up in the darkroom), then chant an incantation after sacrificing some of her blood by pricking her finger with a brooch that should be in the inventory, the demon will be trapped, unable to harm anyone again. But if the player fails to do any of the above, again the game ends with Adrienne dead and the player anything but victorious.

18. "Dead time" is a convention employed by art and avant-garde cinemas. It implies actions that unsettle traditional narrative structures dependent on cause-and-effect relations associated with classical Hollywood cinema. Rather than functioning to move narrative action forward, the events associated with dead time freeze linear narrative development by focusing on situations that have nothing to do with story progression.

19. The Catholic Church was intent on minimizing the brutality that initiated colonization. In 1568 Pope Pius V established commissions that aimed to prevent "acts of criminal vio-

lence and coordinate, under the control of the Holy See, the action of catholic missions in the world" (Ferro 1997, 37–38). And in 1659 Alexander VI forbade "collusions between the Church and political authorities," while also demanding respect for local traditions (Ferro 1997, 38).

20. Scientists and cartographers of seventeenth-century France made great strides in plotting France: At the order of Louis XIV, Jean Picard (using instruments of his own invention), Gabrielle Phillipe de la Hire, and the astronomer Giovanni Domenico Cassini surveyed Paris and the coasts of France; the results of their work were published in 1670 "as a series of nine topographic sheets of the Paris area made by David du Vivier" (Thrower 1996, 105–111).

21. The Houtman brothers were arrested by the Portuguese authorities for their spy escapades, though they were later released.

22. As Thrower explains, the "influence of Ptolemy's work on Western cartography would be difficult to exaggerate." Following the Turkish invasion of Byzantium in the fourteenth century, refugees fled Constantinople and took with them Greek copies of Ptolemy's *Geographia*. These manuscripts reached Italy, where they were translated into Latin in Florence by 1410. See Thrower 1996 (58).

23. The Contarini map was discovered in 1922 and is now in the British Library. See Thrower 1996 (71). Contarini included lines of longitude and latitude on his map, which was printed in Florence.

24. Later, Waldseemuller realized that he had given too much credit for the discovery of the New World to Vespucci. He tried to correct this on a plane chart of 1513, but it was too late: the name "America" had by then stuck (Thrower 1996, 70).

25. As a result of land surveying, Mercator also produced more accurate maps of Europe in 1541 and 1554. Furthermore, Mercator's map included a partial outline of the continent Terra Australis, which was to be mapped more effectively following the voyages of James Cook in the latter part of the eighteenth century. Soon after, the first edition of Abraham Ortelius's *Theatrum Orbis Terrarum* (1570) was published and included seventy map compilations. The success of Ortelius's *Theatrum* is attested to by the fact that it went through multiple editions (including the last printing dated 1612) and was translated into Dutch, German, French, Spanish, Italian, and English. The 1584 edition also included the map titled "La Florida," which consisted of the Southeast coast of North America. See Thrower 1996 (76–80) and Harvey 2000 (110).

26. As Thrower observes, while espousing a geocentric universe like Aristotle and Hipparchus the astronomer before him, Ptolemy "made giant strides in various phases of cartography that were not materially improved upon for many centuries after his death." Geocentrism was not to be contested until Copernicus infamously presented his theories regarding a heliocentric system (1996, 23).

27. Such maps, however, lacked the accuracy of later periods, such as the second half of the eighteenth century, during which time cartographers and navigators could correctly measure longitude because the invention of portable timepieces called chronometers. See Thrower 1996 (77). On technological advances in eighteenth-century cartography, see Sobel and Andrewes 1998.

28. According to Ptolemy, in addition to the fixed stars in the heavens, the moon, the sun, and "the five wandering stars" (the planets Mercury, Venus, Mars, Jupiter, and Saturn) all revolve around the Earth. He disagreed with Aristotle on particulars regarding the order of the sequence of planets (Easlea 1980, 51).

29. Aristarchus of Samos (d. 230 B.C.) is also known as the "Copernicus of antiquity" because of his early espousal of a heliocentric rather than a geocentric view of the universe (Thrower 1996, 20).

30. Guthke observes that although the belief in the "plurality of worlds" was increasingly supported in the context of the scientific revolution, the belief can be traced back (albeit lacking empirical, scientific analysis) to the philosopher Anaximander (sixth century B.C.), some Pythagoreans (sixth to fourth centuries B.C.), the atomists Leucippus and Democratus (fourth century B.C.), Epicurus (fourth to third centuries B.C.), and Lucretius (first century B.C.). Anaximander "taught not a plurality of worlds in space but a succession of worlds in time," whereas the atomists "speak of a plurality of worlds" that constitutes "a multitude of universes that both succeed one another in time and exist simultaneously in space" (Guthke 1990, 36–37).

31. Johannes Kepler published his *Rudolphine Tables* of planetary star positions based on the observations of Tycho Brahe (1546–1601). By observing the rim of the moon in relation to a known star, or a lunar eclipse, it is possible to calculate longitude at the point of observation by calculating local time and comparing it to the time stated in Kepler's tables. On this basis, a world map was made by Philipp Eckebrecht and published in Nuremberg in 1630, with its prime meridian at Tycho Brahe's observatory in Denmark. This is the first map to establish longitude by difference in time (one hour equals fifteen degrees longitude) through observation of celestial phenomena. With the greatly improved longitudinal position provided by such maps, further progress in cartography could be made. See Thrower 1996 (100).

32. Mitchell makes the point that

 [t]he incipient networked city is clearly visible in the ruins of Pompeii, with its hillside civic reservoir, network of lead water-supply pipes running down through the town, and gravity-fed wastewater drainage system. In the aftermath of the industrial revolution, cities greatly elaborated their networks by improving streets to handle greater traffic volumes, adding streetcar and rail transportation systems to meet the demands of larger and more widely distributed populations. (1999, 23)

Furthermore, Mitchell states that from early in the history of humanity, "cities came to depend on combining synchronous and asynchronous communication." Speech combined with text, the handshake with the written contract, the telephone call with the pre-recorded message: "It was the beginning of the economy of presence" (131).

33. Wilbur states that "the notion of an electronic frontier has gained considerable currency online, even among computer users who might otherwise have reservations about a meta-phor so steeped in traditions of imperialism, rough justice and the sometimes violent opposition of any number of others" (1997, 7–8). For an analysis of the Internet from the perspective of American frontier history, see Healy 1997.

34. The following Web sites (among many others) provide links to multiplayer sites: ⟨http://www.q3center.com/⟩, ⟨http://www.mplayer.com/⟩, ⟨http://www.gamespyarcade.com/webgames/⟩, ⟨http://www.3dactionplanet.com/⟩, and ⟨http://www.planetquake.com/⟩.

35. Players also must pay, in addition to the price paid for the game itself, a subscription fee to 989 Studios to remain registered on the *EverQuest* servers.

36. One such forum can be found at ⟨http://boards.station.sony.com/ubb/everquest/cgi-bin/Ultimate.cgi?action=intro⟩. This forum provides a way for *EverQuest* developers to make announcements and reply to comments submitted by players using the Developer Comment Submission Form. The site states that "[r]epresentatives of the EverQuest Quality Assurance team will use this forum to make announcements and respond to test-ing and bug related issues submitted via the QA Comment Submission Form."

37. The Norrathian cities are Ak'Anon, Erudin, Felwithe, Freeport, Grobb, Halas, Kaladim, Kelethin, Neriak, Oggok, Qeynos, Rivervale, Cabilis, and Thurgadin.

38. The writings and scientific instruments of contemporary and long-gone scientists were also displayed in Kircher's museum: Telescopes, compasses, microscopes, and perspecto-graphs, in addition to the works of della Porta, Galileo, and Kepler, were all accessible to visitors. For a comprehensive overview of the history and function of the *wunderkammers*, see Bredekamp 1995, Findlen 1995 and 1996, Stafford 1994, and Stafford and Terpak 2001.

Chapter 4. Virtuosity, Special-Effects Spectacles, and Architectures of the Senses

1. As Justin Wyatt has so effectively explained, the conglomerate and cross-media logic of contemporary Hollywood cinema has resulted in the emergence of the "high-concept" film. High-concept films are produced on multimillion-dollar budgets that also aim at large profits. Film production integrates film style, marketing and merchandise, and greater emphasis is placed on the aestheticization of the image, which addresses the needs of a new global market and the easier transfer of spectacular images (and, I might add,

sound) across numerous media (Wyatt 1994, 7, 17). These merging entertainment commodities and tie-in products has resulted in a "new form of image production" (Gabilondo 1991, 130–131). The visuals of the high-concept film are integral to the "marketability of a concept" radiating around a film. Production also takes into consideration the crossover possibilities of films and their cross-media competition. The image becomes a crucial factor in that it can be extracted from film and placed within another media context.

2. Jay argues that the baroque scopic regime has coexisted with two other visual systems. The first, he argues, is aligned with the Renaissance tradition, depends on Cartesian perspective and a "monocular static point of beholding" (1994, 60). This tradition also demands narrative clarity and order, which has an impact on the visual articulation of narrative events. The second system is "empirical descriptivism," characterized by the Dutch painting tradition, which emphasizes a world of description "mapped in two dimensions" (Wollen 1993, 9). Although all three regimes can coexist, during any particular point in history, one ocular regime may dominate others. Periods dominated by a baroque order of vision interrogate "the privileged scopic regime of the modern era" that is dominated by "Cartesian perspectivalism aligned with Renaissance spatial order" (Jay 1994, 60).

3. Damisch states that "[a] curious polemical debate took shape in these fields [photography and cinema] in Paris in the 1970s, the fallout from which can still be observed today. Basing their arguments, as I myself did in 1963, on the fact that the photographic box, and the camera which is its technical extension, function optically in a way wholly consistent with so-called one-point perspective . . . some maintained that photography and film disseminate spontaneously, and so to speak mechanically, bourgeois ideology (because perspective, having appeared at the dawn of the capitalist era, must of necessity be essentially 'bourgeois')" (1995, xiv–xv).

4. Bazin viewed the photographic realism of the cinema as having "characteristics of the ripeness of a classical art" (1967, 29). In particular, Bazin focused on classical form and themes that Alberti also highlighted in his *Della Pittura*: an art that has perfect balance, narratives that stress dramatic and moral themes, and a realism that is self-effacing.

5. There is a long tradition of film theory that aligns classical Hollywood cinema with a form of narration that does not draw attention to itself as a construction. Laura Mulvey's important feminist analysis of the gaze and the male spectator in her "Visual Pleasures and Narrative Cinema" (1975) was one example, as were the writings of Colin MacCabe (1974, 1976). Both of these authors were influential in discussing Hollywood films as "classic realist texts" that reflected the broader ideological ramifications of a cinema that strived to disguise its artifice. Stephen Heath has also compared cinematic narration to a Renaissance order of vision. Heath states that the favored Renaissance painting technique of mathematical perspective aimed at producing a representation that the audience believed as "truth" (1981, 30). The cinema, argues Heath, extended the notion of "truth," and "[i]n so far as it is grounded in the photograph, cinema will contribute to the circulation of this currency [of truth], will bring with it monocular perspective, the posi-

tioning of the spectator-subject in an identification with the camera as the point of sure and centrally embracing view" (30). Aligning itself with classical realism, the spectacle produces an "impression of reality" that relies on the relationship between the "space 'in frame,' . . . the space determined by the frame, held within its limits; [and] . . . the space 'out of frame,' the space beyond the limits of the frame" (31).

6. Noel Carroll (1988), Vivian Sobchack (1992), Judith Mayne (1993), and Jim Collins (1995), among numerous other film theorists and historians, have contested whether the passive-spectator model was ever a viable one.

7. The fresco is part of a series of paintings that Raphael was commissioned to paint in the Stanza della Segnatura in the Vatican. See Levey 1975 (51–53).

8. The capacity of the baroque to expose the artifice of construction has led writers such as Buci-Glucksman, Wollen, and Jay to associate the "baroque ocular regime" with modernist aesthetics. It must be acknowledged, however, that above all, the baroque, as an art form, is associated with entertainment and the masses.

9. The phrase "madness of vision" is taken from Merleau-Ponty.

10. In this respect, Pozzo employs a different technique from that of Cortona in the Barberini Ceiling. Cortona uses a polyfocal system of perspective: Each narrative section is provided with its own vanishing point; the spectacle that unifies each scene is the result of trompe l'oeil.

11. A similar illusion is at work in a scene in which the dinosaurs stalk the children in the kitchen; here there is a similar play between reflection and reality, but in this instance the raptor sees the reflection of one child, a girl, in one of the steel cupboards and lunges at the reflection, mistaking it for reality. This further mirrors the way the audience is seduced by a reflection (the film) as reality.

12. As Stafford (1996) and Jay (1994) argue, the eighteenth-century attitude toward the denigratory aspects of spectacle have been inherited by twentieth- and twenty-first-century theories on visuality.

13. For example, prior to the seventeenth century: Della Porta's *Magia Naturalis* (1558, 2nd ed., 1589), and in the seventeenth century Galileo's *Sidericus Nuncius* (1610), Descartes's *La Dioptrique* (1637), Kircher's *Ars Magna Lucis et Umbrae* (1646), Niceron's *Thaumaturgis Opticus* (1646), Locke's *Essays on Human Understanding* (1690), and Newton's *Opticks, or a Treatise of the Reflections, Refractions, Inflections and Colours of Light* (1704).

14. Findlen makes the point that "[b]y assembling the portraits of all the rulers, Catholic as well as Protestant, known for their patronage of learning, Kircher transformed the museum into a political theater that linked the wisdom of the hieroglyphs with the learning of Europe's leading natural philosophers and the power of its most successful princes. Rome, as Kircher constantly suggested, was the one setting in which all of these different

activities came together. And his museum was the site of this sublime synthesis" (1995, 642).

15. Hanafi refers to Baltrusaitis 1979.

16. As Stafford explains, "an instructive, cross-disciplinary and entertaining spectacle, based on a conversational give and take," was integral to the baroque period (and witnessed, for example, in Kircher's museum displays) and developed further during the period of the Enlightenment (1994, 279).

17. Jan Vermeer is the artist most famous for using the camera obscura as an aid to his paintings.

18. For a description of the camera obscura, see Kemp 1990 (188–189) and Crary 1994 (26–66).

19. On the connection between the cinema and precinematic technologies, see Gunning 1995b. Panoramic devices themselves, although first employed by Baldassare Lanci in the sixteenth century, became popular in the seventeenth century for the construction of panoramic and topographic viewpoints. See Kemp 1990 (212–213).

20. Easlea succinctly summarizes Newton's three laws of motion as follows: "The first . . . states that a body not acted on by forces continues in its state of rest or constant rectilinear motion as the case may be; the second states that any acceleration of a body is caused by an impressed force and takes place in the direction of the force and that . . . the magnitude of the acceleration is equal to the magnitude of the force divided by the mass of the body; the third law states that the force one body exerts on a second is equal and opposite to the force that the second exerts on the first" (1980, 172).

21. Galileo's sunspot theory was published as *Istoria e Demostrazioni Intorno alle Macchie Solari e Loro Accidenti* (Rome 1613).

22. Although Stafford is more concerned with the Enlightenment as the period of transition from a visual to a text-based culture, she briefly suggests that our era of computer graphics, interactive technology, fiber optics, and videos (to which I would also add special-effects blockbusters, computer games, and theme park attractions) implies a return to the visual culture characteristic of the baroque.

23. For further information on this project, see the Web site for the NASA Goddard Space Flight Center at ⟨http://nvo.gsfc.nasa.gov/mw/mmw-sci.html⟩ and ⟨http://arxiv.org/abs/astro-ph/0005045⟩.

24. Although science fiction cinema has always deliberated on the philosophical and cultural effects of technological advancement, not until the late 1960s (with the release of Kubrick's *2001: A Space Odyssey* in 1968) did science fiction find a venue in the multi-million-dollar production format. Prior to this period, the science fiction film had been relegated to lower-budget production, most typically in the B-film or serial format.

25. As is explained by Gunning (1990, 58), Méliès's trick films were more concerned with the display of magical attractions than with the development of plots and characterization; Méliès's approach to filmmaking owed a great deal to his background as a magician. See also Barnow 1981.

26. Numerous contemporary writers have drawn attention to the correlations between contemporary entertainment media and the early cinema of attractions (see Bukatman 1998; Moran 1993; Ndalianis 2001). With regard to contemporary effects cinema, however, we need to keep in mind that, although it reflects elements of the attractions tradition, current cinema is the product of a radically different industry, one that also relies on narrative structure (no matter how minimal) in ways that pre-1907 cinema rarely did.

27. In addition to the pre-1907 period of the cinema of attractions, attractions traditions have been present throughout the history of the cinema in "performative" and "spectacle" genres such as epics, musicals, comedies, horror, and science fiction. For a detailed account of the early cinema of attractions, see Gunning 1990 and Gunning 1993.

28. Belton explores the transformations occurring in social, film-historical, and film technology environments during the 1950s, arguing that the social conditions of the 1950s—the boom of suburbia, the success of television, the rise of a new leisure culture, and the growth of the amusement park industry—paved the way for audience rejection of films in the tradition of the classical Hollywood model in favor of more participatory forms of cinematic viewing provided by more invasive forms of cinematic spectacle. The redefinition of traditional notions of spectatorship suggests, for Belton, a need to rethink ways in which cinema studies has theorized the spectator's relationship to the screen as a passive and static one. For a detailed account of the changes that occurred in 1950s culture and cinema, see Belton 1992.

29. Cinerama operated on the principle of a triple screen, onto which were projected images from three film projectors. When projected in unison, the images from all screens appeared to unite, producing a 180-degree curved image that incorporated the audience's peripheral vision. The Cinerama format was later modified for other wide-screen formats, allowing the film to be projected onto one screen using a single projector. For a detailed account of the history of Cinerama, see Belton 1992.

30. For a detailed account of the transformations that occurred in the film industry in the 1960s, see Schatz 1983; Ray 1985; Hillier 1992; and Wyatt 1994.

31. For the production of *Star Wars*, for example, Lucas emulated effects departments of the 1950s by establishing ILM, which searched Hollywood for old, abandoned cameras and printers such as those for the VistaVision format, which was more appropriate for a cinema of spectacle. Along with other 1950s technologies, VistaVision was largely abandoned for economic reasons. See Cotta Vaz 1996 (6–9).

32. Although baroque spectacle prioritizes the visual, it often brings into play other senses—in particular, sound (the digital surround sound systems) and sometimes touch and smell.

The engagement of all senses is most commonly experienced (among neo-baroque entertainment forms) in amusement park attractions.

33. The principle of neo-baroque virtuosity is not limited to films. The designers of computer games, for example, are similarly fascinated with displaying the technology that has made their computer game spaces possible. In particular, it is in the introductions to computer games that we locate the performance of special-effects spectacle in its purest form. Game introductions are often used to exhibit the state of game technology in a highly exhibitionist way. *Under a Killing Moon* is a case in point. The eight or so minutes of the game's introduction provide the player with a homage to film history through allusions to *It's a Wonderful Life*, *Citizen Kane*, the Marlowe hard-boiled detective tradition, Gothic horror, and *Blade Runner*. But this form of exhibitionism does not stop at intertextuality. This is not merely a game of sight concerned with our recognizing the sources. Instead, this exhibitionism operates like many blockbuster sequels that consciously attempt to outdo their predecessors by showcasing advances in optical technology. *Under a Killing Moon* is asking us to acknowledge this blockbuster film tradition that is now influencing CD-ROM interactive games, but it is also asking us to recognize these CD-ROMs as the future of entertainment. The introduction becomes a virtuoso performance that is concerned with claiming the interactive movie as the entertainment form that will supersede the movies as a new (and more interactive) visual entertainment form.

34. In the wake of *Jurassic Park*, "creature shop" methods are now largely computer processed. ILM created "digitally 3-D, full body creatures" that combined with the physical creatures made by Stan Winston. Traditional stop-motion photography was fused with the "direct input device," (Cotta Vaz 1996, 76) so that individual dinosaur skeletons were set up with encoders and, after they were manipulated, were translated in the computer realm as three-dimensional creatures. Using the software package *Viewpaint*, computer graphic artists later added skin and texture to the computer-generated dinosaurs. This method revolutionized the way artists created surface texture, allowing the artist to "paint on" the dinosaur flesh in three-dimensional, sculptural terms (Cotta Vaz 1996, 218–219). Another in-house program developed was *Enveloping*. Combined with the *Bodysock* software devised for *Terminator 2*, this gave computer-generated flesh the illusion of moving with the realism of real skin that was attached to bone and muscle. The effects' crew's capacity to simulate living creatures had radical ramifications. *Jurassic Park* became the biggest box office hit in the history of the cinema, grossing almost one billion dollars, and as Cotta Vaz notes, "perhaps no other film so illustrates the power of visual effects" (231).

35. In *Willow*, rather than using traditional makeup and stop-motion effects in the metamorphosis of the sorceress Fin Raziel into an array of creatures (including a possum, goat and ostrich) and back to her human form, the special-effects crew pushed advances in computer graphics further to achieve more fluidity and realism in the transformation. The result was the development of new morphing software created by Doug Smythe of ILM. As is Cotta Vaz explains, Dennis Muren, the effects cosupervisor on *Willow*, wanted to

"do a *Jurassic Park*" and create each creature digitally, but the technology in 1987 could not make this feasible. The effects crew opted instead for photographing each "real" action element (human, animal, puppet), then scanning it into the computer, where the metamorphosis took place. When the metamorphosis was completed, the images were scanned back onto film. See Cotta Vaz 1996 (114, 132–135).

36. Cotta Vaz states that "[a] major breakthrough software (which would be published by Adobe and go on the commercial market in 1990) was Photoshop. Designed to manipulate pictures, Photoshop received its first extensive ILM use for *The Abyss* (1989), helping to manipulate digitized photographic data of background plate sets and creating a digital model in which to integrate a computer-generated water creature.... Photoshop edits digitized pictures, allowing computer artists to perform such image-processing functions as rotating, resizing, and color-correcting images and painting out scratches, dust, and other flaws" (1996, 117); the result is, of course, that the effect is "disguised."

37. At the time, the young Silicon Graphics team was responsible for producing computer workstations for ILM during *The Abyss*'s production; by 1993 the company had made profits of over a billion dollars (Cotta Vaz 1996, 195).

38. Images of the actors were scanned, and the morphing system enabled metamorphoses from one image to the next to take place. For details of the effects required to produce the water creature, see Cotta Vaz 1996 (115–117, 194–200). Also refer to Cameron 1992 and Shay 1989 for further details on the effects produced in *The Abyss*.

39. Despite initial advances made with *Photoshop* in *The Abyss*, the full impact of *Photoshop*'s potential for giving realistic, digitized life to digitized characters was felt with the release of *Terminator 2* (1991) and *Jurassic Park* (1993).

40. The film, for example, became a testing ground for the new trilinear multicolor high-resolution CCD digital scanner. Problems with achieving a continuous and flawless progression from one image to the next in the morphing process (which were partially solved by *Photoshop*) were further resolved by the introduction of *Body Sock* software that allowed for an even smoother transition from image to image. And *Make Sticky* software made it possible for the 3D form of the T-1000 to rise from the 2D checkered floor and to emerge through the bars in the psychiatric institution. For more information on the effects used in *Terminator 2*, see Cotta Vaz 1996 (200–209) and Duncan 1991.

41. *Star Trek II: The Wrath of Khan* (1982) achieved a technological breakthrough in its Genesis sequence by totally constructing it in 3D computer graphics rather than relying on traditional models and matte effects. This achievement was soon surpassed by the first digitally manipulated matte painting of an image: that of a stained-glass knight come to life in *Young Sherlock Holmes* (1985). This was followed soon after by ILM's major breakthrough in morphing software, first witnessed in *Willow* (1988) and taken further still in 1989 by *The Abyss* and in 1991 by *Terminator 2*. The first digitally produced skin in *Death Becomes Her* in 1992 was soon overshadowed in 1993 by the digitally produced dinosaurs of *Jurassic Park*.

For more detailed accounts of the advances in digital cinema and film effects, see Shay 1989; Duncan 1991; Cameron 1992; Suskind 1996; and Cotta Vaz 1996.

42. In fact, throughout the last century and into the current one, the film industry has relied on spectacle and seriality during periods of more intense media competition. While in direct competition with other attractions such as magic lantern shows and amusement park rides, early cinema unleashed the illusionistic capabilities of the new film medium onto the world. The competition of television and the rise of a new leisure culture that preferred more active forms of entertainment motivated cinema of the 1950s along the lines of more directly invasive cinematic forms such as wide-screen formats (Cinerama, CinemaScope, Todd-AO) and 3D cinema.

43. On the showcasing of technologically produced spectacle and media differentiation, see Wyatt 1994 and Collins 1995.

44. Numerous writers, including Sobchack (1987), Gabilondo (1991), Soloman (1992), and Gross (1995), situate the turning point in the effects rebirth of contemporary cinema around 1977, the year that the special-effects feasts *Close Encounters of the Third Kind* and *Star Wars* were released. The success of these two films revived the industry's (and audience's) fascination with the spectacle of special effects. In the process, special-effects technology was also revived. Although Kubrick's *2001: A Space Odyssey* brought to the cinema the wide-screen experience and the cutting-edge effects of Douglas Trumbull, the film was not as concerned with aligning the spectator's sensory experience as it was interested in the effects themselves in an all-embracing, mass-appeal entertainment spectacle. On the importance of Trumbull's effects in *2001*, see Bukatman 1998.

45. The effects devised through the motion control camera (called the Dykstraflex, after its inventor, John Dykstra) were the first stages in allowing the computer to control the movement of the camera.

46. Ironically, in achieving a specific kind of special effects spectacle, Lucas' revival of traditional film technology and its melding with new technological developments devised by ILM, also initiated the eventual demise of traditional film technology. Along with *Close Encounters*, *Star Wars* signaled the final break away from an era dominated by classical form toward one dominated by the baroque on a blockbuster level. Gabilondo has pointed to the dilemma that constitutes contemporary cinema studies as a result of this break (which he views in economic and ideological terms). The Theorists' persistence in analyzing contemporary cinema according to a classical model, or what he characterizes as the "Elizabethan moment of the cinema," results in a lack of constructive theory in relation to a New Hollywood cinema that is not primarily characterized by the classical (1991, 127).

47. Like so much of contemporary blockbuster cinema, *Star Wars* reflects on itself as entertainment cinema through the numerous intertextual references to its influences. The film, for example, relies nostalgically refers to B movie adventure serials such as *Flash Gordon*, westerns such as *The Magnificent Seven*, and science fiction films (especially those of the

"space opera" tradition), as well as a comic-book tradition of space adventures. But again, the intention is both homage and a virtuoso performance intent on outperforming predecessors through the technological advances introduced in the film.

48. The episode of *Movie Magic* about stop-motion animation from which this quotation is taken was shown on the Discovery Channel, Melbourne, January 19, 1997.

49. A similar point may be made regarding the *Star Wars* narrative. With regard to narrativity, however, a neo-baroque attitude is reflected in the sequel and cross-media serial narratives that have extended the *Star Wars* narrative.

50. Continuing the allusion to and virtuoso enhancement of *Flash Gordon*, the text narration at the beginning of the film also highlights its ability to create infinite screen depth. The opening scenes of *Flash Gordon* included text that, like that in the introductory sequence of *Star Wars*, retold the events occurring in the previous episode. The text scrolled from bottom to top on the screen, minimizing in a pyramid-like formation as it reached the top. In attempting to give the illusion of text fading into the depth of the screen, it merely highlighted the two-dimensionality of the screen surface.

51. Belton makes this point in relation to the wide-screen experiences that became popular in the 1950s. As he suggests, however, the wide-screen phenomenon is more of an integral factor in contemporary "spectacular entertainment values." Whereas in 1955 only four theaters were equipped to show 70 mm films, since the release of *Star Wars* (which was released in the 70 mm format), every "potential blockbuster" is released in this format. In addition, in the United States alone, the number of theaters equipped to show the 70 mm format has risen to over nine hundred.

52. Belton also quotes Howard Hughes, who responded negatively to wide-screen technology because "it's very hard for an audience to focus—they have too much to look at—they can't see the whole thing" (1992, 199). Belton makes the important point that the conditions of realism and suture asserted by writers like Stephen Heath (1981) were reliant on classical framing ratios (1.33:1) that adhered to Renaissance laws of perspective and systems of framing. Wide-screen cinema radically transformed these ratios, producing a more invasive and participatory audience involvement with the image. As Belton states, in the 1950s, in "selecting widescreen aspect ratios, Paramount, Republic, and RKO opted for 1.66:1; MGM for 1.75:1; Warners, Universal, and Columbia for 1.85:1; and Fox for 2.55:1" (see Belton 1992, 116, 186–188). Fox Studios has traditionally maintained the widest screen ratios, and the release of *Star Wars* in a wide-screen, 70 mm format harked back to the wide-screen heyday of the 1950s.

53. Because of his insistence on the omniscient, singular viewpoint, Descartes was still linked by Leibniz with Renaissance perceptions of the world.

54. Douglas Trumbull, who constructed the spectacles of *2001: A Space Odyssey*, *Close Encounters of a Third Kind*, and *Brainstorm* (Trumbull 1983), is the pioneering figure in simulation

rides. His company, Future General, in conjunction with Paramount Pictures, produced the simulation ride Tour of the Universe in the mid-1970s. In Tour of the Universe, Trumbull combined motion simulators with his own Showscan filming process (which employed a 70 mm film projected at sixty frames per second). The effect and heightened realism of the attraction was groundbreaking but was not implemented in a sustained manner in the theme park environment until the *Star Tours* ride in 1987. See Pourroy 1991 and Bukatman 1998.

55. During the seventeenth century, opera began in court but soon shifted to the public sphere with productions opening in Venice in 1637, which addressed a new mass clientele (Molinari 1968, 155).

56. See Molinari 1968 (143). The intermezzi were also the rudimentary beginnings of opera.

57. Roughly translated, "astounding because of their magnificence, and marvelous because of their machines." For descriptions of the intermezzi, see Blumenthal 1980.

58. Belton's examples include *The Robe* (Koster 1953) and *How to Marry a Millionaire* (Negulesco 1953). In *The Robe*, the opening credits of the film appear against a red curtain that then parts "to reveal the panoramic spectacle of ancient Rome," and in *How to Marry a Millionaire*, the credits appear against green and gold curtains that then part to reveal the Twentieth Century Fox studio orchestra (1992, 191).

59. Another day of the festivities included the *Notte d'Amore*, which comprised a theater stage and performances set up in the Pitti Palace and also involved the celebrants as active participants in the theater itself. For a detailed account of the events of the festival, see Nagler 1964 (111–112).

60. For technical information on *Terminator 2: 3D Battle across Time*, see Suskind 1996 and Magid 1996.

61. During the implementation of Dolby surround sound in the 1970s, sound designers attempted to be spatially faithful to the sound source (Altman 1995). If a character spoke left of screen, the sound could be heard from the speakers to the left of the auditorium. When the spaceship in *Star Wars* appeared to enter the screen space from the back of the theater, audiences could hear its rumbling progression through sound effects that shifted progressively from speakers at the back of the theater, to those at the front, and then from the screen. However, as Altman explains, Ben Burtt (the sound designer of *Star Wars* and *The Empire Strikes Back*) realized that poor equipment in theaters meant that the sound he had carefully distributed across numerous channels became distorted. For *Return of the Jedi* he initiated an alternative approach whereby narrative sound came from the central speakers and special sound effects from those distributed at the sides and back on the cinema. See Altman 1995 for a detailed account.

62. The theater design is similarly cutting edge: New theatrical rigs and motors designed by Scenic Technologies allow props like a 1,500-pound Harley-Davidson to plunge smoothly

onto the auditorium stage on cue and in perfect synchronicity with events taking place on screen.

Chapter 5. Special-Effects Magic and the Spiritual Presence of the Technological

1. Early in the film Neary voices his nostalgic desire to see the Disney film *Pinocchio*, in which the Disney animated character Jiminy Cricket first sang the song "When You Wish upon a Star."

2. Two seventeenth-century writers of Bernini biographies who discussed Bernini's concept of *bel composto* were Filippo Baldinucci and Bernini's son, Domenico Bernini (see Careri 1995, 47).

3. Key sources dealing with the significance of affection include J. Nucius, *Musices Poeticae* (1613); G. B. Doni, *Compendio del Trattato de'generi e de'modi della Musica* (1635); J. Crüger, *Musicae Practicae Praecepta* (1660); and W. Schönsleder, *Architectonice Musices Universalis* (1631).

4. See Wittkower 1985 (24, 139). In the emphasis on supernatural and sensuous experiences available through spectacle, artists such as Bernini were influenced by the teachings of the Jesuit Order. The Society of Jesus and S. Ignazio of Loyola's *Spiritual Exercises* had a strong effect on seventeenth-century religion and art, especially in the belief in man's capacity to attain a spirituality that raised him from earthly limitations. Martyrdom, ecstasy, and rapture scenes were popular subjects of the era primarily because they remained perfect vehicles for evoking exalted states of perception and transcendence of the material world.

5. The denarrativization inherent in baroque form is one of the reasons Jay (1994), Buci-Glucksman (1994), and Wollen (1993) equate the baroque with modernist aesthetics.

6. Ezekiel reflects a concern that lies at the center of the (neo-)baroque: It attempts to make visible the invisible. Despite the numerous details conveyed in the prophet's description, the actual specifics of the vision itself elude the reader (Lieb 1998, 8). This has made the prophecy particularly susceptible to interpretation.

7. As Lieb explains, Vallée's "theories, writings, and presence resonate throughout the dramatization that underlies *Close Encounters of the Third Kind*" (1998, 48).

8. Lieb provides a detailed account of Blumrich's history. As an aeronautical engineer, Blumrich joined the U.S. space program in 1959, where he was in charge of the Structural Engineering Branch of the Propulsion and Engineering Laboratory at the National Aeronautics and Space Administration (NASA). As a scientist, what "Blumrich offers in his reading of Ezekiel's text is the new religion, that of science, with its particular system of beliefs and practices, indeed, its own 'gods,' one that demands a form of worship all its own" (Lieb 1998, 57). Blumrich claimed that "NASA actually holds patents for a vehicle corresponding to the visionary objects Ezekiel beheld" (Lieb 1998, 59).

9. The Web site further explains:

> These extra-terrestrials, the Elohim, have requested that their embassy be as close to Jerusalem as possible. They wish to descend and land inside the embassy in front of representatives of all the world's media and be open to everyone. From their embassy, they will be able to come and go as they wish and control their own accessibility, rather than being controlled by anyone else. They wish to be able to invite representatives of governments and other institutions to the embassy and also particularly individuals who have clear records of a positive effect on humanity. ("The Raëlian Religion" 2002)

For the Raëlians as for many other New Age groups, the Bible becomes an important source that confirms prior alien visitation as well as the superior and divine nature of our off-world saviors. Biblical passages that refer to aliens and alien craft cited on the Raëlian Web site include Ezekiel's vision, four wheels turning in the sky (Ezekiel 1:4); the column of clustered clouds guiding the Hebrew people by day during the Exodus (Exodus 13:21); the pillar of fire guiding them at night (Exodus 14:19); Yahweh's descent in a "glory of hosts" on Mount Sinai (Exodus 24:17); the prophet Elijah swept up in the sky in a whirlwind (Kings 2:1); and the star guiding the three kings who came to bring their help and material support to the newborn Jesus (Matthew 2:2).

10. In light of the new digital era, the image of the industrial gear has now aged.

11. Although Kircher's status as inventor of the magic lantern is under dispute, he was certainly instrumental in propagating its success as both scientific tool and entertainment.

12. On the history of the panorama, see Oettermann 1997. For further information about stereoscopic and 3D technology, see Belton 1992. On binocular visual technologies, see Crary 1994.

13. As Kemp states, the panorama was designed to overcome the limitations of traditional painting and the "static eye." The first documented instances of the panorama are Baldassare Lanci's sixteenth-century panorama images of cities from high viewpoints. In the seventeenth century, however, the concern with panoramic and more expansive views of the world became a widespread phenomenon (1990, 211–213).

14. The natural museum (whose function was to contain the natural wonders of the world in microcosmic form) as context for the magic lantern illusions further emphasizes the baroque's concern with creating encyclopedic illusions of reality through artificial means.

15. Like computer effects illusions, pre-twentieth-century effects technologies evolved in the effort to outperform prior effects devices. As Castle notes in relation to the magic lantern: "the desire for illusions" produced changes in the magic lantern, and the candle-lit lantern progressed from lime ball, to hydrogen, to magnesium, to gas-lit, with each of these changes improving the "realism of the phantasmagoria image" (1988, 37–40).

16. The interplay between the disguised and visible effect has resonances with the psychoanalytic tradition of film theory that relates the process of film spectatorship and suture as one

based on Lacanian and Freudian theories of "presence-absence" and subject construction. The presence-absence fetishization of film effects is further explored by Metz (1977), Landon (1992), and Gunning (1993).

17. Many nineteenth-century magic shows, including those of the magicians David Devant, Carl Hertz, and George Méliès, included screenings of films such as those first produced by the Lumières. Louis Lumière also entrusted the magician Félicien Trewey with the premiere Lumières screening in London in 1896 (Barnow 1981, 50); the premiere took place at London's Royal Polytechnic Institute, which was the location of spectacular lantern shows featuring ghosts and transformations, including the famous "Pepper's ghost." After the success of the Lumières' film premiere in 1896, magicians began investing in film cameras and set up their own productions, often including films of themselves performing magic tricks. A number of magicians produced such films, including David Devant, Leopoldo Fregoli, Alexander Victor (also known as Alexander the Great), Walter R. Booth, and Harry Houdini, who, after visiting Méliès's Theatre Robert-Houdin, produced a number of films that captured Méliès's acts of illusionism (Barnow 1981, 27–28, 50, 56–81).

18. The theatre had been established by the famous magician who later became Houdini's namesake.

19. For further details of these early examples of science fiction, see Remnant and Bennett 1996 (lxxix) and Guthke 1990. The parallels between some of these writings and twentieth-century examples of science fiction are, at times, quite startling. Cyrano de Bergerac's lunar traveler, for example, traveled to the moon in a rocket, and in his *États et empires du soleil*, the hero travels to the sun in a solar-powered space vehicle.

20. Guthke (1983, 144) amusingly relates that Wilkins's "heresy" was countered by books such as Alexander Ross's *The New Planets: or, The Earth Is No Wandring Star; except in the Wandring Heads of Galileans* (1646).

21. The other lands are Toon Lagoon, Jurassic Park, Lost Continent, and Seuss Landing.

22. The classical paradigm associated with pre-1960s Hollywood cinema and its associations with narrativity and the "passive spectator" (a paradigm that persists to this day in film theory in relation to contemporary cinema) no longer seems viable given new entertainment experiences concerned with spectacle, multimedia formations, and active audience address and participation. Spectacle engulfs the audience in invasive, spatial, and theatrical terms, producing participatory and sensorially engaging experiences. Indeed, film theorists such as Noel Carroll (1988), Vivian Sobchack (1992), Judith Mayne (1993), and Jim Collins (1995) have queried whether the "passive-spectator" model was ever viable.

References

Aarseth, Espen J. 1994. "Nonlinearity and Literary Theory." In *Hyper/Text/Theory*, ed. George P. Landow, 51–86. Baltimore: Johns Hopkins University Press.

Aarseth, Espen J. 1997. *Cybertext: Perspectives on Ergodic Literature*. Baltimore: Johns Hopkins University Press.

Ackerman, James S. 1991. *Distance Points: Essays in Theory and Renaissance Art and Architecture*. Cambridge: MIT Press.

Adelman, Jeremy, ed. 1999. *Colonial Legacies: The Problem of Persistence in Latin American History*. New York: Routledge.

Alberti, Leon Battista. 1966. *On Painting*, trans. with an introduction by John R. Spencer. New Haven: Yale University Press.

Alewyn, Richard, ed. 1965. *Deutsche Barock forschung. Dokumentation einer Epoche*. Cologne: Kiepenheuer & Witsch.

Altman, Rick. 1995. "The Sound of Sound: A Brief History of the Reproduction of Sound in Movie Theaters," *Cineaste* 21(January 1): 68–72.

Altman, Rick. 1999. *Film/Genre*. London: BFI.

Amabile, Luigi. 1891. *Due Artisti ed Uno Scienziato. Gian Bologna, Jacomo Svanenburgh e Marco Aurelio Severino: nel S.to Officio Napoletano*. Naples.

Anderson, Perry. 1998. *The Origins of Postmodernity*. London: Verso.

Anwar, Farrah. 1990. "Bloody and Absurd." *Monthly Film Bulletin* 57(683, December): 347–348.

Bakhtin, Mikail. 1984. *Rabelais and His World*. Bloomington: Indiana University Press.

Bal, Mieke. 1999. *Quoting Caravaggio: Contemporary Art, Preposterous History*. Chicago: University of Chicago.

Baltrusaitis, Jurgis. 1979. Le miroir: Révélations, science-fiction *et fallacies*. Paris: Seuil.

Barnow, Eric. 1981. *The Magician and the Cinema*. Oxford: Oxford University Press.

Baudrillard, Jean. 1983. *In the Shadow of the Silent Majorities . . . or the End of the Social and Other Essays*, trans. Paul Foss, Paul Patton, and John Johnson. New York: Semiotext(e).

Baudrillard, Jean. 1984a. *The Evil Demon of Images*. Waterloo: Power Institute.

Baudrillard, Jean. 1984b. "Interview: Game with Vestiges." *On the Beach* 5 (winter).

Baudrillard, Jean. 1986. *Amérique*. Paris: B. Grasset.

Baudrillard, Jean. 1994. *Simulacra and Simulation (The Body, in Theory: Histories of Cultural Materialism)*, trans. Sheila Faria Glaser. Ann Arbor: University of Michigan Press.

Baudry, Jean-Louis. 1981. "Ideological Effects of the Basic Cinematographic Apparatus." In *Apparatus*, ed. Theresa Hak Kyung Cha, 25–40. New York: Tanam.

Baur-Heinhold, Margarete. 1967. *Baroque Theatre*, trans. Mary Whittall. London: Thames & Hudson.

Bazin, André. 1967. *What Is Cinema?* Vol. 1. Berkeley: University of California Press.

Belton, John. 1992. *Widescreen Cinema*. New York: Columbia University Press.

Benedikt, Michael, ed. 1991. *Cyberspace: First Steps*. Cambridge: MIT Press.

Benjamin, Walter. 1998. *The Origin of German Tragic Drama*, trans. John Osborne. London and New York: Verso. (Originally published 1963.)

Berard, Victor Roland, and Patrick Cannière. 1982. "Michael Curtiz: Maitre du Baroque." *Image et Son* 396(February): 79–100.

Berger, Robert W. 1985. *In the Garden of the Sun King: Studies on the Park of Versailles under Louis XIV*. Washington: Dumbarton Oaks.

Best, Steven, and Douglas Kellner. 1991. *Postmodern Theory: Critical Interrogations*. London: Macmillan.

Best, Steven, and Douglas Kellner. 1997. *The Postmodern Turn*. New York: Guilford.

Beverley, John. 1988. "Going Baroque?" *Boundary* 15(3)–16(1): 27–39.

Blumenthal, Arthur R. 1980. *Theater Art of the Medici*. Hanover, N.H.: University Press of New England.

Blumrich, Josef F. 1974. *The Spaceships of Ezekiel*. New York: Bantam.

Bolter, Jay David, and Richard Grusin. 1999. *Remediation: Understanding New Media*. Cambridge: MIT Press.

Boni, Dino. 1994. "The Freudian Software House." *Gamestar* 5(October): 22–24.

Bonitzer, Pascal. 1981. "Partial Vision: Film and the Labyrinth." *Wide Angle* 4(4): 56–64.

Bordwell, David. 1989. *Making Meaning: Inference and Rhetoric in the Interpretation of Cinema.* Cambridge: Harvard University Press.

Bordwell, David, Janet Staiger, and Kristin Thompson. 1985. *The Classical Hollywood Cinema: Film Style and Mode of Production to 1960.* London: Routledge.

Bordwell, David, and Kristin Thompson. 2001. *Film Art: An Introduction.* New York: McGraw-Hill.

Borges, Jorge Luis. 1964. *Labyrinths.* Middlesex, England: Penguin.

Bornhofen, Patricia Lynn. 1995. *Cosmography and Chaography: Baroque to Neobaroque: A Study in Poetics and Cultural Logic.* Ann Arbor: UMI.

Boulez, P. (1958–1961). "Serie." In *Encyclopédie de la musique*, 3 vols., ed. François Michel et al., 434. Paris. Fasquelle.

Bredekamp, Horst. 1995. *The Lure of Antiquity and the Cult of the Machine: The Kunstkammer and the Evolution of Nature, Art and Technology.* Princeton: Markus Wiener.

Brophy, Philip. 1986. "Horrality—The Textuality of Contemporary Horror Films." *Screen* 27(January–February): 2–13.

Brophy, Philip. 1988. "The Body Horrible: Some Notions, Some Points, Some Examples." *Intervention* 21(2): 58–67.

Buci-Glucksman, Christine. 1986. *La folie du voir: De l'esthétique baroque.* Paris: Editions Galilée.

Buci-Glucksman, Christine. 1994. *Baroque Reason: Aesthetics of Modernity.* London: Sage.

Buci-Glucksman, Christine, and Fabrice Revault D'Allonnes. 1987. *Raoul Ruiz.* Paris: Dis Voir.

Bukatman, Scott. 1993. *Terminal Identity: The Virtual Subject in Post-Modern Science Fiction.* Durham: Duke University Press.

Bukatman, Scott. 1995. "The Artificial and the Infinite: On Special Effects and the Sublime." In *Visual Displays: Culture beyond Appearances*, ed. Lynne Cook and Peter Wollen, 255–289. Seattle: Bay.

Bukatman, Scott. 1998. "Zooming Out: The End of Offscreen Space." In *The New American Cinema*, ed. Jon Lewis, 248–272. Durham: Duke University Press.

Bukofzer, Manfred F. 1947. *Music in the Baroque Era from Monteverdi to Bach.* New York: Norton.

Burkholder, Mark A., and Lyman L. Johnson. 1998. *Colonial Latin America.* New York: Oxford University Press.

Cabanillas, Francisco. 1992. *Severo Sarduy: The Flight of Desire (Severo Sarduy: El vuelo del deseo).* Ann Arbor: UMI.

Calabrese, Omar. 1992. *Neo-Baroque: A Sign of the Times.* Princeton: Princeton University Press. (Originally published as *L'Eta Neobarocca*, Editori Laterza, Rome, 1987.)

Calloway, Stephen. 1994. *Baroque Baroque: The Culture of Excess.* London: Phaidon.

Cameron, James. 1992. "Effects Scene: Technology and Magic." *Cinefex* 51(August): 5–7.

Careri, Giovanni. 1995. *Bernini: Flights of Love, the Art of Devotion.* Chicago: University of Chicago Press.

Carmody, Adrian. 1999. "EverQuest." *Quandary Computer Game Reviews* (June). Available at ⟨http://everquest.station.sony.com/⟩, ⟨http://www.quandryland.com/1999/everquest.htm⟩.

Carroll, Noel. 1988. *Mystifying Movies: Fads and Fallacies in Contemporary Film Theory.* New York: Columbia University Press.

Cascardi, Anthony J. 1997. *Ideologies of History in the Spanish Golden Age.* University Park: Pennsylvania State University.

Castle, Terry. 1988. "Phantasmagoria: Spectral Technology and the Metaphorics of Modern Reverie." *Critical Inquiry* 15(Autumn): 26–61.

Cervantes, Miguel. 1999. *Don Quixote.* Oxford: Oxford University Press. (Originally published 1605 (part 1), 1615 (part 2).)

Clover, Carol. 1992. *Men, Women and Chainsaws: Gender in the Modern Horror Film.* Princeton: Princeton University Press.

Cohen, Walter. 1985. *Drama of a Nation: Public Theater in Renaissance England and Spain.* Ithaca: Cornell University Press.

Collins, Jim. 1989. *Uncommon Cultures: Popular Culture and Postmodernism.* New York: Routledge.

Collins, Jim. 1991. "Batman: The Movie, Narrative: The Hyperconscious." In *The Many Lives of the Batman: Critical Approaches to a Superhero and His Media*, ed. Roberta E. Pearson and William Uricchio, 64–181. New York: Routledge.

Collins, Jim. 1995. *Architectures of Excess: Cultural Life in the Information Age.* New York: Routledge.

Conley, Tom. 1993. "Foreword." *Gilles Deleuze, The Fold: Leibniz and the baroque.* Minneapolis: University of Minnesota Press.

Consagra, Francesca. 1995. "De Rossi and Falda: A Successful Collaboration in the Print Industry of Seventeenth-Century Rome." In *The Craft of Art: Originality and Industry in the*

Italian Renaissance and Baroque Workshop, ed. William U. Eiland, 187–203. Athens: University of Georgia Press.

Corrigan, Timothy. 1991. *A Cinema without Walls: Movies and Culture after Vietnam*. London: Routledge.

Cotta Vaz, Mark. 1996. *Industrial Light and Magic*. New York: Del Rey.

Crary, Jonathan. 1989. "Spectacle, Attention, Counter-Memory." *October* 50(Fall): 97–107.

Crary, Jonathan. 1994. *Techniques of the Observer: On Vision and Modernity in the Nineteenth Century*. Cambridge: MIT Press.

Cro, Stelio. 1995. "Fellini's Freudian Psyche Between Neo-Realism and Neo Baroque." *Canadian Journal of Italian Studies* 18(5): 162–183.

Damisch, Hubert. 1994. *The Origin of Perspective*, trans. John Goodman. Cambridge: MIT Press. (Originally published as *L'origine de la perspective*, Paris: Flammarion, 1987.)

Damisch, Hubert. 1995. "Introduction." In Giovanni Careri, *Bernini: Flights of Love, the Art of Devotion*, vii–ix. Chicago: University of Chicago Press.

Davis, Erik. 1995. "Calling Cthulhu H. P. Lovecraft's Magick Realism." Available at ⟨http://www.levity.com/figment/lovecraft.html⟩. (Originally published as "Calling Cthulhu," *Gnosis* 38(Fall 1995).)

Davis, Erik. 1998. *Techgnosis: Myth, Magic + Mysticism in the Age of Information*. New York: Harmony.

Degli-Esposti, Christina. 1996a. "The Neo-Baroque Scopic Regime in Postmodern Cinema: Metamorphosis and Morphogeneses. The Case of Peter Greenaway's Encyclopedic Cinema." *Cinefocus* 4:34–45.

Degli-Esposti, Christina. 1996b. "Sally Potter's *Orlando* and the Neo-Baroque Scopic Regime." *Cinema Journal* 36(1, Fall): 75–93.

Degli-Esposti, Christina. 1996c. "Federico Fellini's *Intervista* or the Neo-Baroque Creativity of the Analysand on Screen." *Italica* (Spring).

Deleuze, Gilles. 1993. *The Fold: Leibniz and the Baroque*, trans. Tom Conley. Minneapolis: University of Minneapolis Press. (Originally published 1988.)

del Paso, Fernando. 1987. *Noticias del Imperio*. Mexico Diana Literaria.

Derobert, Eric. 1985. "Raspoutine, l'Agonie: Aberration Baroque." *Positif* 298(December): 61–62.

Descartes, René. 1637/1999. *Discourse on Method and Related Writings*, trans. Desmond M. Clarke. London: Penguin.

Descartes, René. 1644/1988. *Principles of Philosophy*, trans. Blair Reynolds. Lewiston, N.Y.: E. Mellen.

Desneux, Ariane. 2000. "Edward Aux Mains D'Argent." Available at ⟨http://cinescape. voice.fr/FILMOS/BurtonTim/edward.htm⟩.

Dika, Vera. 1990. *Games of Terror: Halloween, Friday the 13th and the Films of the Stalker Cycle*. Toronto: Associated University Presses.

Docker, John. 1994. *Postmodernism and Popular Culture: A Cultural History*. Cambridge: Cambridge University Press.

Dodge, Martin, and Rob Kitchin. 2001. *Mapping Cyberspace*. London and New York: Routledge.

Donne, John. 1967. "First Anniversarie: An Anatomy of the World." In *John Donne. Poetry and Prose*, 201–214. New York: Modern Library.

Doob, Penelope Reed. 1990. *The Idea of the Labyrinth from Classical Antiquity through the Middle Ages*. Ithaca: Cornell University Press.

"Doom: Evil Unleashed." 1994. *Edge* 6(March): 30–31.

"Doom the Movie!" 1994. *PC Zone* 21(December): 8.

d'Ors, Eugenio. 1936. *Du Baroque*. Paris.

Drake, W. Raymond. 1974a. *Gods and Spacemen in the Ancient East*. New York: Signet.

Drake, W. Raymond. 1974b. *Gods and Spacemen of the Ancient Past*. New York: Sphere.

Duncan, Jodi. 1991. "A Once and Future War." *Cinefex* 47(August): 4–59. (Special issue on *Terminator 2*.)

Dussel, Enrique. 1998. "Beyond Eurocentrism: The World System and the Limits of Modernity." In *The Cultures of Globalization*, ed. Fredric Jameson and Masao Miyoshi, 3–31. Durham and London: Duke University Press.

Eamon, William. 1994. *Science and the Secrets of Nature: Books of Secrets in Medieval and Early Modern Culture*. Princeton: Princeton University Press.

Easlea, Brian. 1980. *Witch Hunting, Magic and the New Philosophy: An Introduction to Debates of the Scientific Revolution 1450–1750*. Hertfordshire, England: Harvester Wheatsheaf.

Ebert, Teresa. 1996. *Ludic Feminism and After: Postmodernism, Desire, and Labor in Late Capitalism*. Ann Arbor: University of Michigan Press.

Eco, Umberto. 1984. *Semiotics and the Philosophy of Language*. London: Macmillan.

Eco, Umberto. 1989. *The Open Work*. Cambridge: Harvard University Press. (Chapters 1–6 originally published 1962.)

Eco, Umberto. 1992. "Foreword." In Omar Calabrese, *Neo-Baroque: A Sign of the Times*, i–xiv. Princeton: Princeton University Press.

Edwards, Phil, and Alan Jones. 1983. "The Evil Dead Speak." *Starbust* 57:24–29.

Eliade, Mircea. 1961. *The Sacred and the Profane*. New York: Harper Row.

Ferrell, Keith. 1994. "Interactive Storytelling." *Electronic Entertainment* (August): 30.

Ferro, Marc. 1997. *Colonization: A Global History*. London and New York: Routledge.

Findlen, Paula. 1994. *Possessing Nature: Museums, Collecting, and Scientific Culture in Early Modern Italy*. Berkeley and Los Angeles: University of California Press.

Findlen, Paula. 1995. "Scientific Spectacle in Baroque Rome: Athanasius Kircher and the Roman College Museum." *Roma Moderna e Contemporanea* 3:625–665.

Findlen, Paula. 1996. "Courting Nature." In *Cultures of Natural History*, ed. N. Gardiner, J. A. Second, and E. C. Spary, 57–73. Cambridge: Cambridge University Press.

Fisher, Philip. 1998. *Wonder, the Rainbow, and the Aesthetics of Rare Experiences*. Cambridge: Harvard University Press.

Fleming, William. 1946. "The Element of Motion in Baroque Art and Music." *Journal of Aesthetic and Art Criticism* 5(2, December): 121–128.

Flitterman-Lewis, Sandy. 1987. "Psychoanalysis." In *Channels of Discourse: Television and Contemporary Discourse*, ed. Robert C. Allen, 172–210. Chapel Hill: University of North Carolina Press.

Focillon, Henri. 1992. *The Life of Forms in Art*. London: Zone Books. (Originally published 1934.)

Foster, Hal, ed. 1983. *The Anti-Aesthetic: Essays on Postmodern Culture Port Townsend*. Washington: Bay Press.

Foster, Kirsten. 1995. "System Shockers." *PC Power* 13(January): 32–35.

Foucault, Michel. 1986. *The Order of Things: An Archaeology of Human Sciences*. London: Tavistock.

Fuentes, Carlos, and Terra Nostra. 1976. Translated by Margaret Sayers Peden. New York: Farrar, Straus, Giroux.

Gabilondo, Joseba. 1991. *Cinematic Hyperspace*. New Hollywood Cinema and Science Fiction Film: Image Commodification in Late Capitalism. Ph.D. diss., University of California, San Diego.

Gallagher, Tag. 1995. Shoot-Out at the Genre Corral: Problems in the "Evolution" of the Western. In *Film Genre Reader II*, ed. Barry Keith Grant. Austin: University of Texas Press.

Ghosh, Aparisim. 2001. "Watch and Wear." *Time* (June 4): 46–47.

Gibson, Ross. 1992. "Yondering: A Reading of *MAD MAX Beyond Thunderdome*." In *South of the West: Postcolonialism and the Narrative Construction of Australia*, 158–177. Bloomington: Indiana University Press.

Godzich, Wlad, and Nicholas Spadacchini. 1986. "Popular Culture and Spanish Literary History." In *Literature among Discourses: The Spanish Golden Age*, ed. Wlad Godzich and Nicholas Spadacchini, 41–61. Minneapolis: University of Minnesota Press.

Gribbin, John. 1998. *Q is for Quantum—Particles from A–Z*. London: Phoenix Giant.

Grizzard, Mary. 1986. *Spanish Colonial Art and Architecture of Mexico and the U.S. Southwest*. Lanham, Md.: University Press of America.

Gross, Larry. 1995. "Big and Loud." *Sight and Sound* 5(8, August): 6–10.

Guardini, Francesco. 1996. "Old and New, Modern and Postmodern: Baroque and Neobaroque." *McLuhan Studies* 4. Available at ⟨http://www.chass.utoronto.ca/mcluhan-studies/v1_iss4/1_4index.htm⟩.

Gunning, Tom. 1990. "The Cinema of Attractions—Early Film, Its Spectator and the Avant-Garde." In *Early Cinema—Space, Frame, Narrative*, ed. Thomas Elsaesser with Adam Barker, 56–62. London: British Film Institute.

Gunning, Tom. 1993. "'Now You See It, Now You Don't': The Temporality of the Cinema of Attractions." *Velvet Light Trap* 32(Fall): 3–12.

Gunning, Tom. 1995a. "Phantom Images and Modern Manifestations: Spirit Photography, Magic Theater, Trick Films, and Photography's Uncanny." In *Fugitive Images: From Photography to Video*, ed. Patrice Petro, 42–71. Bloomington: Indiana University Press.

Gunning, Tom. 1995b. "'Animated Pictures,' Tales of Cinema's Forgotten Future." *Michigan Quarterly Review* 34(4): 465–485.

Guthke, Karl S. 1990. *The Last Frontier: Imagining Other Worlds, from the Copernican Revolution to Modern Science Fiction*, trans. Helen Atkins. Ithaca and London: Cornell University Press. (Originally published as *Der mythos dir Neuzeit*, Bern: A. Francke A. G. Verlag, 1983.)

Hagedorn, Roger. 1988. "Technology and Economic Exploitation: The Serial as a Form of Narrative Presentation." *Wide Angle* 10(4): 4–12.

Hammond, Frederick. 1994. *Music and Spectacle in Baroque Rome: Barberini Patronage under Urban VIII*. New Haven: Yale University Press.

Hanafi, Zakiya. 2000. *The Monster in the Machine: Magic, Medicine, and the Marvelous in the Time of the Scientific Revolution*. Durham: Duke University Press.

Harvey, David. 1982. *Limits of Capital*. Chicago: University of Chicago Press.

Harvey, Miles. 2000. *The Island of Lost Maps: A True Story of Cartographic Crime*. London: Weidenfeld & Nicolson.

Haskell, Francis. 1980. *Patrons and Painters: Art and Society in Baroque Italy*. New Haven: Yale University Press.

Hatherly, Ana. 1986. "Reading Paths in Spanish and Portuguese Baroque Labyrinths." *Visible Language* 20(1, Winter): 52–64.

Hayward, Philip, and Tana Wollen, eds. 1993. *Future Visions: New Technologies and the Screen*. London: British Film Institute.

Healy, Dave. 1997. "Cyberspace and Place: The Internet as Middle Landscape on the Electronic Frontier." In *Internet Culture*, ed. David Porter, 55–68. New York: Routledge.

Heard, Mervyn. 1996. "The Magic Lantern's Wild Years." In *Cinema: The Beginnings and the Future*, ed. Christopher Williams, 24–32. London: University of Westminster Press.

Heath, Stephen. 1981. *Questions of Cinema*. Bloomington: Indiana University Press.

Heim, Michael. 1991. "The Erotic Ontology of Cyberspace." In *Cyberspace: First Steps*, ed. Michael Benedikt, 59–80. Cambridge: MIT Press.

Hillier, Jim. 1992. *The New Hollywood*. London: Studio Vista.

Hind, Arthur M. 1963. *A History of Engraving and Etching from the 15th Century to the Year 1914*. New York: Dover.

Houghton, Walter E. 1942. "The English Virtuoso in the Seventeenth Century." *Journal of the History of Ideas* 3:190–219.

Ignatius, Adi. 2001. "We Have Contact." *Time* (June 4): 37–39.

Impey, Oliver, and Arthur MacGregor, eds. 1985. *The Origins of Museums: The Cabinet of Curiosities in Sixteenth and Seventeenth Century Europe*. Oxford: Clarendon.

Jameson, Fredric. 1984. "Postmodernism: The Cultural Logic of Late Capitalism." *New Left Review* 146:53–93.

Jameson, Fredric. 1991. *Postmodernism, or, the Cultural Logic of Late Capitalism*. Durham: Duke University Press. (First published in *New Left Review* 146 [1984].)

Jameson, Fredric. 1998a. *The Cultural Turn: Selected Writings on the Postmodern, 1983–1998*. London: Verso.

Jameson, Fredric. 1998b. "Notes on Globalization as a Philosophical Issue." In *The Cultures of Globalization*, ed. Fredric Jameson and Masao Miyoshi, 54–77. Durham and London: Duke University Press.

Jameson, Fredric, and Masao Miyoshi, eds. 1998. *The Cultures of Globalization*. Durham and London: Duke University Press.

Jay, Martin. 1994. *Downcast Eyes: The Denigration of Vision in Twentieth-Century French Thought*. Berkeley and Los Angeles: University of California Press.

Jenkins, Henry. 1995. "Historical Poetics." In *Approaches to Popular Film*, ed. Jane Hollows and Mark Jancovich, 99–122. Manchester, U.K.: Manchester University Press.

Jennings, Pamela. 1996. "Narrative Structures for New Media: Towards a New Definition." *Leonardo* 29(5): 345–350.

Jessup, Morris K. 1956. *UFO and the Bible*. New York: Citadel.

Kemp, Martin. 1990. *The Science of Art: Optical Themes in Western Art from Brunelleschi to Seurat*. New Haven: Yale University Press.

Kuhn, Thomas S. 1970. *The Structure of Scientific Revolutions*. 2nd ed. Chicago: University of Chicago Press.

Lablaude, Pierre-André. 1995. *The Gardens of Versailles*. London: Zwemmer.

Landon, Brooks. 1992. *The Aesthetics of Ambivalence: Rethinking Science Fiction Film in the Age of Electronic (Re)production*. Westport, Conn.: Greenwood.

Landow, George P. 1994. "'What's a Critic to Do?': Critical Theory in the Age of the Hypertext." In *Hyper/Text/Theory*, ed. George P. Landow, 1–48. Baltimore: Johns Hopkins University Press.

Laquer, Thomas. 1990. *Making Sex: Body and Gender from the Greeks to Freud*. Cambridge: MIT Press.

La Valley, Albert J. 1985. "Traditions of Trickery: The Role of Special Effects in the Science Fiction Film." In *Shadows of the Magic Lamp: Fantasy and Science Fiction in Film*, ed. George Slusser and Eric S. Rabkin, 141–158. Carbondale: Southern Illinois University Press.

Leibniz, G. W. 1898. *The Monadology and Other Philosophical Writings*, trans. Robert Latta. Oxford: Clarendon.

Levey, Michael. 1975. *High Renaissance*. Middlesex, England: Penguin.

Levey, Michael. 1987. *Early Renaissance*. Middlesex, England: Penguin. (Originally published 1967.)

Lévi-Strauss, Claude. 1994. *The Raw and the Cooked—Introduction to a Science of Mythology*. London: Pimlico. (Originally published 1964.)

Lieb, Michael. 1998. *Children of Ezekiel: Aliens, UFOs, the Crisis of Race, and the Advent of End Time*. Durham and London: Duke University Press.

Lima, Luiz Costa. 1981. *Dispersa Demanda*. Rio de Janeiro: Francisco Alves Editora.

Lotman, Yuri M. 1990. *Universe of the Mind: A Semiotic Theory of Culture*. London: I. B. Taurus.

Lyotard, Jean-Francois. 1984. *The Postmodern Condition: A Report on Knowledge*, translated by Geoff Bennington and Brian Massumi, foreword by Fredric Jameson. Manchester: Manchester University Press.

MacCabe, Colin. 1974. "Realism and the Cinema: Notes of Some Brechtian Theses." *Screen* 15(2): 7–27.

MacCabe, Colin. 1976. "Theory and Film: Principles on Realism and Pleasure." *Screen* 17(3): 7–27.

Magid, Ron. 1996. "Eminent Domain." *Cinescape* 2(6, March): 24–34.

Mahon, Denis. 1971. *Studies in Seicento Art and Theory*. Westport, Conn.: Greenwood.

Maravall, Jose Antonio. 1983. *Culture of the Baroque: Analysis of a Historical Structure*, trans. Terry Cochran. Minneapolis: University of Minnesota Press. (Originally published 1975.)

Maravall, Jose Antonio. 1986. "From the Renaissance to the Baroque: The Diphasic Schema of a Social Crisis." In *Literature among Discourses: The Spanish Golden Age*, ed. Wlad Godzich and Nicholas Spadacchini, 3–40. Minneapolis: University of Minnesota Press.

Martin, Adrian. 1993. "The Impossible Scene." *Photofile* 38(March): 45–48.

Martin, John Rupert. 1977. *Baroque*. London: Penguin.

Martin, Richard. 1997. *Gianni Versace*. New York: Metropolitan Museum of Art. (Catalogue accompanying exhibition, December 11, 1997–March 22, 1998.)

Mayne, Judith. 1993. *Cinema and Spectatorship*. New York: Routledge.

McDonagh, Maitland. 1991. *Broken Mirrors, Broken Minds: The Dark Dreams of Dario Argento*. London: Sun Tavern Fields.

McGrath, Roberta. 1996. "Natural Magic and Science Fiction: Instruction, Amusement and the Popular Show 1795–1895." In *Cinema: The Beginnings and the Future*, ed. Christopher Williams, 13–23. London: University of Westminster Press.

McQuire, Scott. 1987. "Horror: Re-makes and Offspring." *Antithesis* 1(1): 21–25.

Meehan, Eileen E. 1991. "'Holy Commodity Fetish, Batman!': The Political Economy of a Commercial Intertext." In *The Many Lives of the Batman: Critical Approaches to a Superhero and His Media*, ed. Roberta E. Pearson and William Uricchio, 47–65. New York: Routledge.

Metz, Christian. 1977. "*Trucage* and the Film." *Critical Inquiry* 4(Summer): 657–665.

Mignolo, Walter D. 1998. "Globalization, Civilization Processes, and the Relocation of Languages and Cultures." In *The Cultures of Globalization*, ed. Fredric Jameson and Masao Miyoshi, 32–53. Durham and London: Duke University Press.

Miller, R. J. 1991. "The Lost World." (Notes to *The Lost World* laser Disc.)

Mitchell, William J. 1999. *E-topia: "Urban life, Jim—But Not as We Know It."* Cambridge: Massachusetts Institute of Technology.

Miyoshi, Masao. 1998. "'Globalization,' Culture, and the University." In *The Cultures of Globalization*, ed. Fredric Jameson and Masao Miyoshi, 247–270. Durham and London: Duke University Press.

Molinari, Cesare. 1968. *Le Nozze degli Dei: Un Saggio sul Grande Spettaccolo Italiano nel Seicento.* Rome: Mario Bulzoni.

Moran, James. 1994. "Reading and Riding the Cinema of Attractions at Universal Studios." *Spectator* 14(1): 78–91.

Mulvey, Laura. 1975. "Visual Pleasure and Narrative Cinema." *Screen* 16:6–18.

Mulvey, Laura. 1981. "Afterthoughts on 'Visual Pleasure and Narrative Cinema' Inspired by King Vidor's *Duel in the Sun.*" *Framework* nos. 15–17:12–15.

Munck, Thomas. 1990. *Seventeenth Century Europe: State, Conflict, and the Social Order in Europe, 1598–1700.* London: Macmillan.

Murray, Linda. 1986. *The High Renaissance and Mannerism.* London: Thames and Hudson.

Nagler, A. M. 1964. *Theatre Festivals of the Medici, 1539–1637.* New Haven: Yale University Press.

"Natural Born Killers" (interview with id Software members). 1994. *PC Gamer* 1(11, October): 36–42.

Ndalianis, Angela. 2001. "Paul Verhoeven and His Hollow Men." In *Screening the Past*, 1st December 2001 ⟨http://www.latrobe.edu.au/screeningthepast/firstrelease/fr1201/anfrl3a.htm⟩.

Neale, Stephen. 1980. *Genre.* London: British Film Institute.

Newman, Kim. 1988. *Nightmare Movies: A Critical History of the Horror Film, 1968–1988.* London: Bloomsbury.

Oettermann, Stephan. 1997. *The Panorama: History of a Mass Medium.* New York: Zone.

Orringer, Nelson R. 1994. "The Baroque in Francisco Ayala's *El Rapto.*" *Monographic Review* 10:46–59. (Special Issue: Hispanic Contemporary Baroque.)

Overesch, Lynne Elizabeth. 1981. "The Neo-Baroque: Trends in the Style and Structure of the Contemporary Spanish Novel." Ph.D. diss., University of Kentucky, Lexington, Ky.

Palisca, Claude. 1968. *Baroque Music.* Englewood Cliffs, New Jersey: Prentice-Hall.

Paul, Carole. 1997. "Pietro da Cortona and the Invention of the Macchina." *Storia dell'Arte* 89:74–99.

Pearson, Roberta E., and William Uricchio, eds. 1991. *The Many Lives of the Batman: Critical Approaches to a Superhero and His Media*. New York: Routledge.

Penn, Gary. 1994. "Rendered Dull and Devoid." *PC Gamer* 1(10, September): 86.

Perniola, Mario. 1995. *Enigmas: The Egyptian Movement in Society and Art*, trans. Christopher Woodall. London and New York: Verso. (Originally published 1990.)

Perry, Nick. 1998. *Hyperreality and Global Culture*. New York: Routledge.

Plantinga, Carl, and Smith, Greg M. eds. 1999. *Passionate Views: Film, Cognition, and Emotion*. Baltimore: Johns Hopkins University Press.

Pluche, Noel-Antoine. 1770. *Spectacle de la Nature*. Vol. 7. Paris: Fréres Estienne.

Porter, David. 1997. "Introduction." In *Internet Culture*, ed. David Porter, xi–xviii. New York: Routledge.

Pountney, Michelle. 2002. "Birth of a Galaxy." *Herald Sun*, Melbourne (September 10): 9.

Pourroy, Janine. 1991. "Through the Proscenium Arch." *Cinefex* 46(May): 30–45.

Prince, Stephen. 1996. "True Lies: Perceptual Realism, Digital Images, and Film Theory." *Film Quarterly* 49(3, Spring): 27–37.

Raël. 2000. *The Message Given by Extra-Terrestrials*. Paris: Author. (Includes material from *The Book Which Tells the Truth* [1974] and *Extra-Terrestrials Took Me to Their Planet* [1976])

"The Raëlian Religion." 2002. Available at ⟨http://www.rael.org/⟩, February 2, 2002.

Ray, Robert. 1985. *A Certain Tendency of the Hollywood Cinema 1930–1980*. Princeton: Princeton University Press.

Remnant, Peter, and Jonathan Bennett. 1996. *Leibniz: New Essays on Human Understanding*. Cambridge: Cambridge University Press.

Reynolds, Ronald J. 2002. "The Gas between the Stars." *Scientific American* 286(1): 34–43.

Rheingold, Howard. 1993. *The Virtual Community: Homesteading on the Electronic Frontier*. Reading, Mass.: Addison-Wesley.

Roa Bastos, Angusto Antonio. 1975. *Yo, el Supremo*. 3rd ed. Buenos Aires: Siglo Veintiuno.

Robinson, David. 1996. *From Peep Show to Palace: The Birth of American Film*. New York: Columbia University Press.

Roelens, Maurice. 1979. "Maddalena et Comet over Broadway: Baroque et a Lumière." *Cahiers de la Cinemateque* 28(August): 175–178.

Rosasco, Betsy. 1991. "Bains D'Apollon, Bain De Diane: Masculine and Feminine in the Gardens of Versailles." *Gazette des Beaux Arts* 117:1–26.

Rowland, Ingrid D. 2000. *The Ecstatic Journey: Athanasius Kircher in Baroque Rome*. Chicago: University of Chicago Library.

Saisselin, Rémy G. 1992. *The Enlightenment against the Baroque: Economics and the Aesthetics in the Eighteenth Century*. Berkeley and Los Angeles: University of California Press.

Sarduy, Severo. 1975. *Barroco*. Paris: Editions du Seuil.

Sarduy, Severo. 1978. "The Baroque and the Neobaroque." In *Latin America and Its Literature*, ed. Cesar Fernandez Moreno, 115–132. Madrid: Siglio XXI Editores. (Originally published 1973.)

Sassone, Helena. 1972. "Influencia del barroco en la literatura actual." *Guardenos Hispanoamericos* 90(268, October): 147–160.

Savile, Anthony. 2000. *Leibniz and the Monadology*. New York: Routledge.

Schatz, Thomas. 1981. *Hollywood Genres: Formulas, Filmmaking and the Studio System*. New York: Random House.

Schatz, Thomas. 1983. *Old Hollywood/New Hollywood: Ritual, Art, Industry*. Ann Arbor, Mich.: UMI Research Press.

Scott, John Beldon. 1991. *Images of Nepotism: The Painted Ceilings of Palazzo Barberini*. Princeton: Princeton University Press.

Selim, Jocelyn. 2002. "I See, I Cut, I Sew." *Discover* 23(1): 42.

Shay, Don. 1989. "Dancing on the Edge of *The Abyss*." *Cinefex* 39(August). (Special issue on *The Abyss*.)

Silverman, Kaja. 1983. *The Subject of Semiotics*. New York: Oxford University Press.

Sitwell, Sacherverell. 1971. *Southern Baroque Art: A Study of Painting, Architecture and Music in Italy and Spain of the 17th and 18th Centuries*. Freeport, N.Y.: Books for Libraries Press. (Originally published in 1924.)

Sjöström, Ingrid. 1977. *Quadratura: Studies in Italian Ceiling Painting*. Stockholm: Almkvist and Wiksell International.

Snyder, Ilna. 1996. *Hypertext: The Electronic Labyrinth*. Melbourne: Melbourne University Press.

Sobchack, Vivian. 1987. *Screening Space: The American Science Fiction Film*. New York: Ungar.

Sobchack, Vivian. 1990. "Toward a Phenomenology of Cinematic and Electronic 'Presence': The Scene and the Screen." *Post-Script: Essays in Film and the Humanities* 10(1, Fall): 50–59.

Sobchack, Vivian. 1992. *The Address of the Eye: A Phenomenology of Film Experience*. Princeton: Princeton University Press.

Sobchack, Vivian. 2000. "Nostalgia for a Digital Object: Regrets on the Quickening of Quick Time." The Digital Cultures Project, Fall 2000 Conference, November 3–5. ⟨http: dc-mrg.english.ucsb.edu/conference/2000/PANELS/AFriedberg/nostalgia.html⟩.

Sobel, Dava, and William J. Andrewes. 1998. *The Illustrated Longitude*. London: Fourth Estate.

Soloman, Gregory. 1992. "The Illusion of the Future." *Film Comment* 28(2, March–April): 32–41.

Spencer, John R. 1966. "Introduction." In Leon Battista Alberti, *On Painting*, 11–32. New Haven: Yale University Press.

Stafford, Barbara Maria. 1994. *Artful Science: Enlightenment Entertainment and the Eclipse of Visual Education*. Cambridge: MIT Press.

Stafford, Barbara Maria. 1996. *Good Looking: Essays on the Virtue of Images*. Cambridge: MIT Press.

Stafford, Barbara Maria. 2001. "Revealing Technologies/Magical Domains." In *Devices of Wonder: From the World in a Box to Images on a Screen*, ed. Barbara Maria Stafford and Frances Terpak, 1–142. Los Angeles: Getty.

Stafford, Barbara Maria, and Frances Terpak. 2001. *Devices of Wonder: From the World in a Box to Images on a Screen*. Los Angeles: Getty.

Stallabrass, Julian. 1996. *Gargantua: Manufactured Mass Culture*. London: Verso.

Stein, Barbara Hadley, and Stanley, J. 1999. "Financing Empire: The European Diaspora of Silver by War." In *Colonial Legacies: The Problem of Persistence in Latin American History*, ed. Jeremy Adelman. New York: Routledge.

Steinhauser, Gerhard. 1976. *Jesus Christ: Heir to the Astronauts*. New York: Pocket Books.

Stenger, Nicole. 1991. "Mind Is a Leaking Rainbow." In *Cyberspace: First Steps*, ed. Michael Benedikt, 49–58. Cambridge: MIT Press.

Strauss, Frédéric. 1992. "Horreur Baroque: Ruiz au Portugal." *Cahiers du Cinéma* no. 452:12–13.

Strong, Roy. 1984. *Art and Power: Renaissance Festivals 1450–1650*. Berkeley, Calif.: University of California Press.

Suskind, Sydnie. 1996. "Hollywood Bytes." *Cybersurfer* 7(October): 28–40.

Sypher, Wylie. 1960. *Rococo to Cubism in Art and Literature*. New York: Vintage.

"*Terminator 2: 3D* Fact Sheet." 1997. Available at ⟨http://www.usf.com/new/news/press/factt2.html⟩.

Thomas, Peter N. 1995. "Historiographic Metafiction and the Neobaroque in Fernando del Paso's *Noticias del Imperio*." *Indiana Journal of Hispanic Literatures* 6–7(Spring–Fall): 169–184.

Thompson, Kristin. 1999. *Storytelling in the New Hollywood: Understanding Classical Narrative Technique*. Cambridge: Harvard University Press.

Thrower, Norman J. W. 1996. *Maps and Civilization: Cartography in Culture and Society*. 2nd ed. Chicago: University of Chicago Press.

Tuve, Rosemond. 1947. *Elizabethan and Metaphysical Imagery: Renaissance Poetic and Twentieth-Century Critics*. Chicago: University of Chicago Press.

Vallée, Jacques. 1965. *Anatomy of a Phenomenon*. New York: Ace.

Von Daniken, Erich. 1969. *The Chariots of the Gods?* London: Souvenir.

Wasko, Janet. 1994. *Hollywood in the Information Age: Beyond the Silver Screen*. Oxford: Polity.

Weinstock, Maia. 2002. "The Great Moon Race." *Discover* 23(1): 64.

Wertheim, Margaret. 1999. *The Pearly Gates of Cyberspace: A History of Space from Dante to the Internet*. Sydney and London: Doubleday.

Wilbur, Shawn P. 1997. "An Archaeology of Cyberspaces: Virtuality, Community, Identity." In *Internet Culture*, ed. David Porter, 5–22. New York: Routledge.

Wittkower, Rudolf. 1985. *Art and Architecture in Italy 1600–1750*. Middlesex, England: Penguin. (Originally published 1958.)

Wölfflin, Heinrich. 1932. *Principles of Art History: The Problem of the Development of Style in Later Art*. New York: Dove. (Originally published as *Kunstgeschichtliche Gundbegriffe*, 1915.)

Wölfflin, Heinrich. 1965. *Renaissance and Baroque*. (Originally published as *Renaissance und Barock*, 1888.)

Wollen, Peter. 1993. "Baroque and Neo-Baroque in the Age of Spectacle." *Point of Contact* 3(3, April): 9–21.

Wright, Karen. 2002. "When Is a Star Not a Star?" *Discover* 23(1): 28–29.

Wyatt, Justin. 1994. *High Concept: Movies and Marketing in Hollywood*. Austin: University of Texas Press.

Zatlin, Phyllis. 1994. "If It's Baroque, Fix It: French Response to Hispanic Theatre." *Monographic Review* 10:25–36. (Special Issue: Hispanic Contemporary Baroque.)

Index